THE
MYSTERIES
OF
CINEMA

PETER CONRAD

THE MYSTERIES OF CINEMA

Movies and Imagination

With 61 illustrations

Frontispiece
Jean Marais in Jean Cocteau's *Orphée*.

First published in the United Kingdom in 2021 by
Thames & Hudson Ltd, 181A High Holborn, London WC1V 7QX

First published in the United States of America in 2021 by
Thames & Hudson Inc., 500 Fifth Avenue, New York, New York 10110

The Mysteries of Cinema: Movies and Imagination
© 2021 Thames & Hudson Ltd, London
Text © 2021 Peter Conrad

Typeset in Carat Regular by Dieter Hofrichter
Additional design & layout by Mark Bracey

British Library Cataloguing-in-Publication Data
A catalogue record for this book is available from the British Library

Library of Congress Control Number 2020940836

ISBN 978-0-500-02299-3

Printed in China by Reliance Printing (Shenzhen) Co. Ltd

Be the first to know about our new releases,
exclusive content and author events by visiting
thamesandhudson.com
thamesandhudsonusa.com
thamesandhudson.com.au

CONTENTS

1

THE CINEMA AGE

At the end of the nineteenth century, an eerie marvel startled the world. A product of science, it challenged religion: thanks to a machine that could do the work of a god, light materialized in darkness and made images move. 'But the films!' exclaimed Leo Tolstoy in 1908. 'They are wonderful!' They had, the nonagenarian novelist declared, 'divined the mystery of motion', and he excitedly mimicked the insect-like buzz of the contraption that performed this feat: 'Drr! Drr!'

The shock of animation recaptured the moment in Genesis when clay was first imbued with life. Better yet, these moving pictures told stories without needing to rely on words, so the new art earned extra praise for overcoming the curse of Babel. In Genesis, when the earth was 'of one language', men built a sky-scraping tower that reached up towards heaven. A jealous God toppled the structure and, to ensure that his creatures could never again undertake such a grandiose collective work, confounded their speech. According to the myth, this was how monoglot mankind splintered into linguistic tribes whose members babbled at each other without being able to communicate. Cinema, which bypassed language altogether in its silent days, restored a universality that we supposedly lost when the tower fell.

In 1918, in an essay rejoicing in the advent of cinema, the surrealist poet Louis Aragon said that he was happy 'to be deprived of everything verbal': so much for the humanist definition of *Homo sapiens* as an animal uniquely endowed with the power of speech. Language had enabled us to argue, to tell lies. Cinema, by contrast, possessed an ecumenically sympathetic reach. Because Charlie Chaplin's battered but eternally resilient tramp never spoke, viewers everywhere could

7

laugh at his physical pranks or shed tears over his emotional distress. As cinema's first global celebrity, he made the whole world kin.

George Bernard Shaw took stock of an epochal change in 1914 when he welcomed cinema as 'a much more momentous invention than the printing press'. Shaw admired Chaplin, but thought that the possibilities of 'dramatic dumb show and athletic stunting' would soon be exhausted; instead he expected cinema to begin educating people as soon as 'the projection lantern begins clicking'. He hoped that these silent lectures delivered in what he called 'electric theatres' would contribute to the sum of our shared knowledge, 'spreading news, demonstrating natural history and biology' and so on. Cinema's true mission turned out to be less worthily literate: its gift to us is not information but empathy. Shaw's own drama upheld the primacy of talk, and in 1919 he forbade a cinematic adaptation of *Pygmalion*. 'How,' he demanded, 'can you film "Not bloody likely"?' But he was wrong to think that 'The silent drama is exhausting the resources of silence', as he claimed in 1924. Words can only approximate to the ideas or emotions they seek to translate, whereas the camera's first close-ups, studying the face as a living organism not a pictorial mask, suggested that it might be possible to film thought.

The new art looked at the world in new ways, and endowed human beings with sensory capacities and mental powers unknown before; this book sets out to explore the altered, heightened state of awareness that films induce, and to show how it has permanently changed our understanding of life. In 1929 the critic André Levinson boldly declared that cinema was responsible for the greatest 'philosophical surprise' since the eighteenth century, when Immanuel Kant demonstrated that time and space were subjectively perceived, not entities in themselves. Cinema, Levinson implied, went further: it made Kant redundant because it merged two categories of experience that had always been kept apart, and as a result it was able to convey the sensation of being alive.

Vitagraph, a studio that opened in Brooklyn in 1897, came up with an apt coinage: its products exhibited vitality. The Bioscope, a travelling film show that toured fairgrounds for a decade or so after the late 1890s, used a similar etymology to advertise the living things that could be seen on its screens. The name of cinema establishes that it is a product

of kinesis, devoted to the physical exhilaration of speed. Emerging among the gadgetry of the machine age, it has tirelessly invigorated us with the sight of people running or chasing each other or driving vehicles at maximum velocity. But cinema from its earliest days flouted the customary laws of physics in ways that athletes and automobiles could not. Time, no longer ticking at a steady pace, quickened or slowed down to match the speed at which film spooled through the projector, and space turned dynamic as the camera travelled through it. Reversed motion sent bodies skittering backwards, or made swimmers vault out of the water in defiance of gravity. Sitting still to watch a film, people twisted and turned through a demonstration of what Albert Einstein called relativity.

More than a technical innovation, Levinson considered cinema to be a Messiah-like 'cosmic agent'. It addressed a new audience of multitudes whom it turned into converts, worshippers of the exotic beings they saw on screen: a fan is a fanatic – the Latin word identified a temple servant, charged with tending the sacred fire. Vachel Lindsay, a proselytizing American bard who preached the gospel of cinema, said in 1915 that films were an answer to 'the non-sectarian prayers of the entire human race'. The Italian poet and essayist Ricciotto Canudo sensed a more Manichean force at work. In 1908 he declared that cinema's clockwork mechanism placed it under the sign of 'Ahriman, the master', the destructive spirit who rules the world in the dualistic doctrine of Zoroaster. When seen through the camera, substance becomes shadow, and our familiar world dematerializes. As Man Ray pointed out when describing the solarized photographs he made during the 1920s, images on film are 'oxidised residues… of living organisms' – luminous ashes. The same principle reduced the phantasmal gods and goddesses on the screen to will-o'-the-wisps, clouds of light.

Another disillusioning shock lay in wait. The animation that so thrilled Tolstoy turned out to be deceptive: in fact nothing in the movies actually moves. We are duped by a rapid succession of stills, which dazzle us and make us overlook the black bars between the frames; we surrender because cinema has skills that our blinking eyes lack. The camera can close in to focus on details, or it can retreat to a distant height to look

down at cities that float beneath us and mountains whose tops we graze as we seem to glide through the air. Now, as Shaw said about a 1912 documentary that followed Captain Scott's expedition, it was possible to see 'what the South Polar ice barrier is really like'. Impressed by such ocular forays, Shaw complained that films wasted our time by showing us people getting out of cars, opening doors, crossing rooms, mounting stairs – yet when those unremarkable movements are studied by the camera, they too exhibit character in action, as drama is supposed to do. A staircase was only of interest, Shaw said, if a comedian tumbled down it. Not so: just think of all the staircases that people apprehensively climb in the films of Alfred Hitchcock. These are life ladders or even a domestic Via Crucis, with unwelcome revelations on every landing and an abyss below for those who lose their footing, and it is only the cinema that has the flexibility to negotiate their convolutions.

Acting is not necessarily required of the astral creatures on the screen: what we want is simply to watch other people existing. We often find ourselves staring in wonderment as characters in films walk down a street away from us – sometimes swaggering, sometimes wiggling, occasionally improvising dance steps. And if they turn back to smile, we long to believe that they are recognizing our watchful, expectant presence in the dark. The surrealist André Breton asked himself 'what radiation, what waves' keep us there, hypnotized by those molten images. He suspected that the attraction was aphrodisiac, because no painting could equal the heat emitted by an on-screen kiss. He may have been right: in 1924 the Hollywood mogul Samuel Goldwyn complimented Freud as a 'love specialist', and said that he hoped to lure the psychoanalyst into a collaboration that would make his studio's products more erotically potent.

This was an art that worked out its aesthetics on the run. Cinema's early days were its most ingenious and idiosyncratic, and for that reason my book, while roving to and fro through the history of the medium, devotes much of its attention to the silent era. The filmmakers of that period – many of whom were brilliant theorists and critics as well as practitioners – had to devise wordless narratives, and in the process they unsettled ancient assumptions about the importance of language

and logical thinking. Snobs decried cinema as barbarous or savagely irrational. More often than not, the filmmakers took that as an accolade.

The camera wanted to look at everything, though it had no interest in seeing life steadily and seeing it whole, which was how a Victorian sage thought that serious-minded artists should proceed. Movies are inevitably jittery, unsteady, over-excited, and they present a world that is fractured, cubistically jarred, rendered strange by odd angles of vision or partial points of view. For cinema, reality has never been more than raw material, to be rearranged at will when editors piece together the scrappy alternative versions of the same thing that the camera has recorded.

Beginning in monochrome, cinema stages a metaphysical battle between white and black. The art's existence depends on the sun, but its most compelling stories are invaded by nocturnal devils or vampires who shun the daylight, and the cinematic genre of film noir is named after the blackness of its settings and the sombre, melancholy mental state that its dark cities induce. This dualism has a technical source. It reflects the reversibility of positive and negative: before a reel of film is developed, the bright carnal forms we admire on the screen look like skeletons or spectres. Sometimes the extremes at opposite ends of the spectrum overlap in a haunted obscurity, like that of the so-called grey matter we picture behind our eyes. When colour belatedly arrived on the screen, four decades after the first films were exhibited, it came as a virtual transfiguration. The street that leads to the celestial city of Oz is literally paved with gold.

Whatever the colour of the road, we are always being taken somewhere, with a breeze or a whirlwind behind us, because we are travelling on the celluloid ribbon that the director Frank Capra called 'the MAGIC CARPET of film!' Louis Aragon made a similar point: in 1918 he called cinema a form of 'modern magic' and marvelled at its 'superhuman, despotic power'.

When Aragon paid it this tribute, cinema's power already seemed superhuman, because it trapped ghosts and projected them through the air like spirits from a nether world; it exercised that power despotically by stirring up contagious sensations. Aragon thought that comedy on

film provoked the only truly uninhibited public laughter he had ever heard – a howling riot. The art historian Erwin Panofsky remembered that Berlin's first 'kino' early in the twentieth century had the English name of The Meeting Room, although its patrons did not go there to meet. Instead they huddled in the dark, side by side but not together, and waited for tidal waves of emotion to wash over them. Cinematic genres accordingly define themselves by the nervous responses they are designed to produce. Feel-good movies make it their business to put us in that mood, and thrillers are defined by the deliciously tingling alarm they engender.

Terror is no disincentive to this communal enjoyment, and several recent films picture the destruction of our world by nuclear winter, alien invasion or a cosmic traffic accident. In the beginning, cinema – still elated by the miracle of motion – was content to record everyday comings and goings in the street or on a railway platform. Now, having graduated from Genesis to anticipations of Armageddon, its ambitions are bolder: it wants to envision things we should hope never to see. Here is the ultimate proof of what André Breton, emphatically but a little nervously, called its 'power to disorient'. Breton believed that cinema was where 'the only absolutely modern mystery is celebrated', and more than a century after it helped to modernise the world, it remains mysterious.

The first half of my book considers the novelty of cinema, the often exalted claims made for it by early exponents, and its relations with the other arts. Next comes a section on technique and vision, dealing with the treatment of time and space, the advance from monochrome to colour, the trade-off between silence and sound, and the unique quirks of the editing process. The concluding chapters look at films about filmmaking, and lastly at the fate of cinema in our current audiovisual age, when images as a result of their very omnipresence have been cheapened and demystified.

* * *

When Breton fondly remembered the first silent films he saw – Chaplin comedies, or detective serials like Louis Feuillade's *Les Vampires* – he was in his mid-fifties and had outgrown what he called 'the cinema age'.

'This age,' he explained, 'exists in life – and it passes.' He might have been farewelling the age of faith, not without regret.

Breton wrote that in 1951. A few years later, my own cinema age began, and it lasted throughout my adolescence, ending when the play of light gave way to the more abstract games played by words. Back then it did not occur to me that films might be works of art; instead they were an enchantment. I doubt that I had ever heard the word 'cinema', which in Australia in the late 1950s would have sounded pretentious and British, just as 'the movies' would have been too brash, requiring an American accent. Even 'film' was a later and more adult designation, which I adopted in the mid-1960s when I joined a Film Society and began to watch people who spoke in French, Swedish and Russian. My weekly treat was known as 'the pictures'. A slangier and perhaps more accurate name was 'the flicks', because these pictures flickered, bemusing the eye and pleasantly confounding the brain.

The buildings where I spent my Saturday afternoons had outlandish names. One local haunt was called the Avalon, which alluded to a mystical island in Arthurian lore; nearby was the Odeon, which in classical Greece or ancient Rome would have housed song contests or recitations of poetry. True to their pedigree, these oblong boxes contained both blazing illumination and murky deception, and inside them I was introduced to primal emotions – feelings of awe and tingling astonishment or icy dread and outright panic, along with some unaccustomed sensual itches – that had no place in my suburban life during the rest of the week.

I always arrived early, wanting to enjoy the anxious wait for the moment when the lights dimmed, the curtains slid apart and the introductory fanfares sounded. My skin prickled at the sight of the studio logos, which transmitted siren calls from afar. London Films had Big Ben, staid and stern as its hands approached noon. Columbia personified America with a glamourized version of the Statue of Liberty, dressed for a Hollywood premiere but without her spiked crown. It rankled a little that the swivelling globe behind the golden letters of Universal-International stopped revolving when it got to what Americans call the western hemisphere and never reached Australia – but I accepted that

images had to be imports, generated by countries above the equator. What excited me was that films offered access to a larger world, commensurate with the elongation of CinemaScope or the widescreen process called VistaVision. I wanted to be taken, quite literally, out of myself. THE END, even if it was a happy ending for the characters in the story, always depressed me. Expelled into the daylight, I was left to count off the days before the heady experience could happen again.

My Saturday matinees consoled me for a few childish woes, and served as my equivalent to the Sunday mornings of my churchgoing Catholic relatives. It was a fair exchange, because cinema had the capacity to make mysteries visible. On a school outing to see Cecil B. DeMille's *The Ten Commandments* in 1957 we all gaped in amazement when the Red Sea parted, happily unaware that water mixed with gelatin had been dumped into cavernous tanks, then projected back to front and upside down. A year after the Red Sea performed its stunt, I was even more excited when I saw the detonator pressed at the climax of David Lean's *The Bridge on the River Kwai*. An expensive explosion – always one of the cinema's proudest feats, this time blowing up a train full of dignitaries along with the painstakingly fabricated bridge – surely outdid a divine portent.

Once I got past the piety of *The Ten Commandments* and the staunch military stoicism of *The Bridge on the River Kwai*, most of what I could discover about sex, crime and other transgressive matters came from films. At the start of the 1960s I was officially debarred from seeing *Some Like It Hot* and *Psycho*, which thanks to their delayed release in our remote location just about coincided with puberty. I sneaked in to see them anyway, and privately balanced their previews of what lay ahead – in one case, snuggled intimacy in a curtained bed on a train as it sped south through the night; in the other, purgative death in a shower and burial in the trunk of a car that is swallowed by a swamp. Perhaps Billy Wilder's wicked farce and Hitchcock's perverse black comedy were not so very different, because they both catered to a curiosity that deliciously mingled desire and fear.

Breton's cinema age coincides with the time of life when imagination is at its most febrile, and I impatiently checked off every

birthday as I came closer to the year when I would be admitted to films labelled AO, meaning ADULTS ONLY. Cinema's offerings had to be scrutinized and graded by the censors because it never subscribed to the ennobling agenda of the classical arts: it aimed instead to ravish the senses and probe the shadier recesses of the mind. In *A Matter of Life and Death*, written and directed by Michael Powell and Emeric Pressburger in 1946, we glimpse the process at work. Here while David Niven is being readied for brain surgery, the camera looks out from inside his head as he is anaesthetized, and his eyelid draws down a translucent screen lacily flecked with veins and fringed with curly lashes, like a curtain. Is he in an operating theatre or at the cinema? Frank Capra dared to call cinema 'a disease', claiming that it hormonally bullied the enzymes and took charge of the pineal gland. It 'plays Iago to your psyche,' he said – an entirely justifiable remark, although in Shakespeare's play Iago, lacking 'ocular proof' of Desdemona's infidelity, has to fall back on verbal suggestion to mislead Othello. Capra even likened cinema's effect to that of heroin. Among the surrealists, Robert Desnos shamelessly recommended films as 'superior to opium', all the more intoxicating because the drug was administered in the 'perfect night' of a theatre.

In those nocturnal rooms, an invisible border separated light from darkness, fantasy from reality, stardom from anonymity. When Chaplin stepped down from the screen to fraternize with his admirers, he felt diminished as he travelled the wrong way across the frontier. People, he said, were dismayed to discover that he was 'just human'. The appeal of the larger, more exalted cinematic existence that Aragon called superhuman is so irresistible that even characters watching films-within-films sometimes wish that they too could enjoy it. 'Why can't life be more like the movies?' asks a crestfallen actor in Anthony Asquith's *Shooting Stars*, released in 1927, as he sees himself swashbuckling on screen. It is a common complaint, virtually a syndrome. A young man and woman in *People on Sunday*, made in Berlin in 1929, resent having to compete with the gallery of pin-ups on their bathroom wall. As they prepare for a day out, he dabs shaving foam on the dapper Willy Fritsch, and she uses her curling tongs to singe the operetta star Lilian Harvey, to whom

he is partial – an early acknowledgement that such idols are secret sharers in our emotional lives.

Cinema supplies the personae we try out when auditioning to play a starring role in our personal stories. In the screwball comedy *Bringing Up Baby*, Katharine Hepburn bluffs her way out of jail by pretending to be a gun moll who has decided to co-operate with the police; to carry off the act, she draws on scraps of hard-boiled banter recalled from gangster movies she has seen. Elvis Presley memorized James Dean's dialogue from *Rebel Without a Cause*, and said he could have watched the film a hundred times because he viewed it as his autobiography. A would-be gangster in Quentin Tarantino's *Reservoir Dogs* is ordered to work on his swagger and his slurred speech: 'An undercover cop's gotta be Marlon Brando,' he is told. Cinema endorses a myth of self-reinvention, as it famously did in the case of a man born in Bristol who was advised by a Hollywood producer to change his name to 'something more all-American, like Gary Cooper'. Reversing Cooper's initials, Archibald Leach became a debonair mid-Atlantic fellow called Cary Grant – or at least he impersonated that entirely fictitious being. 'Everyone wants to be Cary Grant,' the former Archie later said; Tony Curtis's sly adoption of his geographically unplaceable accent in *Some Like It Hot* proves the point. 'Even I want to be Cary Grant,' Grant plaintively added.

Appropriating terminology from the Eucharist, the avant-garde director Jean Epstein said in 1921 that cinema, which magnifies the human face and then minutely examines its emotional tremors, makes manifest 'the miracle of real presence'. Or does it mock the sacraments, making manifest an unreal absence and tantalizing us with images of perfection – the face of Greta Garbo, the body of some gym-fit Adonis – that are beyond our grasp? In Fritz Lang's 1952 thriller *Clash by Night*, Paul Douglas tries to impress his wife Barbara Stanwyck by boasting that his friend Robert Ryan is 'in the movie business', although he merely works part-time as a projectionist at a small-town theatre. Perhaps Ryan's job explains his rancorous temper and his eventual attack on Stanwyck: his business is 'running movies', but they always outrun him. He wants, he says, to slash the 'celluloid angel' who simpers on screen as he changes reels; though he manhandles such beauties all day,

they are unresponsive to his touch. In 1968 in John Cassavetes' *Faces*, a woman fends off her husband's clumsy entreaties by saying she's not 'a sex machine'. 'No,' he grumbles, 'you'd rather go to the movies.' That is where we both lose and find ourselves.

Cinephiles hope, as I did in my own unmapped world, that their lives will be validated by fiction. In Walker Percy's novel *The Moviegoer*, published in 1961, the narrator goes to see *Panic in the Streets*, a grimy thriller about pneumonic plague, in a cinema very near one of the New Orleans locations used in the previous decade by the director Elia Kazan; he emerges feeling that his home town has been 'certified' – given permission to exist. An early Michelangelo Antonioni film, *I Vinti*, re-enacts a series of crimes committed by members of a post-war generation who grew up as imitators of the bolder, larger life represented by movies. Like Brando in 1954 in Kazan's *On the Waterfront*, the characters in *I Vinti* want to be 'contenders'; their offences are an attempt, Antonioni said, 'to affirm, in the sinister light of a cruel gesture, the victorious culture of the self'. The gesture no longer needs to be cruel, and the affirmation nowadays is instant and potentially limitless in its reach. Smartphones allow any of us to star in a self-directed and self-flattering biopic, with friends and acquaintances as a supporting cast and scenic landmarks as backdrops, all squeezed onto a screen no bigger than the hand that holds it.

Is this the dead end to which the art and its offshoots have led, after only too successfully taking over the world? Luckily, an alternative appears in Giuseppe Tornatore's *Cinema Paradiso*, made in 1988 – a myth of origins in which the miracle-making art reconvenes a communal Eden. Here the cinema in a Sicilian village, more inviting and more truly consoling than the local church with its dreary Masses, welcomes and embraces everyone. In its darkness, adolescent boys masturbate and courting couples make love; a mother suckles her baby while laughing at a comedy, and an over-excited old man dies of a heart attack in his seat as gangsters from another film discharge their machine guns at him. Because the building can hardly contain the teeming illusions conjured up inside it, the projectionist says 'Abracadabra' and redirects the animating beam of light from his booth onto a wall in the public

square, where the villagers congregate to enjoy this walking, talking mural. And although the local priest forces the projectionist to cut out all suggestive embraces from the films he shows, he secretly hoards the deleted fragments and splices them together into a reel that consists of nothing but kisses, ranging from chaste to torrid – an anthology that confirms Breton's point about the vital heat that attracts us.

Tornatore's hero, who begins as a schoolboy helping out in the projection booth and grows up to direct films of his own, looks back at an unfallen paradise. When the cinema age ends, what follows is likely to seem an anti-climax.

2

FANTASTIC VOYAGES

The world's enthralment began during an industrial conference in Paris in March 1895, when Louis and Auguste Lumière hired a room in a café to display the results of a technique they had patented for feeding perforated film through a camera and a projector. They presented ten cinematic glimpses of daily life, each lasting less than a minute. Their subjects – street scenes, a prank with a garden hose, blacksmiths at work – now seem ordinary enough, but to unaccustomed eyes they must have looked like the documentation of a world freshly created, stocked with a busy plethora of living beings.

A jovial muddle pours through factory gates in Lyon, with women carrying babies and baskets, and some stray dogs going nowhere in particular. In Paris, the Lumières filmed a more orderly Eden, as a convoy of nurses deliver tots sitting up in prams to a nursery: have they emerged from another factory where the human race is reproducing itself? At the end of this little film, a runaway infant scampers off in the opposite direction – evidence that cinema might not be able to control the frisky vitality it records. In their home movies, the Lumière brothers advanced from Genesis to the first Christmas, with a family gathered around a crib. During breakfast at a table in the garden, Auguste Lumière's baby daughter reaches out smiling, as if offering a rusk to the parent who begot her and is now conferring on her a kind of immortality. Another child takes her first steps along a path and – because this new art has already begun to fabricate drama – is allowed by her nurse to stumble into a crack.

Later the Lumières and their collaborators discovered that their machine could stage the supreme biblical miracle, effecting a resurrection. In *Accident d'automobile* we see the battered corpse of a pedestrian

who has been run over by a car. Then, once the camera has stopped to allow for the dummy to be replaced, the victim recovers and staggers away. Disaster can be undone or reversed: in another film, a gang of workers demolish a wall, battering it into powder, after which it instantly pieces itself back together and stands up again.

Despite these feats, Louis Lumière supposedly claimed that 'The cinema is an invention without a future', a novelty that would soon go out of fashion. Others disagreed. Canudo, in one of his rhapsodies about the new art, said that the images it projected had a 'spiritualized character', transforming solid objects into ether, and he predicted that the rooms in which people gathered for these séances would become the temples of the future. In 1924 Jean Epstein saluted Canudo – who by then was dead, having missed the chance to see the medium turn into an art – as a missionary. The cinema, Epstein said in his tribute, was now in its apostolic period; aligning it with the history of religion, he saw this as the time of the church militant.

'Transubstantiation must begin,' demanded Vachel Lindsay. As he saw it, the camera mystically changed whatever it photographed, like the body and blood of Christ when offered to believers as bread and wine. The metaphor suited Lindsay's exalted view of filmmakers as 'prophet-wizards' who, as he put it, wrote inscriptions on the air with letters of fire. He rallied these visionaries to move their art's headquarters from New York to California, whose landscape set an example of 'Patriotic and Religious Splendour'. Raoul Walsh answered that challenge in his Western *The Big Trail*, released in 1930. Here John Wayne guides a group of pioneers from Missouri to a fabled valley on the Pacific coast where the trees, he says, look as if they wanted to grow tall enough to touch heaven. For Lindsay too, the giant sequoias were the pillared aisles of American nature's own cathedral, and he thought that they exhorted 'the California photo-playwright' to join the 'campaign for a beautiful nation'. Cinema could not remain in the domesticated Eden of the Lumières; its manifest destiny lay, according to Lindsay, in a virgin land that the camera was seeing for the first time.

Although Jean Epstein lacked that wide-open American perspective, the version of the way ahead that he propounded in essays written

during the 1920s foresaw an equally intrepid metaphysical adventure. Epstein thought that cinema specialized in the 'subtle metamorphosis of stasis into mobility, of gaps into wholes'; it took over from the medieval pseudo-science of alchemy, which challenged God's creative priority by pretending to deploy 'the power of universal transmutations' to turn base metals into gold. That project may have been bogus, but Epstein's modern alchemists could rely on a mind-bending technical trickery. Cinema altered temporal duration and disrupted space by shifting the camera's position, and this made it, for Epstein, 'a kind of witchcraft, akin to that of the prophet Joshua' – presumably a reference to Joshua's visualizing of God's tabernacle, and intriguingly close to Lindsay's description of directors as 'prophet-wizards'.

Epstein claimed that cinema's jump cuts, substitutions and metamorphoses introduce us to an 'anti-universe', a less holy and healthy place than Lindsay's California with its 'genius for gardens and dancing and carnival', its 'plant arrangement and tree-luxury'. Nature is excluded from Epstein's ludic realm, where we are freed 'from servitude to the single rhythm of external, solar and terrestrial time'. René Clair's *Le Voyage imaginaire*, released in 1926, is set in just such a wonderland: in a warped Paris, an amorous bank clerk is chased around the ramparts of Notre Dame by a bulldog and locked up overnight among the gibbering waxworks of the Musée Grevin. Clair's film inadvertently shows off the kind of transmutation that Epstein likened to the experiments of the alchemists. At one point in the film a close-up of a young woman is instantly followed by one of the angry bulldog that persecutes the clerk. Clair reported that a boy watching the film yelped in alarm when he saw this: not having adjusted to the medium's abrupt transitions, he thought that black magic had turned a person into an animal.

The title of Clair's fairy tale was opportune, because Epstein called cinema 'the most fantastic voyage, the most difficult escape, that humans have ever attempted'. The escape was difficult because it had to discard centuries of indoctrination. Rather than lecturing the left brain, which thinks in words and operates rationally, cinema ingratiated with the right brain, the home of visualization; it favoured the free association of images rather than the logic of constructed sentences. For that

reason, moralizing intellectuals mistrusted it – in 1926 Virginia Woolf said that cinema 'agreeably titillated' the brain, allowing it 'to watch things happening without bestirring itself to think', and Graham Greene complained in 1925 that 'exaggerated sex is the hallmark of the average film' – while audacious immoralists exulted in its sense of liberty.

In 1939 the novelist Henry Miller praised Walt Disney's cartoons because they encouraged audiences 'to rape and kill and bugger and plunder' – or at least to imagine doing so. Miller was equally enthusiastic about the outrages in Luis Buñuel's *L'Age d'or*, where a dog is run over, a blind man is roughed up, and a pair of lovers grind their bodies together on the ground during an open-air concert: this surreal farce, Miller said, bypasses the intellect and the heart and 'strikes at the solar plexus' or incites a 'distillation of the glands'. Seen this way, the ideal cinematic subject is the lethally amoral Lulu, played – or incarnated – by Louise Brooks in *Pandora's Box*, G. W. Pabst's silent version of Frank Wedekind's play *Erdgeist*, released in 1929. In one astonishing episode Lulu storms offstage in a jealous fury when her protector Dr Schön brings his well-born fiancée to see her dancing in a revue, and in a showdown backstage she compels him to break his engagement. Her methods of persuasion are those used by infants: a pouting face, a stubbornly shaking head, the angry kicking of a bare leg as she throws herself onto a divan and pretends to sob. We do not need to hear the verbal argument, because Brooks' body does the talking, after which – having made Schön agree to marry her instead – she instantly forgets her tantrum and scampers away to perform her titillating routine.

Films are a playground for such instinctive creatures, who are seemingly unburdened by self-reflection. In 1932 Salvador Dalí, who collaborated with Buñuel on *L'Age d'or*, suggested that cinema's gift to us was a 'systematic and concrete irrationality', which for him was exemplified by the Marx Brothers' comedy *Animal Crackers*. The revelry here is mindless, which is why it so effectively sabotages the respectability of Margaret Dumont, the hostess who unwisely welcomes the rampant fraternity of Marxes into her house. Groucho befuddles the guests with his logorrhea, Chico's piano-playing gives a sentimental Victorian ballad a raucous honky-tonk inflection, and Harpo ether-

izes a crowd with insecticide from a Flit gun. Meanwhile the electricity goes randomly on and off, like the light and darkness that subliminally alternate as we watch the film. Cinema doubles as a hilarious Bedlam.

Among other things, Epstein's humans were escaping from the tug of gravity. In 1924 in Raoul Walsh's *The Thief of Bagdad*, Douglas Fairbanks and his princess leave the minareted city on a flying rug, and when Albert Einstein visited a Hollywood studio in 1931, he was filmed in a car that sped down a city street at reckless speed, then soared directly into the sky. The vehicle was stationary, and in any case Einstein never learned to drive; the aerial excursion depended on back projection, but it proved his theory about inertial observers who – like all of us as we watch events on a screen – feel themselves to be in a state of relative motion. Such ventures proudly demonstrate the sublimation that cinema offers us. Federico Fellini's overwrought director in *8½*, played by Marcello Mastroianni, plans to take his entire cast of grotesques into orbit in an unbuilt spaceship, perhaps calculating that the earth is too humdrum a setting for them. With no need for jet propulsion, Andrei Tarkovsky filmed two such excursions: a hot-air balloon has a short, bumpy flight from the roof of a church in *Andrei Rublev*, and in *Ivan's Childhood* a boy chases a butterfly and then skims above a birch wood, lifted up by sheer elation. Floating over Berlin, the angels in Wim Wenders' *Wings of Desire* enjoy what one of them calls 'this spiritual existence', a privileged perspective that is a gift of the camera.

In its first decades, cinema made two very different trips to the moon, one humorously lunatic, the other sternly scientific, with the directors Georges Méliès and Fritz Lang as respective flight commanders. In Méliès' *Le Voyage dans la lune*, made in 1902, a cannon fires a deputation of white-bearded astronomers into outer space; reaching its destination, their capsule pokes the man in the moon in his eye. They ogle a twinkly feminized star attired in a ballgown, muddle through a skirmish with the natives, then gratefully career back from the stratosphere to their earthly habitat. In 1929 Lang's *Woman in the Moon* took the enterprise more seriously, hiring a rocket scientist as a technical adviser. The aim of this empire-building expedition is to bring back the moon's supposed reserves of gold, and an armed conflict ensues between physicists and

profiteers. Eventually the disillusioned pilot decides to stay behind on the moon, with a female colleague as his partner in this pale, infertile Eden. Between them the two films offer a choice: is cinema a fantastic voyage that ends in a soft landing, or might it be a symptom of our engineered alienation from reality?

* * *

The camera can scrutinize subjects through a microscope, or look at them telescopically from afar; either way, it dislocates the ordinary focus of our gaze.

In 1928 Carl Theodor Dreyer's *La Passion de Jeanne d'Arc* used the close-up as a form of psychological surgery, exposing 'a soul behind the façade' by examining the misery and anguish registered in the eyes of Renée Falconetti, who played the martyred saint. In Roberto Rossellini's *Fear*, made in 1955, the visual inquisition has a high-minded alibi. Here Ingrid Bergman's husband is a scientist whose research ventures into 'the dangerous territory between life and death'; he justifies his cruelty to laboratory animals by saying he hopes to discover a form of 'narcosis' that can be used 'to rid humanity of a terrible scourge'. A director as much as a doctor, he applies the same techniques when he enlists a blackmailer to torment his wife, and as the plot unfolds we see Bergman's face subjected to an agonizing stress test. The experiment continues in 1966 in Ingmar Bergman's *Persona*. The film's title refers to the hieratic masks worn in the classical theatre, and it warns that his two characters – Liv Ullmann and Bibi Andersson, respectively an actress who has suffered a nervous breakdown on stage and the nurse who looks after her as she convalesces – will be allowed no such armature.

At close range, the camera studies individuality and idiosyncrasy, but the further it retreats, the more interchangeable and perhaps insignificant it shows us to be. For *The Gold Rush*, Chaplin emptied a hobo camp in Sacramento and transported its five hundred residents north to trudge up the distant vista of a steep mountain in a desperate quest for wealth, so that society's dropouts could play themselves. At the Atlanta train station in *Gone with the Wind* a crane shot strands Vivien Leigh among the remnants of the Confederate army: eight hundred wounded

soldiers littered across the red earth, supplemented by the same number of inert dummies that were surreptitiously rocked from side to side to simulate dying agonies – cannon fodder and now camera fodder as well. To fill up such panoramas, cinema invented the category of the 'extra', referring to people who are superfluous (and who nowadays would be made redundant by digital fiddling).

In 1922 the art historian Élie Faure said that cinema embroiled its audiences in 'synthetic poems' that released energy as a volcano does when it erupts. King Vidor's *The Big Parade* and *The Crowd*, released in 1925 and 1928 respectively, are early examples. The big parade, which convinces a rich playboy to join the army when America joins the war in 1917, is a big show. The hero signs up because of a catchy patriotic chorus that has him tapping his feet, and when the GIs reach the front in France an intertitle exclaiming about the cacophony that greets them might be an advertisement on a movie marquee:

> Men! Guns! Men!
> Men! Guns!

A similar regimentation prevails back in New York in Vidor's later film: the harassed hero of *The Crowd* is yelled at for not facing forward in a packed subway car. Instead of risking himself in the trenches or wriggling on his belly across no man's land like the recruits in *The Big Parade*, he is merrily pummelled and discombobulated at Coney Island, where the violent delights include a slippery slide, a churning boat, and an array of spinning platforms. Back in Manhattan, his daughter is run over by a truck outside the tenement in which they live; the accident is one more thrill ride for the jostling crowd, which gathers around to enjoy the show and even invades the bedroom of the injured, dying child when she is carried indoors. As at the movies, the woes of others count as entertainment.

Cinema's demagogic appeal made it a useful vehicle for propaganda, regardless of ideology. In Russia in 1925, Sergei Eisenstein's *Battleship Potemkin* used the techniques of the art as training in agitprop, with the associative leaps of montage enforcing moral equations. The verminous carcases fed to the sailors suggest that people are being treated

like worms. Below decks, off-duty sailors rock in chrysalis-like hammocks, which implies that they need to be awakened, aroused. When flags semaphore the message 'Join us!' to the admiral's ship, we are all being exhorted. 'The individual personality,' as an intertitle in *Potemkin* proclaims, must be 'dissolved in the mass', a claim that is illustrated by breakers foaming as they lash the shore.

In Germany, the mass was less oceanic than in *Potemkin*; its unanimity – marked by helmeted heads and a robotic strut in Leni Riefenstahl's *Triumph of the Will* – looked metallic and mechanized. Joseph Goebbels called politics an art, 'the highest and most comprehensive there is', and said that 'modern German policy' sculpturally moulded the raw clay of the mass into 'the firm concrete structure of the people'. Riefenstahl's documentary about the 1934 Nazi Party congress at Nuremberg shows a society being forcibly melded into solidarity, with torch-lit marches by concrete beings from whom all humane vulnerability has been expunged. Goebbels called the camera 'our modern artificial eye' and said that it acted as 'a sworn witness to the new age': visual testimony, no longer random, was taken under oath.

In America, Busby Berkeley offered musical uplift to a 'forgotten man' in *Gold Diggers of 1933*, where Joan Blondell grieves over the once-triumphant veterans of the Great War who now slump drunkenly in gutters or shuffle in depressed breadlines. At first she speaks rather than sings, and delivers a sermon about social justice; finally a needy mob kneels at her feet as she keens a lament. The unemployed return to the land in King Vidor's *Our Daily Bread*, setting up an agricultural commune where skills are pooled. An impoverished fiddler is initially turned away because only manual workers are wanted, but he is allowed to join after he pleads that he uses his hands when playing his instrument.

Frank Capra dedicated himself 'to the service of man, to the making of films about "we the people"', and sketched radical forms of relief for 'the pushed-around little guys'. His *Meet John Doe*, released in 1941, begins with a montage of madding crowds, including a scene of workers leaving a factory at the end of their shift, looking glummer and wearier than those photographed by the Lumière brothers in Lyon. But the populist pledge is contradicted by the camera's aesthetic snobbery. A

newspaper searches for a homeless man whom it can depict as John Doe, a typical victim of economic circumstances. The quest turns out to be a beauty contest, won by Gary Cooper thanks to his height, lanky grace, and bashfully ingratiating manner; others are rejected because they are genuinely average-looking, which makes them unphotogenic. As if augmenting Epstein's view that cinema was in its apostolic period, Capra devised blueprints for salvation and imagined a pair of quixotic saviours. In *American Madness* a banker makes loans based on the moral character of applicants, not their credit-worthiness; in *Mr. Smith Goes to Washington* a bucolic idealist who ought to be marshalling a Boy Scout troop is elected to the Senate and calls to order a corrupt, ineffective government.

Perhaps the furthest reach of this ministry to mankind came at the end of 1959 when Stanley Kramer planned a worldwide premiere for his adaptation of Nevil Shute's novel *On the Beach*. The book envisions the gradual extermination of the human race after a brief and pointless nuclear war; it is set in Melbourne, where the doomed citizens prepare to die as radioactivity drifts down from the northern hemisphere. Kramer arranged for *On the Beach* to open simultaneously in Europe, the Americas, Asia and Australia, as proof of his ambition 'to create a film for people in the power of their mass, a film that might make people everywhere feel compassion for themselves'. The mass medium first convened a global community, then confronted it with the spectacle of its own extinction.

* * *

But can a contraption with a glass eye really exhibit the solicitude Kramer hoped for? In practice, as the philosopher Rudolf Arnheim said in 1933, 'Film is the incorporation of people into the world of objects.'

This had alarming consequences. The camera did not discriminate between the corporeal and the incorporeal, and people in early films, moving jerkily as a result of variable projection speed, often looked more like objects than subjects. Chaplin gets away with camouflaging himself as a sideshow automaton in *The Circus*, exactly mimicking its stiff, angular gestures. In 1928 in René Clair's farce *The Italian Straw*

Hat props no longer remain subservient and safely inanimate. During his wedding ceremony an agitated bridegroom worries about the devastation back at his apartment, which an irate soldier has threatened to trash. He imagines his home dismantling itself: furniture sails out the window in slow motion, a double bed solemnly trundles through the front door, and the walls then peel off, so that the building seems to be flayed by some invisible force. Cinema often surveys a world that consists of objects that have rejected or outlasted the people who once owned them. The vast open-air market of stolen goods in Vittorio De Sica's *Bicycle Thieves*, released in 1948, is one example; another, from 1993, is the pile of shoes left behind by the gassed internees of the concentration camp in Steven Spielberg's *Schindler's List*.

In 1929 the Russian newsreel director Dziga Vertov presented his *Man with a Movie Camera* as 'an experiment in cinematic communication' that did without intertitles, script, trained actors and theatrical sets. As the film begins, a camera magnified to the size of an industrial machine stares at us with its 'Kino-Eye'; a miniaturized cinematographer – played by the director's younger brother – briefly bestrides it before climbing down into its shuttered interior. He reappears intermittently, seen usually from behind, as he carries the tripod through a crowd or crouches like a rider on horseback while he cranks it in a car speeding through the streets of Moscow. He sets up the camera in between tramlines, or hovers with it above the racing water of a hydroelectric installation, apparently expecting it to protect him from danger.

During the frantic montage of images, a human eye is superimposed on the vitreous lens, to announce that the Kino-Eye has transformed sight into an unblinking scrutiny of what Vertov called 'visible events'. It was Vertov's aim to 'emancipate the camera' from its subservience to the 'none too clever human eye', and finally we see the machine dispensing with its human operator. Granted its own curtain call at the end of the film, the spindly tripod performs a three-legged mechanical ballet, then screws the camera onto this base as if the trunk had decided to attach a head; it twiddles its knobs, gesticulates with its levers, and inclines its square cranium to acknowledge the applause of a proletarian audience. Does this self-confident, apparently indestructible movie camera even

need a man to operate it? Vertov ingratiated with the machine by jokily dehumanizing himself: born David Abelevich Kaufman, he adopted a pseudonym that referred to a vertiginous spinning top, which made him a personification of cinema's perpetual motion.

Buster Keaton derived a more fearful comedy from his efforts to keep pace with the machine. Keaton was entranced by Fatty Arbuckle's Bell & Howell cameras, which he first encountered in a Manhattan studio in 1916. He asked to borrow one overnight, and sat up disassembling it to discover how it worked. The machine, he knew, might possess skills superior to his own, or a maliciously playful independent will. In *The Cameraman*, released in 1928, Keaton plays an incompetent photographer who ekes out a living making tintype portraits in the Manhattan streets. Engaged to shoot newsreels, he is befuddled by his new equipment. He cranks the handle the wrong way so that athletes jump backwards; when he films the traffic, his double exposures create a pile-up. His career is salvaged by an organ grinder's monkey, which seizes control of the camera and records Buster heroically rescuing his girlfriend after a mishap during a boat race. As in Vertov's film, the man is the camera's appendage, not vice versa.

The symbiosis of man and machine prompted others to think again about the internal operations of their minds and bodies. Emile Vuillermoz, a French musician who wrote incisively about cinema during the 1920s, compared the frames on a reel of film to human brain cells, and thought that the way those reels shuttled through the projector duplicated the mind's 'overwhelming rapidity of perception'. Franz Kafka called himself 'an eye-man', but felt he was 'too "optical" by nature' to permit his gaze to be directed and disciplined by the camera. 'The cinema,' Kafka told his friend Gustav Janouch in the early 1920s, 'puts the eye into uniform, when before it was naked.' The painter George Grosz had fewer qualms about renouncing his physiological liberty. Grosz likened himself to a filmstrip, with 'someone... always cranking the handle': his thoughts and sensations unreeled in obedience to automated, mechanistic instincts. The forms preserved on celluloid are ghosts or skeletons, which startled Ingmar Bergman into a chilling self-realization. Remembering his youthful emaciation, Bergman once said 'I was as thin as a scratch on

a negative'. The comment translated self-dislike into a technical flaw, and came close to self-erasure. On another occasion Bergman claimed that certain convulsive episodes in life embed themselves 'in your own cinematograph' and are projected unstoppably inside the head. In childhood, the world around him seemed 'unreal' because unedited: random events were 'like bits of film loosely put together'. Later, film studios offered Bergman a sense of security he could find nowhere else. He rejoiced in a shared intimacy inside 'the magic circle of the lights': human warmth, for this austere man, was supplied by arc lamps.

We have all absorbed cinematic conventions, which by now are second nature to us, a shorthand for emotional crises or psychological attitudes. In Richard Linklater's *Before Midnight*, an unexpected fight ruptures the marriage of Julie Delpy and Ethan Hawke. 'Definitely not a slow fade,' Delpy says, editing her emotional history as it happens. Camera angles likewise define our world view. Orson Welles suggested that tragedy is life seen in close-up, whereas comedy – as in the last scene of his Shakespearean digest *Chimes at Midnight*, when Falstaff's outsize coffin trundles off into the distance – withdraws to a long shot, retreating from individuals. Bergman had a more psychologically fraught version of the choice between angles. A close-up for him was the equivalent of studying yourself in a mirror and goading your demons to express themselves, which is what Robert De Niro does in *Taxi Driver* when he taunts his own reflection; the long shot, by contrast, withdrew to a safe distance out of 'revulsion and fatigue', signifying for Bergman a failure of courage rather than Welles's all-encompassing acceptance of the way the world is.

Taking note of the cine-camera's photo- and electromechanical sensors and its chemical memory, Epstein decided in 1946 that it belonged to the genus of 'still partially intellectual robots'. This 'cinematographic apparatus', as he called it, is responsible for a series of disillusionments. It disproves the solidity of our world, which atomizes before our eyes. Energy has condensed into granules; in the fuzzy texture of monochrome film the grains separate again, just as later the searingly vivid palette of Technicolor served as a reminder that the prismatic spectrum is subjective, a trick of light like cinema itself.

The camera's 'robot-brain', Epstein argued, induced a further 'upheaval in the hierarchy of things'. Objects when enlarged are invested with 'an immense emotional force'. As examples, Epstein randomly listed 'a key, a knotted ribbon in a woman's hair, or a telephone'; films made by Hitchcock show these very objects undergoing that metamorphosis. The key, which opens a cellar and discloses a nuclear secret, is tightly clasped in the hand Ingrid Bergman holds behind her back in *Notorious*, and the telephone, whose rotary dial is able to order a death, controls the plot of *Dial M for Murder*. Although Kim Novak in *Vertigo* wears no ribbon, the whorl into which she twists her blonde hair impels the camera to peer closely at the back of her head, probing an aperture that might allow entry to her consciousness.

The hierarchy of things – of valued belongings, of the language that identifies them, and of narrative, which is supposed to proceed, like life, from beginning to end – undergoes yet another upheaval in *Citizen Kane*. Kane's mouth, which is all we are allowed to see of him, utters the enigmatic word 'Rosebud' as he dies at the start of the film. At the end, we see what this refers to – a sled left over from childhood, glimpsed as the lettering on it blisters and melts in a funeral pyre. It possesses only sentimental value, but for that reason it may be the magnate's most treasured possession. None of the bystanders investigating Kane makes the connection; the camera, undistracted by what people wrongly consider significant, is a more reliable narrator.

* * *

The painter Fernand Léger welcomed cinema because it was 'on an equal footing with the street, with life…It is in shirtsleeves.' Writing in 1933, he might have been describing the Lumière film that began it all, in which shirt-sleeved workers stroll out of their factory in Lyon and amble off down the street. Cinema, however, had other aims, less rudimentary than Léger's insistence on an art that was 'mass-produced, ready-made'.

A friction between cinema's mechanical sources and its more otherworldly yearnings runs through its history. A movie studio, Jean Cocteau said, is 'a factory for making ghosts', and the films made there

occasionally tell stories about manufacturing such ectoplasmic creatures. A potter in Kenji Mizoguchi's *Ugetsu* has a fatal romance with a spectre, Kim Novak in *Vertigo* plays a Doppelgänger who may be a revenant, and a detective in Otto Preminger's *Laura* becomes so obsessed with the portrait of a murder victim that he is almost disappointed when she turns out not to be dead. In Antonioni's *L'Avventura* a bored social-ite on a Mediterranean cruise disappears on a rocky volcanic island. She simply evanesces, like a projected image effaced by daylight; no explanation is ever given, and her friends soon abandon their search for this wraith. Here lies cinema's outer limit, the border of visibility across which it has repeatedly ventured.

At their most ambitious, films do more than document the human and mechanical traffic of the streets; they contemplate a reality we usually take for granted, which is rendered significant, perhaps even redeemed, by being studied so compassionately. 'Doesn't Christ see us?' asks Anna Magnani in Roberto Rossellini's *Rome – Open City*, made in 1945 during the last days of the German occupation. She is talking to a priest, who paraphrases her question by agreeing that people often ask 'Doesn't the Lord see us?' Later, when Magnani is shot down in the street by German soldiers and the priest is executed for espionage, it is the camera that sees them, paying tribute to their courage and memo-rializing their sacrifice. Fritz Lang, cast as himself in 1963 in Jean-Luc Godard's *Le Mépris*, acknowledges the change when he broods about his efforts to make an absurdly improbable film of *The Odyssey*. 'The eye of the gods,' he says, 'has been replaced by the cinema.' Homer's Olympians saw human beings as a lower, feebler species. In defiance of that haughty attitude, we have developed a technology that venerates the human face and tries to intuit what lies behind it, while scanning the upper air to ascertain that there are no gods installed there.

To compensate for this evacuation of the sky, cinema gave birth to divinities of its own. MGM placed on show a pagan pantheon, claiming that it had under contract 'more stars than there are in heaven' – mortals etherealized by light and smoothed into perfection by cosmetics. In 1940 Busby Berkeley's musical *The Ziegfeld Girl* arrays three aspirants on a spiral staircase. At the apex, Hedy Lamarr is explicitly celestial,

with a head-dress of sparklers sprouting from her shoulders; on a lower step, the plumply cherubic Judy Garland is one of the lesser angels; still further down, Lana Turner, with spangles below the waist and bare legs, might be a temple prostitute, available to acolytes (or film fans) for whom prayer and erotic fantasy intermingle. In 1947 in Alexander Hall's *Down to Earth* the Olympian deities overhear rumours about a Broadway show in which 'hot goddesses' are to be rescued from neo-classical pallor and presented in Technicolor as man-hungry hoydens. Terpsichore indignantly descends from the sky to correct this irreverence; because she is played by Rita Hayworth, she confirms it instead.

The casting of Charlton Heston in *The Ten Commandments* was clinched, for Cecil B. DeMille, by his resemblance to the craggy Moses sculpted by Michelangelo. Somewhat more daringly, the movie-mad heroine of Gore Vidal's novel *Myra Breckinridge* suggests that 'the actual Christ' could not have possessed 'a fraction of the radiance and mystery of H. B. Warner' in *King of Kings*, a messianic biopic made by DeMille in 1927. Given that the biblical original had no Hollywood lighting technicians to embellish his charisma, she may have been right. In 1966 the Bollywood matinee idol in Satyajit Ray's *The Hero*, described as 'a modern-day Krishna', has a similar status wished on him by his female followers. His mentor disapproves when he deserts the theatre to take a film role, and asks if he wants to be 'a comet with a tail', ablaze but liable to burn out. The star, however, watches as a clay idol representing the Hindu goddess Durga is lowered into the Ganges, where it will decompose: it is no longer possible to believe in rebirth, so why not opt for the immortality of the image, even if the star and his colleagues, as he admits, are merely 'creatures of shadow and light'?

As well as the god-like specimens of perfection it puts on show, cinema has designed a range of ogres, trolls and bogeymen, grotesque exceptions to the biological norm. The tradition began in 1920 with John Barrymore twisting and contorting to change before our eyes from an upright, idealistic scientist to a lewd fiend in *Dr Jekyll and Mr Hyde*, and continued with Lon Chaney's prosthetic self-deformations as the ghoulish organist in *The Phantom of the Opera* and Quasimodo the misshapen bell-ringer in *The Hunchback of Notre Dame*. In *The Man*

Who Laughs, directed by Paul Leni in 1928, gypsies have carved onto Conrad Veidt's face the cheerless rictus of a permanent grin; he is exhibited as a fairground curiosity, beside a double-snouted pig and a cow with five legs.

In 1932 Tod Browning's infamous horror film *Freaks* displayed a menagerie of such weird creatures from a carnival sideshow – conjoined twins, a sorority of so-called 'pinheads', a human skeleton, a slug-like torso without appendages, and a woman who suffers from a genetic condition that has caused her to be reclassified as a stork. When the able-bodied trapeze artist Cleopatra calls Browning's freaks subhuman, they take their revenge by lopping off her legs, melting her hands, then tarring and feathering what is left of her; all she can do by way of protest is squawk. Her accomplice Hercules, the circus strongman, is punished by being castrated, and in Browning's uncut version of the film he ends as a squeaky falsetto. Also in 1932, Charles Laughton as H. G. Wells's Dr Moreau experiments with grafts between species in *Island of Lost Souls*. After many surgical blunders and disgusting mismatches, his supreme creation is a Panther Woman clad in a sarong like a frizzier Dorothy Lamour. Though her fingers still taper into feline claws, the vivisectionist pimps her to a handsome sailor to see if she is capable of mating.

In *Fiend without a Face*, released in 1958, another mad professor working on experiments in telekinesis at a long-range radar station engenders a fiend in his over-developed head; it somehow breaks out and sets off on a killing spree, nourishing itself on the brains of its victims, which it sucks out through puncture holes in the neck. It also borrows their spinal cords and extends them into tendrils with eyes at the tips. This repellently squishy physique is optional: the fiend is faceless because it is the projection of a thought.

In the cinema's darkness, such horrors are meant to induce existential qualms. The slimy pods in Don Siegel's *Invasion of the Body Snatchers* hatch replicas of individuals who are reborn as bland, vegetative conformists, and in John Carpenter's *The Thing* an amorphous, unseen alien usurps the identity of the people it consumes. David Lynch's *Eraserhead* offers glimpses of a bandaged infant that was rumoured

to be a skinned rabbit or even a foetal lamb, although Lynch swore all concerned to secrecy about the ghastly mewling organism. Arnold Schwarzenegger in James Cameron's *The Terminator* and Peter Weller in Paul Verhoeven's *RoboCop* are halfway between the organic and the cybernetic. In Cameron's *Aliens* a grave, glassy-eyed robot clad in sensitive flesh resents being referred to as a 'synthetic' and says 'I prefer the term "artificial person" myself': either term suits the reified beings we see in such films. Miscegenated life forms abound in the *Star Wars* series, among them the four-eyed Annoo-dats, the feathery Besalisks with their extra arms, Watto the junk-dealing bluebottle, and the slinky reptilian changeling Zam Wesell. 'Which *Star Wars* creature are you?' asks a marketing site that offers themed costumes to match all these options. No art has done more than cinema to both amplify and unsettle our sense of what it means to be human.

These are the hybrid inhabitants of Epstein's cinematic 'anti-universe', which operates according to newly modernized rules. Dreyer claimed in 1954 that Einstein's physics had supplemented our three-dimensional existence with a fourth dimension, and he hoped that film would add a fifth, 'setting ajar for us a door into other worlds'. This happens in his own *Vampyr*, where the traumatized hero is said to 'experience events that have not happened yet': his eyes still open, he is sealed in a coffin with a glass window through which he watches his own funeral. In William Dieterle's *Portrait of Jennie*, released in 1948, an artist pursues a young woman who is both carnal and ethereal. Apparently alive, she is better described as undead, since she perished in a storm at sea decades earlier. Her story begins as thick clouds churn like a witches' brew while a narrator's voice portentously asks 'What is time? What is space?' – questions that cinema answers by making the two dimensions overlap, so that Jennie can travel throughout the century as she drifts around New York.

The philosophical queries that introduce *Portrait of Jennie* point to the mystery of an art that flexes or twists those coordinates. In Terry Gilliam's *Time Bandits*, released in 1981, a boy escapes from his parents and their dreary routine of television-watching when his suburban home starts to swell, dilating into cinematic infinity. A crusader on horseback

gallops out of his wardrobe, then leaps through a wall that, doubling as a movie screen, has become a forest glade. Another fantastic voyage begins, roaming free through history and geography. The guides to this larger life are six dwarfs who possess an Einsteinian map that identifies holes in space-time, left unrepaired when the universe was cobbled together by its hard-pressed creator. 'Can we really go anywhere?' asks the boy. Yes, cinema promises to grant our every wish.

3

WHEELS AND WINGS

The Lumière brothers called their invention the Cinématographe because it wrote with movement, just as photography, defined by a similar etymology, wrote with light. The writing dispensed with pens and the hands that held them, and it required no translation. Tolstoy, captivated by the circulation of film as it clicked through the projector, conceded that cinema was better than literature at conveying 'changes and transitions that flash by before our eyes'. Writing is retrospective, recording things that have already happened, whereas the default tense of film is the present. Ricciotto Canudo astutely defined cinema as 'a kind of energy' – a force or flow, process not product.

Thomas Edison called the peepshow he developed between 1888 and 1893 a Kinetoscope, and the short films he distributed favoured kinetic beings. Sioux warriors dance to vent their aggression, trapeze artists pirouette in thin air, a diver skids down a chute into a pool far below, and a woman flaps around pretending to be a butterfly. The visual excitements included a bucking bronco at a rodeo, fighting cocks, and a bout of fisticuffs between pugilistic cats. Liveliness proves to be madly contagious in Edison's *Laughing Gas*, made in 1907, where a maid who is given nitrous oxide by a dentist has fits of hilarity that she passes on to everyone she meets. Emergencies also had a visceral appeal. Another of Edison's films dramatized a rescue from a burning building, with horses dragged out of their stables through the flames and a pack of dogs farcically chasing the firemen. Along with the flammability of American cities, Edison's cameramen also documented the elemental turbulence of nature at the rim of Niagara Falls and from the deck of a liner that lurches in a stormy sea. They even captured the vertical gust

from a grille in the sidewalk on 23rd Street in New York as it billows inside the skirts of an embarrassed passer-by.

'Man,' the director D. W. Griffith declared, 'is a moving animal.' The definition was a tautology – moving is what animals do, because their animation separates them from vegetables or minerals – but it suited the movies. Chaplin, arriving in America in 1913, found he was in a kinetic society. People spoke telegraphically, 'in a rapid, clipped way', and he worried that his more precise English accent wasted their time. He felt, as he said, 'alien to this slick tempo', and he never entirely adjusted: the dandified gait of his tramp put a brake on the hectic haste of Mack Sennett's Keystone Kops, who pursued their quarry, Chaplin remarked, in a 'crude deluge'. Films show people in motion, not in repose like figures in painting and sculpture or stalled in thought as literary characters often are. In the notes Frank Capra made when sketching gags for Sennett's silent comedies, he reminded himself that every second word should be 'a verb, a visual action verb'. Louis Aragon admired Pearl White in the silent serial *The Perils of Pauline* because she did not behave as her conscience or consciousness directed, which a heroine in a novel might have done; her concerns, Aragon said, were 'sport and hygiene – she acts for the sake of action'. Douglas Fairbanks was a similar specimen. 'We can use his body,' said Griffith, who thought little of Fairbanks as an actor but enjoyed his acrobatics. Griffith always looked for 'expressive bodies', and he screen-tested Lillian Gish and her sister Dorothy by ordering them to run around a room emoting while he threatened them with a gun that they were sure was loaded with live ammunition.

Lillian at first found the pace of the new art to be unseemly, and recalled that stage actors, proud of their stately poise, disparaged movies as 'galloping tintypes'. But Griffith believed that 'You can't beat a rush to the rescue', and he exemplified the rule in the climactic chases he choreographed in *Intolerance* or the wild ride of the avenging Ku Klux Klansmen in *The Birth of a Nation*. Cinema is always in a hurry, for reasons that have to do with the workings of its apparatus and also with the convenience of customers: Hitchcock thought that a film's optimum length or 'running time' – a significant term – matched our bladder control, as after ninety minutes most people need a bathroom break.

* * *

True believers found in this unstoppable velocity the promise of progress and future glory. Tolstoy predicted that the 'revolving handle' of the cine-camera would 'make a revolution': mechanics served as a model for political change. The director Abel Gance claimed that his art preached 'the gospel of tomorrow', and in 1927 it led the way to the future when the triptych of screens in his silent epic *Napoléon* unfolded horizontally to show tempests, floods and victorious armies rampaging through apparently boundless space. With three lenses pointing in different directions, Gance's camera superseded the three-panelled altarpieces set up in cathedrals. Religious triptychs converged on a central point, and the outer panels, designed to be folded over for ease of transport, were occupied by donors or lookers-on, seemingly confined to side chapels. In *Napoléon*, however, the impetus is outwards: the spectacle opens into universality as troops commanded by the omniscient emperor rush off to carry out his dream of global dominion.

The camera had no trouble keeping up with horsepower, already obsolete as a mode of measuring the rate at which work is done: when the young Bonaparte absconds from Corsica brandishing the flag in *Napoléon*, his urgency and exhilaration are conveyed by a camera mounted on horseback, which risks inducing motion sickness in the viewer. In Victor Sjöström's *The Wind*, made in 1928, Lillian Gish plays a prairie wife tormented by gales and cyclones that buffet her cabin and batter her brain. She is told that the Indians mythologize this torment-ing wind as 'a ghost horse that lives in the clouds', and we promptly see a spectral stallion crossing the sky – a metaphorical companion for the winged horse on which Douglas Fairbanks makes his getaway in *The Thief of Bagdad*.

Graduating through the phases of industrialized energy, cinema followed the example of a steam engine running on rails. The earliest batch of Lumière films included one in which a train slid into the station at La Ciotat near Marseille. Supposedly people scattered in alarm as they watched in 1895, because they thought the locomotive might crash through the screen and run them down. That may have been an urban legend, but it is what eventually happens in 1972 in the Western *Joe Kidd*,

where Clint Eastwood drives a train off its tracks, through the buffers, and into the main street of a New Mexico town, capsizing buildings and coming to rest inside a saloon bar. The Lumière train is better behaved, yet it still looked sinister. Kafka, probably thinking of this scene, noted in his diary in 1909 that 'The spectators froze as the train passed by': in a creepy paradox, the picture moves while the living beings in the audience are paralyzed with fright. Just as balefully, the filmmaker Germaine Dulac said in 1927 that at La Ciotat the Lumière brothers established cinema's cult of 'movement in its brutal and mechanical visual continuity'. In fact the train slides smoothly along the edge of the frame, neither hissing nor rumbling as it advances, and is out of harm's way as it halts, though its disciplined course is contradicted by the messy jostling on the platform, with passengers who want to board bumping up against those who pile out.

Georges Méliès put trains to a more skittish use. Mostly he worked in studio sets where he could stage-manage magical stunts and pseudo-alchemical transformations, but in one of the few films he made outdoors he captured the view from the top of a carriage, looking ahead as the engine expels blasts of steam like the smoke into which his conjurers make people vanish. Here was a vantage point no ordinary traveller could have, an excursion into the four-dimensional realm of space-time. Méliès' *Voyage à travers l'impossible* – a pendant to *Le Voyage dans la lune*, released abroad in 1904 with the title *Whirling the Worlds* – has the sun as its destination, and it gets there with the help of every conceivable means of transport: automobile, submarine, dirigible, all loaded onto a flying train that takes off from the Jungfrau. But those dotty vehicles are two-dimensional cut-outs, and it is the camera that does the travelling.

The locomotive in Edwin S. Porter's *The Great Train Robbery*, made in 1903, ventures into a geometrical chaos that is no less fantastic. When bandits hold up the train in mid-journey, the passengers are ordered off at gunpoint and lined up parallel to the rails, where they wait to be relieved of their valuables. Then one of them makes a diagonal dash to escape, running towards us as if to escape from the screen; he is shot down. The camera notices other trajectories – the sideways jolt when

the dead body of a guard is hurled off the speeding train, the patterned circles and squares of some dancers whose enjoyment is interrupted by news of the robbery, the lines of force from gunshots that intermittently put a stop to all such movement – and these vectors overlap and collide in a blitz of stabbing optics and unstable physics. At the end, a sneering robber fires his gun directly at the camera, with puffs of grey smoke discharged from the barrel. Gance envisaged a streamlined future when, as he predicted, 'a rail will become musical' and 'a wheel will be as beautiful as a Greek temple'. Porter's archetypal Western has no faith in such orderly constructions: the frame is a cage that can barely contain the accidents happening inside it. In 1905 in Edison's *The Train Wreckers*, bandits plan a derailment; the film's climax is a graphic showdown between the locomotive's fuming steam and the flapping white petticoat of the heroine, which she tears off and waves to warn of an obstruction on the track. Recaptured by the outlaws, she is laid out unconscious on the line, ready to be bisected by the train, although of course an engineer scoops her up just in time. The excitement of early cinema lay in this kind of visual chaos, averse to the stable, disciplined perspective of classical painting.

F. W. Murnau's *Sunrise* – made, like *Napoléon*, in 1927 – travels at a more sedate pace. Here, seated in a trolley car that was perched on an automobile chassis and tracked by a moving camera, a farmer and his wife ride from the woods to the centre of an unidentified city. Their tram has a penchant for S-bends: the route meandered around other sets for the film that had already been built on the Fox lot. The journey takes the rural couple on a circuitous digression through space that also advances through time, speeding up history as it emerges from the agricultural past. They board the conveyance in a village with medievally pitched Gothic roofs, but after passing through a hinterland of smoking factories and new apartment blocks they disembark among the branching, car-clogged avenues of an Everytown where epochs overlap and idioms merge. A placard points to Waterloo and St Paul (not St Paul's), while a shop advertises Modes; a neoclassical church has a Venetian campanile, but a glass-walled café is starkly modernist. Another façade is labelled Metropa – perhaps a cinema? The distant pedestrians in the congested

square were all children or midgets, hand-picked to ensure that the perspective seems to slope towards its vanishing point with startling haste. Gance's three screens in *Napoléon* open out into world-encircling breadth; in *Sunrise* a single screen tunnels into telescopic depth.

Motion pictures sought to mobilize the audience as well, with reels of film serving, in Canudo's description, as 'celluloid railway tracks'. For a few years after 1904, a chain of theatres known as Hale's Tours offered customers a mock-up of train travel. Ticket-holders pretending to be passengers sat in ersatz railway carriages to watch a display of scenes from around the world pass by outside the window. Sound effects that suggested clacking rails and hissing brakes were added, the seats rocked to and fro, and a conductor checked fares. Max Ophuls sardonically jokes about the illusion in his *Letter from an Unknown Woman*, released in 1948. Here the Viennese pianist played by Louis Jourdan sweeps shy Joan Fontaine off her feet, but only metaphorically. As a treat, he takes her around the world on a train parked in the Prater; outside their compartment, a listless bicyclist operates the cyclorama to make sketchy painted views of Venice or Switzerland circulate, and blows a whistle to signal that they are theoretically on the move. In later films like *La Ronde*, Ophuls made his camera prowl, rove and waltz in circles to accompany the fickle dance of sexual connection and the punctual change of partners it requires. At the Prater, however, he acknowledges that cinematic travel happens only in our heads.

Yet the affinity between films and trains was more than a pretence. In the early 1930s the director Alexander Medvedkin and his colleagues travelled throughout Russia in a Kinopoezd or Kino-Train, a studio on wheels that carried equipment for developing and projecting the documentation of communist life shot along the way. John Ford's epic *The Iron Horse*, released in 1924, is an account of building the transcontinental railroad that spanned the American West, but it doubles as an anthem to what Dziga Vertov called 'cinematic communication', which easily and instantly conquers space. When the railway shifts its headquarters across the prairie from North Platte in Nebraska to Cheyenne in Wyoming, whole settlements are uprooted, and an intertitle announces 'Everything but the old houses moves on wheels'. Ford's

narrative starts with heavy engineering, supported by earth-moving and the back-breaking labour of ethnic work gangs; the next stage comes when cowboys and reformed outlaws construct a telegraph network along the line in Fritz Lang's *Western Union*, released in 1941.

The idea for Lang's *Woman in the Moon*, which is about the exploration of space made possible by liquid-fuelled rockets, came to him during an entirely terrestrial trip. On an overnight train, Lang said he felt himself being 'carried from one place to another without having to do anything but lie still dreaming'. His reverie anticipated the plot of a different film: in Douglas Sirk's *Sleep, My Love*, released in 1948, Claudette Colbert awakens in the sleeping compartment of a train from New York to Boston, not knowing how she got there or why she has a gun in her purse. Lights from an oncoming express locomotive scare her; a doctor shines another pencil-thin light into her eye, and a phony psychiatrist hired by her scheming husband adds to her bewilderment. As we sleep, the inert body moves, and images cavort in a mind whose rational defences have relaxed: this is the journey we go on when we watch a film. 'Movies,' as Godard put it in an American television interview in 1980, 'are the train, not the station.'

* * *

In one of his essays saluting the arrival of cinema, Jean Epstein argued that each new technological boon augments our bodily powers. An axle outperforms a leg; by the same logic, a camera can see better than our eyes do. Russian filmmakers brought the two inventions together in small graphic parables of progress. A close-up of a tractor's wheel in Alexander Dovzhenko's *Earth* announces the arrival of a tractor that will boost the productivity of the jubilant peasants, and in Eisenstein's *October* the recruits in the Bicycle Corps furiously pedal to enlist in the uprising in Petrograd. Those kinetic icons refer to cinema as well: the zoetrope – a contraption that displayed moving pictures in a peep show, first marketed as a toy during the 1860s – took its name from the Greek term for the wheel of life.

Early films often summarize the millennia of evolution that began with the invention of the wheel. In 1923 in *Three Ages*, Buster Keaton

wins victories against hulking adversaries during prehistoric times, in ancient Rome, and finally in the present. Each epoch features a chase – the immemorial story of human striving and also, as Hitchcock said, 'the final expression of the motion picture medium'. But in Rome, Keaton removes the wheels from his racing chariot and replaces the horses with dogs: he competes in the arena by driving a sled, which is not, he soon discovers, a good idea. When a panorama of downtown Manhattan brings Keaton's film up to date, the twentieth century is identified as the era of 'Speed, Need, and Greed', a formula that gets an extra fillip from the clickety-clack of the rhyme. Joe May defines urban modernity just as succinctly in the German silent film *Asphalt*, released in 1929. An opening montage displays the wheels and tyres of horse-drawn carts, cars, trams and buses, with finally some human feet that busily attempt to keep up. Asphalt is a petroleum product, so this Berlin thoroughfare, reconstructed inside the studio, is a coagulated river of oil, a stream of solidified energy. Eventually the camera settles on the film's hero, a helmeted policeman who marshals the armies of vehicles in Potsdamer Platz: he is directing traffic, which is what harassed filmmakers on sets as large as this had to do.

As its title declares, the wheel is the subject of Gance's railway drama *La Roue*, released in 1923. The film's epigraph quotes Victor Hugo, who said that 'Creation is a great wheel, which cannot move without crushing someone!' But does the wheel cover ground – like cinema, which for Gance was 'a bridge of dreams from one era to another' – or merely turn in obsessive circles like the innards of a movie camera or a projector? Perhaps its exertions are as repetitive as the pointless labour of Sisyphus, after whom the film's protagonist, an engineer called Sisif, is portentously named. As *La Roue* begins, an over-heated kinetic machine proves Hugo's point by heading towards disaster. A montage of straight rails evokes the geometry of classical fates, after which the parallel lines of iron curve, flex, converge and crisscross, leading to the red-tinted inferno of a derailment. Sisif rescues an orphaned baby from the crash, and adopts her as his daughter; later, jealously unable to accept her marriage, he employs his locomotive as an engine of retribution. He first plans to crash it with the young woman on board, to

prevent her from meeting her intended husband in Paris. Then he goads it to pass judgement on him by lying down on the tracks as it shunts through the yards. Reprieved, he finally drives it at speed against the buffers, destroying it rather than himself. But why should the machine be sacrificed to human mania? Emile Vuillermoz, who admired Gance, praised cinema for challenging our anthropocentric complacency: the art, he argued, brought 'the soul of things to light', and forced us to recognize that an engine also possesses intelligence and might be capable of experiencing pain.

After Sisif's crime, Gance places him at the centre of a revolving platform in the roundhouse, where he surveys the other stationary trains. He moves while remaining still, mockingly reduced to futility. Then, stepping down, he trudges away along the rails, dwindling into obsolescence. In retirement, he mans a wheezing funicular that toils up and down the gradient at Mont Blanc, while a stoker who takes his place on the express train behaves as if auditioning for the title role in Gance's subsequent film: nicknamed Napoléon, he poses as a Corsican general among the heaped coal.

For Gance as for so many other enthusiasts in those early days, cinema re-enacted the creative feat chronicled in Genesis, and he planned his screenplays as a reprise of the Bible's first week, with an amended outcome on the sixth day. To begin with, he said, 'the earth is created', although *La Roue* begins not with the soil but with rails laid on top of it. After that, the landscape must be peopled: 'little by little,' Gance added, 'the heart beats, the human machines are ready'. One of these is the actor Séverin-Mars, cast as Sisif, who is a mechanomorphic Adam. His eyes madly blaze like headlights; his cardiac convulsions are likened to the engine's red-hot connecting rods, and its smoking chimney relieves emotional pressure on his behalf as if in heaved sighs; the detonator of the stop signal, which he overrides, is the taboo against incest that he is driven to ignore. Vuillermoz described *La Roue* as 'the experimental study of a mechanical fairyland, from drive-rod traction to hissing steam', which made it 'the very image of cinema'. Fernand Léger likewise acclaimed the film's 'moving geometry' and called it a 'plastic event', a dance of pistons, gauges, levers and flashing signals

that made sure to single out Sisif's invention of a slide-valve vaporizing process. Eisenstein's *Battleship Potemkin*, released two years later, provides a nautical replica of Gance's vision: as the Hungarian poet Béla Balázs pointed out, the valves and flywheels that power the insurgent vessel throb and quiver like the robotic gestures of 'Comrade Machine'.

Chromatically too, *La Roue* refines and subdivides the light that passes through the camera. Gance said that the narrative began as a symphony in black, darkened by the soot and grime of the railway in the charred lowlands, but concluded as a symphony in white, after the action transfers to the icy peaks of Mont Blanc. Sisif's accident almost blinds him, and in his exile on the mountain he gradually loses what remains of his sight. His damaged eyes are at first glazed, unfocused; by the end, all he can see is a whited-out blizzard. Has the lens proved its superiority to the jellied globes crammed into sockets in our heads?

Two later films extend Gance's technological epic, which is a song not of arms and the man but of the male engine and its encounter with a more fleshly, sensual female body. In 1938 Jean Renoir directed *La Bête humaine*, based on Emile Zola's novel about a railway engineer's affair with a colleague's wife who entices him to kill her husband; Fritz Lang remade Renoir's film as *Human Desire* in 1954.

Both begin with prologues on the rails as the trains speed through tunnels or across bridges, but their moods differ – Renoir's is breezy, Lang's grimly determined. Renoir refuses to accept the modern, metallic inhumanity that for Dulac and Epstein was the glory of cinema. The driver in *La Bête humaine*, played by Jean Gabin, fondly pets a locomotive he nicknames La Lison. A beast but not a brute, she fumes like a dragon on the sidings at Le Havre. Once, we are told, she ran over a cow, but her speed as she charges across the landscape merges her with nature. A low-flying partridge skims within reach of the stoker; Gabin enjoys watching rabbits sit up in the fields, their ears twitching as La Lison hurtles past. A rude democracy prevails, equalizing all creatures and embracing machines as well. Gabin and his stoker invigorate themselves with hot drinks, while La Lison's gullet is fed with coal. When her axle box overheats after guzzling too much oil, Gabin compassionately offers to pay for repairs with his own money. The stationmaster's wife who

seduces him deserves less sympathy than La Lison: he kills her in a fit of rage, then jumps to his death from the train. In Zola's novel the adulteress is feral, vicious, maddening and destroying her sexual victims; in Renoir's film her moral turpitude perhaps matters less than her visual incuriosity. Gabin, his eyes protected from cinders by goggles like those worn by early aviators, rejoices in the privileged view from his open cabin. 'On voit tout,' he says, 'on connaît tout.' Simone Simon, playing the wife, ignores the world that races by outside the train's window: when she travels, she replies, she never notices a thing.

Lang, telling the same story, reverts to a view of trains and films as relentless, potentially deadly gadgetry. *La Bête humaine* begins in the hot, hissing mist exhaled by La Lison. The train in *Human Desire*, powered by diesel fuel, is less vociferous and steamy. Glenn Ford, inheriting Gabin's role, works in a sealed compartment, literally 'in camera', and cannot lean out to keep an eye on the line ahead as Gabin does. He commands the train instantly by flicking switches to open or close an electric current; desire too is a matter of ignition, which Gloria Grahame, in the role earlier played by Simone Simon, can turn on at will. Lang, here as always, emphasizes entrapment, claustrophobia, with film as a closed system, its circuitry as inescapable as electrical wiring or a moving train.

In Hitchcock's *The 39 Steps* a cleaner opens her mouth to scream when she discovers a corpse; thanks to a quick editorial cut, the alarm is sounded for her by the whistle of a steam train as it carries away the suspected killer. The transference stifles the traumatized woman, and allows the engine to let off steam in a way that is high-pitched and perhaps heedlessly high-spirited. Lang has a more devious and disturbing equivalent to this substitution. Ford, persuaded by Grahame to murder her husband, stalks him when he drunkenly stumbles through the railway yards. Clutching a wrench from his toolbox, he hurries across the rails and closes in on his prey, only to disappear from view when a freight train shunts past. It travels slowly, diverting us with a series of territorial labels – one box car belongs to the Louisville and Nashville line, another services New Haven and Hartford – and a commercial display that even manages a rhyme: the last car says BE SPECIFIC, SHIP

UNION PACIFIC. For as long as the intrusion lasts, we are encouraged to assume that Ford is committing the murder out of sight. We soon discover that he thought better of it, but why should a train pause to clarify a moral conundrum? Film for Lang is an exercise in inevitability.

There is a footnote to this alliance between cinema, sex and the railway in François Truffaut's *Jules et Jim*, about two young bohemians and their shared mistress who live – kinetically, hilariously, and in the end tragically – in the era of silent film. Vivacious to the point of mania, they match the agitation of Chaplin or Pearl White, and one of their last encounters is at the Studio des Ursulines, the Left Bank cinema that showed the scandalously experimental works of René Clair and the surrealists throughout the 1920s. A minor character called Thérèse comes and goes throughout Truffaut's film, regaling her sexual partners with a celebrated trick. She places a lighted cigarette in her mouth backwards, then blows the smoke out and announces that she is a steam train.

* * *

Wheels can also run on the spot, going around not ahead. When Sisif's daughter arrives in Paris for her wedding in *La Roue*, an intertitle composed by the poet Blaise Cendrars says she has entered 'the City of the Wheel'. This refers to the Grande Roue, a gigantic Ferris wheel erected in the Place de la Concorde for the Exposition Universelle and financed by an industrialist who also, appropriately enough, sponsored a bicycle race from Paris to Roubaix in northern France. Lang in his futuristic fable *Metropolis* dreams up another city of the wheel, run by industrialists for whom, as an intertitle puts it, 'every revolution of a machine wheel meant gold'. Pleasure, like profit, here implies rotation, and the nightclubs in the district of the metropolis called Yoshiwara are introduced by a montage that includes a roulette wheel.

Cinema in its early decades was fascinated by such hedonistic wheels and their unproductive expenditure of energy; they recur in contexts that range from the absurd to the depraved. The comedian Harold Lloyd goes on an excursion to Coney Island in *Speedy* and rides on the bone-rattling Human Roulette Wheel, nicknamed the Social Mixer. For its own unsocial reasons, film can make our heads spin and

our vision blur. In 1922 in Murnau's *Phantom*, a lovelorn poet takes his vampiric muse to a nightclub. Above the dance floor there is a helix-shaped track made of slats, with a single cyclist skidding around its involutions – although, given the subjectivity of the scene, this may be just the poet's metaphorical fantasy. In E. A. Dupont's *Variété* – a drama about the quarrels and crimes of trapeze artists, made in 1925 – a wild Berlin party is photographed through a scything ventilator fan set in a wall, which chops our vision into fragments; the blades blur at high speed to offer glimpses of dancers cavorting on top of a restaurant table.

Sometimes the wheels do more than generate giddy excitement, as if determined to honour the original meaning of the zoetrope or the epigraph about creation by Victor Hugo that introduces *La Roue*. During the carnival to celebrate the Day of the Dead in Eisenstein's *Qué Viva Mexico!*, a Ferris wheel grinds through its rounds while in front of it a line-up of dancers give a jazzier display of mobility. The women have shimmying rumps, and one of the men splits his legs and turns his crotch into a fulcrum on which he hoists himself upright, mocking the aerodynamics of the rickety wheel. A few of these jigging figures wear skull masks, which makes them symbols of what Eisenstein's commentary calls 'the eternal circle' – death reconstituted as new life, like cinema when it animates frozen frames and gives bodies to grey ghosts. A cheeky version of the same metaphysical marvel occurs in René Clair's surrealist farce *Entr'acte*, made in 1924. The mourners who are following a hearse pulled by a camel start to skip and syncopate a little indecently; the hearse runs off on its own chased by the frantic mourners, before the camera jumps sideways onto a rollercoaster, which sends it on a hysterical trip up and down a wooden alpine range. Finally the coffin vaults into a field, where after a solemn pause its lid pops open to release the corpse, which has now bounced back to life: has the pace of the journey somehow resurrected the dead? That too was a teasing promise made by cinema.

During a Canadian television interview in 1964, Hitchcock likened directing a film to designing a rollercoaster. 'The grades and dives,' he said, 'create the crudest and broadest emotions in the rider', and his own plots put the viewer through a series of torments that correspond

to those stomach-churning drops and head-compressing take-offs. Eisenstein – who shared Hitchcock's desire to startle cinemagoers out of their complacency, and concocted a blackly humorous scheme to set off fireworks under their seats – was also fond of rollercoasters. The runaway pram in *Battleship Potemkin* may have been his joke about what would happen if one of the carriages on what the Russians called 'American mountains' came unmoored. The pram's wire wheels are poised on the top of the Odessa steps, and when the mother pushing it is shot by Cossacks she knocks it over the edge; the baby squalls during the bumpy descent, which ends when the pram overturns.

Cinema's habit of wheeling in circles led it logically to the circus. The camera shows off its head for heights in Dupont's *Variété*, swinging above the heads of the crowd during a trapeze act. In Chaplin's *The Circus*, the wheel stays flat on the ground and goes nowhere fast, sketching a geometrical diagram of futility. A cop pursuing the little tramp follows him onto a revved-up turntable beneath the big top; as they circulate, it is unclear who is chasing whom. Eventually the cop gets ahead and the tramp lazily hitches a ride by attaching his cane to the cop's collar so that he can be carried round by inertial motion. At the end of the film, the show is packed up and loaded onto wagons that depart for the next town, leaving Chaplin behind in the middle of what Rudolf Arnheim described as 'a bright nothingness', a circular arena that during performances seemed all-encompassing as the great globe; the camera's iris then contracts until there is only room for his isolated, immobile figure, cramped in the aperture. The courtesan in Ophuls' *Lola Montès*, released in 1955, reaches a similarly dejected conclusion. Her shape-changing and her shuttling between countries and lovers make her, for most of the film, mobility in person, but the last time we see her she is caged in the centre of the circus ring and obliged to bestow kisses on a queue of paying customers. The eternal circle goes on turning, but she occupies its sadly stilled point.

The gyration closest to cinema's self-image is that of the carousel. In *Coeur fidèle*, directed by Jean Epstein in 1923, a naive barmaid is taken to a village fête by her rakish lover; on the merry-go-round she cowers away from him, rigid with apprehension, as the crowded square

revolves behind her. Then we are shown the view from the carousel, with trees and buildings melting into streaks of light and gobbets of blackness. This is said to have afflicted some members of its first audiences with dizzy spells; René Clair, however, surrendered to the 'visual intoxication' of the episode, in which, he said, 'the visage of Dionysian poetry is reborn'. Later cinematic funfairs are more blatantly drunken or deranged. A carousel goes berserk in Hitchcock's *Strangers on a Train*, and Vincente Minnelli's *Some Came Running* ends with an armed chase through a small-town carnival which has a Ferris wheel, orbital rides and a shooting gallery: the result, thanks to jittery editing, is a riot of fluorescent colours that flash through the air in front of pink and tomato-red walls and explode like comets or bullets.

A reckoning occurs in 1946 in Fritz Lang's *Cloak and Dagger*, where Gary Cooper plays a physicist sent to Italy to frustrate Nazi research into nuclear fission. Waiting for Lilli Palmer, he hides inside the central engine room of a carousel that has been shut down for the duration of the war, and passes the time by scribbling a web of mathematical equations on the curved internal wall. He is trying to work out how far he would travel if the carousel were in operation, and with pedantic exactitude he measures the speed of its rotation and factors in the up-and-down bouncing of the horse on which he would ride. When Palmer arrives, she tries to distract him by giving him an apple to eat, but that prompts him to speculate about the energy the piece of fruit contains, which is set free when he bites into it. Cooper seems ill at ease with such abstruse calculations, but the interlude is Lang's editorial about the illusoriness of movement in motion pictures, and the upheavals with which cinema flirts when it unleashes so much pent-up vitality.

* * *

Wheels can only manage horizontal travel. *Wings*, William Wellman's 1927 film about American fliers during the First World War, celebrated another of the new art's emblems, which here lifted cinema into the sky.

The story begins as Buddy Rogers customizes his jalopy, ripping off the outer casing to transform it into a racer. He calls it Shooting Star, which becomes both the title of his fighting plane and his nickname

in combat against the Germans – apt because stardom has the same flaring flight path as his flimsy contraption of canvas and baling wire. At his windiest, Vachel Lindsay rhapsodized about cinema's ultimate goal, which is to show us 'the human soul in action, that arrow with wings which is the flesh of fire from the film, or the heart of man, or Pygmalion's image, when it becomes a woman'. Demythologized, this amalgam appears in *Wings* in the racy person of Clara Bow, then notorious as the 'It' girl. When America mobilizes, she signs up for the Womens' Motor Corps. True, she can drive a Ford, but in France she proves to be altogether too fast, and is sent home in disgrace after being caught in Rogers' bedroom, clad in a glittery evening dress.

To perform the film's stunts, Wellman recruited pilots whose risk-taking would never have been tolerated by the air force, and on location in Texas he had a French village constructed for these mavericks to strafe. At first the iconography of battle in *Wings* is antique, chivalric. A German Gotha bomber has a writhing dragon painted onto its fuselage, and an intertitle describes an American aerodrome in France as a 'nest of eagles', even though the unaquiline planes look more like a swarm of gnats among the clouds. The aviators obey a sporting code, which prompts a German to spare Richard Arlen during a dogfight because his machine gun has jammed. But as the film continues, Wellman abandons this etiquette, as if realizing that the movies are a realm of happy catastrophes where one of our keenest pleasures is watching machines flamboyantly crash and burn. He therefore supplies the deadly mayhem we desire. An American plane wildly pirouettes as it goes down, with added arrows of orange flame sparking from it; a German casualty veers all over the sky in looped arcs before its last nose dive.

Wings also offers a new view of a familiar reality it has spurned. As Wellman's airborne cameras soar aloft, the land beside the runway slurs into an inebriated muddle; then comes a sudden fogging of sight as we are enveloped by a cloud. The earth seen from above is unrecognizably diagrammatic, everything on it levelled and equalized, with the zigzagging trenches of the battlefield like surgical scars. An intertitle refers to 'the high sea of heaven', but at this altitude life forfeits its sacrosanct value and death its heroic mystique. When Arlen's plane

crashes, it slams into the village church and knocks off its steeple like a dunce's cap. During the attack on a distended German observation balloon – described as 'the monster' by an intertitle – the photographic evidence is painfully raw. Its cloth ripped by bullets, the balloon crumples, then expires in a plume of black smoke. Evacuees from a second balloon cling to parachutes that look like tiny buffeted umbrellas, and are dragged awkwardly along the ground when they land. Wellman had an extra cockpit fitted to the front of the planes in his squadron, which enabled a cameraman to film the airmen at close range. In one scene the pilot is shot. He jerks, coughs up blood, then slumps and lets the plane tip sideways; luckily the stuntman stopped acting in time to grip the controls and tug the plane out of its descent. The camera's eye is cold, neutral. Equally affectless, Rogers shoots down Arlen, his best friend, because he happens to be piloting a stolen German plane. His frantic signals are disregarded; he is simply a target.

In 1930 the same story told by Wellman received a more puffed-up treatment in *Hell's Angels*, directed by Howard Hughes. Here the two heroes are students at Oxford who enlist in the Royal Flying Corps to fight the squadron commanded by Baron von Richthofen. An aviation pioneer who set airspeed records, Hughes assembled a fleet of eighty-seven decommissioned military planes to act out the battles, and built a sixty-foot-long model of a German dirigible. Like Wellman he favoured swashbuckling pilots, three of whom were killed while filming.

The title of *Hell's Angels* suggests theological strife, with the fliers as princes of the air whose biplanes breathe fire: as with Sisif in his locomotive in *La Roue*, cinema celebrates man deified or demonized by the engine he drives. Hughes, however, made the clashes look like sublimated sex. Clara Bow's place is taken in *Hell's Angels* by Jean Harlow, whose contribution to the war effort was her breasts, which Hughes described as 'the bomb department'. Hughes transferred filming north to Oakland in northern California because there were no cumulus clouds above the San Fernando Valley; those bulbous puff-balls reminded him of mammaries and, as the director Lewis Milestone wryly observed, he 'wanted to show the planes fucking the clouds'. The Zeppelin that attacks London is grossly phallic: the rounded tip of its long leathery

shaft burrows through a fluffy, blue-tinted cumulus formation. John Darrow is lowered from its underbelly to spy out the ground below, squeezed into a miniature pod with an elongated tail like a runaway sperm. When he is ditched to offload excess weight, Hughes inserts a huge close-up of the shears that cut through the cable from which the pod dangles: a glimpse of castration? Other sacrifices are required of the crew to help the Zeppelin regain altitude. The men form a line, stand erect, stiffly salute, and then jump to their deaths through a vaginal orifice in the floor.

As the dirigible advances towards central London, it is tracked on the ground by a rotating battery of listening devices shaped like trumpets, poised to blow an inaudible fanfare; defensive searchlights rake the sky, just as arc lamps used to do at notable movie premieres. Shredded when hit by a brave British kamikaze pilot, the Zeppelin falls from the midnight-blue heights in a mass of rosy flame. Although the incinerated remains are tumbling on top of them, Ben Lyon and James Hall pause to admire the display before they sprint to safety. 'Look at that thing – great, isn't it?' says one of them. For Hughes, disaster had to be spectacular, and indeed he organized a low-flying dogfight above Hollywood Boulevard outside Grauman's Chinese Theatre on the night *Hell's Angels* opened. Here, as so often in later decades, film is the continuation of warfare by other means.

In 1939 in *Only Angels Have Wings*, Howard Hawks – himself a wartime aviator like Wellman – made sure that his pilots never sacrifice their grounded humanity as they fly their fragile, rattling planes through the razor-edged Andes mountains to deliver mailbags. A Spanish-speaking doctor volunteers for a dangerous mission of mercy in one of these aircraft by quoting a speech in which Shakespeare's Hotspur defies death; Cary Grant, intent on running the business, ignores him. Exhibitionism is no part of the ethos here. Thomas Mitchell's neck is broken when condors shatter the windshield of his plane, but he insists on dying alone, and in a reproach to our intrusiveness he says 'When I made my first solo I didn't want anyone watching then either.' Aeronautical angels and daredevils were at home in cinema from the outset; it took human beings a little longer to appear.

* * *

This was an art that answered to the industrial obsession with ever swifter and more profitable movement, boosted by Edison's generators and his incandescent bulbs. In 1925 in Eisenstein's *Strike*, the workers sentence a factory to death. 'Without our labour,' says their leader, 'the furnaces will go out, the machines will stop, the plant will die.' After they down tools, birds nest on the idle engines – an image that ought to be lyrical here seems quaint or decadent, because it defies the kinetic principle that made the art possible. Warner Baxter, playing the stage director who drills the exhausted chorus girls in Busby Berkeley's musical *42nd Street*, gives voice to cinema's unremitting dynamism. 'Fast, faster!' he barks, satisfied only when their rat-tat-tat tap-dancing sounds like machine-gun fire.

The same urgency impelled Buster Keaton. His parents trained him to accept knockabout abuse when he appeared with them in vaudeville during his boyhood, even attaching a handle to his back so they could toss him through the air, and his professional name celebrated his hard landings: a 'bust' was a fall. Apparently impervious to pain, Buster uses his body like a missile. In the final section of *Three Ages* he evades the police by hiding in a phone booth that is inconveniently carted away by removal men. Tipped into the road, he zigzags up a fire escape, uses a plank on a parapet as a diving board to bounce between two tall buildings, crashes through a window into what turns out to be a fire station and slides down a pole to the ground floor, just in time to land on an engine as it speeds off to a blaze. Despite his serial recoveries, the journey is circular, like that of a reel in the projector: he is taken straight back to the police station from which he thought he had escaped, because that is the location of the fire.

Vertov devised a new visual sensation in *Man with a Movie Camera* when he dug a trench under some railway tracks and filmed a train charging towards the camera and running over it. Watching, we anticipate certain death and yet survive it – an experience only the cinema can provide. Endlessly repeated by others, this shot became almost an operating manual for cinema: the philosopher Theodor Adorno, aghast at the brain-bludgeoning effect of Hollywood movies in the 1940s, thought

that 'the cultural apparatus assails the spectator with the frontal force of an express train coming towards him'. DeMille's *The Greatest Show on Earth*, released in 1952, does exactly that. Though it is about a travelling circus, its greatest show is the collision of two trains, which hurls a carriage and its occupants into the air and cracks open some animal cages, setting free half a dozen irritable lions. DeMille in his personal prologue emphasizes the 'whirling thrills' of the arena and goes on to militarize this 'massive machine whose very life depends on discipline, motion and speed'. In calling the circus an 'army on wheels' or 'a fierce, primitive fighting force', he looks forward to something more than athletic displays on a high wire. This, in 1952, was DeMille's attempt to heat up the Cold War, but it also serves as propaganda for cinema. Andrei Konchalovsky followed the same self-referential course in 1985 in his *Runaway Train*, where a driverless locomotive charges through the Alaskan wilderness towards a crash that Jon Voight, trapped on board, awaits as eagerly as the rest of us in the audience do.

The over-stimulated thermodynamics of cinema derive from its physical ingredients. Hitchcock's *Sabotage*, released in 1936, contains an ominous parable about the art's combustibility. Terrorists plotting in a shabby East London cinema conceal a bomb in some canisters of film that they give to a boy to deliver to the luggage room at Piccadilly Circus underground station, where it is timed to go off later in the day. He has to walk across the city: back then, film could not be taken on public transport because its nitrocellulose coating – also used in gunpowder and as a propellant for military weapons – made it flammable. He dawdles, unaware that the timer is ticking towards the inevitable explosion, and the intensifying anxiety that we feel on his behalf is another uniquely cinematic sensation: Fritz Lang is said to have invented the habit of counting down to blast-off when he filmed the rocket launch in *Woman in the Moon*. Eventually the lad is able to talk his way onto a bus, though because it is caught in traffic jams it travels more slowly than he might have done on foot. As a result, the bomb detonates before the bus reaches Piccadilly, and everyone on board is killed. Hitchcock was attacked for so nonchalantly sacrificing a guileless child and all the other innocent passengers, but the contents

of the can transferred blame for the outrage: was it the director's fault that film is potentially lethal?

Our violent delights arrive at a similar destination in Monte Hellman's *Two-Lane Blacktop*, a road movie released in 1971. Here the finishing line of a cross-country drag race coincides with the self-consuming combustion of the celluloid. As the screenplay visualizes it, 'We're instantly propelled forward within the Car. The Car seems suspended outside of time' – an exact description of our sensations as we watch. But then the car slows down, seeming to float or coast until 'The film stops. The heat of the projector lamp burns a hole in the frame and the entire frame DISSOLVES.' Those capital letters raise the alarm and abruptly terminate the show.

Mobility remains cinema's basic imperative, which was wittily flouted by Andy Warhol in 1965 when he aimed a camera at the Empire State Building for eight immutable hours. Warhol's friend Jonas Mekas reported that an audience member at the first screening of *Empire* demanded a refund after only ten minutes, citing a breach of contract: 'This movie doesn't move!' the disgruntled customer yelled. Perpetual motion is what we pay for. At the end of the bloodthirsty thriller *Payback*, Mel Gibson staggers back to his car after killing a pack of Chicago gangsters and unexpectedly orders his girlfriend to take the wheel. 'Where to?' she asks. 'Just drive, baby,' he replies, uttering a directorial motto (though he does add that they are going across the border to have breakfast in Canada). Cinema had unleashed a propulsive excitement not available to the older, tamer, supposedly civilizing arts – a creative élan that has as its underside a destructive frenzy.

4

BRAVO FOR
DARK ROOMS

A journalist's report on the Lumière brothers, sent back from Paris to New York in 1895, transmitted the good news: cinema offered a cure for mortality, since now that our loved ones could be preserved on film, 'death will no longer be final'. A year later, the novelist Maxim Gorky had a more sobering premonition. At the All-Russian Fair of Industry and Art in Nizhny-Novgorod he saw some Lumière 'actualités', which despite their al fresco setting made Gorky feel that he had descended into what he called 'the kingdom of shadows'. Not wanting to be 'suspected of madness or indulgence in symbolism' – mental ailments that are almost endemic to cinema, which maddens reality by turning objects into symbols – he explained that the films had shown him 'not motion but its soundless spectre', with people 'deprived of all the colours of life', condemned to a grey and dismal muteness. Entire streets had apparently been 'bewitched' by some scheming Merlin. Characters in one snippet laughed as they played cards, but because Gorky could not hear them he found their jollity hollow. Here was a preview of Hades.

The show seemed all the more funereal because Gorky saw it on the premises of a café-concert run by Charles Aumont, a French entrepreneur who expected his staff of chorus girls to entertain clients more intimately in private rooms. The good-humoured exit from the factory in Lyon, representing a life of honest toil, hardly suited these louche surroundings; following his visit, Gorky learned that one of Aumont's employees had attempted to kill herself in shamed despair, and he wrote a story in which a young prostitute commits suicide after she

watches Auguste Lumière and his wife cooing over their baby in an unfallen garden.

As Gorky sensed, the artificial gloom of cinema combined fear and desire. Until recently cameras and projectors had to be fed with film, and what they showed was somehow filmy – gauzy, elusive, sensitive to light but ruined by over-exposure to it. Bodies on screen melt into each other, or expand and contract to make the world look fluid and fungible. Words when filmed can dissolve or turn eerily biomorphic, far from the rationality of print. The title of Dreyer's *Vampyr* materializes like ectoplasm, pulsing and throbbing, with a black embryonic blob behind it; in Murnau's *Nosferatu* an intertitle muses about the Hungarian-Romanian archaism that names the demon, and its crabbed, tentacular Gothic script makes his menace palpable.

In an echo of Gorky's phrase, the Tatra mountains in *Nosferatu* are described as 'the land of the phantoms', and the prospective visitor to the vampire's castle is warned that he must reach his destination before nightfall and told 'Beware that his shadow does not engulf you.' For those of us watching the film, the advice comes too late: we are already spellbound. Our dread of the dark is inborn, and cinema never forgets it. Fritz Lang's films compulsively resort to the kingdom of shadows in a variety of subterranean locales: the catacomb beneath the futuristic city in *Metropolis*, the lair of the dwarf Alberich in *Die Nibelungen*, the lepers' den in the Indian adventure *The Tiger of Eschnapur*. Even the open-air setting of Lang's Western *Rancho Notorious* is denounced as a morgue, a twilight realm peopled by men who are Marlene Dietrich's bewitched captives.

Inhibitions relaxed in the dark, which is why Edison's Motion Pictures Patents Company advised theatre owners to install ambient lighting to deter misbehaviour. In France, the surrealists disagreed: one of their slogans was 'Bravo pour les salles obscures.' Robert Desnos said in 1927 that cinemas were like bedrooms in which you settled down and hoped to nod off, trusting that the screen would duplicate your dreams. And what if the lights were also dimmed in the grandiose spaces where people worshipped or celebrated the rites of high culture? Writing about Lang's *Metropolis*, Buñuel called cinema a 'monstrous cathedral', like the

cavernous church that still stands among the futuristic city's skyscrapers and elevated highways, now consecrated to the worship of strange gods: a pyre is erected on top of crashed buses outside the portico for the execution of a robotic witch, and on the roof a mad scientist torments his victims while devilish gargoyles leer down at an infuriated mob. The Palais Garnier, in the 1925 *Phantom of the Opera*, is a similar place. When a chandelier crashes to the floor, the audience is plunged into the same darkness that envelops cinemagoers; the disbanded orchestra is replaced by sounds from wheezing subterranean pipes played by Lon Chaney, a cinema organist who has taken up residence in the basement of the opera house.

Cinema is a light that only shines in darkness: its images resemble the indistinct forms that riot in our heads while we sleep, telling us weirdly alluring stories that daylight erases. In André De Toth's *Pitfall*, a moody fable about moral entrapment released in 1948, dreams are explained as our built-in 'picture show'. Dick Powell here plays a bored suburbanite who succumbs to sexual temptation and stumbles into a morass of guilt and deception. Undressed for bed but unable to relax, he is about to confess his lapse to his wife when his young son screams from an adjoining room, terrified by a bad dream. Powell blames comic books for this mental agitation; he exempts the movies, and later he even tries to persuade his wife to get the boy out of his pyjamas and bundle him off to a late-night screening – a way of removing both of them from the house before he has a showdown with an armed avenger who has emerged from the secret life he wants to cover up. To calm his son, he says that 'The mind is like a very wonderful camera', which captures and stores photographs of everything that happens to us, then replays them in a cranial theatre. 'Now and then one of those pictures comes loose,' he continues, 'and that becomes a dream – so the trick is to take only good pictures and have only good dreams.' The remedy prescribed by Powell was also the policy of the Hollywood studios: you decide on the scenario and its genre, while a home-grown censor ensures that the product is fit for what the certificates used to call 'general exhibition'. But psychological health, as *Pitfall* demonstrates, is not so easy to regulate, and cinema has made a speciality of nightmares.

The director Jean-Pierre Melville invented a term to define the psychological precondition the medium required. A filmmaker, he suggested, should be 'traumatizable'. Not a comfortable state to be in, but one that is familiar to characters in films – to Victor Sjöström in Ingmar Bergman's *Wild Strawberries* when he imagines a coffin opening its lid to reveal his own corpse, to Vera Miles when she explores the stale, stuffy bedroom of the mummified Mrs Bates in *Psycho*, and to Kyle MacLachlan in *Blue Velvet* when he hides in a closet to spy on a scene of sadomasochistic sex – and to all of us as we peer over their shoulders. Second sight comes easily to Giulietta Masina, the put-upon wife consoled by her otherworldly fantasies in Fellini's *Juliet of the Spirits*. As a child, she says, she had only to close her eyes and the visions came to her like bright, beaming fairy godparents. The insomniac painter played by Max von Sydow in Bergman's *Hour of the Wolf* is persecuted by creepier spirits. He sketches their grotesque faces, acknowledging that these gnawing internal tormenters have made him the artist he is.

Andrei Tarkovsky wanted cinema to ensure that 'the individual is traumatized', and Melville hoped we would feel imprisoned, 'in a state of submission'. Hallucination and delirium come naturally here. A famished miner in *The Gold Rush* sees Chaplin as a man-sized chicken, plump, strutting and very edible. In Billy Wilder's *The Lost Weekend* the alcoholic writer played by Ray Milland imagines a mouse nibbling a hole in his wall. A carnivorous bat circles around the room, then attacks the rodent. Wings flap, a tail lashes, and to the sound of a dying squeal a rivulet of blood trickles down the plaster. Bingeing on acid in Terry Gilliam's *Fear and Loathing in Las Vegas*, Johnny Depp recoils as a snooty hotel receptionist turns into a moray eel, while drinkers in the bar become rutting reptiles.

Fireside Reminiscences, a short film distributed by Edison in 1908, puts a more philosophical frame around Maxim Gorky's shadowland. Here in a bourgeois home we find a replica of the allegorical cave that Plato in his *Republic* presents as the hideout of aesthetic delusion, where human beings turn away from the sun and gaze instead at the shadows cast by a flickering fire they have kindled. The falsehoods symbolized by the distracting, illusory fire led Plato to banish poets

from his ideal republic, and Jean Epstein joked that the ban would also have applied to cinema, which is 'a high-performance poetry machine'. In Edison's film a husband sits by the hearth brooding about his early happiness with a wife who betrayed him. The fireplace, like the rest of the furniture in the upholstered room, is flat painted scenery, but it contains an inset screen: onto the black bricks of the unlighted hearth a snow scene is projected, and a little film within a film shows that the banished wife, now destitute, has collapsed in the wintry street outside. Unlike Plato's cave, this recess allows for a glimpse of reality, and the husband, roused from his misery, brings the fallen woman in from the cold and forgives her.

The Platonic scenario unexpectedly reappears in 1973 in Truffaut's *La Nuit américaine*. The title refers to the practice of photographing night scenes in daylight by under-exposing the film: light and dark change places, so we can dream without closing our eyes. Truffaut, playing a film director, is amused when he notices a gas fire on his set. People used to spend their evenings staring into the flames, he remembers, whereas nowadays they watch television instead; either way, apparently 'we need to see moving images, especially after dinner'. But the glow from the cathode-ray tube and its phosphorescent screen merely supplied a semi-soporific digestive aid. Cinema prepares us for a deeper sleep.

Other directors have their own versions of this subliminal state into which it draws us. For Fellini, the darkness was uterine, a safe place for sensual play, and in *Amarcord* he describes the cinema that he frequented in Rimini during his adolescence as 'a warm sewer of vice', where he could sidle close enough to fondle and nuzzle the women in adjoining seats. Ingmar Bergman's equivalent was a place of penance, which he was able to transform into a private theatre of dreams. As a boy, he was often punished by being shut in a cupboard; this happened so often that he hid a torch in there, and whenever the door closed he cheered himself up by letting the beam play across the wall. Ensconced in his version of Plato's cave, he defied the adults who had locked him in. 'I pretended,' he writes in his memoir, 'that I was at the cinema.'

* * *

Vachel Lindsay pointed out in 1915 that the 'first reader of picture-writing' lived in an actual, non-Platonic cave, comparable perhaps to the series of caverns with painted galleries of totemic animals that were discovered at Lascaux in southwestern France in 1940. The 'machine-ridden' men of the twentieth century should rejoice, Lindsay said, at having caught up with the artistic achievment of their Neolithic ancestors. 'The invention of the photoplay,' he believed, was 'as great a step as was the beginning of... the Stone Age', and men now once more had the power 'of seeing their thoughts as pictures in the air'.

The violent physicality of the stories told by films in those first decades matched what the painter Umberto Boccioni in 1914 called the 'barbaric quality' of modern life, still dominated by a brutal struggle for existence. The first epoch in Keaton's *Three Ages* is Neanderthal, and in it Buster is tied to an elephant and dragged through a cactus patch. In Chaplin's *His Prehistoric Past* the tramp dozes off on a park bench and drifts into a reverie about cave-dwelling days. Despite being wrapped in a flea-bitten animal skin, he still wears his bowler hat; he outwits an abusive thug, as he often does in the modern city, although here he celebrates his victory by smooching with the polygamous ogre's wives. Between 1912 and 1914, D. W. Griffith made a series of comedies based on Darwinian evolution. In the first, *Man's Genesis*, the caveman Weak Hands fits a rock to the end of a stick, bludgeons an overbearing ruffian who is identified as Brute Force, and wins the love of the maidenly Lily White. Griffith called the impromptu club a 'Bright Idea', which produces 'a New Force': he might have been referring to cinema.

In *Adam's Rib*, released in 1923, Cecil B. DeMille imagined another version of our early history. The heroine is Tillie the jazzy flapper, disapprovingly described by an archaeologist as a 'product of the Movies' and those other modern maladies, 'Women's Suffrage, and the War!' Pondering a specimen of 'picture-writing' in the Hall of the Mammoths at a museum, the misogynistic professor falls asleep, which as in Chaplin's film switches on his private cerebral cinema. He has been poring over a Neolithic carving in which two hirsute males are brawling for possession of a female, and in his dream the image comes to life. When he wakes up, he recognizes that 'bare legs, short skirts and feminine resourceful-

ness are nothing new': the modish Tillie is a direct descendant of the basket-weaving 'Cave-Woman' in her shaggy pelts who appeared in his dream. Frank Capra had his own flashback to our beginnings when he noticed the gooey weapons flung about in Mack Sennett's comedies. The Bible, he recalled, told us that man originated as 'a mud pie: a holy mixture of dust, water, and the Almighty's breath'. Whenever a mess of custard is smeared on someone's face, human beings laughingly forfeit their exalted rank in creation.

Virginia Woolf said that anyone who considered modern society to be over-civilized had 'forgotten the movies' or had 'never seen the savages of the twentieth century watching the pictures'. Terror and fear, she believed, were what 'the picture-making power' existed to inculcate. René Clair agreed, and regarded films as a 'school of unlearning'; they shocked us out of the pensive introversion we absorb from literature, which blunts our 'primitive sensitivity' and makes us incapable of 'emitting a cry of ecstasy'. Less sniffy than Woolf, Clair wished he could turn the people who saw his films into 'fine, simple savages'.

That aim is shared by the movie-making impresario played by Robert Armstrong in *King Kong*. He gives Fay Wray a screen test as they sail to Skull Island for their encounter with the giant ape, and tells her that all she needs to do is scream at the camera; indeed she does little else for the rest of the film, whether she is being strung up as bait by the islanders or flinching as the infatuated Kong drools over her. The savagery Woolf and Clair had in mind was atavistic, and their comments apply both to the tribal revels on Skull Island and the fashionable scrum in the Broadway theatre where Kong is exhibited in chains. Those 'fine, simple savages' could just as well be dressed in classical costume. In 1932 in *The Sign of the Cross*, DeMille sent a mob of Romans to the arena to see Christians martyred, and as the entertainment bloodies the sand they behave like rowdy moviegoers, squabbling over seats in the gallery, fretting about lost tickets, and gorging on snacks that are somewhat greasier than the flower that Charles Laughton's Nero eats, petal by fastidious petal. DeMille lays on a ghastly variety show in the run-up to the main event, when the Christians are at long last attacked by the ravening lions. As a teaser, elephants crush the heads of prone

slaves, alligators waddle towards a trussed woman whom they intend to eat, an Amazon beheads her male adversary, and – anticipating *King Kong*, released the following year – another sacrificial victim who has been bound to a stake squeals as an ape lumbers hungrily or lustfully towards her.

When Woolf wrote her essay on the cinema in 1926, DeMille's Neronic orgy still lay ahead, as did the romance between the beast and the screaming beauty he abducts and carries to the top of the Empire State Building. The film that set Woolf thinking was Robert Wiene's *The Cabinet of Dr Caligari*, released in 1920 – a psychiatric fable about insanity not savagery, in which the deranged director of an asylum uses a fairground somnambulist to commit murders on his behalf. Woolf referred to *Caligari* only in passing, and instead concentrated on an accident that became the pretext for her poetic whimsy. A tadpole on the screen, she said, had swollen to horrific proportions as she watched – could this be an emanation of the crazed Caligari's brain? No, it was a shadow cast by another audience member who in standing up had obstructed the projector's beam. All the same, this chimerical larva confirmed Woolf's point about the power to make pictures, which entails the power to make us form them in our heads and perhaps to disrupt our mental balance. Near the end of the film, the asylum director sees a slogan that pulses in space and is projected onto walls – an example of what Vachel Lindsay described as thoughts materializing in the air. It tells him 'Du musst Caligari werden!': he must become Caligari, taking on the mania of the fairground mountebank by whom he is obsessed. The instruction applies to us as well, because as we watch we become Caligari, locking ourselves in his cell or cabinet.

Wiene's film convinced Woolf that in cinema 'all is hubble-bubble, swarm and chaos. We are peering over the edge of a cauldron in which fragments of all shapes and savours seem to simmer', with 'some vast form' heaved up occasionally from the stew. A hubble-bubble is actually a hookah, a pipe for brewing visions, yet her reference to a cauldron suggests that she heard in the word a punning echo of 'Double, double, toil and trouble', the refrain the witches in *Macbeth* chant to make their stewpot simmer. Shadows are painted onto *Caligari*'s Gothic sets and

stark wintry trees imprinted on a sky-cloth behind them, because the claustrophobic atmosphere debars daylight. But the coloured tints added to the surface of the film itself – icy lunar blue or jaundiced yellow – sometimes look blotchy, as if the celluloid had a viscous coating, and this may have suggested Woolf's bubbly image.

Woolf's description of *Caligari* coincides with the atmosphere of Paul Leni's *Waxworks*, made in 1924. Again the setting is a fair, this time a place of over-charged electricity; two actors from Wiene's film return as wax bogeys in a sideshow, brought to life by a writer's musings – Werner Krauss, who played Caligari, is here the serial killer Spring-Heeled Jack, and Conrad Veidt, cast as the sleepwalker Cesare by Wiene, is Ivan the Terrible. There are chases through intestinal tunnels, and a hiding place in a smoky baking oven. The mad Czar visits a steamy laboratory where poisons are concocted for his use, and Jack stalks victims through a thick urban fog. Leni sought, he said, 'to engender... an indescribable fluidity of light, moving shapes, shadows, lines and curves' – a frothy crucible from which moving images emerge.

Those images not only moved but mutated, producing strange hybrids. According to the biblical myth, God stocked Eden with species that were carefully differentiated and hierarchically arranged – man in charge of the other animals, the snake demoted by being made to slither along the ground. Woolf likened the shadow on the screen to a tadpole because it was a lowly protozoon, far down the chain of being, but cinema overlooks such gradations. The cartoon character Betty Boop began in 1930 as a cross between a squeaky-voiced, scantily clad vamp and a French poodle; her creator Max Fleischer subsequently replaced her floppy canine ears with earrings, allowing her to pass for human. To allay any biological disquiet, an introductory jingle to a 1932 cartoon advised that this 'queen / Of the animated screen' was 'made of pen and ink', not flesh and blood. For a musical number set in Trinidad in *The Ziegfeld Girl*, Busby Berkeley dressed his chorines as tropical flora and fauna. Some of them are hibiscus bushes with open-mouthed blooms, others impersonate swans, parrots and a shoal of fish. Once at least a character slithered between species in full view. When Max Reinhardt's touring production of *A Midsummer Night's Dream* was

filmed in Hollywood in 1935, there was no need for Bottom to dodge offstage to be fitted with an ass's head; thanks to the camera's trickery, we can watch James Cagney's human features blur and coarsen as the exchange occurs. The metamorphoses in Shakespeare's enchanted wood are aural as well as visual. The writer Colette, reviewing *A Midsummer Night's Dream* when it opened in Paris, thrilled to the noises made by Mickey Rooney's raucous Puck, who mimics the screech of a peacock, the snuffling of a boar, and the chatter of a squirrel.

Eisenstein made this revision of our origins explicit in his tribute to Walt Disney. On his trip to Hollywood in 1930, he visited Disney's studio, and was photographed with his arm around the shoulder of the great animator; a cut-out Mickey Mouse saluted them both. Eisenstein revered what he described as Disney's 'divine omnipotence', and placed him in a reconceived biblical epic whose purpose was to sanctify the early history of cinema. Chaplin's comedies, Eisenstein said, were cinema's *Paradise Lost*, whereas Disney's cartoons corresponded to *Paradise Regained*. In the first poem, Milton concludes with the expulsion of Adam and Eve from the garden; they wipe their tears and bravely venture out into an uncertain future, just as the tramp always recovers from disappointment and resiliently totters off down an open road. Milton's second poem describes Christ's victory over Satan, which ensures salvation for us all. Eisenstein justified the comparison with Disney by arguing that his cartoons had renewed and reinterpreted the incarnation, which is the New Testament's miracle. In the Bible, God becomes man; at Disney's studio, a logical sequel extended the blessing to other species as a mouse, a duck and a dog were humanized.

Three Disney cartoons made in the late 1930s charmed Eisenstein because they illustrated this delight in augmenting nature with crossbreeds that were not envisaged in Genesis. *Merbabies* and *Hawaiian Holiday* take place on the water or under it, which is where life began; here Disney studies what Eisenstein called 'the amoebic-plasmatic stage of movement in liquid'. *Lonesome Ghosts*, closer to Woolf's essay, makes spirits visible and explores cinema's affinity with the supernatural.

Merbabies presents a circus parade on the ocean floor, which turns out to be a march-past of metaphors. The seahorses are properly

equine, a tropically striped tiger fish plays a caged tiger, squid are cast as elephants, a sea snail stretches into an aquatic giraffe, and a shark assumes the lion's role. The merbabies evolve from and dissolve back into bubbles, like Woolf's tadpole, and in *Hawaiian Holiday* the ocean off Waikiki Beach, as Eisenstein said, resembles 'a giant, living, formless amoeba', which magically or maliciously plays tricks on Goofy the dog, who is himself a morphological jest. When Goofy tries his luck surfing, a breaker pauses to allow him to mount it, then retracts at speed and deposits him back onshore; at last he manages to balance on his board until another wave twists sideways, knocks him off and swallows him. Unmanned, the plank is launched onto the beach where it props itself upright in the sand to serve as Goofy's tombstone. In *Lonesome Ghosts*, Mickey, Goofy and Donald Duck run a ghost-busting service that is hired by the spooks who haunt a ramshackle house. Rather than asking to be exorcized, the ghosts need new victims to terrify, but of course their scheme comes to grief. Chased into a larder, Mickey, Goofy and Donald upset a supply of flour and molasses; the sticky treacle glues the three exterminators together, and the cloud of powder blankets them as effectively as the white sheets worn by would-be phantoms in the skits filmed by Méliès. The ghosts, outwitted, take fright and quit the house.

The biblical genealogy proposed by Eisenstein was extravagant, but he understood the audacity of Disney's so-called Silly Symphonies. For Eisenstein, these were little parables that showed how America – where, as he said, 'man has become more merciless than in the Stone Age, more doomed than in prehistoric times' – could regain paradise by recovering the naive animistic faith of childhood. His faith was movingly confirmed in 1941 by Preston Sturges' comedy *Sullivan's Travels*, in which Joel McCrea plays a director who rejects Hollywood's frivolity and fantasy and goes on the road to research conditions among the dispossessed. He ends, by misadventure, as a prisoner in a labour camp, mentally confused and unable to convince the warders of his true identity. As a respite after a week's forced labour, he and the other bowed, shuffling prisoners are led by an armed guard to a broken-down church where they are allowed to enjoy a picture show in the company of the black congregation. The entertainment, projected onto a sheet strung up

behind the altar, is *Playful Pluto*, a Disney cartoon that dates from 1934. As the chain gang is led to the pews, the churchgoers sing 'Let my people go'; freedom, it turns out, is the gift of the animated romp on the sheet. Watching Pluto the dog try to unglue his snout and paws from some adhesive flypaper while Mickey Mouse battles with a messy fry-up in the kitchen, the morose and defeated prisoners are convulsed by laughter, surprised by joy. 'Am I laughing?' asks McCrea incredulously. Paradise may not have been regained, but Disney gives these people back some sense of pleasure in being alive.

Eisenstein's account of Disney mixed theology with a kind of meta-biology: the animators took their cue, he argued, from the behaviour of 'primal protoplasm', and this fascination with mutability led him to propound a rule that illuminates one of cinema's most tantalizing mysteries. 'The unstable hero,' Eisenstein said, 'with purely protean greed seeks ever newer and newer forms of embodiment.'

Cartoons are free to redraw the outlines of bodies; that process is more questionable if it goes to work on human characters. What if the unstable hero demands that a heroine re-embody herself, as James Stewart does when managing the makeover of Kim Novak in *Vertigo*? In Minnelli's *Undercurrent*, made in 1946, Robert Taylor plays a sinister tycoon who has invented an obscure but suggestive 'long-distance controller' that supposedly helped win the war against the Nazis. He is currently engaged in what gossiping acquaintances call 'reconversion', which means that he is demilitarizing his firm, though the film mainly concerns his conversion of Katharine Hepburn, a dowdy academic whom he forcibly glamorizes. As Stewart later does with Novak, Taylor takes Hepburn to a dress shop where parading models show off the latest fashions; resenting the makeover, she suspects that after recreating her he will consummate his power by killing her.

Elsewhere in cinematic history, the 'protean greed' identified by Eisenstein leads to feats of self-multiplication, as unstable heroes undergo re-embodiments that would be impossible in any other medium. There is an uncountable proliferation of Buster Keatons in *The Playhouse*: he conducts the band at a vaudeville theatre, plays all the instruments in the pit, is both partners in a dancing duo, drills a regiment of lackadaisical

Zouaves, performs every part in a minstrel show, and has a speciality turn as a bow-legged chimpanzee. Another Buster pulls the curtain up and down, and a few more of his duplicates sit in the audience, where he appears as a tippling grannie and the ill-behaved boy in a sailor suit who accompanies her, as well as a dozing gent and his starchy wife. In *Dr Strangelove* Peter Sellers plays three characters – a German scientist, a British soldier and an American president – while in *Kind Hearts and Coronets* Alec Guinness impersonates eight members of the same aristocratic clan (or nine if a brief flashback is added to the quota). Robin Williams has a mere five roles in *Being Human*, but they span the history of *Homo sapiens* from caveman to contemporary New Yorker, with intermediary incarnations as a slave in ancient Rome, a medieval Scot returning from the crusades and a Portuguese voyager in the Renaissance.

Some of cinema's protean creations are non-human: the metallic robot that assumes the form of the heroine Maria in *Metropolis*, or the ruthless computer HAL in Stanley Kubrick's *2001: A Space Odyssey*, bodiless except for a single glowing red eye. A xenomorph gives birth to itself by erupting from John Hurt's stomach in Ridley Scott's *Alien*, and in Guillermo del Toro's *The Shape of Water* the male love interest is a green, vaguely feline amphibian who lives in an aquarium or a bathtub. As the visitor from another planet in Nicolas Roeg's *The Man Who Fell to Earth*, David Bowie is at best humanoid: his freakish skills include the capacity to watch seven different television channels simultaneously.

One hero seeks a new form of disembodiment. In 1933 in James Whale's adaptation of H. G. Wells's *The Invisible Man*, a chemical experiment causes Claude Rains to vanish, and for most of the film he is a notional volume sheathed in bandages. Unwrapped, he vanishes, though he has to be careful about the weather. 'In fog,' he explains, 'you can see me, like a bubble', or like one of the exhalations from Virginia Woolf's hookah; he only returns to view for a few moments as he dies. And Hitchcock's *Rebecca* teases us with its evocation of an invisible but all-pervasive woman who after her death is represented by her signature and by the empty undergarments stored in her vacant bedroom. The 'picture-making power' on which cinema relies is not sight but imagination.

* * *

Officially the camera is an extrovert, looking out at the world. In 1923 René Clair said that it opens white doors or windows in walls that prove to be transparent screens. On one occasion, it opens a black door in a more grimly fortified wall. John Ford's *The Searchers* starts with an entirely dark screen, which is split apart as a panel is removed. From inside a shuttered cabin we look out across a dazzlingly sunny landscape as a distant rider appears among the tumuli of Monument Valley. The story is ready to begin.

Yet there is another model for the screen, more domestic and introverted than those doors or windows: it can be a mirror, and when we look at it we may find that it looks back at us or even inside us. The analogy has a long history – Hamlet says that actors hold the mirror up to nature, and Stendhal called the novel a mirror carried down a highway – but cinema makes that mimetic task trickier. Harold Lloyd's *Speedy* shows off the untrustworthiness of mirrors when Harold takes his date to Coney Island: bodies are stretched out of shape or bulbously deformed by the glass in the funhouse. Chaplin escapes from a policeman in *The Circus* by rushing into a mirrored maze, and although he evades the law he is trapped in a labyrinth of simulacra. In *Duck Soup*, Chico and Harpo Marx, both disguised as Groucho in identical nightgowns and nightcaps, stalk each other on either side of what was once a mirror, though its glass has shattered. During an imitative ballet, they exactly reproduce one another's postures and gestures; Groucho himself eventually joins them, but is pushed aside. People when filmed are copies made from an original we never see, so there is no room here for the real thing. Gags like these challenge the notions of identity or singularity, which we hold so dear. Cinematic idols, infatuated by the reflection they see in the glass, are not immune. The gun battle in the San Francisco hall of mirrors at the end of Orson Welles's *The Lady from Shanghai* is a literal act of iconoclasm, destroying Rita Hayworth because she is an immaculate, unfeeling image rather than a person. When the hero of Fritz Lang's *The 1000 Eyes of Dr Mabuse* fires a gun through the two-way mirror in a Berlin hotel, he has a different purpose: targeting not a person but a sinister panopticon, he disables the cameras that spy

on people and reduce them to a source of confidential information and prurient entertainment for the thousand-eyed Mabuse, who watches the wall of screens in his basement control room.

The films directed by Jean Cocteau debate the uses and misuses of mirrors. In *La Belle et la Bête*, released in 1946, Belle's suitor – who is also La Bête, as both roles are played by Jean Marais – discovers her scrubbing the floor, which after being polished allows her to see her own face. That menial function can be left to the surface we walk on; the castle of La Bête has a magic mirror with sharper eyes. It offers one of Belle's vainglorious sisters a preview of how she will look in the future, plain and faded, and when the other sister checks on her appearance it shows her a gibbering monkey. It assures Belle that their relationship will be reciprocal: 'You reflect me, I shall reflect you,' it says. The image it presents is like the ideal version of yourself you see in the eyes of a lover – a self that is validated and beautified by someone else, not by your own preening. More than that, this mirror has telepathic or even televisual skills, and with its help Belle keeps a distant eye on the sick father she has left at home.

Attempting to reconcile cinema's opposed tendencies, Cocteau said that films were a realistic documentation of unreal events. To go from one extreme to the other, as if from Lumière to Méliès, involved a trip through the looking glass. The venture begins in *Le Sang d'un Poète*, a dreamy tour of Cocteau's own head, made in 1930. Here a poet who is trying to find a way out of his room gropes along the wall towards a door, only to discover that it has been replaced by a mirror. He shakes the frame, stares down his own reflection, then throws himself against the glass, which fails to splinter. Despite this resistant surface, he is next seen on the other side of the mirror, splashing in a pool. In *Orphée*, which followed in 1950, the grieving hero played by Marais takes the same route. Longing to be reunited with the dead Eurydice, he is ordered to wear a pair of shiny rubber gloves, which in a moment of photographic trickery slip themselves onto his hands. They are part of a surgeon's kit, and they may be needed because he is crossing the border between life and death. Or their purpose may be to make him waterproof: as soon as he presses his outstretched hands to the surface, the glass ripples, lique-

fies, and lets him wade through into the underworld. When he falters, distracted by his own sad face in the mirror, the friend who serves as his guide or psychopomp tells him that to believe in what might happen matters more than understanding the technicalities of the transition.

Science fiction continues this critique of mirrors, which curtail cinema's fantastic voyaging because they can only replicate what already exists. At the space station in Tarkovsky's *Solaris* the dead remain alive, formed and reformed from a protoplasmic fog that resembles Eisenstein's notion of the sentient, malleable substance from which cartoon characters are made. The mystery baffles and bores one astronaut, who says 'We don't need other worlds, we need a mirror'; another character dismisses a female apparition as 'a mechanical reproduction, a copy, a matrix'. *The Matrix* and its sequels, written and directed by the Wachowski siblings, make the same point: the restive hero Neo finds that he is living inside an illusion, a virtual womb that is as insubstantial as a movie set. Laurence Fishburne plays the charismatic leader Morpheus, who is named after the Greek god of dreams even though his mission is to liberate the remaining humans from the computerized simulation in which they are trapped.

The way ahead depends on turning the glassy barrier into an open border. In 1995 in Jim Jarmusch's Western *Dead Man*, a native shaman conducts the moribund Johnny Depp on a journey that leads, he says, 'to the bridge made of waters, the mirror. Then you will be taken up to the next level of the world.' Lying dead in a canoe, Depp drifts away and disappears at the grey horizon where sea and sky merge. The small screens that nowadays rest on our laps or fit into our hands offer the same access to a world beyond what the Lumière brothers thought of as actuality. In Krzysztof Kieślowski's *Dekalog*, a series of films made for television in 1989, a desktop computer switches itself on, after which the image of a child who is soon to die fuzzily forms on its screen: perhaps this is the limbo in which the boy will wander after he drowns. In 2016 in Olivier Assayas's occult thriller *Personal Shopper*, an iPhone transmits text messages apparently sent to Kristen Stewart by her dead brother – and why not? The technology that supplies us with intermediaries like the telephone or Cocteau's televisual mirror

calls on us to make leaps of faith, as people at a séance do when they trust a medium to connect them with spirits. Instead of huddling in the darkness to look at the tremulous light in Plato's cave, we occupy a middle ground between superstition and electronics, and it is here that cinema sets up shop.

5

IN THE REALM OF HERMES

Early on, cinema acquired a celestial patron: the director Marcel L'Herbier said that it placed us 'in the realm of Hermes'. Otherwise known as Mercury, Hermes is credited in the history of myth with having invented the pseudo-science of alchemy, which executed distillations by using an air-tight tube with a secret seal that was said to be hermetic. The alchemists believed that everything in creation was malleable, awaiting transmutation, just as Eisenstein thought that Disney's cartoons melded and moulded the 'poly-formic' prime material of nature into shapes hitherto unknown. Jean Epstein had good reason for claiming that alchemy was an anticipation of cinema.

Mercury was a notorious trickster, as slippery as the chemical element of quicksilver that is named after him; officiating as the messenger of the gods, he often muddled up or altered the news he was supposed to convey. Cinema gleefully took over his reputation for manipulation and adroit fakery. In 1907 in *Creative Evolution*, the philosopher Henri Bergson argued that the motion-picture camera exploits 'the mechanism of our ordinary knowledge', which is only too liable to be duped. Unable to penetrate 'the inner becoming of things', we recompose reality artificially as we 'take snapshots' of passing events. In doing so, Bergson pointed out, we accept 'the absurd proposition that motion consists of immobilities'. Movies, as Ingmar Bergman acknowledged, depend on the same 'imperfection in the human eye': by showing us static frames at the rate of twenty-four per second, they persuade us that we can see armies charging, the Keystone Kops chasing crooks, Indians galloping

behind a stagecoach, or Fred Astaire dancing with Ginger Rogers. Aptly enough, Mercury lent his name to the theatre company Orson Welles founded in 1937, whose members he later cast in *Citizen Kane* and *The Magnificent Ambersons*. The god with the mercurial temperament sponsored Welles's enjoyment of cinema's technical guile, and contributed to the persona he cultivated: performing magic tricks in his autobiographical film *F for Fake*, Welles presents himself as a genial charlatan.

Jean-Luc Godard likewise rejoiced in Mercury's patronage. Cinema, he declared, was 'the most beautiful fraud in the world'. Fraudulent or truly hermetic? The Greeks gave Hermes the honorific title of Trismegistus, thrice-greatest, because his lore condensed the mysteries of art and science; among other achievements, they believed, he used esoteric formulae to animate Egyptian idols. The magic-lantern shows of the nineteenth century cast the outlines of jigging skeletons onto walls, and in 1908 Emile Cohl mechanized the imposture in *Fantasmagorie*, which is thought to be the first animated cartoon. Cohl's own hand draws a clown, then sets the figure free to perform a series of circus tricks. When the two-minute demonstration is over, the phantasm makes its getaway on a horse that Cohl obligingly sketches for it to use.

In his anthem for moving pictures, Vachel Lindsay channelled the ancient mysteries of Hermes into the new art. A filmmaker, Lindsay said, was in the first place a magician, 'who lays hold on the unseen for the mere joy of it' and does not shirk from stealing 'the holy bread and the sacred fire'. As if glancing sideways from Hermes the mystic to Mercury the deceiver, Lindsay added that every artist who sought to make the unseen visible belonged to 'an ostracized and disestablished priesthood' and operated as 'a free-lance in the soul-world'.

Georges Méliès was just such an impish magus. He began his career with performances at the Cabinet Fantastique in the Paris wax museum; for his engagements at the Théâtre Robert-Houdin, he had a stage fitted with trapdoors and rigged with automata. After attending one of the first screenings of the Lumière brothers, Méliès bought a cumbersome Animatograph, worked out how to load it with film, and patented a noisy cast-iron projector. Between 1896 and 1912, taking advantage of more efficient equipment that had become available, he recorded his

magic tricks in five hundred short films, incorporating extra optical flourishes that were made possible by cinema – the dissolve, the fade-out and the opening or closing iris – together with time lapses and double exposures that bemused literal-minded viewers.

Méliès regarded the camera and its antecedents as kit for a conjurer, serving what he called his 'spiritisme abracadabrant'. In one film a photographer tumbles out of a fifth-floor window while using his tripod camera. He is still covered by the black sheet that shuts out the light, and when he lands on top of a passer-by in the street below the two of them are conjoined by the collision. With their agitated legs protruding from the sheet, they look like a large beetle with twitchy antennae; a flabbergasted policeman attempts to arrest the insect. Another escapade involves two clowns who fabricate a magic lantern from strips of wood, then get it to disgorge half a dozen live ballerinas. In *La Photographie électrique à la distance*, a cameraman whose studio boasts a generator and a piston-driven wheel uses these machines to project his stout bourgeois models directly onto a screen, where – like the sisters reflected by the magic mirror in Cocteau's *La Belle et la Bête* – they appear as caricatures of themselves: a man becomes a monkey, a woman a toothless cackling crone.

Cinema allowed Méliès to turn bodies into images, or better yet into ghosts. In one of his films a lady vanishes when covered by a cloth and is replaced by her own skeleton, after which she reassumes her cladding of flesh and blood. Something not very different happens in 1938 in Hitchcock's *The Lady Vanishes*, where the abducted woman, a very matronly spy, is swathed unrecognizably in mummy cloths and passed off as a patient awaiting surgery. The feat is varied by Méliès in *Le Portrait spirite*. Here a female model somehow flattens herself into two dimensions to be imprinted on a sheet of white paper; she regains corporeality when the photographer – defined as a spiritualist by the title of the skit – removes the sheet from its ornate frame and rolls it up. In *L'Homme à la tête en caoutchouc*, Méliès places a tiny rubberized version of his own head on the end of a tube and inflates it with bellows, puffing air through the throat and into the swollen cranium. This is his gruesome anticipation of the close-up, a novelty of cinematic vision

that D. W. Griffith and his colleagues referred to on their worksheets as a 'Big Head'.

Paying homage to Hermes, Méliès assembled a cast of astrologers, fakirs and mountebanks as co-conspirators. In one of his comedies the alchemist Parafaragaramus brews homunculi in a uterine retort. In another an engineer who wants to travel round the world at high speed is persuaded to exchange his conveyances for some pills concocted from the seven deadly sins, which will supply instant propulsion. Elsewhere an illusionist duplicates himself, then caps that trick when he produces a talking head without a body. A prankish demon scares off the twin mischief-makers; removing his operatic cape, he reveals that he is their triplet. Méliès of course played all three roles.

Méliès reassumed the role of Mephistopheles in *Faust aux enfers*, where he leads the impious philosopher to the inferno. Only half in jest, Jean Epstein suggested that 'the phantasmagorias of the screen are inspired by the Devil', the witty innovator who was responsible for so many 'achievements of human ingenuity'. Murnau, in the *Faust* that he directed in 1926, used the art's magical techniques to flout biological and physical rules. Here the swarthy Mephisto played by Emil Jannings rejuvenates the enfeebled elderly scholar by burning away his wrinkled skin with a magic fire; he then instantly reincarnates himself as a sleek, satin-clad tempter. Spreading his cloak, he takes Faust on a journey above the spinning world. They graze the spire of a Gothic cathedral, burrow through thick clouds, cross shaggy forests and glide over an alpine waterfall, narrowly avoiding a squadron of flying dragons. This heady 'play of pure movement', as Murnau called it, was entirely contrived inside the studio, and it shows off a power that may be diabolical but is also innately cinematic.

Murnau's Mephisto tempts Faust to wager his soul by conjuring up a vision of the virginal Gretchen, whose figure suddenly shimmers in the air. This devious magic prefigures the technology Murnau was using: in those experimental days the beam of quivering light that travelled through the darkness from the projector to take form on a screen still seemed mysterious, possibly sinister. Perhaps as we watch we are performing the psychic manoeuvre that Freud during the 1890s defined as

'projection'. The word means 'to throw in front of', and Freud used it to describe the way we displace our fantasies onto the outside world and attribute them to someone else. G. W. Pabst's *Secrets of a Soul*, made in the same year as Murnau's *Faust*, shows the process at work. Werner Krauss is tormented by nightmares after a murder in a neighbouring house. He sees himself ineffectually sounding the alarm as two bodies tussle on the other side of a window blind, etched in sharp relief by a light behind them. Worried about these obsessive re-enactments, he consults a psychoanalyst, who diagnoses an ambiguous mental state that Krauss shares with many filmgoers. Can we be sure that we are awake, not dreaming? Do our fears and desires make us responsible for what we see?

For Buster Keaton in *Sherlock Jr.*, released in 1924, the transference is less troubling, and it leads towards elucidation. Keaton here practises a trade aligned with the psychic manoeuvre named by Freud: he plays cinema projectionist. Buster, framed for a robbery by his rival in love, dozes off in his booth while showing a film about a comparable crime. In a dream he projects himself onto the screen, where he takes over as a detective and identifies the crook. Waking up, as if after a session of self-administered hypnalysis, he finds he has been cleared of the real-life theft of which he was wrongly accused.

The white wall onto which Buster projects his fantasy is wiped clean of doubt and guilt. But his small comic victory ignores the original purpose of the surface where the shadows do their dance: screens are meant for concealment. DeMille's *The Cheat*, released in 1915, concerns marital, financial and legal cheating, though it also cheats our eyes as we observe these vicious activities. Sessue Hayakawa plays a lewd Japanese ivory trader who blackmails the wife of a New York grandee and seals his power over her by marking her skin with the red-hot brand he uses on the polished tusks he sells. Attempted rape, mutilation and murder happen on his Long Island estate in a Japanese room whose translucent paper walls serve, like the shower curtain in *Psycho*, as a teasing intermediary, revealing yet blurring those proscribed scenes. The victim's betrayed husband watches from outside, at first unable to understand the flailing of the silhouetted bodies. Hayakawa falls

to the floor, then struggles upright again. As he slides back down, his blood smears the paper wall and his arm thrusts through it, as if he were puncturing the cinema screen. Ingmar Bergman made explicit what DeMille hints at. Employing a metaphor that is surgical, even obstetric, Bergman said that making a film enabled him 'to stick [his] hand through the membrane of reality'.

Cinema's game of optical hide and seek inevitably took a theological turn. In DeMille's *The Godless Girl*, released in 1929, a young atheist injured in a clash with some muscular Christians undergoes a last-minute conversion. As she lies dying, a kindly Irish cop assures her that a forgiving God will usher her into heaven, and in her last delirious moments she cries 'I see it! I see it!' DeMille's *King of Kings*, released two years earlier, sets a stern test for doubting Thomas, who is told 'Blessed are those that have NOT seen, and yet have believed!' Despite this profession of faith, DeMille was adept at the kind of visual legerdemain deployed by Méliès. When Mary Magdalene's sins are cast out in *King of Kings*, the exorcism is illustrated by superimposition: obliterated when Christ stares at them, the imps of vice claw at her and then fade.

Christ here qualifies as one of the 'prophet-wizards' who for Vachel Lindsay were the genii of cinema, and such freelance dabblers in the spirit world abound in the early history of the art. In *Der Golem*, an expressionist fable released in 1915 with Paul Wegener as the clay ogre, an astrological rabbi in Prague conjures up the Wandering Jew as a diversion for some carousing courtiers. They laugh at the illusory figure, who responds by causing an earthquake that makes the palace collapse. In *Dr Mabuse the Gambler* – the first film in Lang's trilogy about the criminal genius, released in 1922 – the disguised Mabuse conducts an experiment in mass suggestion that he supposedly learned from an Indian fakir. The audience gathered in a concert hall is directed to look at an empty wooden stage. Suddenly the bare boards become a palm desert, with armed natives leading a horse and a camel; they move forward into the third dimension, then burst through a notional fourth wall or cinema screen and troop down the aisles, only to vanish at Mabuse's command. The customers applaud, delighted by this exploitation of their gullibility.

In an essay written in 1928 the dramatist Antonin Artaud explained the febrile appeal of cinema to modern audiences by arguing that 'Today is a time for sorcerers and saints.' The remark was not made lightly. Cast as one of the inquisitors in Carl Dreyer's *La Passion de Jeanne d'Arc*, Artaud had to decide whether Joan was a crazed fantasist or a clear-eyed visionary: the trial was also a debate about this mad or mystical art.

* * *

In 1933 in *The Testament of Dr Mabuse*, Lang's demented mind-controller is locked in an insane asylum, from which he issues commands to his minions by means of 'telepathic hypnosis'. When Werner Herzog directed *Heart of Glass* in 1976 he put that theory to the test on a film set.

Herzog's story is about mass psychosis in eighteenth-century Bavaria, where a mountain-dwelling mystic who possesses the 'evil eye' has entranced an entire village, populated by glassblowers who produce a ruby-red glass that has wonder-working powers. Perhaps the fable alludes to the 'poly-formic' capacities of cinema described by Eisenstein: molten glass is bubbly, like the shapes that arise from the cauldron in Virginia Woolf's essay on her trip to see *The Cabinet of Dr Caligari*. Herzog recruited a cast of non-actors to play the villagers; it was the director himself who undertook to possess the evil eye, because he hypnotized the performers to prepare them for filming and made them memorize their lines while under his spell. The result on screen looks alarmingly authentic. Herzog's subjects or victims twitch, blink, stare, slur or stumble over their words, doze off, collapse in a stupor, stumble along like sleepwalkers and sometimes gratuitously scream or weep. Is this the fugue state we are in when we surrender to a film?

Cinema sends images and sounds travelling through the air like the transmissions of an enchanter's will. In *The Testament of Dr Mabuse*, Lang jokes about the paranormal oddities of a technology we take for granted. The police inspector has an imaginary long-distance conversation with a madman while the two of them are in the same room at the asylum. The madman grips a non-existent telephone; the inspector uses the alarm bell on his pocket watch to pretend that he is receiving the call. One of cinema's home-grown photographic tricks enables Mabuse

to make the asylum director Professor Baum a deputy or mouthpiece: in a double exposure, Mabuse steps out of his own body and sits in the chair occupied by Baum, fusing with him both physically and mentally. An instruction written in the air tells the asylum keeper in Robert Wiene's film that he must become Caligari; Lang actually shows us how Mabuse becomes Baum. Mabuse is described as 'the man behind the curtain' – or perhaps behind the screen – but when that curtain is parted he turns out to be only a shadow, a wooden effigy, powerful because a microphone and a loudspeaker serve as his means of projection, as if he were a more malevolent wizard of Oz. Baum, having taken on Mabuse's identity, leaves a gramophone record to stand in for him by replaying a gruff recorded announcement that tells callers to keep out of his office. The inspector chuckles at the smart mechanism, as he describes it, and explains that it makes possible 'eine neue-technische Übertragung' – a new-fangled technical transference, designed to convey a voice and the volition behind it.

Lang was fascinated by such messaging devices because, like cinema, they work mesmerically. In *Spies*, released in 1928, the criminal mastermind Haghi – another role for Rudolf Klein-Rogge, who played Mabuse as well as Rotwang, the inventor of the bewitching metal succubus in *Metropolis* – conducts espionage by using a variety of these contrivances. He pretends to be disabled, which is his sour jest about the body's obsolescence in a technological society. In a wheelchair, pushed by an acid-visaged nurse, he is fitted with headphones and a speaking tube. His sustenance is information rather than food: a pneumatic outlet dispenses newspapers hot off the press, and windows on the wall open to relay visual reports from afar. When Lang completed the trilogy in 1960 with *The 1000 Eyes of Dr Mabuse*, he showed the underworld empire using closed-circuit television to stage what a clairvoyant in the film calls a 'telepathic séance'. In *While the City Sleeps*, one of Lang's last American films, Dana Andrews is a newsreader who treats television interactively. He taunts a suspected killer during a broadcast, daring him to come out of hiding; raging at the screen as he watches, the young man obliges.

God's spies and sleuths, seen at work in Lang's *Liliom*, rely on technological aids of their own. This film, made in France in 1934, is

based on a play by Ferenc Molnár that later became the source for the
Rodgers and Hammerstein musical *Carousel*; it concerns a wife-beating
carnival barker who after being killed during a hold-up is permitted
to return briefly to earth to make amends for his marital failings. The
anteroom to the afterlife has a telephone switchboard connected to a
command centre higher up, with loudspeakers that issue urgent divine
summonses. Recording angels replay Liliom's past life in a screening
room as he watches and listens in dismay: an episode in which he
slapped his wife is projected in agonizing slow motion, with an added
voice-over that eavesdrops on his enraged internal monologue. Back on
earth, a gramophone preserves a sweeter memory on a cylinder. Liliom's
widow, remembering the best of him, plays the tune that accompanied
the rotation of the carousel on which he worked.

The prophetic wizardry extolled by Vachel Lindsay could easily turn
into profiteering hokum. Was the realm of Hermes merely an amuse-
ment park, set up to swindle those who ventured into it? In *Dante's
Inferno*, directed in 1935 by Harry Lachman, a well-intentioned old
man who runs an eschatological sideshow at a funfair hopes to promote
moral reform by offering visitors an illustrated lecture about perdition.
Spencer Tracy – a carnival barker, like the hero of *Liliom* – takes over this
run-down inferno and re-outfits it with flaming pits and inescapable
caverns. 'We're gonna put hell on a paying basis,' he says; a tour of the
deadly sins becomes a cinematic thrill ride, which pays well until the
structure catches fire and kills a number of its customers.

In Edmund Goulding's *Nightmare Alley*, released in 1947, Tyrone
Power begins as a carnival fortune-teller who fleeces unsuspecting
yokels. He improves his prospects when he convinces an unprincipled
psychoanalyst to pass on information about her rich patients; privy to
their secrets, Power claims that he can make contact with dead loved
ones, and capitalizes on his success as a 'mentalist' by raising funds
for a tabernacle. At one point he stages a resurrection, with a female
accomplice pretending that she has returned from the dead to comfort
an elderly client: his cynical charade fails, although this miracle, the
ultimate test of cinema's ability, remained one of the art's ambitions.
In 1955 Dreyer filmed it in earnest, defying us not to believe what we

see: in *Ordet* we watch as a holy fool, relying on faith alone, restores a corpse to life. By the end of *Nightmare Alley* Power, exposed as a fake, has retreated to the tawdry carnival, where he now performs as Sheik Abracadabra. Like cinema, he travels from conjuring tricks to spiritual divination and back again.

Mercurial spirits run riot in the films of René Clair, playing practical jokes on slower-witted mortals. In *The Ghost Goes West*, released in 1935, Robert Donat plays a heraldic Scottish spook, obliged to emigrate when the mouldering castle he haunts is shipped across the ocean by an American tycoon who has bought the place wholesale. Being a shadow, the pallid ghost recoils from the Florida sun, and from an impertinent flash bulb: 'Take that infernal machine away!' he snaps at the owner of the camera. *I Married a Witch*, made in 1942, is about a sorceress burned by puritans in colonial Salem who is set free in the present when lightning fells the tree beneath which her incinerated remains were buried. 'Thou hast no substance,' she tells her equally bodiless father during a prologue that is set in limbo. 'We are smoke,' he replies. 'Give me a body,' she pleads. She at once materializes as the blonde siren Veronica Lake and sets about beguiling a descendant of the bigot who condemned her.

Although Clair relished what he called the 'miracles' made possible by Hollywood's special effects – Donat walks through a closed door, Lake slides up a banister – he made sure that those comic whimsies never irrevocably overturned staid reality. Hence his cautious retelling of the Faust legend in *La Beauté du diable*, released in 1950 after his return from Hollywood to France. Clair's Faust believes in 'transforming the world through science' and boasts that 'anything can be changed'. Sand turns into gold; cinematic magic permits the ageing, bloated Michel Simon and the debonair Gérard Philippe to swap bodies on a whim, so that Simon plays Faust in his dotage and also a decrepit Méphisto, while Philippe handsomely incarnates both characters when young.

Offering Faust a less playful pact, Méphisto allows him a glimpse of his unbridled future in a magic mirror. In 1944 Clair had already employed such a cinematic flash-forward in his fantasy *It Happened Tomorrow*, where Dick Powell is an obituary writer who receives pre-

mature digests of the next day's news from a dead journalist; in league with a clairvoyant girlfriend and the phony fortune-teller who is her partner, he uses the tips to scoop rival newspapermen. This harmless cheating ends when he reads his own death notice in one of the not-yet-published papers. Although he manages to avoid the inevitable, Faust's preview of his later life in *La Beauté du diable* is more sobering. The mirror shows him that his quest to probe the secrets of matter and to generate energy from dust will take him from alchemy to nuclear physics and will ultimately make him responsible for the atom bomb. He therefore rejects the bargain; instead, teaming up with a gipsy and her performing dogs, he joins a carnival. Cinema's extravagant ambitions – to control the mind, to transform the body – are all very well, but sometimes weary humans just want to be amused.

* * *

John Boorman's *The Emerald Forest*, set in the Amazon, begins with the abduction of a white boy, the son of an American engineer who is ravaging the jungle to construct a hydro-electric dam; the child is taken by a tribe known as the Invisible People and brought up as one of them. Approaching adulthood, he is sent on a quest, a rite of passage that ends when a spirit assigns him a purpose in life. Boorman needed the co-operation of tribal elders for his project, and on one preliminary expedition to the rainforest in 1983 he encountered a shaman, to whom he tried to explain the nature of his art – almost as alien, surely, as the bulldozers that clear land for the dam or the bottle rockets and carbines with which the boy's would-be rescuers arm themselves. Without ever having seen a film, the shaman understood the pitch immediately. 'You make visions, magic,' he said to Boorman: they were colleagues.

Films do not necessarily document events that transpire in the world outside; perhaps the scenes we stare at are already stored in our minds, tightly wound like reels of celluloid in canisters. In Fritz Lang's *Fury*, released in 1936, a lawyer badgers Sylvia Sidney, who was an eyewitness to Spencer Tracy's apparent death when arsonists set fire to the prison where he was being held. Isn't it possible, the lawyer asks, that she saw 'only the image of him your imagination had created in

your head?' The over-deliberate phrasing reminds us that imagination creates images, as if cinematographically; the point is enforced when he demands 'You can see the picture now too, can't you?' She has to admit that her disturbed mind is always screening it, and in fact the scene she describes so vividly is finally shown to have been a hallucination.

Less fearfully, the films made by Jean Vigo before his early death in 1934 concoct scenes of saturnalian revelry that turn out to be exercises in wishful thinking. Vigo's anarchism is joyful or even frivolous, like that of René Clair who in *A nous la Liberté* prescribes vagabondage as a liberation from dreary industrial labour. In *A propos de Nice* – made by Vigo in collaboration with Boris Kaufman, Dziga Vertov's brother – the resort and its promenading visitors are assailed by a jokey cinematic artillery. Here is ribald proof of the cinema's 'power to disorient', which so elated André Breton: indiscreet views snatched on the sly, drunkenly tilted camera angles, a jeering association of ideas that cuts abruptly from a shot of a strutting dowager to another of an equally snooty ostrich, plus some sudden reminders of what the moneyed tourists are not supposed to see – the scabrous skin of a boy in the slums, garbage festering in a gutter. Carnival, when it overtakes the streets of Nice, is a noisy rehearsal for revolution.

The boarding school in Vigo's *Zéro de conduite* exists to repress its inmates, and if marks were given out, most of whom would receive the title's grade of 0 for conduct. Disciplinarians police locations where instinct prevails – the latrine, the playground – but in the dormitory a pupil escapes reproof when he sleepwalks: how can he be punished, since he is unconscious? The example of Chaplin and the techniques of Disney cartoons contribute to this release from prohibition. In one scene a monitor forgets his duty and impersonates the little tramp, an eternal outsider who spends his life flouting authority. In another episode set in a classroom we watch as the 'poly-formic' sorcery that Eisenstein admired goes to work on the pompous Surveillant-Général: in a scribbled caricature he is undressed, squeezed into a bathing suit, and then, in a flurry of stop-motion animation, changed to a sulky Napoléon in a military greatcoat. Filming a bedtime pillow fight, Vigo urged the boys to be rambunctious. Then by projecting the scene in

slow motion he turned the sticky, suffocating cloud of feathers into a snowfall: thanks to one of cinema's simplest but most fantastical tricks, the riotous upheaval is soothingly reabsorbed by nature.

'One gets the world one deserves,' Vigo said in 1930 in a talk introducing *A propos de Nice*. *L'Atalante*, his last film, is about a heroine who deserves a better world. Juliette, a young bride – played by the wide-eyed Dita Parlo, a bruised angel – comes from her village to live with her husband on a sooty barge that chugs through greasy water past slag heaps on an industrial canal outside Paris, with a stop to unload near the abattoir at La Villette. Depressed and disgusted, she absconds briefly, but a revolt like that of the schoolboys in *Zéro de conduite* or the carnival roisterers in *A propos de Nice* is not an option for her. Instead cinema dreams of release on her behalf, and it does so by demonstrating the strangeness of a world that otherwise looks squalid. On the towpath, a pierrot-like peddler unpacks his wares and turns himself into a one-man band, playing cymbals, a drum and a trumpet while he rides a bicycle and doffs a Chaplinesque bowler to salute Juliette. On the barge, the unkempt and sottish Père Jules of Michel Simon shows her the 'Wunderkammer' in his seamy cabin, which contains the horns of mythical beasts, a sawfish skeleton, a Navajo knife, some orchidaceous female pin-ups, and a friend's severed hand bottled in brine. His most surreal exhibit is the animated figure of a decrepit conductor in a frayed suit, who when wound up directs a symphony with a fragile baton and then slumps forward on the podium, dead until his next automated resurrection. When Juliette runs away to Paris, what entrances her is the window display in a department store, with jigging mannequins that simulate a parade on the Champs-Élysées; her childishly delighted face is reflected in the glass, as if she were watching a film.

Reconciliation between Juliette and her husband Jean occurs inside Vigo's camera in two brief, lyrically outlandish scenes. Dismayed by her absence, Jean dives into the canal fully clothed. This may be a mock-suicide, but the water buoys him up: beneath the scummy surface he swims in elegant loops rather than drowning, and then in the wet gloom he sees Juliette's glowing figure afloat upright in her white satin wedding dress. They are submerged or immersed in a shared dream. Later in

their separation, the two of them toss in sleepless yearning, Jean in his bunk on the barge, Juliette in a rented room far away. Alternating shots are cut together and made to overlap, so their bodies look tantalizingly close to fusion. In both places, an unexplained pattern of nocturnal sunspots speckles their bare flesh. 'Tattoos keep you warm,' Père Jules tells Juliette when he shows her his scarified belly, and to prove the point he sticks a cigarette in the mouth that has been inked around his navel; the dots that flicker between the two bedrooms have the same calorific purpose, making desire palpable and visible. Artaud said that cinema worked like 'a subcutaneous injection of morphine', and Vigo here seems to X-ray the skin of his characters to reveal the drug working on their pulses. In 1911 the novelist Jules Romains welcomed 'the night of the cinema'. Of course audiences were apprehensive as the lights went down, but Romains thought he overheard a sigh of relief when brightness reappeared on the wall at the far end of the room: now, thanks to this false dawn, what he called 'the group dream' could begin. The same subliminal connection enables Jean and Juliette to make love telepathically.

Luis Buñuel called dreams 'the first cinema invented by mankind', and expressed surprise that it had taken so long to devise a machine for recording them. In *Un Chien andalou* and *L'Age d'or* he and Dalí almost randomly collate images salvaged during the sleep of reason: episodes of mutilation, dismemberment and indecency that possess, as Vigo said, a 'savage poetry'. The outrages in Buñuel's films are conceptual but not entirely harmless, because they rehearse actions that the dreamers have at least thought of committing. The uncle in *Viridiana* persuades his niece, a novice from the convent, to wear his dead wife's wedding dress; he then drugs her, intending to rape her while she is unconscious. Although he cannot bring himself to defile her, he tells her that he has done so, then reverses himself and says he only possessed her in his thoughts. In *The Criminal Life of Archibaldo de la Cruz*, made in Mexico, Archibaldo the would-be psychopath enthusiastically confesses to using a straight razor to murder a succession of women whom he has pursued. A judge listens to his gruesome ramblings, then pardons him. 'If we arrested everybody who'd ever committed a crime

in his imagination,' he says, 'there'd be more people in prison than out.'
The cinemas might also be empty.

Buñuel's *Los Olvidados*, released in 1950, purportedly documents
life in the slums of Mexico City, but as Octavio Paz pointed out it
stretches to include desire and delirium, 'the nocturnal part of life'. A
gang of urchins beat up a legless beggar and leave him to flail on the
pavement as the wheeled platform on which he props his torso scuttles
off down the alley on its own. The similar attack on a blind man in *Un
Chien andalou* is the product of a Sadean imagination that delights in
gratuitously offending human decency; the incident in *Los Olvidados*,
by contrast, may have been all in a day's work for those ragamuffins,
who act out fantasies the rest of us suppress. Elsewhere one of the boys
dreams that when he asks his un-nurturing mother for food she presents
him with a bleeding slab of raw meat, held next to her chest as if she
had ripped out her heart. Another child lies down under a donkey and
suckles its udder, while a girl in the same stable smears the fresh warm
milk on her legs and thighs to make them silky – a rude equivalent to
the bath in asses' milk enjoyed by Claudette Colbert as the courtesan
Poppaea in DeMille's *Sign of the Cross*.

In 1967 in Buñuel's *Belle de jour*, Catherine Deneuve enjoys her
nocturnes in broad daylight. She spends her evenings as a bourgeois
wife in an apartment near Parc Monceau, but during the afternoons she
prostitutes herself in a swanky brothel, occasionally moonlighting – again
during daytime – in the Bois de Boulogne. The bordello she frequents
is set up like a cinematic peepshow, with a hole in the wall so that she
can learn the trade by studying the other employees. Or is she in a pro-
jection booth, like Keaton in *Sherlock Jr.*, beaming her covert longings
into that enclosed, obscured chamber? On one occasion, a fetishistic
tryst is designed and directed as if it were a film scene. An aristocrat
takes Deneuve back to his château, costumes her as a corpse, and lays
her out in a flowery coffin; he then produces a camera on a tripod, and
photography takes the place of necrophiliac sex. Paz believed that the
stories Buñuel told were 'an exposure' – of himself, of human truths,
of our private parts and our psychological secrets, bared to the light
like photographic plates. In *Viridiana*, mendicants invade a patrician

estate and trash the dining room during a rowdy banquet. A female beggar lines the others up behind the table in a bacchanalian semblance of Leonardo's *Last Supper* and tells them to freeze for a photograph. Lacking a camera, she hoists up her skirt and pokes her groin at the company. That surely counts as one of Paz's exposures: her third eye is between her legs.

Like Buñuel's brothel, the psychiatric hospital in Georges Franju's *La Tête contre les murs* is a place devoted to imagining. The hero (Jean-Pierre Mocky), who has been committed to the institution by a punitive father, says that when you are locked up all alone, you dream. At least Catherine Deneuve's customers have their wishes fulfilled; Franju's characters dream in solitude, unavailingly. Buñuel claimed that cinematic poetry implied liberation from what conformists call reality, but in *La Tête contre les murs* those surreal freedoms remain a mad, frustrated fancy. Charles Aznavour, cast as an epileptic, escapes into the countryside with Mocky. 'On est sauvé,' he says, then collapses in another fit. Mocky's dash for freedom is cut short when a rabbit hunter shoots him, though on his second attempt he gets as far as Anouk Aimée's room in Paris. She assures him that she is not a dream; all the same he is at once recaptured. An apologetic preface to Franju's film insists that the inhumane clinical methods it depicts were no longer current in 1959, when the film was made; it then refers to 'le monde étrange où vous allez pénétrer' – the asylum or the cinema? In this shadowy realm one of the internees pretends to be blind and wears dark glasses, we are told, so that he can see better. A doctor objects to an intern's use of the term 'lunatique'. Nevertheless the word suits the cinemagoer, who is addicted to half-lights.

In Samuel Fuller's *Shock Corridor*, released in 1963, a murder has been committed in a mental hospital; a reporter who wants to solve the crime goes undercover in the ward where it took place. To gain admission, he has to have himself declared psychotic. He therefore confesses to incest and enlists his girlfriend, a highbrow stripper, to pretend that she is the sister he molested. Having got himself locked up, he attempts to identify the killer by interviewing three incurably crazy witnesses. His sleuthing succeeds, but he ends as a mute schizophrenic, suffering

from 'a form of dementia praecox... characterized by childish behaviour, hallucinations, emotional deterioration'.

The doctors who prescribe shock therapy and strap the reporter into a straitjacket claim to be concerned for his 'mental hygiene', but the delusions they try to eradicate are cinematic, as Fuller discloses on three startling occasions when his monochrome film – depressingly grey, as if viewing the drab hospital with barbiturate-blunted eyes – explodes into colour. Its purpose in doing so is to illustrate the exotic dreams that vex the inmates. A belligerent veteran who imagines he is still fighting for the Confederacy in the Civil War starts to babble about Japan, which he visited during his service in Korea: we see a colossal Buddha, a parade of children dressed as geishas, and a playground on the roof of a Tokyo department store, with a globe turning above the smoggy city. Extracted from the madman's addled brain, the coloured imagery is meant to look weirdly illogical, yet in fact it is documentary footage taken during preparations for *House of Bamboo*, Fuller's thriller about racketeering in post-war Japan. When the reporter wanders into a female ward, he is mauled by famished women whom he calls 'nymphos'; he says he has been 'attacked by Amazons', and a guard remarks 'That's a secret dream most men have.' A little later, the dream migrates to the head of a different character, a black victim of racial segregation who fancies that he is a white supremacist and claims to be the founder of the Ku Klux Klan. When he fantasizes about a blood transfusion that will change his race, Fuller inserts a few moments from another tropical travelogue, with grass-skirted tribal dancers in the Amazon performing a fertility dance. Like the earlier glimpses of Japan, this is 'cinéma verité', recycled from Fuller's research trips to Brazil while preparing for an unmade film in which John Wayne was to play a jaguar hunter. A last coloured snippet visualizes the emotional deluge in the reporter's mind by plunging us into the Iguazu waterfall on the border between Brazil and Argentina – one more leftover from Fuller's location-scouting.

Siegfried Kracauer, the analyst of mass hysteria in the Third Reich, thought that cinema could permeate the boundaries that the self erects and dissolve us into 'all things and all beings'. Something like that happens when Fuller assigns his own touristic mementos of Japan

and Brazil to the patients in *Shock Corridor*. The reporter believes that having himself declared insane is a risk worth taking, because the resulting exposé may secure him 'a movie sale'. Instead he discovers that madness and movies are much the same.

* * *

In a burst of theoretical bravura, Buñuel praised the camera as 'a machine that manufactures miracles'. It did so, he said, because it could speed up to show a seed as it germinates and begets a flower, or slow down to make a vase that has been shattered by a bullet splinter with elegant deliberation. Those examples refer to the camera's scientific dissection of time and motion, but Buñuel's example of the exploding vase also recognizes a new and uniquely cinematic mode of dramatizing events. Arthur Penn in *Bonnie and Clyde* and Sam Peckinpah in *The Wild Bunch* decelerate movement to choreograph violent deaths, with blood spurting as if from ornamental fountains: the marvel here is the terrible beauty of such carnage.

The miracles manufactured by the camera do not necessarily vouch for the existence of God, which is why Buñuel said they could be manufactured. A miracle literally means something to be admired or to be astonished by; religion co-opts such wondrous events, arguing that they are only explicable if we believe in higher powers. Buñuel's films do on occasion trifle with the kind of miracles that depend on divine intervention. *Simon of the Desert*, released in 1965, restages the ascetic feat of Saint Simeon Stylites, who spent six years living on top of a pillar in a desert. Thanks to the saint's prayers and the camera's sneakier magic, a thief whose hands have been chopped off as a punishment finds that they have regrown from his wrists. Yet he expresses no gratitude to Simon, and immediately uses his new extremities to cuff a refractory daughter. No doubt he will soon be back to picking pockets.

Buñuel's *The Milky Way*, released in 1969, is about two undevout French beggars who go on the pilgrimage route to the apostle's shrine at Santiago da Compostela, scrounging and carousing in transit instead of looking at the galactic 'field of stars' evoked in the city's name.

Along the way the Virgin Mary, dolled up in a blonde wig and a tiara, greets them from her perch in a roadside tree, the Devil offers a lift in his sports car, and the Marquis de Sade detains them in order to make propaganda for atheism. When they stop at an inn, they find a local curé explaining how Christ managed to be conceived and born while his mother's hymen remained intact. The curé's case depends on a pair of rhetorical questions with which he challenges sceptics. Do not thoughts emerge from the brain without harming the cranium, and is it not true that sunlight can travel through a window without breaking the glass? His theology may be strained, but both analogies work well as accounts of cinema: in a chemical and mechanical miracle of its own, it extracts dreams from their cerebral hiding place and translates them into light. At the end of *The Milky Way*, Christ appears in person and restores sight to a pair of blind men, who are commanded to tell no one about this act of healing. Perhaps the reason for secrecy is that the saviour's quick fix was bogus. In the last seconds of the film, the eye of the camera sees through the make-believe: one beneficiary of Christ's conjuring still uses a cane as he fumbles over a ditch.

'In my films,' Michael Powell declared, 'miracles occur on screen.' The arcane phenomena in the films made by Powell and Emeric Pressburger include the navigation of a legendary Gaelic whirlpool in *I Know Where I'm Going*, a plunge into a swimming pool that serves as an underwater time tunnel in *The Life and Death of Colonel Blimp*, and a stage of dry boards that is suddenly inundated by breaking waves during a ballet performance in *The Red Shoes*. Powell described cinema as 'my religion', and called himself 'a high priest of the mysteries'. He was not being ironic. In the novel that he and Pressburger based on *The Red Shoes*, a young dancer listens to the impresario Lermontov and thinks 'It was like a god talking: Apollo through the mouth of one of his priests.' But Powell had no need for transcendental assistance, because photography uses light as a means of resurrection. In *A Matter of Life and Death* a camera obscura at the top of a village doctor's house gathers up the happenings in the street outside and projects them in fuzzy colour on a concave screen in a dark, empty room. The doctor, like any artist, prefers life to be refracted, composed, granted a second coming; recalled

to the chores of ordinary existence, he opens a window and daylight at once erases the show.

Miracle in Milan, directed by Vittorio De Sica in 1951, is about the derelicts in a shantytown whose wishes are fulfilled by a magic dove that may or may not represent the Holy Spirit. The benefits it brings are both physical and material: a dwarf gains a foot in height, a black man changes his skin colour, and modest requests for a radio or a wardrobe are instantly gratified. Harassed by the authorities, the beggars fly off on brooms donated by street-sweepers, and we see them soaring above the city's cathedral on their way 'towards a land where "buon giorno" always means "buon giorno"'. Special effects take responsibility for enforcing faith, and these magical stunts are meant to be viewed with trusting naiveté. Later films have to command or even bully cinemagoers into acceptance. In 1978 Richard Donner's *Superman* was advertised by a slogan predicting 'You'll believe a man can fly', as if we could take it on trust that Christopher Reeve was actually skimming above Manhattan or swooping westwards to fix a fissure in the San Andreas fault. In 2019 the trailer for Tom Hooper's *Cats* – in which human performers are digitally and a little disgustingly clad in fur – was more curtly insistent: 'You will believe,' said its tagline, though few people did. Even if we choose to remain agnostic, we are still liable to be challenged by the camera, which ever since the beginnings of cinema has shown us things we cannot see for ourselves and might not be able to comprehend. Hal Ashby's *Being There* derides the credulity of those who believe in the supernatural grace of the dim-witted savant played by Peter Sellers; then in a dumbfounding epilogue it shows this apparent fraud walking on water.

Andrei Tarkovsky's *Stalker*, released in 1979, is about a psychopomp – like Mercury, a guide or medium whose task is to usher people from this world to whatever lies beyond it. The Stalker takes questers out of their rusted, rotting, colourless city, leads them down a disused railway line, and brings them into a bright, polychrome fourth dimension that is known as the Zone. Here, among debris from a meteorite, the detritus of a forgotten war, and invisible traps and barriers designed by extraterrestrial guardians, there is a fabled Room in which the wishes

of those who have made the journey will be dangerously fulfilled: an allegorical cinema? One of the Stalker's customers is a writer, who like Faust wants to free himself creatively with the Devil's aid. The other is a scientist, a Faustian of a different kind. He hopes to analyse the Zone's mysteries, after which he intends to destroy the Room by exploding a nuclear weapon he has secreted in his backpack; that, he believes, will prevent the misuse of its powers. In the event both men hesitate on the threshold of the Zone, then return to the city to resume their dissatisfied lives, accompanied by an alert black dog that the Stalker has befriended – their unmenacing Cerberus?

Railing about the bad faith of his clients, the Stalker collapses into bed. As he falls asleep his wife addresses the camera, tearfully telling us that he does not belong in these grey, dull, supposedly real surroundings. Then, in the film's final scene, the depressed monochrome of the Stalker's bedroom gives way once more to colour, and the interrupted quest is effortlessly completed by his young daughter. In a part of the house where the air is alive – cloudy with drifting white spores, hazy from steam exhaled by a glass of tea – she has been silently reading a poem, an extract from which is recited by someone else's voice: it describes a lover's eyes, which can blaze like lightning but semaphore desire when they are bashfully lowered. What happens next suggests that the eyes we are using to watch the film also possess such telekinetic or, to use Tarkovsky's term, 'cinemagenic' skills. The daughter stares intently at the glass of tea, and by the intensity of her gaze she is able to make it move, squeaking a little, across the marble table top. She then does the same to a jar that contains a broken eggshell. Leaning her head on the marble, she impels another glass to travel all the way to the edge; it tumbles to the floor, audibly bumps, but seems not to shatter. The table shakes and rumbles, though not because of a malign force like that unleashed by the possessed girl in William Friedkin's *The Exorcist*. The vibration is caused by a train that clatters past, incongruously broadcasting an extract from Beethoven's setting of Schiller's 'Ode to Joy', as if Alexander Medvedkin's film-train were still dispensing uplift throughout the Soviet empire. The musical summons might be intended for us: Tarkovsky recommended that we should view another of his films as

'the window in a train passing through your life'. The girl's face remains expressionless, not overjoyed; it guards the fifth-dimensional domain that Dreyer called 'the psychic', the realm of Psyche, which by order of Cupid was also hermetically sealed and guarded against intrusion.

Is this what Octavio Paz envisaged when he said that Buñuel in *Los Olvidados* proves that 'a man with his hands tied can, simply by shutting his eyes, make the world jump'? Not quite: the girl's eyes remain open, the glass does not execute a suicide leap when it gently slips off the table, and apart from these feats of psychokinesis, the scene has a placid pictorial beauty that is entirely natural. The webbed, leafy pattern of the golden shawl the girl wears, the eggshell's combination of fragility and strength, the feather-light spores at their work of germination – when seen by the camera, these become the ingredients of a waking dream.

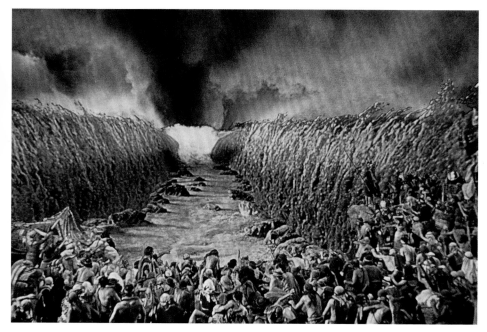

1 A miracle in Cecil B. DeMille's *The Ten Commandments*, achieved by special effects: the Red Sea opens at the behest of Charlton Heston's Moses.

2 A happy catastrophe in David Lean's *The Bridge on the River Kwai*, achieved by pyrotechnics: saboteurs detonate the bridge built by inmates of the Japanese prisoner-of-war camp as the first train crosses it.

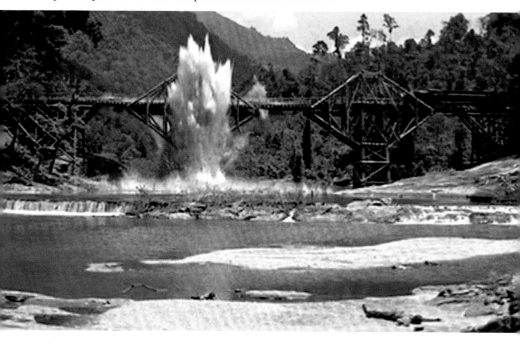

3 The lunar explorers assess the terrain in Fritz Lang's *Woman in the Moon*: Gustl Gstettenbaur as the stowaway, Willy Fritsch as Helius and Gerda Maurus as Friede.

4 The astronomers in Georges Méliès' *Le Voyage dans la lune* land on a differently imagined moon: on the left, Méliès himself leads the expedition as Professor Barbenfouillis.

5 Olga Baclanova as Cleopatra, the trapeze artist who is mutilated, tarred, feathered and transformed into a human duck at the end of Tod Browning's *Freaks*.

6 Vivien Leigh as Scarlett O'Hara in Victor Fleming's *Gone with the Wind*, with the remnants of the Confederate army – 800 extras and the same number of dummies lying on the railway tracks at the station in Atlanta.

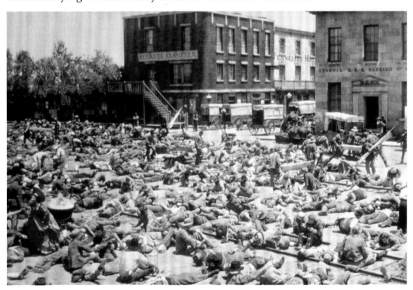

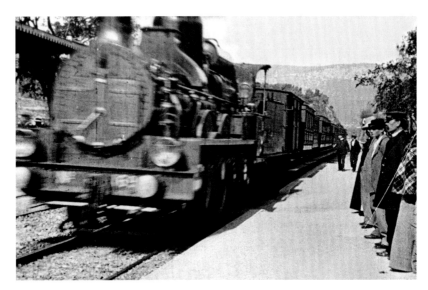

7 A train arriving at La Ciotat station near Marseille, filmed by the Lumière brothers: according to Germaine Dulac, this is where cinema's cult of movement began.

8 The Zeppelin goes down in flames after a kamikaze pilot crashes into its gas tank during a battle above London in Howard Hughes' *Hell's Angels*.

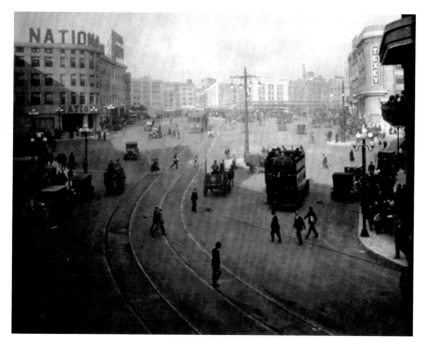

9 The city built at the Fox studio for F. W. Murnau's *Sunrise*, with a sharply receding perspective to suggest depth and signs in an indeterminate language.

10 Séverin-Mars as the railway engineer Sisif in Abel Gance's *La Roue*.

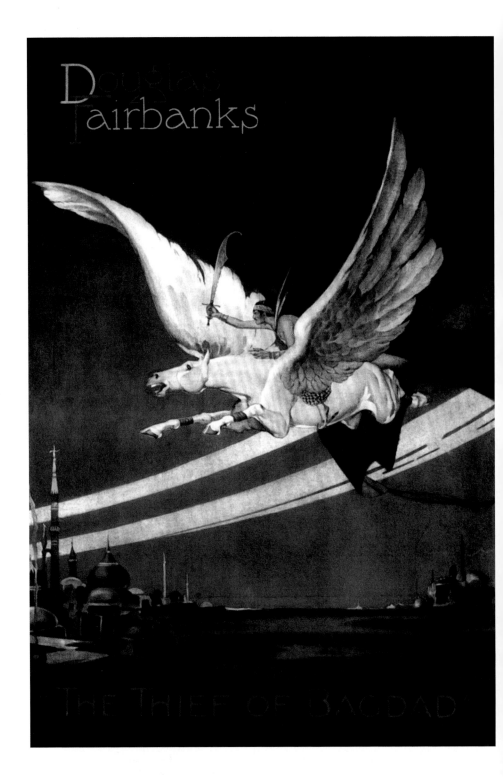

11 Douglas Fairbanks as Ahmed the thief on his flying white horse in Raoul Walsh's *The Thief of Bagdad.*

12 Workers leaving the factory in Lyon, filmed by the Lumière brothers: the building, where the family firm manufactured photographic plates, is now the Institut Lumière, 'hangar du premier film du cinéma'.

13 Jean Marais as the poet in Jean Cocteau's *Orphée*: the mirror, representing the dead end of realism, liquefies to let him cross into a surreal underworld.

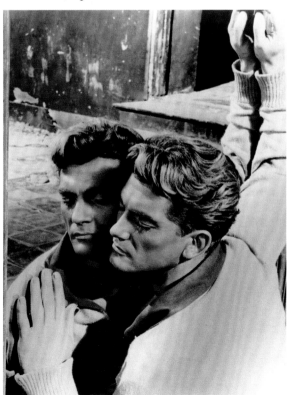

14
S. M. Eisenstein with Walt Disney and Mickey Mouse during his visit to Hollywood: the director Grigori Alexandrov is on the left, the cinematographer Eduard Tisse on the right.

15 Werner Krauss and his shadow in Robert Wiene's *The Cabinet of Dr Caligari*, in which Krauss plays the mad asylum-keeper Caligari.

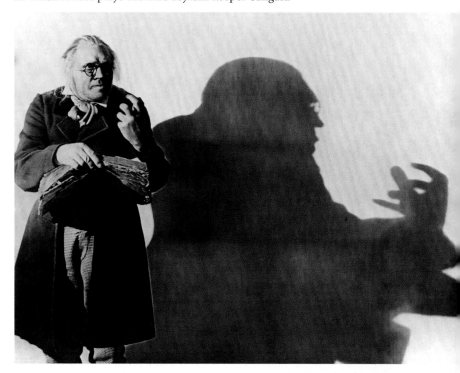

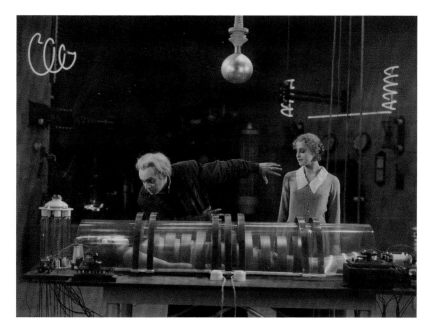

16 The laboratory of the mad inventor in Fritz Lang's *Metropolis*: Rudolf Klein-Rogge as Rotwang and Brigitte Helm as Maria with the robot – known as Parody or Futura – that is waiting to be animated.

17 Rudolf Klein-Rogge as the criminal mastermind Dr Mabuse, mesmerically directing events from the asylum in Lang's *The Testament of Dr Mabuse*.

18 Georges Méliès as Mephistopheles directing an infernal ballet in *Faust aux enfers*.

19 Emil Jannings as Mephisto folding his wings over the world in Murnau's *Faust*.

20 Jaque Catelain as Einar, at work with technicians as they electrically resurrect his dead mistress in Marcel L'Herbier's *L'Inhumaine*: Einar's laboratory was designed by Fernand Léger.

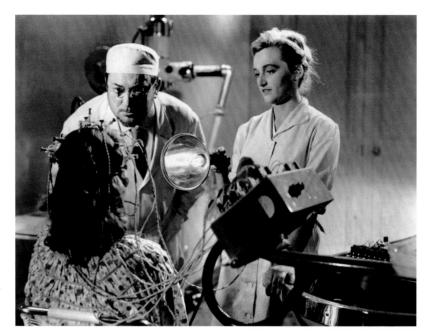

21 Pierre Brasseur as Professor Génessier in Georges Franju's *Les Yeux sans visage*, with Béatrice Altariba as his patient, here rigged up for a tachistoscope administered by the nurse (although Génessier intends to use her as the donor in a face transplant).

22 The laboratory in James Whale's *Frankenstein*: Edward Van Sloan as Dr Waldman, Colin Clive as Frankenstein and Dwight Frye as his hunchbacked helper Fritz, with the monster still under wraps.

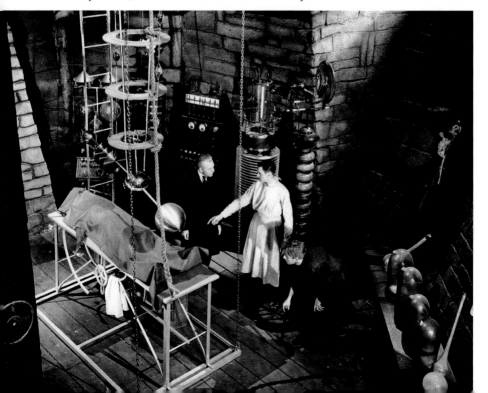

23 The ballet on the dirigible in Cecil B. DeMille's *Madam Satan*, with an allegorical figure representing Electricity and a chorus line of batteries and spark plugs.

24 Gennaro Pisano as Celestino, the photographer with the machine that kills evil-doers in Roberto Rossellini's *La macchina ammazzacattivi*.

25 The summit of the musical tower from Robert Z. Leonard's *The Great Ziegfeld*, with the pianists playing Gershwin: the rotating volute had 175 steps, and the costumes for the female chorus used 23 kilos of sequins and 11 metres of ostrich plumes.

26 The Babylonian set for D. W. Griffith's *Intolerance*, built at the junction of Sunset Boulevard and Hollywood Boulevard in Los Angeles: with its elephants rearing atop walls that were 90 metres tall, it was left in place to moulder for three years after filming was completed.

27 Fred Astaire and Ginger Rogers on the Lido in Mark Sandrich's *Top Hat*: Carroll Clark designed this indoor Art Deco Venice under the supervision of Van Nest Polglase.

28 A living statue from the prologue to Leni Riefenstahl's *Olympia*, which documents the 1936 Olympic Games in Berlin: the Discobolus of the classical sculptor Myron takes on flesh and prepares to migrate from Greece to Germany.

6

CINEGENESIS

Seated in the opulent Ufa-Palast am Zoo in Berlin in 1925, the novelist Joseph Roth watched the show begin with a slightly heretical reprise of the world's beginnings. A velvet curtain covering the cinema screen slid open, and the auditorium's palatial void was infused by 'a mysterious light that God could never have created and that nature will never manage to reproduce'. The radiance must have derived from some 'unknown and powerful divinity', whose intent may have been satanic: this strange glow wavered between 'heavenly clarity and hellish vapours'. Although Roth did not say so, his unknown divinity reversed the proclamation made in Genesis, because cinema cannot exist without the command 'Let there be darkness'. Ricciotto Canudo, one of cinema's first and most fervent critical promoters, called for 'a new myth' to celebrate an art that recreated life rather than imitating or representing it, and here it was, made manifest by a lambent dawn that, when ironically described by Roth, shaded into sunset.

Early films retold the story of creation in equally unorthodox ways, emphasizing the shock of animation – the kinetic surprise that inaugurated life and was at last captured by cinema – but usually giving no credit to God. The first copyright issued to Edison's company in 1894 was for a 'kinetoscopic record' of a man taking a pinch of snuff and sneezing. The incident has a right to its place at the start of the company's inventory, because it comically recalls the way God's breath implanted life into a lump of red clay and gave Adam a soul, his anima: we say 'Bless you' at such moments to protect a spirit that has been violently expelled from its bodily sanctum. Cocteau's *Le Sang d'un poète* makes a sacrilegious joke about the same biblical moment of creation. A mouth

squirms free from a painting, nests in the poet's hand, then starts to speak; he next affixes it to a statue, onto which he sneezes, at which point the marble figure, no longer inanimate, walks away.

The Lumière brothers showed mankind obeying the injunction to 'Go forth and multiply' in the parade of prams arriving at a crèche in *Défilé de voitures de bébés à la pouponnière de Paris*, made in 1899. The nursemaids here are struggling to keep up with the rate of productivity, and one has two infants laid end to end in the pram she pushes, while she carries a third in her arms. The disciplined march-past is impressive, even if two slightly older toddlers have escaped from custody and set off on their own. We are reminded that technology is in competition with biology, and has its own modes of mechanical reproduction. The command to populate the earth is obeyed only too literally in *The Strenuous Life*, directed in 1904 by Edwin S. Porter, who also made *The Great Train Robbery*. The title mocks Theodore Roosevelt, who warned Americans of Anglo-Saxon stock that they would commit 'race suicide' if they did exert themselves to match the fertility of people from warmer climes. A businessman returns home from the office to wait downstairs while his wife is in labour. He is delighted when a tightly swaddled newborn is carried downstairs by a nurse, less elated when another three babies follow in quick succession: quadruplets ought to be his contribution to racial health, but they are more than he bargained for. In Berlin, Ernst Lubitsch produced a sly variant of the tale in his comedy *Die Puppe*, made in 1919. It begins with Lubitsch himself unpacking a toy chest and assembling a set – a little house, a garden, some miniature trees – for the humanized dolls who are his characters. The deity in this case is a puppeteer, directing events in an artificial Eden. Soon, however, his place is taken by a doll-maker with a devilish moustache called Hilarius, who fabricates compliant female automata for the private use of bachelors and widowers. The religious myth has been bent into an erotic fantasy.

Later, when the miracle had become a matter of routine, films fondly remembered those early attempts. In 1930 in Josef von Sternberg's *The Blue Angel* the smutty schoolboys besotted by a cabaret singer have their own recipe for coaxing a body into motion. They go to work on a still photograph of Marlene Dietrich's Lola, which has wispy fronds

attached to its surface at her waist; when they blow on the image, their breath ruffles the skirt and exposes Lola's legs. Here cinema knowingly winks at its illusory liveliness, as it does once again in Truffaut's *Jules et Jim* when Henri Serre tells Oskar Werner about a gunner he met at the front, who died of his wounds in hospital. Jim has some photographs of his friend, and tells Jules to flick through them quickly: 'You'll think he's alive.' Like the zoetrope, a flipbook is the answer to our insatiable longing for images to move and for the dead to awaken.

Fellini's version of the founding myth appears in his autobiographical extravaganza *8½*, released in 1963. Here his deputy, the director played by Marcello Mastroianni, remembers that as a boy he believed he could startle a painted image into life by chanting the magic phrase 'asa nisi masa'. With a few extra letters inserted to perplex us, the spell alludes both to the anima – which for Fellini was a feminine self that he thought of as the source of his dreams and his creativity – and to cinema. Animation entices the anima to give proof that it exists. In Dreyer's *Ordet* the messianic Johannes declares that the biblical Word, when he pronounces it, will revive his dead sister-in-law Inger. We spend long moments staring at the unbreathing effigy in the coffin; at last, a finger twitches and an eyelid flickers. 'Life,' murmurs Inger – a synonym for the film we are watching.

* * *

Light, acting as a divine spark, had given shape to bodies and kindled them into motion – a procedure so astonishing that a new vocabulary had to be devised to define it.

The art historian Élie Faure described filmmakers as 'cinéplasts', moulders of moving forms, while Eisenstein praised the 'plasmation' of Disney's cartoons: his invented word, mixing animation and plasticity, edges around the medium's wizardry, which is exercised only too successfully by Mickey Mouse when he enlists broomsticks as workers in 'The Sorcerer's Apprentice', the episode of Disney's *Fantasia* that illustrates a symphonic poem by Paul Dukas. In 1926 Marcel Duchamp's *Anémic Cinéma* – in which words rotate counter-clockwise on a gramophone turntable – diced with other possibilities. The anagram in the

title possibly implies that cinema bleeds language dry by garbling it, as the nonsensical slogans on Duchamp's rotoreliefs do: one of them is 'Esquivons les ecchymoses des Esquimaux aux mots exquis', which means 'We dodge the bruises of the Eskimos with exquisite words.' Or was it Duchamp's intention to turn language into a kinetic babble? The cardboard discs free words from the fixed, flattened status they have on the page, shaking them out of their singularity and making them overlap as they spin in excited circles. In 1929 the critic Robert Aron said that surrealist films had discovered 'a new universe which opens up through "piscinéma"'. This verbal whimsy treats cinema as a 'piscine': a film is a tank containing liquid unconsciousness, which is why Jules Romains likened audience members to 'swimmers who plunge their heads underwater'. Man Ray's enigmatic home movie *Les Mystères du Château de Dé*, made at the modernist Villa Noailles in the south of France in 1929, dwells on such elemental sources as immersive water and warming light combine to bring forth life. Apollonian revellers – actually Man Ray's socialite friends – splash about in an indoor swimming pool; sunbeams reflected from the water glisten and quiver on the white walls, as if the pool were on the ceiling. When the occupants of the villa transfer outdoors to play ball games on the terrace, an intertitle describes them as 'déités des eaux vives' or 'un peuple de Dieux'. Their rites celebrate the radiant origins of cinema, an art whose mystery is superhuman or supernatural.

Louis Aragon called the images on screen 'cinegraphics', as a tribute to the way the camera could revise or distort appearances. Intelligibility mattered less to him than design: he enjoyed looking at 'the capital letters of unreadable and marvellous words' on the screen, and did not mind if they were advertising slogans written on shop windows in foreign cities. He would have been delighted by a scene in E. A. Dupont's *Piccadilly*, a thriller about theatrical intrigue and criminal skulduggery in London, released in 1929. Here a tipsy streetwalker pauses outside a pub and looks in, scouting for clients. Her eyes fit into the double O of SALOON, which is inscribed backwards on the glass, and the circles give her a pair of incongruously brainy horn-rimmed goggles – a specimen of what Aragon called cinema's 'novel poetry'.

For Jean Epstein, cinema's special and unique charm was 'photogé-
nie'. The word did not merely mean that a subject looked good when
photographed, which is what the adjective 'photogenic' now connotes;
it retained an echo of Genesis, acknowledging that light was a genera-
tive force, able to stimulate what René Clair called a 'visual emotion'. In
Epstein's film *Coeur fidèle*, faces studied at close range resemble land-
scapes, ruffled, as the director said, by 'breezes of feeling', or wracked
by tremors at moments of distress. Flesh and blood had no exclusive
claim to be photogenic, and Epstein paid the same compliment to the
weathered textures in the environment of his downtrodden charac-
ters – the scratched, splintery wood of a table in a bar, and the dry,
crumbling stone of a wall.

From 'photogénie' Epstein advanced to suggesting that cinema was
an exercise in 'théogenie'. Close-ups, he thought, turned innocuous props
into 'charms and amulets, the ominous, tabooed objects of certain primi-
tive religions', provoking 'sacred sentiments' of fear and engendering
strange gods. Louis Feuillade's silent serials show the process at work,
mystifying reality or twisting it into strangeness. In *Fantômas* a jewel
thief who stashes his loot in a church bell starts kicking as he grips the
clapper, which makes him look like an agitated mollusc with a metal
carapace; later, when the bell tolls during a funeral, pearls and diamonds
rain down and send the suddenly jubilant mourners scrambling for
treasure. In another episode, the arch-criminal Fantômas – Feuillade's
equivalent to Lang's Mabuse – transforms himself into a visiting American
investigator whose unidiomatic business card identifies him as Bob
Tom. Not to be outdone, the detective who tracks him assumes the role
of a dirty ragpicker. Fantômas even prises loose the imprint that identi-
fies us, our physiognomic signature: he slices off the fingerprints of a
murder victim and sews them onto a pair of gloves, so that the corpse
can be blamed for further murders that Fantômas himself commits.

The terrorist Satanas in Feuillade's *Les Vampires* has a theogenic
ruse of his own. Disguised as a missionary, he claims that the portable
cannon in his suitcase is a bell he is carrying to Africa to hang in his
colonial church. Other demons inveigle themselves into settings that are
closer to home. The anagrammatically named Irma Vep escapes from

her pursuers across the Paris rooftops, with the Tour St-Jacques in the background; she and her black-hooded accomplice are no weirder than the tower with its mad menagerie of gargoyles. In an instalment entitled 'Les Noces sanglantes', the widow of a concierge who was poisoned by the Vampires goes to consult a psychic called Madame d'Alba on Avenue Junot, which when Feuillade made the serial in 1915–16 had only recently been carved out of the Montmartre hillside. The psychic lives in a new tenement beside a vacant lot that is blocked off by a paling fence; the scaffolded buildings, not properly numbered, are identified only by scrawls on their façades; a stray dog has not yet surrendered its rights to the wet, windy terrain. Thus far, Feuillade is documenting untidy urban reality. But the séance takes place in a room with stuffed owls pinned to the walls, a piano to coax Madame d'Alba into a trance, and suffocating velvet curtains that part to reveal the coven of Vampires. When the police arrive, Irma Vep twines a rope around her waist, clambers onto the roof, and horizontally gyrates down all six storeys of the building's exterior before hopping into a getaway car.

A poem used to advertise *Les Vampires* boasted that 'The shadows are their empire' and said that they undertook their 'black flight' on wings of suede to affright the bourgeoisie. In the episode entitled 'Le Spectre' Irma Vep and her sisterhood of harpies make good on that threat by ambushing a cinemagoer. The banker Metadier cheerfully admits that he is addicted to films, and he invites Irma, disguised on this occasion as a respectable secretary, to accompany him on his usual Saturday outing to the Gaumont-Palace, which was the actual cinema near Place Clichy where *Fantômas* had been shown. The entertainment on that particular Saturday, we see from the marquee, has the baleful title *La Course à l'abîme*: the ride to the abyss was Faust's last journey with Mephistopheles. Metadier emerges from the screening at midnight although, because Feuillade's camera could not operate without the sun, it is broad daylight in the streets, which gives the scene a dazed insomniac glare. Then, on the train home to the suburbs, the vamps stab Metadier with a hat-pin and throw his body onto the railway tracks; in another vampiric contrivance, his spectral double reappears at the bank on Monday, collects the money he has deposited, and absconds by

slithering down a manhole. These are daily happenings in the empire of the shadows.

The police in Paris briefly banned several episodes of *Les Vampires*, alleging that the serial's exaltation of evil threatened public order – a pompous bluff, but also a tribute to the potency of Feuillade's imagination. Was cinema here creating a new world, or replacing the one we know with an otherworldly replica?

* * *

In Marcel L'Herbier's *L'Inhumaine* and Fritz Lang's *Metropolis* cinema's initial creative feat is examined more scientifically, though without explaining away its necromantic allure.

L'Inhumaine, released in 1924, is about a young engineer called Einar Norsen, who is introduced by an intertitle as 'Le SAVANT, "enchanteur moderne"'. Einar is said to be 'passioné de mécanique, de sport, et de la Féerie des sciences modernes', and he dresses the part by wearing a pilot's goggles and leather cap when he drives his sleek sports car. In his laboratory he works with a gallery of wooden contraptions designed by Fernand Léger, and the strictly regulated minions who execute his orders look like the rotating discs, oiled cogs, solemn pendulums, pumps, levers and kitchen utensils that are put through their paces in *Ballet mécanique*, an abstract film that Léger directed in the same year. Defying Genesis, Einar specializes in the invention of media that allow people to go forth and multiply by non-biological means. On his wall a crinkly silver oblong displays messages from the future that glimmer and fade as if written by the finger of some electronic magus; with uncanny foresight, it is described as an 'écran de télévision'. 'Le monde entier est ici,' it says, or 'Déplacez-vous par TSF', which is a cryptic instruction to move around wirelessly. Einar's mistress Claire Lescot, a preening operatic diva, does exactly that. When she sings into a microphone, a radio pylon outside the house transmits her voice around the world, and the screen relays the reactions of her audience, including a huddle of Arabs and a naked African woman taken aback by the bowl-shaped aerial that has landed on the ground before her. Here is L'Herbier's version of the time-space continuum unveiled by Einstein's physics:

Einar's television abolishes space, and as clock dials whirl in speedy circles an intertitle says that Claire has forgotten time – absorbed by the global transmission that has her circumnavigating the earth, she risks missing a concert she is due to give closer to home at the Théâtre des Champs-Élysées.

It is Claire to whom the film's title refers. Both Einar and Claire are 'êtres exceptionels', but he is superhuman while she is inhuman – gelid, haughty, erotically cruel. He lives in a cubist villa that looks like a recti-linear Mondrian painting; her mansion is an expressionist jungle, with a winter garden of luxuriant paper blooms and jagged palm fronds that resemble scimitars – a supplementary cabinet for Caligari, in which the servants wear papier-mâché heads with fixed grins painted onto them. Claire is killed by an asp concealed in a bouquet sent by a cast-off suitor, and after she succumbs Einar deploys his scientific skills in an attempt at resurrection. 'Tout s'anime,' says an intertitle, 'comme dans une symphonie de travail': here cinema has another chance to show off its power to quicken inert matter. Einar clamps on a funnel-shaped helmet while his helpers scurry about in shiny overalls; a montage of sparking electricity, pounding pistons and whirring dials blinds the eyes, stuns the brain, and prepares us to accept that Claire – stretched on a pillowed bier in a silk dress that resembles a chrysalis – has been galvanized back to life.

When the Viennese architect Adolf Loos saw L'Herbier's film he quoted the cry of the deranged, dying hero in Wagner's *Tristan und Isolde*, who asks 'Hör ich das Licht?' as Isolde rushes to his side at the end of the opera. 'Do I hear the light?' is Tristan's protest against the encroachment of daylight reality, which is snuffed out when he chooses to die by tearing the bandages from his wounds. For Loos, the line meant something different: in L'Herbier's blitz of red-tinted imagery, accom-panied by Darius Milhaud's pounding, slashing orchestral score, light becomes flammable and acquires an exultant voice. Loos announced that he had 'witnessed the birth of a new art', which almost made the rebirth of Claire a secondary matter.

In 1927 in *Metropolis* Lang industrialized the mystery. Light, which according to Joseph Roth brought the world to life inside the Ufa-Palast,

here has darker uses. The inventor Rotwang tracks the Madonna-like peacemaker Maria through the catacombs beneath the city with a torch whose beam he aims at his prey. While he remains safely out of sight like a director behind the all-seeing camera, the torchlight rakes over her body as if molesting her, and her limbs jerk in a panicked play of shadows on the wall. Rotwang takes Maria captive so he can graft her likeness onto a faceless robot he has pieced together in his laboratory. This metallic creature is his attempt at recreating the woman he loved, who chose to marry the industrial magnate Fredersen and died giving birth to his son; Rotwang plans to send out his false Maria to seduce and kill Fredersen's heir and to incite a riot among the workers of the metropolis. In the novel that Thea von Harbou derived from her script for the film, Rotwang calls the creature he animates Parody or Futura: like Einar, he has anticipated a time to come when humanity will be left behind by cybernetics and artificial intelligence.

Whereas Einar attempts to humanize the unfeeling Claire, Rotwang's science works in the opposite direction. *Metropolis* is about dehumanization, in which cinema is complicit. Rotwang initially commemorates his lost love Hel with a sculpted head propped on a plinth; this stony effigy is replaced by his robot which, according to von Harbou's novel, has bones of silver and crystalline skin, its eyes sightless 'as though painted on closed lids'. The kidnapped Maria is laid out in a glass sarcophagus with electrodes attached to her head, while the faceless robot sits upright nearby. As light rays jab the recumbent figure, electric coils engirdle the effigy, causing its hard casing to melt into the likeness of Maria. The original Maria is maternal, tender, made of flesh and blood; her replacement is an insubstantial wraith, clad in nothing much but her jewels when she tries out her sexual wiles by licentiously dancing in a cabaret.

Epstein had his own version of the myth devised by L'Herbier and Lang. In *Six et demi, onze*, released in 1927, the place of the inhuman Claire and the false Maria is taken by a non-human camera. *Kodak* was Epstein's original title for the film; he changed it in order to refer more obliquely to the 6.5 × 11 centimetre negatives used in the folding camera owned by his hero, whose name also happens to be Jean.

For Epstein the movie camera was an 'intelligent machine', smart but incapable of sympathy; *Six et demi, onze* transfers the blame for this insentience to a still camera, which is identified in the credits as 'L'Objectif' and placed, along with the sun, above the name of Suzy Pierson, who plays Marie, the actress who is Jean's lover. She is jealous of his new toy, even though he only uses it to capture her image; she explains her dislike by recalling that a magnesium flash bulb once went off in her face and gave her a fright. When she deserts Jean, he decides to kill himself, and while debating the matter he holds his camera in one hand and a gun in the other – balancing life against death, or equating the two as destructive instruments? He rehearses by shooting his reflection in the mirror, then turns the gun on himself. As he collapses, images of the unfolded Kodak and an ignited flash are superimposed on his dying body, as if the bulb were indeed a bomb; he falls to the floor clasping the camera to his chest, which equates it with a crucifix placed there to ensure repose.

Despite the splintered mirror, Jean's image outlasts him, like a secular equivalent to the immortal soul, and Marie recoils when she sees his framed portrait in the house of his brother Jérôme. Unaware of her previous affair, Jérôme becomes her lover; he discovers the truth when he sends the last reel in Jean's Kodak to be developed. As Jérôme points out, Kodak's products are good for an entire year, which means that the camera has a longer memory than the flippant, forgetful Marie. The photographs confront her with evidence of her responsibility for Jean's death, after which she is struck down by the pitiless objectivity that Epstein salutes in the credits: sunstroke fells her as she walks on the beach. Recovering, she does penance by entertaining maimed and disabled hospital patients, among them a blind man who removes a bandage to expose the cavity where an eye once was. We are caught between the fallibility of human perception and the cruelly neutral lens.

In 1928 in *La Chute de la maison Usher* Epstein again hinted at the malice of the machine and its envy of the life it records. As a prologue to his film of Edgar Allan Poe's story about the decadent Usher clan, Epstein adapted a second Poe tale, 'The Oval Portrait'. The Ushers, in this retelling, have a compulsion to paint their wives, but the wan and

wilting Madeline, posing for Roderick, feels that every dab of his brush strips some shine or bloom from her face. What we see inside an ornate frame is not a painting of Madeline but a piece of film which shows her blinking or faintly twitching, alive but expiring. As if acting out Duchamp's equation between cinema and anaemia, the actual Madeline slumps on the floor, slain by the completed picture. Her superstition was confirmed in 1929 when Epstein tried to persuade the islanders off the coast of Brittany to participate in his documentary *Finis Terrae*: the young women on Bannec and Ushant recoiled from the lens, afraid that being photographed would rob them of their virginity.

After Madeline's death Roderick has a breakdown of his own, for which the camera might be held responsible. Epstein believed that cinema aggravates the debilities of modern consciousness, which is torn between 'overworked reason' and a speeded-up irrationality; it disturbs us, he explained, by showing 'things magnified and detailed, in perspectives, relations and movements' that perplex and unsettle us, and Roderick is tormented by a battery of special effects like these. A shuddering of the image produces spectral duplications. Lights flare up and confuse the lens. Space loses its solidity, and time is made terrifyingly visible. The Usher house is full of clocks, and the camera looks inside them, as if dissecting its own operations. Cogwheels turn remorselessly, little hammers poise to strike, a pendulum swings through the air like an axe, and when an alarm bell rings it frightens itself, shivering in apparent terror and shaking off a coat of dust. Assailed by the random jumps and juxtapositions of montage, Roderick, like Jean in *Six et demi, onze*, can hardly go on pretending to be sane.

Cinema is invented all over again in the filmed adaptations of Mary Shelley's *Frankenstein*, about a 'modern Prometheus' who challenges the prerogative of the biblical creator. In the Greek myth, Prometheus shapes a manikin out of wet earth and steals fire from the hearth of the gods to enliven his creation. His descendant in the novel conducts the experiment in a laboratory, and although Mary Shelley is evasive about the details, film is obliged to disclose the technicalities of his attempt.

In 1910 in Edison's kinetogram *Frankenstein*, the ambitious student says in a letter that he wants to 'create into life' a paragon of perfection.

Capering about like the playful alchemists of Méliès, he mixes chemicals and decants them into a cauldron; he is aghast when a deformed monster rears up from the brew, and rushes home to the safety of his family. Edison's Frankenstein is a cook whose recipe goes wrong. In James Whale's *Frankenstein*, released in 1931, the wild-eyed doctor played by Colin Clive goes to work more scientifically, channelling the energy that made the industrial medium of cinema possible. Taking delivery of an unearthed coffin, he taps the box that contains the cadaver he intends to revivify. 'Just resting,' he says, 'waiting for a new life to come.' He stitches together scavenged body parts, which are supplemented by a bottled brain stolen from medical researchers; he then fits the collaged corpse with electrodes and waits for a storm to unleash 'all the electrical secrets of heaven'. A lightning bolt jerks the figure on the operating table into action. 'Look, it's moving! It's alive, it's alive!' he cries. He is celebrating cinema's primal moment, as the engineers in Lang's *Western Union* later do when Indians interfere with the telegraph cables they are stringing across the plains from Omaha to Utah. Randolph Scott gives the meddlesome natives a live wire to handle; the electrical shock that jolts them demonstrates the white god's 'supremely powerful medicine', which overpowers their tribal magic and persuades them to back off.

In *Madam Satan*, released in 1930, DeMille staged his own zany equivalent to the experiments of Einar, Rotwang and Frankenstein. DeMille's heroine is a wronged wife who disguises herself as a feline vamp in order to catch her wayward husband in flagrante. 'He likes it hot?' she fumes. 'All right, I'll give him a volcano.' Slinkily garbed, with claws to augment her fingernails and fiendish horns poking out of her headdress, she pursues her spouse to a masquerade that takes place on a dirigible tethered in a field outside Manhattan. Her husband is duped by her disguise and asks her to dance. 'You may get burned,' she warns. 'My heart is made of asbestos,' he replies. A wisecracking pseudo-scientific flirtation ensues. 'I see inside you,' she purrs. 'What do you see, Madam X-Ray?' he asks. During the aerial party a cavorting ballet of humanized spark plugs and batteries is led on by a representation of Electricity. This Edisonian figure is a masculine variant of Rotwang's robot: he has induction coils as anklets, a radiator strapped to his chest,

a lightning conductor jutting from his helmet, and twitching pincers on his fingers to relay telegraphic code. 'That's the spirit of modern power,' chants a choral voice, which prompts a correction from someone else: 'You mean the power of modern spirit.' In deference to the ultimate origins of that power, the dirigible is promptly ripped to tatters by an electrical storm; Madam Satan and her husband are reconciled as it crashes to the ground.

DeMille piously corrected this delight in devilment when he made *The Ten Commandments*, where Aaron taunts Ramses by turning his rod into a wriggling serpent. Pharaoh dismisses the animation as 'a cheap magician's trick': at least the technical magic that parted the Red Sea was not cheap. On the way to the promised land, Moses climbs Mount Sinai and watches as the Decalogue is inscribed on a stone tablet by a finger of fire – another costly magician's trick. After this revelation, the film cuts away to the revelry in the valley below, and the director's own voice describes the shaping of the golden calf: 'And they overlaid the image with pure gold, and Aaron fashioned it and smoothed it with the hammer ready to be graven by cunning art and man's device. And he fastened it with nails that it should not move.' Despite DeMille's solemn tones, none of this comes from the Bible, which says only that the Israelites offered Aaron their earrings, from which he made an idol, 'fashioning it with a tool'. The nails are an especially notable addition: the graven image is immobile, but the cinematic image moves, and – as the worship of the golden calf gives DeMille the chance to stage an orgy – motion incites desire. Women in diaphanous costumes wiggle their hips, roll on the ground, pour wine into the gaping mouths of their menfolk, and are hauled away for private coupling. The biblical fable is about iconoclasm; the director rewrites Exodus to licence cinema's leaning towards idolatry. DeMille's narration may castigate 'all manner of ungodliness', but as Canudo said in 1908, it is Ahriman, Lord of Darkness and Chaos, who actually runs the show.

* * *

Feuillade's Irma Vep, L'Herbier's frigid diva Claire, Lang's robotic false Maria, Epstein's Marie, DeMille's Madam Satan, the shrieky sexual mate

with the electrified hairdo played by Elsa Lanchester in James Whale's *The Bride of Frankenstein* – these are the muses of cinema's early days. Joining forces to create the bride, Frankenstein and the creepily effete Dr Pretorius seal their pact by welcoming 'a new world of gods and monsters', and their toast succinctly defines the beings who populate these films that tell stories about the genesis of the art.

In 1949 the novelist and screenwriter Cesare Zavattini – De Sica's invaluable collaborator on *Bicycle Thieves, Shoeshine, Miracle in Milan* and *Umberto D.* – offered a more humanistic genealogy for cinema. 'The camera lens,' Zavattini said, 'first opened up to the light of the world.' As he saw it, that light shone out from the world, and after being absorbed by the lens was transmitted to us; it was not spoken into being by God, and neither did it radiate from a heaven-sent saviour. In 1952 Zavattini suggested that 'Christ, if He had a camera in His hand, would not shoot fables' – miracles involving special effects that turn water into wine or smooth out leprous skin – but instead would offer us 'close-ups of the good ones and bad ones of this world'.

Zavattini made another revision to the biblical account of our beginnings when he described how 'cinema begins its creation of the world'. In fact nothing had to be created by filmmakers: the camera simply paid due attention to what already existed, in 'an act of concrete homage'. 'Here,' as Zavattini said, 'is a tree, here is an old man, a house, a man eating, a man sleeping, a man crying.' Or, in 1952 in *Umberto D.*, here in the kitchen of an apartment in Rome is a maid plucking a chicken, torching an infestation of ants, striking a match on the wall to light the gas, grinding coffee beans – routine actions that are somehow absorbing because, sitting unseen in the dark, we are allowed to witness them. Cinema, according to Zavattini, derived from 'two original propositions: the camera and a man', and the proposition worked just as well if the generic man was replaced by a dog. The elderly Umberto, harassed and finally made homeless by a venal landlady, has only his terrier Flike to comfort him. The dog exhibits open-hearted virtues that the disingenuous human beings in the film do not possess, and as Flike mutely commiserates with his master, we seem to be watching reality not art, behaviour not a performance.

Zavattini thought that cinema's defect was its 'mistrust of reality', for which he blamed Hollywood and its synthetic glamour. Rossellini likewise sought, as he put it, to 'demythologize' the camera. He disliked the way 'the rite of cinema' was 'celebrated pompously on studio sets', and thought that the medium should be as easy to use as a ballpoint pen. To make *Rome – Open City* in 1945 he took the camera onto the streets to catch life unrehearsed; he stole electricity and film stock, not pausing to bother about composition or lighting because he needed to dodge patrols by the German army. This rude re-education in the open air did not allay Rossellini's mistrust of a machine that indexes its subjects, immures them in a frame, and makes them vulnerable to detention by the authorities. In *Rome – Open City* a Nazi major claims that he conducts surveillance by going for a stroll without leaving his office. Every evening he leafs through piles of snapshots taken by street photographers, and uses them to identify partisans; after that his henchmen round up the dissidents and haul them in for questioning. *La macchina ammazzacattivi* – Rossellini's comic fable about a camera that kills the wicked, released in 1952 – is a logical sequel. A portrait photographer on the Amalfi coast discovers that he is able to paralyze and disintegrate people he dislikes: an iris shot shows the crocodile eye of the lens as it snaps shut, freezing figures and then obliterating them. The prank is blamed on an over-zealous local saint, and it takes an intervention by the Devil to undo it.

A worried self-interrogation lay behind this fantasy. In 1945, interrupting their Hollywood careers, Billy Wilder and George Stevens made documentary films about the Third Reich's concentration camps: now the camera assumed a new responsibility, as a traumatized witness and a humane conscience. *Nuit et Brouillard*, the documentary elegy for the victims of Nazi genocide directed by Alain Resnais in 1956, retrieves scenes from the camps that are almost impossible to watch: terrified children herded into boxcars, skeletal patients in a make-believe hospital where no one was ever cured, cadavers shovelled into ovens or bulldozed into pits, a mountain of curly female hair waiting to be made into matting for floors. Before and after this sombre monochrome testimony, Resnais uses colour to register the blithe amnesia of nature. Fresh grass sprouts

from a soil fertilized by death, wild flowers grow between the trestles of the railway track that ends at the gates of Auschwitz, and the sun shines on the ruins of the crematoria. In his script for *Nuit et Brouillard* the poet Jean Cayrol – a Resistance fighter who had been interned in one of the camps – doubts that the anguish of the victims can ever be made comprehensible; he and Resnais press at the limits of a medium that they fear might be irredeemably superficial.

Hoping to prove its existential courage, an art that claimed to be synonymous with life began to document death. In 1903 the first snuff film had recorded the clumsy electrocution of a superannuated elephant at Coney Island. In 1939, after so many staged expiries in Hollywood films – Greta Garbo consumptively languishing in *Camille*, Bette Davis stoically mounting the stairs to wait for her brain tumour to kill her in *Dark Victory*, Edward G. Robinson as the gangster in *Little Caesar* indignantly demanding 'Mother of Mercy, is this the end of Rico?' after he is gunned down – Jean Renoir's *La Règle du jeu* shows death at its most indiscriminate and uncaring during a shooting party on an aristocratic estate. Among wholesale carnage, close-ups unforgettably individualize the victims. A rabbit twitches after being knocked sideways by a bullet, agitates its paws as if digging, then almost gaily wiggles its tail before collapsing. Renoir's heroine, played by Nora Gregor, uses a field glass to study an agitated squirrel in a tree it has rapidly scaled. She comments on the clarity of the view that the lens provides; it does not occur to her that the creature is shuddering in terror. Another actual massacre follows in Rossellini's *Stromboli*, released in 1950. Ingrid Bergman here plays a Lithuanian refugee who marries an Italian prisoner of war and is taken home to his harsh volcanic island, which is said to be 'terra di Dio', the land of God. Restive, shunned by her neighbours, she asks to be rowed out to watch her husband and his workmates catching tuna. She expects to be amused, but when the nets are hauled up she sees a mass annihilation, as the fish are speared and dragged into the boats with bulging eyes, flapping gills and thrashing tails; the fishermen then remove their caps and thank Christ – invoked by Zavattini as the patron of humanist compassion – for the plentiful kill.

These exterminations count as a credential of cinematic realism: how better could film establish its authenticity than by photographing actual, irreversible deaths? In 1949 in *Le Sang des bêtes*, Georges Franju set up the camera in another killing field. His documentary about the Paris abattoirs begins with glimpses of a disassembled society on waste ground at the edge of the city: a lamp that belongs in a fancy apartment swings from the wintry bough of a tree, a naked shop-window dummy that has kept its wig but lost its arms poses in the rubble next to a silenced gramophone horn – samples of what will be left when we are gone and our possessions are detritus. On the arch outside the slaughterhouse at Vaugiraud, a bust ornately honours a plump 'propagateur' of equine meat. The word is craftily chosen to pass off butchery as propagation, a matter of life not death. Inside, the genteel pretence falters. A docile, trusting horse paces to its doom through puddles of gore; felled by a blow to its head, it is winched into the air to be skinned. Veal calves are decapitated, and the heads with their abject eyes are thrown aside. A butcher stomps about on a wooden leg, having had to undergo an amputation after he severed an artery with a lancet while flaying one of the beasts. This ordure and obscenity keep us alive, as well as serving daintier aesthetic purposes: the charred bones of the horses, we learn from the narrator, are transformed into feminine toiletries. Nor should it seem strange that Franju finds nuns visiting the abattoir at La Villette to collect fatty scraps from the bowels of oxen, since religion has always depended on sanguinary rites.

In 1975, for reasons of its own, Barbet Schroeder's *Maîtresse* goes on a brief detour to La Villette. The film is about a dominatrix and the paying customers she deliciously tortures, so the den where the butchers ply their trade is a messier and less playful version of her dungeon. Schroeder shows a stunned horse that has been hoisted up so that a worker can slash open its belly; with blood cascading out, its nervous system still transmits frantic, futile messages that make it gallop in mid-air, going nowhere – a ghoulish simulacrum of life that undercuts the myth of cinegenesis. After the Bioscope, this might be called the Necroscope.

* * *

At least Mickey Mouse was effectively immortal, like the other 'prismatic-amoebic' life forms described in Eisenstein's rhapsody about Disney's cartoons. No matter how violently Tom and Jerry pummel each other, neither of them ever sustains any lasting damage. During the 1920s cinemagoers were equally delighted by the indestructibility of Felix the Cat, brought to life by the cartoonist Otto Messmer. Space had no terrors for Felix, who frequently survives falls from tall buildings. Temporality proved equally flexible: in one cartoon Father Time takes Felix back to the Stone Age, where he feasts on dinosaur bones before returning to the present down a flickery tunnel that looks like a stroboscopic film. Béla Balázs said that Felix owed nothing to God but belonged instead in an 'amazing world in which the prime mover and omnipotent ruler is the pencil or paintbrush', supplemented by stop-motion animation. 'What can happen to an image if it's run over by another image?' asked Bálazs. Steamrollered flat, Felix always rebounded, because 'images can be erased or faded out or painted over, but they can't be killed'.

Antonin Artaud declared that 'the human skin of things, the epidermis of reality' was 'the primary raw material of cinema', its 'prima materia' as the alchemists would have called it. The truth of his metaphor is put to the test when the reality is depilated: in 1934 in Edgar G. Ulmer's *The Black Cat* a 'game of death' played out in a Hungarian fortress between a psychiatrist and a Satan-worshipper ends with Béla Lugosi strapping Boris Karloff to a rack to be flayed. In George Cukor's *A Woman's Face*, released in 1941, Joan Crawford's disfigurement has embittered her and turned her into a cynical blackmailer. The plastic surgeon played by Melvyn Douglas repairs her face, but can he change her nature? Unwrapping her bandages after the operation, he says 'Now I unveil my Galatea – or my Frankenstein.' At first Crawford continues to snarl, but when Douglas asks her to marry him she agrees to join the human race and dwindle into a housewife. This attempt to equate beauty with goodness is not quite convincing; more impressive plasmatic feats occur if Hollywood's aestheticized creatures are made to look ugly. Diptheria scars Bette Davis in *Mr. Skeffington*, Gloria Grahame is left with a scorched, crinkled face after Lee Marvin sadistically scalds her with hot coffee in Lang's *The Big Heat*, and in Wilder's *Witness for the*

Prosecution Marlene Dietrich disguises herself as a cockney harridan with the help of snaggled dentures, black contact lenses, and a layer of snaky, scaly skin applied to her grasping hands.

In 1960 in Franju's *Les Yeux sans visage* a plastic surgeon who has the teasingly biblical name of Génessier is working on a technique for what he calls a heterograft. Elderly socialites hope he will use it to rejuvenate them, but his intended patient is his daughter, who has been injured in a car accident that reduced her countenance to a pulp. Génessier kidnaps a succession of young women whose faces he peels off to use as transplants. Meanwhile his daughter hides her shame behind a blank white mask, through which only her frightened eyes peep out. Franju commented that the oneiric appeal of the unidentifiable master criminal in *Fantômas* depended on 'the power of the mask', and when he made his own contemporary version of Feuillade's serial *Judex* he went further by concealing the vigilante hero's identity behind the beaked head of a dark-feathered bird. *Les Yeux sans visage*, however, is about the pathos of the mask, a disguise that conceals our squashy, amorphous interior. During one of Génessier's operations, we see that what lies beneath the epidermis of reality is surreal. With the skin on her face cut away, the patient laid out on the table is a slab of bleeding meat, even more unsightly than the robot's featureless head in *Metropolis*, which von Harbou's novel describes as a 'lump of carelessly shaped mass'. Almost before we have time to look away, the image mercifully blacks out.

Génessier's operation fails: the stolen visage he sews onto his daughter sags, ulcerates and rots. In 2011 the surgeon played by Antonio Banderas in Pedro Almodóvar's *The Skin I Live In* attempts something more elaborate. He has developed a synthetic skin to which he gives the name of his dead wife Gal – surely an allusion to Rotwang's infatuation with Hel in *Metropolis*. We discover in a flashback that Gal's body had been seared and charred when she was trapped in a burning car; the surgeon rescued her and grafted onto her patches of transgenic skin taken from pigs. After that he kept Gal in darkness and deprived her of mirrors, but she caught sight of herself in the glass of a window and committed suicide in self-disgust. Back in the present, the doctor takes

up with a new sexual partner, who happens to have been born male and therefore has to be customized by emasculation and vaginoplasty. Life, it turns out, consists of more than the divine endowment of motion or animation that cinema was invented to record; medical science has made biology a matter of choice not fate, of artifice not nature. *The Skin I Live In* concludes even more gorily than Franju's film, in which Génessier is mauled by his own slavering guard dogs. All the same, the final image presented by Almodóvar is a spiralling molecule of DNA – a reminder of our biological genesis and a token of hope that humanity, with cinema's help, will go on revising and regenerating itself.

7

THE SEVENTH ART AND THE OTHER SIX

Cinema's first enthusiasts claimed that it brought the long history of the separate, complementary arts to a conclusion by combining their specialities. The notion of a 'total work of art' excited the progressive nineteenth century: Wagner's operas fused drama and music, and Baudelaire hoped to appeal to all five senses simultaneously, making words exhale music and evoke colours, tastes and odours. But cinema alone, as Ricciotto Canudo declared in 1911 in *The Birth of the Sixth Art*, managed to recreate life as a whole in a 'powerful modern synthesis' of the five classical arts. For the director Rouben Mamoulian, the bonus was beyond dispute: 'If you can handle five fingers,' he asked much later, 'why should you scorn a sixth?' Canudo, however, had long since rejigged the arithmetic. After publishing his treatise, he decided that his amalgam was not inclusive enough: he recognized dance as a sixth art, which made cinema the seventh.

In 1917, writing in the American magazine *The Seven Arts*, the composer Ernest Bloch regretted the debasement of public taste by 'the weight of mechanical inventions – phonograph, Pianola, cinematograph', facile devices that could not satisfy 'the mystical, emotional needs of the human spirit'. Fernand Léger – who, along with the architect Robert Mallet-Stevens, helped design L'Herbier's *L'Inhumaine* – had no such misgivings, and praised cinema for lacking a pedigree: it was 'young, modern, free' and possessed 'no traditions'. In fact it helped itself to every available tradition, and in its young, modern, free-wheeling way it bragged of its advantage over them all.

* * *

Traditionally, the so-called sister arts fell into two groups, matching the separate dimensions of our physical existence. The plastic arts occupy space; the arts that Canudo called 'rhythmic' work in time. Painting, sculpture and architecture are stationary, whereas literature and music depend on succession and duration. Filmmakers, however, cross the line between those categories. In 1915 when outlining his theory of relativity Einstein alluded to a space-time continuum. Cinema occupies that borderless terrain, as it demonstrates whenever it makes a painting move.

That feat is staged repeatedly throughout the history of the medium. Busby Berkeley's *Fashions of 1934* displays a turntable of niches draped with reproductions of a Velázquez pope, a Titian cardinal and a Frans Hals cavalier. The blinds roll up to reveal the models of Maison Elegance wearing adaptations of the ecclesiastical or courtly costumes in the paintings, and the stiff, haughty male grandees change to female mannequins, who saucily pose with hands on hips and strut towards us. In 1936 in Alexander Korda's biographical drama *Rembrandt* the unveiling of the painter's *Night Watch* resembles a movie premiere: curtains are pulled apart with a flourish to reveal a crowded canvas that is the size of a cinema screen. The civic guardsmen who expected to be singled out for flattery in the painting complain that they can see only 'shadows, darkness and confusion'; Charles Laughton's Rembrandt retaliates by pointing to the alcoholically ruddy nose of one dissatisfied customer, the lecherous mouth of another, and the coarse, stupid features of a third. The accused individuals squirm: the camera has closed in on truths that the painting's sombre gloom tactfully conceals. In 1935 the critic François Vinneuil marvelled that Jacques Feyder's *La Kermesse héroïque* made 'the museums descend into the streets'. Feyder's story of a carnival in Flanders during the Spanish occupation in 1616 animated an entire gallery of Flemish art, just as Vincente Minnelli in 1951 used impressionist paintings from the Jeu de Paume as starting points for the dances in *An American in Paris*.

Museums set a standard of ideal beauty which cinema boldly offers to match. In 1967 the lemon-haired sailor in Jacques Demy's *Les demoiselles de Rochefort* searches for an imaginary woman on his voyages, tries

to identify her likeness in art galleries, and paints her in an outdated figurative style. Then she materializes as Catherine Deneuve, who had already been pictorially consecrated in Demy's earlier film *Les Parapluies de Cherbourg*: there a diamond dealer says that she resembles a painted Virgin he once saw in Antwerp.

The encounter between painting and cinema had a competitive edge, and for André Breton it demonstrated 'the radical powerlessness of the plastic arts'. In Dreyer's silent film *Michael* a society portraitist despairs of capturing the eyes of a Russian countess; the camera, quicker and defter than his paintbrush, catches the play of expression – seductive, crafty, insecure, even desperate – on her face. The young male protégé whom the doting painter adopts looks bland enough, but in his apartment he keeps dolls modelled on Chaplin and Jackie Coogan from *The Kid*, and in private he copies their grimaces of the tramp and the ragamuffin he adopts, which is all it takes to expose his shifty treachery.

By contrast, two thrillers directed by Fritz Lang in the mid-1940s, both with Joan Bennett as Edward G. Robinson's pictorial object of desire, suggest that the still image might be safer than its living, breath-ing cinematic counterpart. In *The Woman in the Window* Robinson is a stodgy middle-aged professor who idly muses about 'playing around' with 'a dream girl'. Leaving his club after dinner, he admires Bennett's portrait in the window of a gallery window and is then accosted by the model, who has been loitering on the sidewalk to watch passers-by admire her likeness. Disasters follow: he murders her protector, and finally kills himself in shame and remorse. Then in a slick editorial suture he comes back to life, waking up from a nightmare to realize that his temptress existed only as a facsimile, luckily confined behind a window and inside a frame.

The situation in *Scarlet Street* is trickier. Here Robinson is an amateur artist, again exploited by Bennett and her lover, who deride his fumbling daubs although they profit from selling his canvases. 'Paint me,' orders Bennett – but she means her toenails, and when Robinson obsequiously kneels to apply the varnish she says that she expects a series of masterpieces. For the naive Robinson, 'every painting, if it's any good, is a love affair'. Lang's film, however, is a brutally unloving

inspection of a reality that paintings are inclined to flatter. Hence the squalor of Bennett's kitchen, with dirty dishes piled in a sink that doubles as an ashtray, or the shabby hotel room in which Robinson attempts to hang himself.

A lineal descent from painting to cinema occurred in the Renoir family: Jean Renoir, Pierre-Auguste's son, made films which rouse his father's subjects from their poised state on the canvas. In 1951 in *The River*, filmed in India, visitors to the house of a colonial family beside the Ganges are welcomed by paintings made on the ground with rice flour, and when 'the image man', as the film's narrator calls him, colours the statue of a goddess, art becomes a devotional observance. In *Partie de campagne*, released in 1946, we look out through the window of a country inn and see Sylvia Bataille being pushed to and fro on a swing suspended from a tree. She giggles deliciously, her skirt opens out like a parachute, the camera swoops through the air with her, and Joseph Kosma's music buoyantly keeps pace. Here is proof that physical pleasure is best conveyed by pictures that move, just as in Jean Renoir's 1959 film *Le Déjeuner sur l'herbe* another of the picnics frequently painted by Pierre-Auguste is enlivened by splashing water, the chirruping of birds, the howling wind of a sudden storm, beguiling melodies from Kosma, and – underlying all this – a discussion about science versus nature and the comparative merits of artificial insemination and procreation of the traditional kind.

Henri-Georges Clouzot hinted at an extra benefit in his documentary *Le Mystère Picasso*, released in 1956. The camera watches as the painter impatiently scrawls designs, erases them or blots them out or covers them with revisions, and when the drawings and collages attain their final form it is almost an anti-climax, because the layered alternatives that Clouzot documents – evidence that creativity is a process, perhaps a struggle – have been effaced. Fittingly, the works Picasso produced for the film were later destroyed, as if the movie camera had persuaded him to question the authority of the fixed, completed image.

Akira Kurosawa's *Dreams*, released in 1990, takes the vivification of painting even further. A Japanese admirer of van Gogh studies his work in a gallery, then merges with it, travelling into a cinematic recreation of

the painted landscapes. In a cornfield, he encounters van Gogh himself, played by Martin Scorsese with russet facial hair, a bandage covering his absent ear, and a paint-spattered shirt. Soon, literally absorbed by the paintings, he chases van Gogh through the chunky ridges and oozy rivulets of pigment. The artist escapes and the admirer ends back in the gallery where he began, now doffing his cap to the canvases on the wall. Moving images are as impalpable as air and as fluent as water; like the sun that Scorsese's van Gogh says made him a painter, they can also be fiery. But they are seldom earthy, because film lacks the manual, tactile quality of paint. *Dreams* is an act of homage to the older art, not an attempt to supersede it.

Scorsese's *The Age of Innocence* is less respectful. Here Daniel Day-Lewis languidly inspects the odd modern pictures owned by Michelle Pfeiffer, whose tastes are too advanced for genteel, gilded New York in the 1870s. Looking over his shoulder, the camera first scrutinizes an impressionist painting in which a head is a blob of pigment, then appraises a narrow horizontal landscape: this coastal vista extends sideways for so long that, as Day-Lewis paces beside it, we seem never to reach the framed edge. Perhaps there is no frame at all, which would be as shocking as that unformed, featureless head. At last the painted scene does run out, while the camera, which spurns all limits, keeps on moving.

* * *

During its exploration of the Villa Noailles in Man Ray's *Les Mystères du Château de Dé*, the camera notices some canvases negligently stacked back to front against a wall. 'Le secret de la peinture,' says a sarcastic intertitle. Elsewhere, in a critical essay that extends this snub to another of the classical arts, Man Ray suggested that 'cinema has supplanted realistic sculpture'. The camera had the power to alter bodies, enlarging what Man Ray called the 'huge pale faces' of its subjects or enveloping their flesh in shadow; that leaves figures carved in wood or stone or cast in bronze at a sad disadvantage.

Like Pygmalion, filmmakers naturally want to animate their poised marble beauties. In Lang's *Das wandernde Bild*, released in 1920, a

mountain-dwelling hermit vows that he will not return to the lowlands until the statue of a Madonna and child on an alpine peak has moved. At the end, the statue is knocked down into the valley by a storm, but the hermit then sees a woman trudging through the snow: an outcast who is now a saintly penitent, she has redeemed herself by rescuing an orphaned child from the blizzard and is carrying it to safety. From the hermit's vantage point, it looks as if the statue had indeed come to life. The film's title is usually translated as *The Wandering Shadow*; it could just as well be called *The Moving Image*, because that is what it is about.

In very different contexts, Eisenstein and Leni Riefenstahl used statues to re-enact the gift of animation, cinema's initial miracle. The prologue to Eisenstein's *Que Viva Mexico!*, released in 1930, begins with the pyramids, geometrical altars that were consecrated to ritualized death, and then shows the sculpted visages of the voracious deities in the Yucután who had to be appeased with human sacrifices. Only after that do we see modern Mexicans wrapped in their blankets, their profiles aligned with the angular faces on their temples, apparently asleep or perhaps still occupying a realm where, as Eisenstein says in his script, time is unknown. *Olympia*, Riefenstahl's documentation of the 1936 Games in Berlin, starts with the camera solemnly touring a display of Greek statues – matrons with chiselled noses, Homeric warriors frozen in threatening attitudes. Then a dissolve abbreviates the centuries and shifts from the Acropolis to a cold northern beach, where the stone body of an athlete begins to ripple and flex. Emerging into life, he hurls a discus; one of his naked teammates throws a javelin and another launches a globular weight that might be a cannonball. The Olympic Games have begun, and so has cinema. In *Le Mépris*, Godard adds a footnote to Riefenstahl's quickening of the statues. During a discussion of Greek religion at Cinecittà, Jack Palance – a Hollywood producer, representing the current master race – loses his temper and picks up a canister of film to toss across a screening room: for a few frames he exactly matches the swinging motion of the classical Discobolus.

In Mamoulian's *The Song of Songs*, released in 1933, Marlene Dietrich is a naive country girl who sneaks out at night to pose for a sculptor. To

her embarrassment, he tells her to undress. She resists, telling him that 'All you need is the face, everything is in the face': a prudish evasion, but true enough in cinema. The cool, naked effigy the sculptor produces is better behaved than the model; irritated by Dietrich's emotional demands, he passes her on to an ageing Pygmalion of a different kind, who wants – he says – to educate and refine her. A statue of the love goddess defrosts in the 1948 musical *One Touch of Venus* and comes to life as Ava Gardner. 'You're moving! You're talking! You're alive!' cries Robert Walker, paraphrasing Frankenstein when he activates the monster in James Whale's film; the first question he asks her is whether they have movies up on Olympus. In fleshly form, the goddess causes such havoc that eventually an angry Jupiter summons her home. In 1954 Gardner returns to her sedate, sepulchral plinth in Joseph L. Mankiewicz's *The Barefoot Contessa*, where she is cast as a tempestuous Spanish dancer who becomes both a Hollywood star and an Italian countess before being murdered by her cuckolded husband. The film begins at her funeral, with a white statue of this multi-coloured woman looming over her coffin. The statuesque countess wears an evening gown; only the bare toes of one foot recall the freedom she once enjoyed. In *Jules et Jim*, Oskar Werner and Henri Serre decide that Jeanne Moreau is the mobile incarnation of a ripe-lipped, enigmatically smiling stone idol on an Adriatic island. The moral may be that cinema's goddesses are easier to manage when they are dead.

'Film petrifies,' said Cocteau, using a sculptural metaphor. In his view, it mortified people rather than immortalizing them, and he peopled *La Belle et la Bête* with hybrids that he called 'living statues', one of which is potentially lethal. A statue of Diana the archer, positioned to guard the pavilion in the Beast's garden, swivels to fire an arrow at an intruder. When the figure moves, it acts out the central tenet of a cinematic religion to which Dalí gave the name 'phoenixology'. In 1960 a character in Cocteau's *Le Testament d'Orphée* explains this as 'the art of repeatedly dying so as to be reborn'; Cocteau puts himself through that rite in the same film, where he lies in a state as a corpse, with open eyes painted onto his closed lids as they might have been on the face of a Greek statue – but breath visibly issues from his mouth, and when

he tires of the sham he stands up straight and walks away. Commuting back and forth to cinema's shadowland is not always so effortless. Beside the fireplace in the Beast's castle, half-human caryatids wearing shells of plaster poke out of the wall. They turn their heads watchfully, and like Cocteau in *Le Testament* they exhale smoke to show they are breathing. These living statues frequently swooned on set because of the heat from the blazing fire; they had to be revived in the air outside, after which, with a fresh application of plaster, they went back to being architectural ornaments.

In 1954 in *Voyage to Italy*, Rossellini traces a more distinct line to separate stone from sentient flesh, effigy from existence. Tormented by the breakdown of her marriage, Ingrid Bergman is taken on a tour of the archaeological museum in Naples. Her guide warns her about the malevolence of a sculpted satyr; she backs away from a naked female torso, but reluctantly allows herself to be impressed by the virile Farnese Hercules. Her face – nervy, bashful, then increasingly excited by these uninhibited pagans – confronts the white, inflexible countenances of Nero and Caligula, whose blank eyes mask their criminal insanity. She is equally perturbed by the mummified bodies and shelves of skulls in the catacombs, and by the calcified corpses locked together in a last embrace at Pompeii: mortality is as distressing as sensuality. At every point the camera finds in her face evidence of an emotional delicacy that is absent from the inert figures in the museum or the tombs. The director Eric Rohmer said that Rossellini's way of photographing Bergman, here or as the penitent mother in *Europa '51* or the guilt-stricken wife in *Fear*, proved 'the existence of the soul' – something that statues and cadavers do not possess.

* * *

The critic Élie Faure called cinema 'a sort of moving architecture' rather than a pictorial medium. Murnau agreed: its true subject, he said, was 'the fluid architecture of bodies with blood in their veins moving through mobile space'. That physical fluency is not usually available to buildings, but in 1924 in Murnau's *The Last Laugh*, the Berlin skyscrapers bend and buckle to threaten Emil Jannings when he loses his position

as hotel porter, and the cars and buses that jostle him in the street are mechanical bodies with oil in their veins, stertorously alive.

In 1920 the poet and architect Herman G. Scheffauer excitedly welcomed the 'stereoscopic universe' of *The Cabinet of Dr Caligari*, in which, he said, 'space has been given a voice' – a somewhat anguished voice, which expresses itself in canted walls, doors wrenched out of their jambs, rooftops like ski slopes, and diagonal lines that stab passers-by in the narrow, crooked streets. The spectacle roused Scheffauer to an ultra-Einsteinian rapture. 'A fourth dimension,' he declared, had begun to evolve, as Wiene's film extended 'the sixth sense of man, his "Raumgefühl"', a feeling for space that amplifies our understanding of material reality.

Maybe the quirks of this extra dimension are explored in the volume Julie Christie is reading at the start of Nicolas Roeg's *Don't Look Now*, released in 1973. The book's title is *Beyond the Fragile Geometry of Space*, and Christie is leafing through it because her young daughter has asked why, if the earth is round, the surface of a lake looks flat. No such book exists; Roeg invented it as a guide to the warped cosmos of his film, in which Donald Sutherland is an architectural restorer, hired to recreate the past in a Venetian church, who foresees a deadly future he cannot alter. Here time curves or doubles back like the alleys of Venice, and space consists of vibrations in the air: a blind woman finds her way through the floating city by listening to the echoes that rebound from its walls.

Architecture in films is often neither solid nor secure, provoking an existential frisson rather than supplying the protective comfort we expect. Hitchcock enjoyed showing how easy it is to penetrate the defences we construct around ourselves or to make them collapse. In *The Lodger* he supplies an East London house with a glass ceiling, allowing us to see as well as hear a landlady's sinister tenant who is pacing in the room above; for *Rope* he designed a modular, self-disassembling Manhattan apartment whose walls slide aside to ease the passage of the nosey camera.

In 2002 in David Fincher's *Panic Room* the technology of surveil-lance relays information to television screens in a closed, supposedly

impenetrable refuge where Jodie Foster and her daughter hide from intruders in their Manhattan townhouse. Meanwhile, spurning such paranoia, Fincher's movie camera roves through the premises at will. It leaps into the stairwell, prowls around empty rooms, squeezes through the handle of a jug on a kitchen counter, explores a ventilation duct, wriggles in and out of a keyhole as a burglar tries the basement door, and even slithers into a propane hose. These incursions by the camera dramatize the state of panic, a word that refers to a Pan-like ubiquity, the capacity to be everywhere at once and invade all available space; a room, no matter how fortified, is no safeguard against this disembodied intruder. In Joel and Ethan Coen's *Barton Fink*, released in 1991, the camera at least turns its back as John Turturro and Judy Davis begin to tussle on a hotel bed, then sidles into the bathroom, peers into the sink, and nuzzles into the dark, clogged drainpipe – a somewhat grimy metaphor for what is happening next door.

At their most ambitious, filmmakers have erected entire cities to be inhabited by our eyes only. D. W. Griffith inaugurated the tradition in 1916 when he rebuilt Babylon for *Intolerance*, with towering walls so broad that horse-drawn chariots could be driven along the top of them; the camera, tethered to helium balloons, hovered above the throng in the cavernous banqueting hall and descended on an elevator to join the party. In *Top Hat*, Fred Astaire and Ginger Rogers twirl along polished Bakelite floors in a sleek, streamlined Venice, with white gondolas gliding under curlicued bridges on water that is dyed black. For Luchino Visconti's *White Nights*, a crumbling, fog-muffled version of Livorno was assembled at Cinecittà in Rome, its twisting alleys, vacant lots and dark canals as mazy as the topography of a dream.

In 1967 Jacques Tati constructed a futuristic Paris of steel and glass for *Playtime*, his comedy about an automated society. In Tativille – which was La Défense or Canary Wharf or Hudson Yards on a smaller scale – centrally heated buildings trundled on rails down streets that had electrical wiring and water pipes in trenches under the tarmac. A wind storm toppled much of the installation; it cost Tati a fortune to have it rebuilt. Fellini was equally extravagant. He believed that the world outside the gates of Cinecittà was 'a vast deposit box' of found objects awaiting the

chance to be recreated inside the studio, so in 1960 he had a custom-made Via Veneto laid out there for *La Dolce Vita*, complete with traffic jams, jaywalkers, mobs of pedestrians and crowded cafés. Later, after deciding to set *Intervista* inside Cinecittà, he insisted on making a replica of the studio in the form of a scale model. This autobiographical essay begins with Fellini's aerial survey of its hangars and workshops, which when seen from on high, with all their glories concealed by metal roofs, look as dreary as a hospital or a penitentiary.

In 1949 at the end of King Vidor's *The Fountainhead*, Patricia Neal rides on a shaky open platform to the top of an unfinished New York skyscraper, said to be the tallest in the world. As she ascends, she gazes up towards her lover, the architect who stands astride the summit and adds a few feet to its height: the role is played by Gary Cooper, who had the physique if not the temperament for Ayn Rand's arrogant over-achiever. Neal is not bothered by the shaky platform that hoists her far above the Empire State Building, nor by the length of limp rope that does duty for a guardrail, because the Nietzschean will that Rand's book celebrated has its own system of self-promoting hydraulics.

By contrast with this wickedly thrilling levitation, Hitchcock in *Vertigo* makes a shorter, stubbier building turn to jelly. As James Stewart defies his fear of heights to chase Kim Novak up to the bell tower of the Mission church at San Juan Bautista, he makes the mistake of looking back down the stairwell. His head reels as the empty space both advances and retreats beneath him. It is the camera that induces his attack of vertigo by performing two physically contradictory manoeuvres: it closes in with a zoom lens while moving backwards on a track or dolly, and with the help of Bernard Herrmann's wailing music the disparity induces a milder version of the nausea that overcomes Stewart. We seem to be tumbling into an unfounded, elastic space, simultaneously drawn into the vacuum and expelled from it. Faure's enthusiasm for a moving architecture did not reckon on this.

* * *

'I am agraphic,' joked Buñuel, 'I'm allergic to writing.' For a filmmaker, that was no disqualification: the new art immediately put language

and literature on the defensive. Who now had time for the long hours of pensive absorption that books demand? In 1923 in Ronald Firbank's novel *The Flower Beneath the Foot*, a haughty queen remarks on the gabbling of the 'lectress' who recites to her, and asks *'where* she had learnt to read so quickly'. 'On the screens of Cinemas,' the maid pertly replies.

Learning to read in the old-fashioned way, we are taught to replace pictures of things with verbal abstractions. The Marx Brothers did cinema's bidding by reversing this process, and their efforts, as Antonin Artaud said, generated 'a special form of magic'. In *Duck Soup* Louis Calhern despatches spies to gather incriminating information about Groucho, and when they report their findings he asks 'Did you bring me his record?' The mute Harpo nods, and hands over a gramophone record. In *Animal Crackers* Chico asks for a flash, meaning a flashlight; Harpo pulls his cheek to indicate flesh, and when that proves unacceptable he proffers a fish, a flask, a flush of cards, a Flit spray gun and a flute. Groucho, who plays a character called Jeffrey T. Spaulding, explains that his middle initial 'stands for Edgar', while Zeppo, put to work as a stenographer, asks how to spell a semicolon and wonders whether Groucho's clearing of his throat should be transcribed. The absurdity establishes that proper names are meaningless labels, that the alphabet trains us in conventionality and routine, and that punctuation marks merely notate empty air.

Jean Epstein declared 'There are no stories', and since its early days cinema has played fast and loose with the kind of consecutive narrative that literature traditionally values. 'Can you picture things?' asks the hero of Dupont's *Piccadilly*. At the start of the film he addresses the question to another character but also to us; testing our aptitude as viewers, it implicitly disparages writing. A surprising command follows, which urges us all to advance from merely seeing to making pictures. 'Then close your eyes,' says the narrator, 'and I will tell you a strange story.' The story is about the murder of a nightclub dancer, and though it is set in a shady nocturnal world, what makes it strange is that it is wordless, shown rather than told: after this brief spoken prologue, Dupont's film – released in 1929, just as the talkies were beginning – reverts to silence. Relying on our eyes alone, we must make our own judgements

about the actions we witness, with no omniscient novelist to clarify motives in a running commentary.

In 1915 posters for Feuillade's *Les Vampires* showed a noose-shaped question mark looped around a black-hooded head, below which an interrogatory volley asked 'Qui? Quoi? Quand? Où?' None of those queries is ever answered; like the master criminal Fantômas in Feuillade's other serial, the Grand Vampire inexplicably escapes in the last seconds of every instalment. In F. Scott Fitzgerald's novel *The Last Tycoon* the movie producer Monroe Stahr gives one of his studio employees a tutorial in screenwriting and in doing so justifies cinema's refusal to rationalize events. Stahr describes a scene in which a woman enters a room, empties her purse, removes her black gloves and burns them in a lighted stove. The phone rings; she answers it and says 'I've never owned a pair of black gloves in my life.' Stahr cannot or will not explain who she is and why she has behaved this way. 'I was just making pictures,' he shrugs: mystification is what entices us, and to have the scene demystified would be a dreary anticlimax.

Hollywood films used to defer to literary convention when adapting respectable literary properties, and sometimes credit titles were inscribed on the turning pages of an open book. This concealed the cheeky liberties the new art was taking with its sources. In *Now, Voyager*, Bette Davis plays a miserable spinster who is awakened to life by a psychiatrist. Reviewing her past for the doctor's benefit, she likens the story of her life to a novel she once read, and the flashbacks that follow are introduced by a blurred montage that flips through the pages of a printed book. It is a false analogy because we do not read backwards, but it points out how fluidly cinema can move to and fro through what seems on screen to be a perpetual present.

The kinetic art had no patience with the gradual, premeditated way that literary narrative manages time. In Thackeray's novel *Vanity Fair* the heroine rejects the schooling she has received at Miss Pinkerton's Academy for Young Ladies and signals her rebellion by tossing the book that is her leaving gift out of the carriage soon after she departs; the bulky volume is Samuel Johnson's *Dictionary*, the eighteenth century's monument to language as a means of codification and a guide to verbal

etiquette. In Mamoulian's 1935 adaptation *Becky Sharp*, that defining act is not an afterthought, and it is no longer an indirect assault on Miss Pinkerton. Miriam Hopkins, playing Becky, hurls the book directly at the starchy schoolmistress she despises. 'Words are but little thanks,' she spits. 'Let this speak volumes.' She then whirls off to begin her career of social and sexual conquest. James M. Cain's novel *Mildred Pierce* begins with the heroine's dull husband bracing trees on a suburban lawn – 'a tedious job', Cain comments. In fact the novelist might be glancing sideways at his own painstakingly detailed introduction to the house and the family that lives there when he specifies that Pierce 'took his time about it, and was conscientiously thorough'. For the film version in 1945, the director Michael Curtiz dispensed with these expository preliminaries and began at the novel's long-delayed climax. With no information to anchor us, we see another house by a stormy shore and hear gunshots, which prompts us to ask Feuillade's questions: who? what? when? where? The next image – Zachary Scott falling to the floor and gasping 'Mildred' as he dies – answers none of those questions, or it prompts us, as we discover almost two hours later, to answer them wrongly. How can we not keep watching?

As well as dodging back and forth through the orderly narrative of novels, films open up or take apart the boxy containers to which stage plays are confined. At the theatre, we occupy an assigned seat and see things from one angle only; the camera by contrast has an indiscreet peripheral vision. In *Nana*, an adaptation of Zola's novel directed by Renoir in 1926, that unfixed eye treats us to a tour of the Théâtre des Variétés, where the heroine appears in saucy satirical operettas. We follow her up a ladder to the flies above the stage, then descend with her as she is lowered into view to portray a lewd version of the love goddess; we travel across the boxes where the titled patrons are acting out their own adulterous playlets, and even investigate Nana's sordid dressing room. In *The Last Warning*, directed by Paul Leni in 1929, the camera sets out to probe the innards of an apparently haunted Broadway theatre. It plunges through trapdoors that suddenly gape in the stage, excavates a pit of quicklime where corpses can be stowed, and traces a live wire running under the floor and into a metal candlestick, where it

is due to electrocute an actor who has to grip it during the performance. The camera enjoys the same right of way in René Clair's 1941 comedy *The Flame of New Orleans*, which begins as an unseen narrator demands 'Open this door please.' Flunkeys immediately usher the camera into an opera house where the performance is already underway; once inside, the cinematic eye ignores the stage and wanders around the auditorium, finally fixing on the box where Marlene Dietrich sits with her back teasingly turned. Dietrich of course upstages the opera, and when she faints as a ploy to attract attention the singers cock their eyebrows, the conductor looks over his shoulder, and the musicians mark time with the bows of their violins hovering in mid-air.

The title of George Cukor's *A Double Life*, released in 1947, refers to the schizophrenia of the Shakespearean actor played by Ronald Colman and also to the split between theatrical feigning and cinematic reality. Colman, with the camera on his heels like a detective, disastrously takes his Broadway performance as Othello offstage. He wanders out of the theatre into the dingy streets around Times Square, and is greeted by acquaintances who find him unimpressive in the daylight; later he strays to a downtown tenement where he strangles a blonde waitress who has picked him up. The murder is a crazed continuation of the role he plays at night, and he believes he is punishing the waitress for being as morally lax as Othello wrongly imagines Desdemona to be. He makes amends for his crime by killing himself in front of the audience at the end of a performance.

The dualism that unhinges Colman afflicts characters in other films in different ways. In Ingmar Bergman's *Persona*, Liv Ullmann lapses into self-mortifying muteness during a performance of a Greek tragedy. Her doctor diagnoses her sickness as a shamed response to the dishonesty of her profession; the cure Bergman's film prescribes is to expose Ullmann's face to the camera, which sees through theatrical masks. Gena Rowlands, cast as an alcoholic actress in John Cassavetes' *Opening Night* in 1977, demolishes the pretence from within. Depressed and befuddled, she drifts offstage in the middle of a scene, asking a fellow actor if the set has a back door or some other exit. After she escapes, her colleagues are left to improvise, and when she reappears she veers off the script and

converses directly with the audience: her nervous breakdown breaks down the fourth wall.

* * *

The composer Virgil Thomson joked that music's initial role in cinema was to keep audiences awake. Film flickered hypnotically, which made it, he said, 'dangerously soporific', and until sound and image could be synchronized, exhibitors hired pianists to sit below the screen and pound out a reveille.

During the mid-1920s Dmitri Shostakovich performed this task at a series of cinemas in Petrograd whose names – the Piccadilly, the Splendid Palace and the Bright Reel – evoked the glamour, pomp and brilliance of an art that had officially escaped from the kingdom of shadows. Still an irreverent student, Shostakovich often free-associated on the keyboard without looking up at the screen. Later, paying more attention, he contributed convulsive symphonic scores to Grigori Kozintsev's films of *Hamlet* and *King Lear*: here the orchestra tests Hamlet's resolve with blasts of percussion and brass when his father's ghost appears, and generalizes Lear's personal distress by voicing what Kozintsev called 'the lament of the earth itself' – a choral threnody beyond the capacity of even Shakespeare's language.

Other composers volunteered their services without a commission. Arnold Schoenberg's *Accompaniment for a Cinematographic Scene*, completed in 1930, orchestrated sensations of quaking dread that are stirred up by a non-existent film. We are left to imagine the details of the cinematographic scene, which ends in a cataclysm: music suits such highly strung episodes, because it too is made from tension, pressure, a nervous quivering that is transferred to strings, reeds or taut, stretched skins. In 1933 Charles Koechlin's *Seven Stars Symphony* sketched a series of notional screenplays, with sinuous oriental melodies that correspond to the exploits of Fairbanks in *The Thief of Bagdad*, a keening electronic homage to Garbo played on the ondes Martenot, a hazy dance in slow motion to honour Dietrich, and a final apotheosis for Chaplin. Does it matter that we cannot see the stars? Music exists only as vibrations in the air, and the bodies on screen are figments of impalpable light. In

Robert Bresson's *Un Condamné à mort s'est échappé*, released in 1956, a few bars of a Mozart Mass celebrate a political prisoner's escape from a closely guarded jail, achieved after careful planning but with the help of some happy accidents that are probably directed from on high. The quotation from Mozart comes from nowhere, which makes it, Bresson suggested, 'no longer simply terrestrial, but rather cosmic – I would even say divine'.

Here music vouches for the intervention of a God who does not appear on camera; otherwise its ethereality is a challenge for this visual medium. In 1940 Disney's *Fantasia* adjusted classical music to cinema by translating sounds into images, and as a start it personified the unseen strip on which music and dialogue are encoded at the edge of the celluloid reel. Deems Taylor, the film's master of ceremonies, says that the lean, shrinking soundtrack is shy, and it has to be coaxed out of hiding to take a bow. Gaining courage, it consents to twang and throb in full view. Later, single instruments are provided with pictorial equivalents: the violin is a buzzy insect, the harp is represented by ripples in water, the bassoon opens a path to the lower depths. After this visual tuning-up, *Fantasia* illustrates Bach's Toccata and Fugue in D minor. Effusions from a colour organ wash away the orchestra, which is replaced by thundery clouds, flights of skimming birds, and meteors on jazzily irregular courses. Finally the aerial excitement settles down, disciplined by a series of pointed arches, and Bach's music is safely rehoused in a church.

A battle between the divine and demonic uses of music, corresponding to cinema's clash of light and dark, rages throughout *Fantasia*. Glowworms dance in the segment from Tchaikovsky's *Nutcracker* and Apollo drives his chariot across the sky in Beethoven's Pastoral Symphony. But Jupiter tosses angry lightning bolts as Beethoven's storm begins, and the sun can be deadly: it parches the earth in Stravinsky's *Rite of Spring*, killing off the dinosaurs. As the bassoon and the other grunting wind instruments evoke primitive origins at the start of the *Rite*, the screen is entirely black, and we are asked by Deems Taylor to picture 'an empty sea of nothingness', a nullity later lit up by blue nebulae and angry red comets. A swarthy demon presides in Mussorgsky's *Night on Bald*

Mountain, though he is banished by worshippers who carry candles to a rustic chapel during Schubert's *Ave Maria*.

When the first cinemas opened, Canudo predicted that a motley urban congregation would regard them as 'our Temple, our Parthenon, and our immaterial Cathedral'. Musicals – which Godard rightly called 'the idealization of cinema' – sketch such unearthly edifices, made of sound and light and dedicated to a religion that is unabashedly pagan. In 1952 in Busby Berkeley's *Million Dollar Mermaid* the cathedral is flooded, and in it we watch the aquatic rebirth of Venus. Esther Williams, clad in a suit of chainmail sewn with flakes of gold, is raised into the sky by a geyser, and balances on an altar of sizzling sparklers. As Georges Guétary sings 'I'll Build a Stairway to Paradise' in Minnelli's *An American in Paris*, a curtain opens to reveal that the stairway has already been built. Its steps are pink, and they light up from below when Guétary treads on them; ornamental women hold candelabra along the banisters, and temple maidens with bare legs usher him into their fluffy dormitory above the clouds. Because the delights of Hollywood's heaven are so sensual, paradise and inferno overlap. In Minnelli's *Ziegfeld Follies*, released in 1945, Lucille Ball rides in on a merry-go-round to which live white horses are attached, using her whip to keep a cavorting pack of feline she-devils in line.

In 1936 in *The Great Ziegfeld* the deceased impresario enjoys a more sedate apotheosis: Dick Powell, attired for the afterlife in silk pyjamas and a velvet dressing down, sips bubbly nectar in a boudoir. As Powell reminisces about his earthly triumphs, the tenor Dennis Morgan sings Irving Berlin's 'A Pretty Girl Is Like a Melody' in front of a curtain that parts to reveal a white column rising from a lacquered black floor. It revolves, and Morgan mounts a spiral staircase wrapped around it, climbing through three centuries of musical history. On a landing, flouncing rococo aristocrats dance a minuet; further up, a troop of military gallants and their partners join in a Viennese waltz. Nearer the top, ten storeys high, a dozen pianists perched with their instruments on the column's outer edges hammer their way through Gershwin's *Rhapsody in Blue*. Niches house operatic characters – Puccini's Butterfly in a towering imperial headdress, Canio agonizing from *I Pagliacci*. The spare steps are

occupied by a humming chorus of melodic women, and at the summit one of these sirens floats in a night sky that is even more galactically starry than the so-called Great White Way, the New York thoroughfare on which Ziegfeld staged his revues.

Blaise Cendrars claimed that this many-tiered melodic totem pole was plagiarized from his novel *Le Plan de l'aiguille*, in which a Promethean miner sculpts bodies from volcanic lava and watches them struggle up a mountain, gradually shedding lowly clay as they reach towards divinity. But Dennis Morgan is no superman; in his elegant tailcoat, he completes Ziegfeld's mission of glorifying the American girl as he elevates frothy nymphs to the status of angels, and the labour of evolutionary ascent described in Cendrars' novel is eased by a crane that lifts the camera into the heights. Finally a twirling curtain sweeps down from above, encircles the column, and causes the masonry, the dozens of extras and the grand pianos to disappear. Time has been visualized in space – an astonishing vision, possible only on film.

In 1938 in *The Goldwyn Follies*, Adolph Menjou plays a Hollywood producer who hires a country girl as a consultant so that his glossy products do not lose touch with social reality. He calls this bucolic conscience Miss Humanity, and keeps her away from the studio to ensure that she remains uncontaminated. The precaution is futile, because folly of every kind prevails on the MGM lot. The film includes a version of *Romeo and Juliet* with the feuding clans as rival exponents of tap dancing and classical ballet, a scene in which Edgar Bergen the ventriloquist tries to chasten the lechery of his wooden dummy, and interludes for the Ritz Brothers, a troop of zanies who run amok as animal trainers, befurred Cossacks and mannish mermaids. Nor does the foolery end at the studio gates. At a diner in Santa Monica, the short-order cook has a gramophone behind the counter and warbles a Gershwin song as he prepares a hamburger.

The sound of music is all very well, but on film what matters is the sight of music. For a nightclub routine in *Small Town Girl*, released in 1953, Busby Berkeley had Ann Miller sing and dance while being exhorted by horns, clarinets and saxophones that jut through the floor, gripped by hands unattached to bodies and deriving their wind from

some subterranean reservoir. Other arms that begin at the elbow poke out to saw at violins. Miller taps around the obstacle course, unaware that the instruments are being played by stumps.

In other cases, music is harvested from nature or scavenged on the street. *The Great Waltz*, directed by Julien Duvivier in 1938, takes Johann Strauss and his favourite soprano on a drive through the countryside at dawn. The piping of a shepherd, the rhythmic clatter of the horse's hooves, the braying horn of a passing mail coach, choirs of trilling birds – all these visual anecdotes contribute to the waltz known as 'Tales from the Vienna Woods'. In 1950 in *Three Little Words*, a pair of songwriters discuss their work while strolling past a row of nondescript New York brownstones. To illustrate a musical point, Red Skelton helps himself to a piano that some removal men are lifting over the gutter and picks out the tune of 'I Wanna Be Loved By You'; Debbie Reynolds, who happens to be passing, adds an impromptu 'Boop-oop-a-doop'. In 1955 in *It's Always Fair Weather*, Gene Kelly and two of his army buddies drunkenly career through Times Square, using the lids of garbage cans as cymbals and tap shoes. *You and Me*, directed by Fritz Lang in 1938 with a score by Kurt Weill, manages to assemble the wherewithal for a musical number inside the cells of a penitentiary. The unmelliflu-ous singing of George Raft and his fellow convicts is orchestrated by percussive effects that recall the Morse code inmates use when tapping on pipes and bars to communicate with adjacent cells or the stuttering of machine guns that terminate a prison break. A warning siren howls an obbligato.

Music in David Lean's *Brief Encounter* voices the yearnings of the discontented wife played by Celia Johnson, but because she chooses duty rather than extra-marital dalliance, it has to be marginalized. She turns on the radio, and asks her stuffy husband whether it will disturb his concentration on the *Times* crossword. Rachmaninov's Second Piano Concerto, a lava flow of impassioned sound, thunders from the receiver. 'Might we have that down a bit, darling?' he asks. Music means emotional surrender, so she adjusts the volume.

In Paul Thomas Anderson's *Magnolia*, released in 1999, music that insinuates itself from some off-screen source is able to perform its

ancient Orphic task of harmonizing human distress. After two hours of yelling and brawling, a half-dozen solitary, disconnected characters in scattered locations across the San Fernando Valley start to sing. Somehow, despite being so far apart, they all overhear Aimee Mann's 'Wise Up', and they mouth or whisper or chant aloud its stoical refrain, with the camera as the only witness; Jason Robards, lying comatose on his deathbed, silently twitches his lips in an attempt to join in. When they finish, the rain that has been soaking Los Angeles providentially ends. In 2016 in *La La Land* the disparate Angelenos trapped in a traffic jam on the freeway overcome their frustration by joining in a song, even dancing and performing joyous somersaults on the tops of their stalled cars. Music in *Magnolia* is a collective unconsciousness, and in *La La Land* a communal therapy.

The charm does not always work. The characters in Demy's through-composed musicals sing rather than talk, although that does not save them from dejection and disappointment. When some salesmen in *Les Demoiselles de Rochefort* make brash sexual advances to Françoise Dorléac, she sighs, 'Jamais de grand moment bouleversant de lyrisme.' The crew setting up a fair exuberantly dance in a public square while the inhabitants of Rochefort traipse around the outskirts, paying no attention. Here music is a symptom of self-delusion: sadly, real life has no soundtrack.

* * *

As Canudo realized after publishing his treatise on the sixth art, dance was an essential ingredient of this new compendium. Epstein thought that cinema could be defined as 'cadenced movement', and Buñuel praised Lang's *Metropolis* as a 'symphony of movement', with 'Physics and Chemistry... miraculously translated into Rhythmics'. Chaplin's short films – notably *Sunnyside*, in which he parodies Nijinsky's performance as Debussy's faun – resemble comic ballets, with pirouettes of defiance whenever the tramp outwits a ruffian. Louise Brooks, who as Lulu in *Pandora's Box* dons butterfly wings when she performs in a revue, said that she learned how to dance while watching Chaplin act and how to act while watching Martha Graham dance.

The way people move in movies defines them. Garbo plays a ballerina in *Grand Hotel*, and although we never see her dance, her erect, sculpted stride as she crosses the hotel lobby attests to her expertise. Mae West skims over the floor without needing to tread on it, resembling a vessel whose sails billow in the wind: she boosted her height by balancing on a platform that her skirts concealed, which enabled her to glide across a room with relaxed nonchalance. John Wayne's hip-swinging manner grew more lazily sensual through the decades, especially if he was ambling into a gunfight. Dancing, James Cagney has the wired energy of a wind-up toy; playing a gangster, he resembles a machine that has been over-wound. 'Cody ain't human,' says his moll in *White Heat*. 'Fill him full of lead and he still keeps coming at ya.'

Buñuel was entranced by what he called Jeanne Moreau's 'unique way of walking' as she wanders through Paris at night in Louis Malle's *L'Ascenseur pour l'échaffaud*, wobbling slightly on her heels to suggest nervous tension. She looks without seeing, distractedly drifting as she waits for a rendezvous that will not happen; her walk is a mute monologue, voiced on the soundtrack by the trumpet of Miles Davis, which translates her thoughts in a jazz version of a mournful passacaglia, the musical form that for baroque composers matched the pace of a walk in the street. Malle himself, smoking, idles past and pauses to accost Moreau. He is hoping for a pick-up, though when he whispers to her he may be imparting a directorial instruction.

Antonioni too must have been intrigued by Moreau's perambulation, because in *La Notte* he sent her on a desultory tour of Milan, from the crowded centre to the rusty industrial outskirts and unbuilt hinterland. In the daylight, the Italian streets are a *commedia dell'arte*, a lively gesticulating drama in which the listless Moreau no longer wants to participate. A little girl cries, some boys fight, men send out half-hearted sexual signals: none of it matters, which is why she keeps moving. Planes shriek overhead, rockets are inexplicably fired off in a field. 'Would you like to go to the moon?' someone is overheard asking. If she could, she would walk out of life, off the earth.

No matter how casual Fred Astaire may seem, his movements are always choreographed. He worked his body like the animators who

brought Mickey Mouse to life, and the critic Alastair Cooke described him as 'the greatest of Walt Disney's creations, who somehow escaped from an inkwell'. Such linear grace and suppleness are not what we expect from brittle bones and pulpy flesh. In 1953 in *The Band Wagon*, he takes a syncopated stroll along the railway platform after he arrives in New York, easing his elegant passage through empty space with swimming motions of his arms and hands; he then gives a giddily exuberant demonstration of dance steps from a sitting position as his shoes are polished on 42nd Street. In *Roberta*, released in 1935, Astaire sings Jerome Kern's 'I Won't Dance'; then, despite the refusal, he does just that without a partner for five astonishing minutes, stamping and tapping his feet with his arms as propellers while the rest of him whirls in dervish-like rotations. In 1934 in *The Gay Divorcee*, he replaces himself and Ginger Rogers with a paper silhouette of their bodies. He leaves the cut-out to circulate on a gramophone turntable, as automated as film unreeling inside a projector; the decoy casts their gyring shadows on the wall and allows them to escape downstairs to dance 'The Continental'. The trick deftly demonstrates that to be alive means using the body as a means of expression, not a mode of transportation.

On stage, ballet is movement that aspires to stillness. Its supreme moments come when leaping dancers defy gravity, which cinema can help them to do: Jack Cardiff briefly altered the exposure when he photographed the ballets in *The Red Shoes* so that Moira Shearer seems to pause in the air. On film, it is easy to resist the tug of the earth. In 1933 the chorus girls in *Flying Down to Rio* jubilantly dance while strapped to the wings and fuselage of biplanes that soar above Copacabana, and in 1951 in *Royal Wedding*, Astaire starts tapping on the floor and then, as the room rotates, continues up the wall and along the ceiling. Despite his dapper poise, Astaire's dancing could lay waste to a set, which in certain moods made him an agent of cinema's explosive dynamism. In *You Were Never Lovelier*, released in 1942, he has a tantrum when the owner of a Buenos Aires nightclub refuses to engage him. He deafeningly taps on the marble floor, kicks up a rug, twirls the curtains, vaults onto a sofa, a side table and a desk, and punishes the rest of the furniture with a walking stick which he then

tosses back into an umbrella stand where, with Astaire-like aplomb, it lands upright.

In 1933 in *Dancing Lady*, Astaire and Joan Crawford begin dancing inside the metal rails of a curved cocktail bar. The floor then lifts up, wafts them a little bumpily across the ocean, and deposits them in beery Bavaria. Elsewhere in the same film, Nelson Eddy arrives from the future to intrude on some pomaded eighteenth-century courtiers whom he summons, while performing a song by Rodgers and Hart, to obey 'the rhythm of the day' and modernize themselves. The courtiers cross the stage, pass under an arch, and emerge as top-hatted swells and jazzy flappers, at large in Art Deco Manhattan. Élie Faure said that cinematic images 'unroll in musical space', and here that space is a tarmac. Crawford enters in a stately horse-drawn carriage that, after crossing another time-space frontier, mutates into a swanky but over-leisurely limousine; she soon abandons this in favour of a smaller, juiced-up Ford. Cosmetic assistance is available for these hustled time-travellers. Black-gowned Victorian widows on walking sticks dodder into a futuristic beauty parlour where beauticians work on them with callipers, drills and scissors, and the old ladies emerge as revved-up floozies. Lorenz Hart's lyrics enthuse about living 'wild and fast', and double as an advertisement for cinema and its kinetic pleasures:

> Motors turning, wires burning,
> Run! Run! Run!
> Even love is electric,
> Even love has a beat.

'This is the time for plenty of action,' sings Eddy. 'Action!' he repeats, like a director issuing orders to the camera and the performers in front of it.

Physical laws, social conventions and emotional qualms conspire to stop the dancing or slow it down when Sami Frey, Claude Brasseur and Anna Karina famously perform the Madison in a Paris café in Godard's *Bande à part*, released in 1964. Music here is an escape from uncomfortable silence, and dance tests the sexual tangents of the triangular association between these urban bandits. Having run out of things to say, the three friends agree on a minute of quiet; the ambient

clatter on the soundtrack is switched off, but without it they are shifty, awkward. Frey puts some coins in the jukebox, which gives Karina a chance to ask Brasseur about their friendship. 'It's like in the movies,' he replies: Frey would be useful to shield him from a bullet. Not knowing how Godard's film will end, Karina is mildly horrified by the answer. Then they dance side by side, stamping, clicking fingers and clapping hands while Godard in his capacity as narrator explains what is in their minds. The musical spell is short-lived. Frey breaks off and orders a coffee, Brasseur drifts away, and Karina is left to continue alone until her smile fades, her energy falters, and she returns to the café table with its messy ashtrays and half-empty Coke bottles.

Choreographed motion relapses into fidgety stasis, and cinema – having first reinvented another art and then critically questioned its purpose – resumes the unique task that the Lumière brothers set for it, which is to observe people as they go about the apparently artless business of existing.

8

THE PHYSICS OF FILM

As we watch, films turn the once regular laws of physics into a vigorous, arduous physiological experience. Time, altered by the images that flash before us, pulses in our bodies more erratically than usual, and space contracts and expands as the camera propels us through the world. What we pay for is the experience of being startled, shaken up, even assaulted. The poet Carl Sandburg praised *The Cabinet of Dr Caligari* for its 'stride and rapidity', and treated it as the equivalent of a raid on the unconscious mind: he said he admired the director's command of 'the smash and the getaway'. Fernand Léger made a scientific attempt to account for these disruptive tendencies by arguing that cinema depended on 'two coefficients', the variable speed of projection and the equally variable pace of what we see on the screen, but such calculations do little to steady us. In 1933 Benjamin Fondane, a Romanian-French surrealist who wrote what he called 'ciné-poèmes', claimed that the art's giddy sensationalism created a 'new reality' that 'mocks space'. For that reason, Fondane thought that films should have remained silent: dialogue wrongly stabilizes the ground beneath our feet.

Cinema's unstoppable momentum is calibrated in 1949 by John Derek in Nicholas Ray's *Knock on Any Door*. Derek plays a flashy young delinquent bound for the electric chair. His aim, he tells his girlfriend, is to 'live fast, die young, and have a good-looking corpse' – the summary of an existence and also the generic plot of a movie. Action on film streaks through the frame with the reckless dynamism to which Derek aspires. In 1959, on two weekend jaunts to a field in suburban London, Richard Lester made his *Running, Jumping and Standing Still Film*, which Peter Sellers described as an 'abstract comedy'. Its brief compilation of stunts

is abstract because there is no story to explain the unremitting high jinks or weigh down Lester's cast of farcical athletes. Over-exertion is the norm; the standing or sitting still in this case is done by the audience.

Looked at more deliberately, those flurries of physical activity reveal what crafty calculations the body makes as it copes with the challenges of existence. In 1980 in Godard's *Sauve qui peut (la vie)*, slow motion analyses movements that are apparently thoughtless, eliciting secrets concealed by what Godard calls 'the silence of speed'. The turbulent relationship of the main characters, played by Jacques Dutronc and Nathalie Baye, often degenerates into fisticuffs. By slowing down their slaps and kicks, Godard shows how close these brawls are to erotic tussling: violence might be their mode of sexual connection. When Dutronc is abruptly run over by a car, slow motion dissects the few seconds in which the accident occurs. He loses his balance, lunges sideways, then collapses with his legs in the air. The movements comprise an elegant ballet, which suggests that, as an incurable narcissist, he may be staging the incident for the benefit of Baye, who watches unconcerned and then strolls away with their daughter. The purpose of the decelerations, Godard said, was 'to see whether there was anything to see'. Indeed there was, though it could only be seen with the help of a camera.

Georges Franju believed that filmmakers ought to reject literature's obsession with time, which determines the tenses of verbs and the conduct of narrative; cinema's true concern should be space, which it mobilizes. Murnau likewise decreed that the camera must 'follow characters... into difficult places', moving 'as swiftly as thought itself'. Between scenes in Laurence Olivier's *Hamlet*, released in 1948, the camera prowls the corridors and staircases of the labyrinthine castle at Elsinore, as if following the digressive tracks of the hero's consciousness. In 1980 the fearlessly intrepid Steadicam negotiates a maze in Kubrick's *The Shining*, and in 2014 in *Birdman*, Alejandro G. Iñárritu takes the eye on a convoluted journey around the backstage warren in a Broadway theatre, seemingly without editorial cuts. Sometimes the camera wriggles into the tightest of corners: in 1967 in John Frankenheimer's Formula 1 epic *Grand Prix*, it squeezes us into the low-slung racing cars, and makes the sensation of taking bends on the

track in Monaco so visceral that gimmicky cinema managers offered sick bags to queasy customers.

Cocteau, toying with the metaphysics of the art, said that 'Films should play tricks with time and space.' He does so in *Le Testament d'Orphée* where, costumed as a rococo fop, he searches throughout Einstein's fourth dimension for a professor who will return him from the eighteenth to the twentieth century by killing him with bullets that travel faster than light. He repeatedly stops his time machine at the wrong moment, only to discover that the professor is still an infant or that he has slid into senility; although their encounters do not happen in chronological order, 'l'intemporel' – as Cocteau calls the zone in which he wanders – is a cinematic space, like a studio backlot where scenic relics from all ages are jumbled together. Cégeste, the director's spirit guide, adjusts his language to this topsyturvydom by uttering back-to-front sentences, a skill he may have learned from the moviola editing machine that was then used to run film backwards and forwards.

Cocteau described *Le Testament d'Orphée* as 'a farce... on the confusions of space-time', and in theory the curvature of space and the tricky variability of time did make possible a new kind of comedy. René Clair praised the 'swift, fresh lyricism' of Mack Sennett's slapstick because it mapped 'a weightless world in which the laws of gravity seem to have been replaced by the joy of motion'. In 1931 in *Animal Crackers*, Harpo Marx shoots a clock, and gloats when he kills the pendulum; later he puts on a bathing suit upside down, which persuades Groucho that 'There is no law of gravity, Einstein or no Einstein.' Free from that onerous discipline, why should we behave gravely? Kubrick's *2001: A Space Odyssey*, released in 1968, offers another glimpse of zero gravity and the lightness of being it fosters. A flight attendant on the space shuttle, wearing shoes that grip the floor to anchor her, retrieves a pen that hovers in mid-air after it drifts out of a dozing passenger's hand. In theory, this floating world should be worry-free, because there is no possibility of a tragic fall. HAL the malevolent computer therefore soothes one of the astronauts by advising him to 'Sit down calmly and take a stress pill'.

At its starkest, cinema can reject the trickery that attracted Cocteau and ask us to contemplate the fixed and fateful conditions of our existence – time's elongation or its wearisome longevity, the painful estrangements of space. In 1949 the last scene of Carol Reed's *The Third Man* shows both those forces at work. After the funeral, Joseph Cotten waits patiently at the side of the frame. Far off down a path in the Viennese cemetery, at the vanishing point of the perspective, we see what he is waiting for: Alida Valli has started to walk towards him while the last autumn leaves drift from the trees. Trevor Howard, having dropped off Cotten, drives away in his military jeep, pointedly emphasizing the slowness with which Valli covers the distance. As she advances we spend more than a minute wondering whether she will forgive Cotten for his betrayal of Orson Welles, who plays her lover and Cotten's friend; the interim suspends time, and creates the same anxiety as Hitchcock's suspensions in space – Eva Marie Saint gripping a ledge on Mount Rushmore in *North by Northwest*, Norman Lloyd dangling from the Statue of Liberty in *Saboteur*. Finally Valli draws level with Cotten; without glancing sideways or relaxing her taut expression, she strides towards the camera and then disappears. Rather than following her, he lights a cigarette and tosses away the match, a gesture that could signify resignation, dismissiveness, or self-disgust.

The director Jacques Rivette, refusing in 1961 to elucidate the plot of his conspiratorial political mystery *Paris nous appartient*, remarked 'Nothing took place but the place.' The same might be said of *The Third Man*'s inconclusive conclusion. Time and space extend outside the frame, and the continuum makes no provision for an ending, happy or otherwise.

* * *

The relativity theory abolished absolutes, but the laws of the old physics still underlie the absurdly onerous tasks that are sometimes set for cinematic characters or the predicaments that torment them. Isaac Newton's analysis of motion described the forces that push and pull us and drag us down: Stan Laurel and Oliver Hardy discover what this means as they try to heft a piano in a clumsy crate up a flight of steps

in *The Music Box,* and Chaplin receives the same alarming lesson in *The Gold Rush* when his cabin, dislodged during a blizzard, teeters on the edge of a precipice.

Newton also observed that every action has an equivalent and opposite reaction. That brutally elementary truth is placed on show in the knockabout disputes and collisions of silent comedy, which excited Artaud because they conveyed 'the physical sensation of pure life'. Artaud applauded the resilience of Buster Keaton, and admired 'the less human Chaplin': allergic to the tramp's more wistful moods, he preferred to see the little man struggling against implacable necessity. Béla Balázs too enjoyed 'the non-psychological and mechanical nature of American slapstick'. A slap stick was a pair of joined wooden slats that clowns banged together as they scrapped with each other, producing a noisy concussion without delivering a blow. In pantomime and then on film – where heavier weapons could be used – the implement defined a kind of comedy that depended on violence. Thoughts and feelings were luxuries that might come later, which is why Balázs called slapstick 'non-psychological'; before acquiring a mind or heart, man must use raw strength to push back against an inimical universe that seems determined to eliminate him. The physical sensations to which Artaud referred were vocalized with grunts and groans, not articulate speech. Even if the silent comedians could have spoken, language would not have helped them: in *Girl Shy,* Harold Lloyd is afflicted with a stutter that can only be overcome when he is blasted by inarticulate noises like a whistle or a horn.

Cinemagoers had work of their own to do. At previews of *Speedy* in 1928, Lloyd's assistants graded responses from audiences that were vying to keep up with the hectic acceleration of the hero. They tabulated reactions on a 'Lafograph', with spikes that registered intensity on a scale from Titter to Chuckle to Laugh to Outburst to Scream to Screech. The graph's upper end recorded pleasure as if it were pain: hysteria was the highest commendation. In a report on the device, the *Daily Telegraph* was sceptical about claims that the apparatus could 'register the "strength" of the laughter aroused', but the quotation marks it placed around 'strength' begged the question. Viewers, like crowds at

sporting matches rallied by cheerleaders, were expected to pull their weight by mass-producing sound with the right volume and density.

Jean Epstein said cinema's subject was 'the whole man', and added that this 'most beloved human machine' was kept under surveillance by the camera's 'inhuman eye'. In one corner a human machine, in the other an inhuman gadget: silent comedy is about the battle between them, and it shows the experimental specimen described by Epstein acquiring and testing the skills we need for survival. Chaplin, Keaton and Lloyd have different personae – respectively the outcast reliant on his wits, the piston-driven engineer and the striving careerist – but all three are engaged in this vital struggle, and if we could hear them they would surely be emitting what Artaud called a 'scream at the extremities of the mind' as their inaudible cry of protest at the ferocity of the combat.

In *Modern Times*, released in 1936, Chaplin is the victim of a time-and-motion system known as Taylorism, devised by an efficiency expert to improve the productivity of American factory workers and later taken up in the industrialized Soviet Union. Charlie is force-fed by a machine to keep him from lingering over his lunch, and the repetitive task of tightening nuts with a spanner leaves him with a jerky manual tic that persists even when he is away from the assembly line. In rebellion against this enslavement, he sabotages the factory's turbines; they suffer a nervous collapse, and so does he. Keaton is not so fragile: in *The General*, made in 1926, his other half is a steam locomotive, whose huffing and puffing metabolism he shares. In *Speedy* – there could be no more pithily cinematic title – Lloyd drives his father's sedate horse-drawn streetcar through New York with such fury that it outstrips the motorized taxis that are competing for the route. In *Girl Shy* Lloyd commutes between a tram, a motorcycle, a succession of cars and a buggy as he races to interrupt his sweetheart's wedding. 'Go on, you spark plug!' yells a freckled newspaper seller to encourage him.

Chaplin played a tramp, but instead of tramping he scampered. His cane, an inseparable prop like his bowler hat, is a souvenir of the more refined rank he has forfeited, but it also functions as a life-support, storing energy and releasing it as he resiliently trots along. In 1918 in *A Dog's Life* he grows a tail for the sole purpose of wagging it. To smuggle

his adopted mongrel Scraps into a saloon, he stuffs the dog down his baggy pants; it wriggles around inside and sticks its tail through the threadbare seat of his trousers, so Chaplin's hindquarters become vigorously expressive. In 1928 in *The Circus*, he runs on the spot while walking a tightrope and trying to cope with a trio of monkeys that clamber over his body, cover his eyes with their paws, and stick their tails in his mouth – a hilarious rehearsal of our efforts to stay upright in unsupported space and ahead in evolutionary time.

Whereas Chaplin often taunts his pursuers by affecting to dawdle, Keaton outpaces them, even when, as in *Cops*, he has a city's entire police force chasing him. He can change gears at will, from jogtrot to canter to gallop to sprint, then grind to a halt as if applying brakes. In 1920 in *The Scarecrow* he gets married on a speeding motorcycle, and presents the bride with a ring that is a steel nut unscrewed from the sidecar; as a rowing coxswain in *College*, made in 1927, he serves as the boat's human rudder. Elsewhere he travels in a Roman chariot, a Mississippi paddle steamer, a submarine, a whaler, a yacht that has slippery masts and a dyspeptic engine room, an amphibious hot-air balloon with a canoe attached, and an aeroplane made of scrap metal and wooden bric-a-brac.

More of a go-getter than Chaplin, less reliant on transportation than Keaton, Lloyd is driven by ambition. The mobility that concerns him is always upward. In 1923 in *Safety Last!*, determined to win a contest, he climbs the outside of a twelve-storey building and relies on time to save him from the terrors of space. Swinging from a clock that juts out of the facade at a terrifying angle, he grabs its hands and makes them run backwards; when he pulls the dial off he is pricked by a live wire, then entangled by electrical coils as he tries to scramble free. Lloyd managed these prehensile stunts while handicapped by a prosthetic glove, which replaced the thumb and finger he had lost during an on-set explosion. In *Never Weaken*, made in 1921, he performs a deranged ballet on the skeleton of an incomplete building high above downtown Los Angeles, capering along girders that swing through the air – a flustered version of Nietzsche's Zarathustra leaping across crevasses between the mountain tops. Our laughter in these cases is a symptom of sheer terror.

Lloyd has an additional physical force to contend with: the mass, as obtuse and obstructive as a boulder. In 1925 in *The Freshman*, bullying jocks jeer at him for being weedy, until he proves them wrong when he is grudgingly allowed to play in a football game. Yet the human machine is also liable to fall apart as we watch. At a dance, Harold's cheap suit unravels on the floor; while he continues shimmying, a tailor who is incapacitated by dizzy spells attempts to sew up the ripped seams and detached sleeves, with predictably ruinous results.

Except in *The Circus*, Chaplin stays closer to the ground than Lloyd, and relies on fantasy as his frail defence against punitive reality. To recover from his ordeal at the steel mill in *Modern Times*, he takes a job as night watchman in a department store, where he is free to gorge on cake in the cafeteria and roller-skate around the section selling toys. In *The Gold Rush*, exhausted and starving, he dines on an old boot, which he bastes like a roast before he nibbles the sole; he treats a bent nail as a wishbone, and twirls a leather lace on his fork before ingesting it as if it were a strand of spaghetti.

Keaton lacks the leisure for such delectation. He has to withstand stiff physical onslaughts, bracing to resist the fury of nature as well as coping with our perennial adversaries, time and space. In *Steamboat Bill, Jr.*, released in 1928, he is battered by gales but leans into the blast at an angle of forty-five degrees, while wind drives a parked car backwards down a soggy street with the supposed driver clinging to the front bumper bar. In *Sherlock Jr.*, four years earlier, water deals him a thundering blow. Here he tumbles off the top of a train and clings to the spout of a water tower beside the tracks, which spills its contents; the gusher that knocks him to the ground left Keaton with a broken neck that, thanks to his hyperactivity, was not diagnosed for years. In 1921 in *The Haunted House* he is obliged to repeat the ordeal of Sisphyus. He repeatedly scurries upstairs in the booby-trapped mansion, but at each attempt the steps retract into a slippery slide and deposit him at the bottom again, even when, imagining that he is dead, he makes the steeper ascent to heaven and is sent slithering towards perdition. In *Daydreams* he is trapped in the wheel of a paddle steamer, where he endlessly rotates like Vitruvian man on a treadmill.

A time limit torments him in *Seven Chances*, made in 1925. Here, in order to qualify for an inheritance, he has to find a bride and marry her by the end of the afternoon. The endeavour takes him on an obstacle course that looks cross-continental: he starts near factories and railway yards, then has to ford rivers, wade through marshes, climb the sierras and traverse a stony wilderness, where he sets off a rock slide that pursues him downhill. Having managed all that, he is finally confounded by relativity. To check how near he is to the deadline, he consults the window of a clock-and-watch repair shop, but each of the faulty timepieces tells its own unreliable story, and the repairman's pocket watch is not working at all.

Elsewhere Keaton deals with more drastic emergencies. A hurricane demolishes the flimsy town in *Steamboat Bill, Jr.* In *One Week*, released in 1920, two newlyweds are presented with a prefabricated cottage, still stored in packing crates, and given a week to assemble it. Inevitably the segments do not fit; after many unworkable mismatches, they finally slot all the parts into place, but do not have a chance to take up occupancy. In their distraction they have positioned their dwelling on a railway track, where moments later it is smashed to pieces by a passing train. Buster is personally responsible for contriving the catastrophe in *The General*, set during the American Civil War: driving his Confederate locomotive to safety, he starts a fire behind it as he crosses a trestle bridge, which collapses spectacularly under the weight of the Union train that pursues him.

Chaplin sometimes snickers wickedly, and Lloyd grins in eager ingratiation. But Keaton's pale, fixed face never relaxes into a smile, because it takes all his concentration to keep the world from disintegrating. Even so, his efforts are usually self-defeating. In *The Electric House*, released in 1922, incompetence makes him a saboteur. Despite his lack of qualifications, he is hired to wire a client's home, where he installs a series of involuntary booby traps. Food is delivered from the kitchen to the dining table on train tracks, which inevitably results in a messy derailment; an articulated arm that extends to remove books on a high shelf and hand them down develops a will of its own, bunches into a fist, and knocks out the hapless reader. In 1924 in *The Navigator*, the

ship on which Buster and his sweetheart are the only passengers is set adrift by enemy agents. Floundering in the ocean as his dinghy goes under, he is concussed by a lifebuoy the heroine tosses to him from the deck. She then hauls him up by a rope she has not fastened to the railings, which means that as he ascends she tumbles into the water. He dives back in to save her and sits her in a deckchair that promptly folds up and expels her all over again. The deserted ship abounds in automated terrors: a scary portrait that has been flung overboard sticks to a hook on the side of the ship, and the face swings to and fro outside the porthole of Buster's cabin, leering at him. Leaden boots clamp him to the floor after he struggles into a deep-sea diver's costume; he nearly suffocates when he attempts to smoke a cigarette with the helmet screwed on. It is all exhaustingly funny: the laughter Keaton provokes is either our aching commiseration or the amusement of the supercilious gods.

During the 1930s, this silent physical affray gave way to screwball comedy, named after a style of pitching in baseball which baffled batsmen by giving the ball a tricky reverse spin. The new form permitted occasional acrobatic stunts – Cary Grant, whose repertory of circus tricks included juggling and walking on stilts, hoists Katharine Hepburn onto his shoulders and performs a double somersault with her in Cukor's *Holiday* – but screwball comedians were mostly content to be verbal gymnasts. Their rapidly delivered retorts replace the hard-hitting assaults to which Chaplin and Keaton were often subjected; punchlines land blows that are merely metaphorical. In Capra's *It Happened One Night*, a passenger seated next to Claudette Colbert on a Greyhound bus tries to sweet-talk her. When she haughtily rebuffs him, he remarks 'There's nothing I like better than a high-class momma who can snap 'em right back at ya': repartee is a sporting contest. By way of admitting that he loves Colbert, Clark Gable later says 'What she needs is a guy that'd take a sock at her once a day', and he volunteers for the task because 'I'm a little screwy myself.' 'If I ever lay my two eyes on you again,' Rosalind Russell tells Cary Grant in Howard Hawks's *His Girl Friday*, 'I'm gonna walk right up to you and hammer on that monkey skull of yours 'til it rings like a Chinese gong!' Minutes later, a machine gun is heard from the adjoining jail; it sounds like a continuation of the rat-tat-tat dialogue.

When words and even fisticuffs fail, comedy can always rely on gravity, the ultimate joker, to stage a comeuppance. The skeleton of a brontosaurus that archaeologists have painstakingly pieced together from fragments of bone slumps to the floor in smithereens at the end of Hawks's *Bringing Up Baby*; in Stanley Kramer's *It's a Mad, Mad, Mad, Mad World* eleven men scrambling down from atop a condemned building are catapulted through the air when the fire engine's extension ladder onto which they clamber swings out of control; and at the end of Steven Spielberg's *1941* a family home that has been eviscerated by an anti-aircraft battery lurches towards a cliff edge and flops onto the rocky beach below, where it smashes into splinters.

One director made a quixotic protest against this helter-skelter fatalism. At the premiere of his comedy *Quadrille* in Monte Carlo in 1938, Sacha Guitry interrupted the screening after half an hour and acted out a scene; after standing up for human freedom with this interpolated live performance, he then signalled for the projector to be turned back on and let the infernal machine have its way with his characters.

* * *

The chase, cinema's archetypal narrative, was described by Vachel Lindsay as 'time-and-space music'. That Einsteinian formula is exactly right. Chases dramatize the capricious relativity of our timekeeping, since they involve a competition between different speeds; they also require space, for which a theatre would have no room. But despite the exertions that we enjoy watching, no one ever gets ahead of time, and space turns out to be circular.

For *Intolerance*, D. W. Griffith filmed Constance Talmadge as a Babylonian warrior maiden furiously driving a chariot, although when he did so he had not yet decided who she was chasing or being chased by – a covert admission that the purpose and outcome of the pursuit hardly matter. Neither do the pursuer's chances of catching up with whatever is being chased: in *Bringing Up Baby*, Cary Grant races through rural Connecticut waving a butterfly net with which he hopes to trap a runaway leopard. What does matter is that there should be no deceleration, which is why the terrorist in Jan de Bont's *Speed*, released

in 1994, rigs a Los Angeles bus to explode if it is driven at less than fifty miles an hour. Space sometimes provides the bonus of a location that makes the mechanical commotion look more dangerous. In 1968 in Peter Yates's *Bullitt*, cars use the vertiginous San Francisco streets as ski jumps, bouncing down the inclines. In 1971 in *The French Connection*, an out-of-control New York subway train on spindly elevated tracks is chased by a police car that heedlessly scatters pedestrians on the streets below; the director William Friedkin had the camera under-cranked to eighteen rather than twenty-four frames a second, which makes our eyes work faster than usual to compensate for the gaps between images. At the start of Godard's *Weekend*, made in 1967, the camera sardonically tracks past an endless line of stalled or abandoned cars, but no such traffic jam will ever spoil cinema's delight in demolition derbies.

In Renoir's films, time does not travel on a highway at a steady pace: it is liquid, fluctuant, overflowing whenever the screen tries to contain it. As his early pastoral romance *La Fille de l'eau* begins, a long barge travels down a narrow canal, advancing so slowly that it seems it will never leave the frame. On top of its cabin a man walks in the contrary direction, while on the towpath the film's heroine – a proletarian water nymph – rides a horse that is roped to the barge; she is first seen by the camera moving from left to right and then, in what tidy minds would call a continuity error, from right to left. Barge, horse, man and woman are all heading out of the frame, but while they coexist they produce a pleasing sense of simultaneity, a recognition that the world is ample enough to accommodate them all.

After this scene on the canal, time for Renoir broadens into a river. The pleasure-seekers in *Partie de campagne* eagerly row their boats up a tributary of the Seine for a hidden tryst, and then, sexually disappointed, retreat downstream during a sudden squall as the surface is puckered by rain. A single day summarizes their lives: youthful hope and middle-aged resignation travel in opposite directions, but pass in midstream. In *Boudu sauvé des eaux*, released in 1932, the anarchic tramp played by Michel Simon is rescued from drowning in the Seine as it flows through Paris. The aquatic chaos he brings with him overwhelms the orderly lives of his landed patrons, after which he returns to

the water and lets it carry him off. Seen from the house of the colonial family in *The River*, all of existence passes by on the sacred Ganges, in a fluid welter that is somehow harmonious as small tragedies – including the death of a child, bitten by a snake in the garden – are washed away and the human comedy surges up again.

As he began work on *La Belle et la Bête*, Cocteau rejoiced in the opportunity to disrupt 'human time, which is normally so painful to live through'. In a slight alleviation of that pain, the candles in the Beast's castle light themselves: Cocteau here defied the second law of thermodynamics by running the footage backwards, and thought of such interventions as a 'triumph over the inevitable'. Liberties of this kind may be allowable in a fairy tale, but they are unavailable to characters in film noir, who have to painfully and purgatorially live through time more than once. In 1945 Edgar G. Ulmer's *Detour* begins with a shot of a highway receding through the desert, seen from the back window of a car – not an optimistic American way ahead but a route that has already been travelled yet must be retraversed by Tom Neal, who has assumed the identity of a dead man. Jacques Tourneur's *Out of the Past* traps Robert Mitchum in the same temporal loop, as its title declares. In *The Postman Always Rings Twice* John Garfield evades responsibility for a murder he did commit, only to be convicted and executed for another death that was entirely accidental. In *Conflict*, Bogart kills his wife, gets away with it, then is apparently hunted down by his victim, who seems not to be dead after all. In 1947 in *Dark Passage*, Bogart escapes from San Quentin and is smuggled back to San Francisco through a traffic tunnel that might be a birth canal; he is invisible, as if unborn, with the camera registering his subjective viewpoint until he acquires a new face from a back-street plastic surgeon. But even then, instead of reincarnating himself, he behaves like a vindictive ghost and haunts the nocturnal city.

In 1999, at the start of Sam Mendes' *American Beauty*, Kevin Spacey introduces himself in a voice-over as the camera floats above a suburb where he too might be an invisible spectre. 'This is my life,' he says, oddly employing the present tense although he goes on to acknowledge that his projected existence has a fixed term, which has already run out: 'I'm

42 years old, and in less than a year I'll be dead.' He speaks as if this were a premonition, although it is the start of a post-mortem flashback.

Science fiction, intrigued by what comes after the end or before the beginning, explores other exceptions to the usual temporal and biological sequence. Paul Verhoeven's *RoboCop* is about a policeman who is mutilated and then killed in the line of duty; with his remaining limbs and organs salvaged and incorporated into a cyborg, he sets out to avenge his own death. In Spielberg's *Minority Report*, mutated humans with psychic powers, known as 'pre-cognitives', foresee murders that have not yet happened. These scenarios are extracted from their brains and projected as holograms, so the police can arrest the culprits in advance. One such pre-vision frames Tom Cruise for a future murder he has no wish to commit, which leaves him scrambling to change the predestined outcome.

There is an antidote in Harold Ramis's *Groundhog Day*, another fable that takes off from cinema's unique capacity to fiddle with the chronometer. Bill Murray, a television weather forecaster, finds himself trapped in a time warp between winter and spring, and is sentenced to experience the same day over and over again – a version of repeating last summer's sojourn at a fashionable spa, as the characters in Alain Resnais' *L'Année dernière à Marienbad* believe they are doing. Murray begins by using his foreknowledge to trip up people he dislikes; gradually he realizes that with each repetition or cinematic retake he has the chance to amend his own life for the better. But reverse gear must be used with caution. In *Back to the Future* Michael J. Fox's plutonium-fuelled DeLorean transports him thirty years into the past and strands him in 1955, before he has even been born – and he worries that he may never get the chance to exist, since his parents seem unlikely to make a match. His putative father, clumsily flirting with the girl who ought to become his mother, flounders between physics and metaphysics. 'I'm your density,' he mumbles as he accosts her in a diner. 'I mean your destiny.'

The fixity of time points to a tragic outcome; if time is stopped in its tracks, the result is a comedy, saving people from danger and death. In 1947 in Epstein's *Le Tempestaire*, a magus curbs the waves that are threatening Breton fishermen; he does so by breathing on a

globe to cloud its glass, a technique similar to Epstein's use of gauzes or strips of celluloid to diffuse or deflect light. In René Clair's *Paris qui dort*, released in 1924, a dotty inventor transmits a radioactive beam that sends the city to sleep, paralyzing its inhabitants in grotesque or indiscreet attitudes. Some revellers high on the Eiffel Tower escape the effects of the ray, and descend to the streets to enjoy the embarrassing contortions of their fellow citizens. When Paris reawakens, everyone wonders whether it was all a dream. No, it was a fantasy, allowing cinema, just this once, to be un-kinetic. In Powell and Pressburger's *A Matter of Life and Death*, a messenger from the afterlife is despatched to earth to collect David Niven, an RAF pilot who was killed in a wartime dogfight but has somehow remained alive as the result of an administrative oversight. The psychopomp stops Niven's watch as they negotiate; he explains that they are conversing in space not time, so these few minutes will not be deducted from his allotted lifespan. The frozen frame, he adds, is 'just a trick' – a machination that is one of cinema's most deceptive lures.

Film stretches between freedom and determinism: the figures we take to be autonomous, alive in the moment, are automata whose movements can be rewound. In Krzysztof Kieślowski's *Blind Chance*, released in 1987, the hero's father says with his last breath 'You don't have to–', leaving the sentence incomplete. Resistance to fate is laudable, but all the same Witek's father has to die, as his son will eventually have to do. We are only at liberty to decide how we get there: accordingly Kieślowski's film splits into three alternative stories about the future, with time running at different speeds on each panel of a spatial triptych. These narratives are framed within anecdotes that dramatize our desperation to overtake time by sprinting through space. In one variant Witek breathlessly rushes to catch a departing train, in another he joins a slow-moving queue to board a plane that explodes just after take-off. Time's arrow should be fired straight ahead, but it can bend sideways like a screwball, following the contours of space. In 1991 Kieślowski's two heroines in *La double vie de Véronique* look through a ball of transparent polymer that enables them to see around corners; the French heroine Véronique avails herself of this ampler vision when she photographs

her Polish double Weronika, who meets her gaze without knowing that this is her alter ego from another country.

Motion is easy to capture, but duration – the time we spend our lives enduring – requires a longer attention span. F. Scott Fitzgerald wrote a short story about a character called Benjamin Button who is born aged seventy and physiologically sheds years rather than accumulating them until he finally reaches infancy as he dies. On the page, the conceit is easy for Fitzgerald to carry off because we have no visual evidence of what this crabwise trajectory might look like. But in David Fincher's *The Curious Case of Benjamin Button*, released in 2008, we see Brad Pitt recede from doddery senescence to carefree childhood – a spectacle that might be gratifying if Cate Blanchett, as Benjamin's love, were not proceeding in the more usual direction, from youth to age. For three hours, into which almost ninety years are compressed, we study mortality, the sourest of practical jokes.

Richard Linklater's films take his characters on a similar journey through the decades, but without recourse to prosthetics. Linklater made *Boyhood*, intermittently and without a pre-planned script, between 2001 and 2013, which allows us to watch young Mason, played by Ellar Coltrane, age from six to eighteen. While the faces and bodies of the characters slowly and almost imperceptibly change, the passage of time is punctuated by a sad assortment of suddenly redundant appliances – a square television set, a clunky desktop computer, a GameBoy or an X Box – that their users have outgrown. Early adoption of the latest technology is a way of living in the present or, better yet, the future: will it keep the past from catching up with us? Mason's mother is eager to be rid of an old house and an unsatisfactory husband, sure that she can improve her lot by moving to another city. Yet *Boyhood* ends by abandoning that competition with time when Mason and some friends drive out to watch the sun slowly setting at Big Bend in Texas. Moments like this are unseizable, someone says, because the sky changes every second; perhaps rather than seeking to arrest moments, we should simply accept their transitoriness.

Such matters are debated in a series of long walks by the on-and-off couple in Linklater's *Before* trilogy, released between 1995 and 2013.

In *Before Sunrise*, Ethan Hawke and Julie Delpy meet on a train and spend a night wandering around Vienna; in *Before Sunset* they resume their rambling conversation in Paris almost a decade later; in *Before Midnight*, now married and on holiday in Greece, they set off again on foot to sort out their strained relationship. Hawke jokes that they are travelling through 'the space-time continuum', and this is what Linklater aims to show us. On the train in the first film, Hawke persuades Delpy to make an unplanned stop in Vienna by saying 'Think of it as time travel': if she refuses, she might look back from the future and regret her decision. In the third film, after a threatened break-up, he persuades her to relent by using a similar argument. 'I've got a time machine up in my room,' he says; he then reads to her a letter he has written, purportedly sent to her from the future by her remorseful eighty-year-old self.

In Greece, the middle-aged Hawke recalls that as a boy he wanted to speed time up, whereas now he wishes it could be slowed down – impossible in life, but easily arranged on film. Hawke's character plans to write a book about people suffering from brain disorders, one of whom is a woman with permanent déjà vu who goes to *On the Waterfront* when it opens in New York and declares that she has seen it before. Of course she has not, but she will probably see it again, and when she does she will revisit not only the film but whoever she was at the moment of that first viewing. Our memories are preserved on those reels of celluloid, which testify to the presence of the past here and now in our minds and bodies. In the Paris bookshop where he is reading from his latest novel, Hawke rejects chronology and propounds a cinematic truth. 'Time,' he says, 'is a lie.'

* * *

Carl Theodor Dreyer pointed out that cinema began on the streets, among the traffic filmed by the Lumière brothers, not in the sealed and insulated space of a theatre or a studio, and this outdoor apprenticeship meant that it naturally possessed 'a certain rhythm-bound restlessness'. By the time that Dreyer made that comment in 1933, the heavy, boxy equipment needed for recording sound had forced the art to sacrifice

much of its early mobility, but in those silent days its rhythms were restless to the point of frenzy.

Abel Gance filmed *Napoléon* using what can only be called an unsteadycam, which was sometimes strapped to the operator's chest or dangled from overhead cables or swung from a pendulum. After Napoléon's escape from Corsica, we suffer seasick qualms as the camera travels in a boat lashed by the sirocco. Then Gance switches abruptly from the churning sea to the equally nautical turbulence of the Constitutional Assembly, where the crowd, according to an intertitle, is 'swept... into the raging whirlpool' of the Terror: rebounding from troughs that suddenly gape in the stormy sea, we bounce above the angry mob and lunge down into the crush, buffeted by gusts of inaudible rhetoric. Here is a case of the camera's movements 'making visible', as Vachel Lindsay wished, 'the unseen powers of the air'.

In 1928 Marcel L'Herbier's *L'Argent* updated Gance's epic, advancing from the territory annexed by Napoléon's military conquests to a more modern and even more expansive empire consolidated by financiers. One of these is Saccard, founder of the aptly named Banque Universelle, who has a metal statue of an equestrian Napoléon on his desk; another is the petrol magnate Gunderman, whose offices include a circular map room where he can track the vessels carrying his oil across the oceans. The camera sets out to match the panoptic ambitions of these magnates, and in doing so it destabilizes space and exposes the infirmity of their society and its economy. For scenes of panic in the Bourse, L'Herbier fitted a wide-angle lens known as a 'brachiscope' to the camera, then let it drop from the skylight or skim on a platform over the milling stockholders as the trading floor gyrated below. Vertigo, with its sensations of disequilibrium, here became an ingrown cinematic ailment.

Murnau too preferred a camera that was, as he said, 'entfesselte' – unleashed or unchained. In *The Last Laugh*, Emil Jannings plays a pompous, proudly bemedalled porter who loses his place at the grand entrance of a Berlin hotel and is demoted to subterranean service as a lavatory attendant. As his place in the world changes, the space he occupies is unsettled, as if by seismic forces. The camera runs mocking rings around him as he slumps at a table, daydreaming about

the rotations of the glass door he once guarded. In the courtyard of the tenement where he lives, a neighbour shouts the news of his dismissal to another woman on a balcony across the way. Murnau adds a close-up of the auditor's cupped ear as she takes it in; although we cannot hear it, the hurtful gossip has been relayed fortissimo, and the silent uproar is visualized in a shot of a trumpet's black, brazen bell. The viewpoint then pulls sharply back, and the jolt marks the way that the cry must have ricocheted off the walls of the courtyard. To convey that inaudible sonic shock, Murnau placed the camera in a gondola that was tugged across the courtyard in mid-air on wires, just as tracks took it on a twisting journey through the forest and into the city in *Sunrise*. He referred to such mobile devices as his 'dramatic angels', because they enabled the camera to intervene invisibly in terrestrial affairs. In his *Faust* this command of space was the gift of a demon: it is the cloak of Mephisto that wafts the camera above the rooftops and over the mountains as the Devil takes his protégé across the Alps to Italy.

For Rouben Mamoulian, the camera could not remain a mere witness or onlooker. It must, he said, be 'the main actor in the picture', 'the person who tells the story'; rather like H. G. Wells's invisible man, it has 'a kind of rhythmic volume' but is 'not limited by space, by time or by people'. It is, in other words, a disembodied directorial eye, and in 1929 in *Applause*, Mamoulian allows it free range. The film's heroine is a broken-down burlesque star played by Helen Morgan, who shields her daughter from sordid Broadway by sending her away to be educated in a convent. When the young woman returns to New York, the camera at first adopts her naive, wide-eyed angle of vision. 'Look, just look! What a sight!' she exclaims as she perches on the observation deck of a downtown skyscraper, with the towers around her emitting plumes of steam and the El far below snaking through narrow streets to the ferry. Later, as the city's moral squalor becomes more evident, we descend from these exhilarating heights. While the daughter waits on a litter-strewn street, the camera's viewpoint ends at her knees, but its lowered gaze takes in all the information we need about her predicament and the seediness of her surroundings. Her legs pace anxiously to and fro, ill at ease, while male feet loiter opportunistically nearby. A yapping

mongrel dog and a stray cat hint at the prospect of homelessness; a fire hydrant and a garbage bin are emblems of the soiled realism found in the work of early twentieth-century painters like John Sloan who were assigned, a little scornfully, to the so-called 'Ashcan School'. In the disreputable burlesque house where Helen Morgan performs, the camera again opts for a defamatory low angle, picking out the chubby legs and wrinkled stockings of the superannuated chorines. The cruellest of these indiscreet glimpses comes as Morgan, bleary and lachrymose, expires on a divan in her dressing room. She sags sideways, and when she dies her face is seen upside down: the angle renders her unintelligible, no longer a person.

Mamoulian specified that the camera must have the power to evade or outsoar all physical limits, and it intrepidly exercises that prerogative in 1975 at the end of Antonioni's *The Passenger*: here it undertakes a leisurely, digressive perusal of space while also meddling with time to deprive us of the causality and sequential logic we crave. Jack Nicholson plays a journalist who takes over the identity of a dead gunrunner, which he hopes will allow him to become a character in one of the stories that he usually reports. Holed up in a cheap hotel near the Andalusian city of Almería, he awaits an inevitable retribution, which happens at some point during the seven-minute tracking shot that concludes the film. As the scene begins, Nicholson opens the windows of his hotel room and looks out through a row of imprisoning bars. There is nothing much to see – a man walking away, a palm tree with rustling fronds – so the camera backs into the room and watches for a while as Nicholson sits on the bed, lights a cigarette and lies down to smoke: this might even be what Zavattini called a neo-realist's 'act of concrete homage' to the ordinary business of the world, which becomes fascinating when it is filmed. Then, reconsidering its position, the camera moves Nicholson aside and deliberately but very slowly closes in on that open window, which frames a view of what appears to be a disused bullfighting arena, a theatre of ritualized death. Moving with extreme stealth, not only invisible but immaterial, the camera somehow squeezes through the window bars: is it miming the soul's sly, unobserved exit from the flesh? In the dusty space outside, it records a series of happenings that may

or may not be significant – people strolling, the comings and goings of cars. Other events are audible but unseen – a long elegiac riff from a military bugle, a momentary explosion that could be a car backfiring or a gunshot, a police siren. Pretending to mere idle curiosity, the camera takes stock of the square in a circuit that revolves through 180 degrees and looks towards the distant hills. Then, alert to a possible drama, it follows a cluster of people who for some reason hurriedly converge on the hotel. Rather than crowding through the door behind them, it slides along the facade until it reaches the same barred window; inside the room, it notices quite casually that Nicholson is now dead. This is the ultimate long shot – as indifferent to individual cases as the woman who shrugs 'I never knew him' when she is asked to identify the body. The camera here is the most discreetly efficient of Murnau's angels: it eradicates a man, then declines to confirm that he ever existed. Like Rossellini's 'macchina ammazzacattivi', it might have been accused of complicity in the killing if it had not been outside in the dusty street with its back turned.

One director resisted cinema's Faustian urge to elasticize space and accelerate time. Yasujirō Ozu did not allow the camera to travel on tracks or to indulge in panning movements, and his establishing shots, usually of nondescript alleys or bare corridors, are unkinetic studies of still life. The people in his films kneel on tatami mats in boxy houses, dutifully accepting their enclosure by the frame. In *Tokyo Story*, released in 1953, an elderly husband and wife are packed off to a holiday resort and told to enjoy themselves: they shuffle along the sea wall but are dazed and depressed by the bright vista and make immediate plans to return home. The excursion proves to be fatal for the old woman; at her funeral, one of her daughters comments on the monotonous drone of the priests and the dull iteration of their drumbeat, and says 'It's as if Mother were becoming smaller, bit by bit.' That, however, is the purpose of the ceremony, which ushers the weary matriarch into non-existence. 'Life is disappointing,' says the widowed daughter-in-law played by Setsuko Hara; she utters the line with a wise, almost grateful smile that is heart-breaking to witness – an acceptance of the limits that Mamoulian urged the camera to challenge.

* * *

Andrei Tarkovsky called cinema 'the instrument humanity had to have in order to increase its mastery over the physical world'. That sounds like the kind of claim a Leninist might have made to supplement the electrification of the Soviet Union or the imposition of collective farming, but the same ambition underlies the American Western, where the work of mastering space is undertaken by the camera.

On the frontier, according to the novelist Jack London, 'men bulked big', and at the beginning of a typical Western we see a man gradually take on that bulk as he rides towards us. John Wayne in *The Searchers*, Alan Ladd in George Stevens' *Shane*, Kirk Douglas in King Vidor's *Man Without a Star*, Clint Eastwood in *High Plains Drifter*, even Gordon MacRae as he moseys through the ears of corn in Fred Zinnemann's *Oklahoma!* – each of them materializes out of the far distance and assumes dominance when reaching the foreground. The title of Alan J. Pakula's *Comes a Horseman* sums up an entire genre, ennobling it with a flourish thanks to its chivalric-sounding inversion, even though the film is set in Arizona in the 1940s and has Jane Fonda driving a broken-down jalopy as well as riding a horse to rope cattle.

More is at stake than dominion: Jack London's image articulates a faith. In John Sturges' *Escape from Fort Bravo*, William Holden, a tough, cynical officer in an Arizona prison camp during the Civil War, is asked to describe his father. He says 'He was big', repeating London's point, but then in an uneasy pile-up of qualifications he adds 'A man is bigger than anything he does – or should be. It's like a Bible that's bigger than any religion. I guess he was my Bible.' These second thoughts let slip misgivings: what did his father do that was not big enough? and is the Bible bigger or smaller when religion is deducted from it? Holden explains that his father set out to find water and raise cattle in the desert; presumably he failed.

The hero of Owen Wister's novel *The Virginian* – filmed in 1929 by Victor Fleming with Gary Cooper as a ranch foreman in Wyoming – wants to 'become the ground, become the water, become the trees, mix with the whole thing. Not know myself from it. Never unmix again.' He says this while camping on the plains with his new bride, and his merger

with the land seems to matter as much as his union with her. More often, the West absorbs individuals by diminishing, even brusquely eliminating them. In 1948 in Howard Hawks's *Red River*, John Wayne shoots those who challenge him, has them buried, and at their graves grumpily recites some lines from scripture to remind the men who bulk so big that they are doomed to dwindle or crumble into the landscape. 'We brought nothing into this world,' Wayne says on these occasions, 'and it's certain that we can take nothing out of it.' When the gunslinger played by John Ireland joins the cattle drive that starts from Wayne's Red River ranch, he is asked how quick he is on the draw. All he will say, in a taciturn drawl, is 'I manage to stay alive', and that counts, for the moment, as an existential victory. A hardbitten fatalism goes with the territory. Even though Yul Brynner wins all his gun battles in Sturges' *The Magnificent Seven*, his last words before riding away at the end of the film are 'We always lose.' In 1962 in Sam Peckinpah's *Ride the High Country*, Joel McCrea, fatally wounded in a shoot-out, sends away his friend Randolph Scott so that he can die alone. Crumpled on the ground, he turns aside to stare at a peak of the Sierra Nevada, then collapses, falling out of the frame. THE END flashes up on the screen as his curt valediction; the mountain, insensible and endless, outlives him.

These vast spaces, whittled down over aeons, measure time geologically. A modern Western directed by Don Siegel concerns gold thieves who quarrel at a mine near the rim of the Grand Canyon and fight on an aerial tramcar above it. The film, released in 1959, is aptly called *Edge of Eternity*: the gulf below, agape to consume the bodies or runaway cars that tumble into it, chronicles the true age of the immemorial earth. But Westerns seldom look so deeply into the evolutionary past, and many adhere instead to the biblical chronology of creation. Outside the town of Medicine Bow, Wister's novel describes 'a world of crystal light, a land without end, a space across which Noah and Adam might come straight from Genesis'. John Wayne, playing Davey Crockett in *The Alamo* which he directed in 1960, gazes at a cypress beside a river and says 'Lord above, that's one beautiful tree.' The camera cranes up to admire it, then looks back from the Lord's point of view at the worshipful faces of Wayne and a Mexican widow. 'Kind of a tree,' Wayne

adds, 'that Adam and Eve must have met under.' Thirty years earlier in Raoul Walsh's *The Big Trail*, Wayne tantalizes a band of pioneers camped by the Mississippi with tales of an arable valley guarded by a white mountain in Oregon. 'Will you undertake to lead us to that valley?' one of them asks. Wayne agrees, but rides off alone just before they arrive; as he departs he asks them to give his regards to the white mountain, an act of reverence appropriate to the dwelling place of God.

Orson Welles suggested filming a version of the Old Testament in the American south-west. Though this notion came to nothing, Ford in 1948 restaged Christ's nativity there in *3 Godfathers*: his Magi are bank robbers on the run, who carry an orphaned baby across Arizona to the town of New Jerusalem. Wayne, who plays the leader of the outlaw trio, initially jokes about his fitness to take part in an allegorical re-enactment of scripture. Having survived a sandstorm, he and his parched cronies arrive at a waterhole that has been dynamited; with its granite base destroyed, he predicts that it will never fill up again, even if it rains 'till I get religion'. Of course that conversion eventually occurs, but only after two of his fellow Magi are left for dead in the desert. In Ford's *Wagon Master*, released in 1950, the Mormons who trudge on foot towards Utah are filmed in filtered light, which solemnizes their migration and makes it look like a pilgrimage. They take their bearings from outcrops of rock that act as totems: 'that tower over there' reminds them of 'a cathedral back in Santa Fe'. A map of other-worldly space is superimposed on the secular American ground, and when a Mormon elder rebukes Harry Carey junior for uttering a profane oath, the young man self-righteously replies '"Hell" ain't cussin', it's geography – like you might say Abilene or Salt Lake City.' Eastwood proves the point in *High Plains Drifter*, which he directed in 1973: playing a vigilante who might be one of the horsemen of the apocalypse, he forces the venal settlers in a lakeside town called Lago to repaint all their dwellings red, after which he officially renames the place Hell.

George Stevens made a last attempt to transform the West into a holy land in 1965 in *The Greatest Story Ever Told*, where the Christ of Max von Sydow penitentially retreats into the scorched wilderness of Death Valley and emerges to preach the Sermon on the Mount while perched

on a crag above a canyon in Utah. The harsh, arid vistas contradict the New Testament's merciful creed and reduce even Christ to a negligible speck; here the best to be hoped for is survival, not salvation. In *Major Dundee*, also released in 1965, Peckinpah abandons this missionary project. Offered a Bible to take on a vindictive Mexican sortie against the Apaches, the ruthless commander played by Charlton Heston says 'With all due respect, God has got nothing to do with it.'

Hawks's *The Big Sky*, made in 1952, begins with an unfurling parchment scroll that remembers 'the great first times' – primordial or only pioneering? – and goes on to recall one of 'the great American firsts', the exploration of the Missouri River from St Louis to Montana. Setting out, Kirk Douglas intends to supplement the work done on the sixth day in Genesis. God, he says, made 'a big country' but 'forgot to put people in it'. That omission is no defect, because Western heroes want to quit society; rather than sharing the frontier with other human beings, they prefer to see it filled with livestock, like the herd of ten thousand cattle driven to market by Wayne and Montgomery Clift in *Red River*. Borden Chase, in the novel that was Hawks's source, finds a thrilling elemental chaos in the spectacle of all those mindless beasts heaving and eddying in terror as a lightning storm strikes them on the plains of Arkansas, while a woman groans in childbirth in a wagon menaced by the stampede: as Chase describes it, the scene is convulsed by 'giant forces' and a 'terrible power', as when 'this world of ours was being born'. In Visconti's *Bellissima* in 1951, that primitivism excites Anna Magnani, who watches *Red River* on an outdoor screen in the sweltering courtyard of a Roman tenement and gasps as the trail drivers coax the horses to jog across the river. Her husband tells her to forget the cinema and its fantasies; she refuses, wanting to believe in wider horizons and the birth pangs of a new world.

The convulsed, cratered West recalls the throes of creation, but its skeletal dessication also suggests a world that is dying. Playing Wyatt Earp in 1946 in Ford's *My Darling Clementine*, Henry Fonda glances at the sterility of Monument Valley and says 'Ain't no cow country.' Without being pastoral, Monument Valley with its spindly, whittled pinnacles provided Ford with an austere terrain where he could stage

repeated battles between banditry and law, or between savagery and human kindness or kinship. Although the Valley straddles Utah and Arizona, Ford moved it around the map – another example of cinema's mobile, mutable treatment of space. In 1956 in *The Searchers*, it stands in for both Texas and New Mexico; in *Cheyenne Autumn*, released in 1964, it stretches across some fifteen hundred miles from Oklahoma to Wyoming, so that the dispossessed Indians who are forced to march north to a reservation never seem to leave it. On location, Ford relied on a tribal medicine man to wrangle appropriate clouds: he favoured cumulus formations, seemingly as solid as boulders, that filled the sky above the Valley with the brooding thoughts of a creator dismayed by fractious humanity.

The West's abraded sentinels, like the pillars in Monument Valley or the buttes Walt Whitman described on the Laramie plans, served as models for obdurate Western characters, subjects who refuse cinema's gift of animation and behave like inert objects. Burt Lancaster, cast as the archetypal lawman Wyatt Earp in 1957 in Sturges' *Gunfight at the O.K. Corral*, faces down a drunken cowboy who pulls a gun on him in a saloon. At close quarters the cowboy fires; Lancaster does not flinch as the bullet penetrates the floor at his feet. This almost geological fixity is proof of Western valour: such men are intent on conserving energy for the next bout of instantaneous violence. James Coburn spends most of *The Magnificent Seven* dozing and utters only the occasional reluctant monosyllable, but he is always ready to leap straight upright and hurl an unerringly aimed knife at a challenger. In this open and uneventful space, time consists of static eternities punctuated by instants that are fatefully decisive. At the start of Sergio Leone's *Once Upon a Time in the West*, three grizzled gunslingers arrive separately out of a dusty, baking nowhere to take up their positions at a train station in the desert. We spend more than ten minutes studying their guarded eyes, which glare into the distance in close-up while they say and do nothing. Then a train arrives, Charles Bronson steps off, and after a short exchange of sullen glances and clipped taunts he guns down all three in a few seconds. Both the tempo and the stark spatial setting are innately, almost abstractly cinematic.

In *The Man from Laramie*, directed by Anthony Mann in 1955, a suspicious rancher asks James Stewart 'Who are you?', a question we long to address to many of the unknowable, unforthcoming protagonists of these films. 'No one you ever heard of,' replies Stewart. The next question is 'Then what are you?' All Stewart will say is 'I come from Laramie': geography replaces personal history. In 1958 in *Man of the West*, also directed by Anthony Mann, Gary Cooper is as eroded as the West he personifies. His face is scarred, and the skin sags beneath his eyes; he resembles the white weathered skull that is the emblem of a hotel he visits called the Longhorn Palace. Julie London, playing an itinerant singer, taunts him by asking 'Do you talk?' At the homestead of an outlaw gang, he admits he lived there once. 'When you were a boy?' asks London. 'I don't know what I was,' he replies, unsure whether monoliths were ever young. 'Whatcha bin doin'?' demands the patriarch of the gang. 'Nothin' much, movin' around,' Cooper answers. 'All by yourself?' the other man wants to know. 'All by myself,' says Cooper. He means that he had no company, but he could also be saying that he moved of his own volition: he is after all an animate being, not a spar of rock.

More vegetable than mineral, Kirk Douglas in *Man Without a Star* burrows into the sparse vegetation rather than standing aloof. In Wyoming he explains that he has come from Texas via Kansas City with his herd of cattle, 'just driftin' north with the grass'; allergic to the barbed wire that closes off the range, he suspects he will wind up in Canada. At least he feels some connection to the pasture. The gunmen hired to protect a Mexican village from bandits in *The Magnificent Seven* are entirely rootless, unlike the farmers they defend. 'Home, none. Prospects, zero,' says Steve McQueen in a long negative inventory of his existence. 'Places you are tied down to, none,' adds Yul Brynner, almost enviously.

During his nineteenth-century journey from Pittsburgh to the Pacific with William Clark, the explorer Meriwether Lewis described the 'grotesque figures' of fissured limestone that stood along the river at the Missouri Breaks in the Montana badlands. Those bizarrely anthropomorphic formations prompted Marlon Brando to do some shape-shifting of his own in 1976 in Arthur Penn's *The Missouri Breaks*, as he hunts down Jack Nicholson's gang of rustlers. Brando begins dressed as a

Native American though he speaks with an incongruous Irish accent; for a while he wears the straw coolie hat of the Chinese labourers who worked on the trans-continental railway; finally he disguises himself as a bonnetted old biddy from a farmstead. Along the way – as if his aim were to 'mix with the whole thing' like Wister's Virginian – he also pretends to be a hillbilly preacher and a silky dilettante who has strayed far from his elegant Southern plantation. God may have forgotten to populate the West, as Kirk Douglas says in *The Big Sky*, but Brando makes up for that with his array of surplus personae.

The amplitude of space is as much of a challenge to the camera as it was to the people who strove to subdue the West or make it habitable. The settlers in *The Big Trail* are looking for 'a likely stretch of country', and Wayne warns them that getting there will be 'a long, tough pull'. Stretching and pulling emphasize horizontality; Walsh accordingly filmed their trek in a 70-millimetre process patented as Fox Grandeur, which used two cameras placed side by side to produce a composite image worthy of the wild rivers, serrated canyons and ragged wastes through which the wagons have to be dragged. When the aspect ratio of the screen changed in the 1950s, René Clair complained that CinemaScope's 'strictly horizontal framework' was uncomfortable for 'creatures whose biped nature most often imposes verticality upon them'. Not necessarily: the solution was to make the bipeds withdraw into the flattened, unravelling landscape.

At the end of *Cheyenne Autumn*, a warrior chieftain abruptly shoots the young brave who has lured away one of his wives, then breaks his rifle and rides off into voluntary exile, estranged from the tribe because he has killed another Cheyenne. Inside the laterally extended frame, the encounter and its aftermath remain at a distance from us: this is a ritual, inevitable and impersonal, not an occasion for drama. In 1958 in William Wyler's *The Big Country*, the camera moves away during the fight between Gregory Peck and Charlton Heston and leaves them to exchange noiseless blows as they slump onto their knees. In *Man of the West*, CinemaScope measures the amplitude and indifference of the setting. The film ends with a wide-angled shot of a ghost town called Lassoo, strewn with corpses after a bank raid. The husband of

a Mexican woman asks for news of his wife. 'I'm sorry,' says Cooper before riding away. At the other edge of the frame, the bereft man goes on calling 'Mi Juanita' and then enters the bank, removing his sombrero as a gesture of respect to the body he knows he will find there. Cooper's laconic expression of regret assigns no responsibility for the woman's death; in this callous landscape, it hardly matters.

Samuel Fuller's *Forty Guns*, released in 1957, is about the antagonistic attraction between a whip-wielding female landowner and the lawman who tries to rein in her private army of enforcers. The main function of Barbara Stanwyck's forty gunslingers is to fill up the CinemaScope screen when they go riding with her in a thundering cavalcade that whips up a storm cloud of dust. The members of the phalanx also dine with their mistress, and when Barry Sullivan arrives with an arrest warrant for one of them Stanwyck demands that it be passed down the table rather than given directly to her. With twenty retainers seated on either side of the long board, Fuller follows the paper's teasingly slow transfer from hand to hand, adding slight pauses so that each man in the relay can peruse it before giving it to his neighbour. CinemaScope here flattens the hierarchy in Stanwyck's household and makes power depend on protraction, not orders from above. As at the station in *Once Upon a Time in the West*, protracted time and congested space collude: made to stand waiting in silence during the document's over-extended transit, Sullivan undergoes a cermonial humiliation.

Later, Sullivan takes an apparently leisurely walk, flanked by the two brothers who are his deputies, up the hilly main street of their little town. Fuller laid tracks covering hundreds of feet for an uninter-rupted dolly shot that lasts four minutes, during which the men pass a gun store, an establishment selling harnesses, a supplier of cattle feed, a doctor's office, and a shack that quixotically offers violin lessons: a virtual diorama of the West's history, with a glance ahead towards a future when there may be a market for civilized musical accomplish-ments. The tour ends at the telegraph office, where the agent says to Sullivan 'Seen you make the walk – little slower than that stroll you took in Dodge City.' In the past he has used such thoroughfares for pistol duels not shopping trips, and on this perambulation, flanked by

his back-up team, he is staking out the arena where he will exercise his skill in the film's inevitable conclusion.

Casual passers-by have no place here, and the bank, the lawyer's office, the liquor store, the livery stable, the cantina and the lodging house are no more than facades on either side of a bare stage where characters confront death. In *Last Train from Gun Hill*, directed by Sturges in 1959, a former saloon hostess played by Carolyn Jones makes a pointed comment about the fate of her lover, a stubbornly wrong-headed idealist. 'They shot him down in the street,' she says, and she later warns Kirk Douglas that the same is about to happen to him in full view of an audience: 'You should see those people out there, all lined up on both sides of the street, waiting to see it happen.' These strips of urbanized desert, cleared for imminent combat, have a vacancy at the centre. In 1993 in George P. Cosmatos' *Tombstone*, Wyatt Earp, played this time by Kurt Russell, asks the Doc Holliday of Val Kilmer to explain the mania of the gang leader Johnny Ringo. Doc says that Ringo kills nihilistically; he needs revenge. 'For what?' asks Earp. The camera closes in on the consumptive, bedridden Doc, who gasps 'Bein' born.' The diagnosis is completed by Doc's remark that Ringo has 'got a great empty hole right through the middle of him'. What gnawing hungers of our own do we expect cinema to satisfy?

René Clair once pointed out that the anamorphic lens was a military invention, first intended to help the drivers of tanks see through their periscopes. When the astronomer Henri Chrétien adapted the device in the 1920s, it broadened our view of the sky. But the way the Western uses the binocular format matches its bellicose origins and confirms Doc's diagnosis of Ringo. Energy is cinema's impetus, keenest when most violent: the wide screen, like a shooting range, serves as its ballistic playground.

9

SUN PLAYS

Cinema has always been an exercise in chiaroscuro, a clash between opposites that are co-dependent. Light is captured in the camera's dark chamber, where it leaves a legible trace; it re-emerges in a larger darkened room, now with the support of a bulb and wheel that can cause static images to move. In 1905 Einstein helped to explain these chemical and mechanical transformations. Light, according to quantum theory, consists of photons that scatter into electrons and give off energy, like cinematic stills roused into life by the whirring projector. Much later, Einstein himself invoked the aid of the new art when he asked a colleague to 'picture the Brownian motion of a particle which has been cinematographically recorded, with the images preserved exactly in chronological order'. Einstein resisted Erwin Schrödinger's suggestion that there might be 'a non-observable negative density in interstellar space', yet cinema, despite its reliance on light, can make that dark energy or dark matter visible.

In Paris, Louis Feuillade built a glass-roofed studio to let in the sun, although the serials he made there – *Fantômas*, *Les Vampires* and *Judex* – dealt with night-prowling criminals. The first Ufa studios in Berlin were glasshouses, placed on rooftops and designed, like conservatories, to receive light from all sides. Jean Epstein condemned the designers of *The Cabinet of Dr Caligari* for painting solar rays onto their claustrophobic indoor sets: this he regarded as 'an unpardonable sacrilege', an offence against cinema's holy light. Working in a cold climate, Epstein relied on man-made suns, and in *Les Feux de la mer*, the documentary about lighthouses in Brittany that he made in 1948, he admires their prodigious output of candlepower, fired by paraffin and augmented by

the invention of polygonal or circular lenses. These guardian beacons, he says, 'all...speak the same language, that of flashes of electric light' – an Esperanto like that of the cinema.

The American industry established itself in Los Angeles to take advantage of the year-round sun, which Vachel Lindsay challenged film-makers to use as 'a dynamo, a transcendent globe... a fire upon the altar'. D. W. Griffith gave *Intolerance* the subtitle *A Sun-play of the Ages*, and upset his cameraman by ordering him to point the viewfinder directly at the sun, though he was warned that this would endanger the eyesight of audiences. The film's Babylonian episode shows Cyrus paying homage to the sun in the form of a many-pointed star that revolves on a wand; his enemy Belshazzar mistakenly puts his faith in Ishtar. Throughout *Intolerance* the maternal figure of Lillian Gish rocks a cradle in a dark room that, like a pinhole camera, had an aperture drilled in its roof so that a sunbeam could grace her head. At the end, in an epilogue that looks forward to the abolition of war, fluttery angels hover like a winged chandelier above a battlefield. Griffith may have deified the sun, but he also called on man-made pyrotechnical effects. When directing battles in *The Birth of a Nation* he relied on the skills of a one-armed assistant known as Fireworks Wilson, who clamped bundles of flares under his stump, fastened lighted fuses between his teeth, and held mortars in the hand that had not been blown off.

On film, divinity registers as halation. The critic James Agee was amused by the fuzzy apparition of Christ in the 1925 *Ben-Hur*, and remarked that 'a Mazda bulb stood in for the Nazarene', which somewhat dimmed the saviour's wattage. In DeMille's *King of Kings* a blind girl implores Christ to 'open mine eyes'. Still unseen by us, his powers not yet made manifest, he sends out a diagonal beam of light. At first the girl's eyes open on an indistinct brightness; then Christ – H. B. Warner, neatly bewigged and whiskered – comes into focus. Writhing on a sofa and smooching with a panther, the harlot Mary Magdalene is unim-pressed by the miracle, and says that her beauty has blinded more men than Christ could ever cure. Nevertheless, light prevails: a white haze shimmers around the Grail, and the first Easter Sunday begins with a rosy dawn.

In the early 1930s, a Theosophical mining engineer called Guy Ballard dreamed up a religion adapted to the Californian climate and to the industry based in Hollywood. Ballard claimed to have been initiated into 'the Ascended Masters' Octave of Light' and charged with 'the Protection of Light... for the Americas'. Like the tablets on Sinai in DeMille's *Ten Commandments*, the sacred texts of Ballard's cult were 'dictated over a visible Light and Sound Ray' by 'the great Divine Director', who sustained his earthly representative with a cup of 'pure electronic essence' and wafers of 'concentrated energy'. The 'pure Life/Light', Ballard's equivalent to the Eucharistic blood and body of Christ, had an 'Electrical-like Effect' on him, authorizing him to serve as a 'Cosmic Messenger from the Great Central Sun' and infusing him with a 'Supreme I AM Beingness'.

That makes Ballard sound like one of the astral specimens Hollywood calls stars, and indeed his hocus-pocus works best as an allegorical account of moviemaking. 'Cyclopea protects and guides our beloved America,' he declared, '... by the projection of stupendous Rays of Light, focused and poured through the Great Eye of the north wall of the Great Audience Hall.' That hall was a spiritual retreat constructed for his followers in Wyoming, but the description suggests a global cinema, with God or his deputy Ballard in the projection booth.

Despite this cult of light, positive and negative alternate in cinema's history, as they do in the craft of photography. The scientist in Lang's *Woman in the Moon* is called Helius: the name casts him as a priest of the art's heliocentric religion, even though the rocket he pilots is bound for a chilly planetary satellite whose light is a pale reflection. The city in *Metropolis* is kept running by a turbine that is installed underground; behind it is a disc like the sun, with razory lightning bolts painted onto it. The false Maria cavorts in a nightclub decorated with incendiary suns that bounce up and down, unfixing the sky. Lang's Indian epic *The Tiger of Eschnapur*, released in 1959, acknowledges that light can be lethal: here the hero, wandering in the desert, madly discharges his gun at the broiling sun, his tormenter and ultimately his executioner.

Abel Gance had his own more inflammatory version of this solar gospel. Danton in *Napoléon*, sweltering in a blaze of red, refers to revolu-

tion as a furnace or a forge; the conquering hero who is manufactured by this industrial cauldron was said by Gance to be 'radioactive'. During his youthful snowball fight or the battle with feather pillows in his dormitory the young Napoléon's aura is icily white, though Gance's colour filters warm it to flame-yellow at the populist Cordeliers Club, where a cyclone seems to blow through the room as the 'Marseillaise' is sung. An intertitle reports that the thrusting upstart feels 'a source of light growing within him' as the monarchy crumbles. Back in Corsica, a fire from his mother's hearth suffuses the room as he vows that the island will never belong to the English. When Napoléon meditates on the coast, Gance positions him with the sun smouldering behind his head, and later, when he stops at the empty Constitutional Assembly on his way to Italy and converses with the ghosts who cluster there, a gaseous blue nimbus flares up from his ignited thoughts. The poet in Gance's *J'accuse* composes a hymn to the sun, and as he declaims it tinted seascapes illustrate his words. Shell-shocked after the war, he completes the ode, but now denounces the sun for shining sadistically on human misery. He tells it to blush with shame, and it obliges as the image instantly reddens.

Like Lang in *The Tiger of Eschnapur*, Jacques Feyder and Erich von Stroheim sought out a scorching, maddening sun. In 1920 Feyder travelled to Algeria to film *L'Atlantide*, a delirious romance about French legionaries who get lost in the Sahara and stumble into the mythical realm of Atlantis, whose ageless ruler Antinéa adds the sun-struck soldiers to her male harem. She is in the habit of embalming her used-up conquests by plunging them into a so-called galvanoplastic bath. Then, transformed into golden effigies, they are placed on exhibition in a trophy room: as a hashish-befuddled captive remarks, 'C'est une mystification!' Refusing to take refuge in a studio, Feyder even filmed interior scenes in a tent outside Algiers; for outdoor scenes, he used saffron and crimson filters to intensify the heat.

Stroheim saw the desert sun as an incitement to vice not sensuality. *Greed*, based on a novel by Frank Norris, is about a miner called McTeague who murders his wife for her savings and then feuds with a prospector over profits from a deposit of quartz that they discover in

the Sierra Nevada. The two men end handcuffed together in the desert, choked by alkali dust and with no water left. McTeague clubs his rival to death, after which their mule dies, followed by a canary in its gilded cage. Unusable golden dollars spill onto the baked sand as McTeague himself expires. To film this conclusion, Stroheim took his cast and crew to Death Valley during the worst of the summer weather in 1923. Blistered by sunburn, the actors had to crawl over the salt-crusted earth in temperatures that reached 142 degrees Fahrenheit; Stroheim calculated that this would make their distress look more authentic.

Plato's fable about the cave describes human beings who huddle by the hearth in a gloomy recess, diverted by shadows from the blaze that warms them. For Plato, that fire was a wan substitute for the sun. Cinema presents the contrast differently: the combustible source deep in the cave can be explosive. Giovanni Pastrone's historical epic *Cabiria*, acclaimed in 1914, begins with an eruption of Mount Etna, while in Carthage the followers of Moloch chant 'I breathe the deep fire born of you.' Behind a flaming altar, a statue of the bestial god has a furnace in its gut, with an oven door that opens to ingest naked babies – a prototype for the man-eating factory in *Metropolis*. During the siege of Syracuse, Pastrone's Archimedes calls for fire to destroy the Roman fleet, and designs a death ray, 'a device… divinely revealed, like a sheaf of silent lightning bolts'. A massive multi-faceted mirror like a spider's web catches the light, focuses it, and pointedly directs it at the wood and canvas of the invading vessels, burning them up.

A Platonic clash of heat against light, illusion against truth, recurs in Murnau's *Faust*. As the film begins, Hell opens and half-rotted ogres wielding swords grapple out of the inferno to scourge humanity; they disintegrate as soon as they are exposed to the rising sun, whose emissary is a shining white-winged angel. When Faust stands at the crossroads under the full moon to summon the Lord of Darkness, the magic circle he has drawn around himself on the ground catches fire, and electric coils – like the force field of energy that engirdles Rotwang's robot in *Metropolis* – rise from it. Angular lightning bolts then rip across the sky, and Mephisto takes shape in a column of flame. At the end of the film, accepting God's judgement, Faust climbs onto the pyre with Gretchen

to share her fate. But they are not burned alive: the angel reappears to change the fireball into an effusion of divine light, just as dawn in Murnau's *Sunrise* sends the sexy temptress back to the city and the faithful wife who has been saved from drowning smiles forgivingly at her penitent husband.

At the start of *The Ten Commandments* a final credit title acknowledges the Holy Scriptures as the film's source, after which DeMille's voice quotes the primal directorial command, 'And God said "Let there be light"'. We see the sun smiting through clouds, and to this image DeMille adds his own apocryphal gloss, which proposes that 'from this light God created life'. It might have been more accurate to say that from sunlight backed up by electricity the Lumières and Edison created cinema, whose genesis altered the Bible's stark moral duality: having seen light, God in Genesis divides it from darkness, as if distinguishing good from evil, but in cinema's twilight zone, the opposites are not so easy to separate. In 1962 in *Ivan's Childhood*, Tarkovsky's young hero has two complementary dreams. In the first he studies a ray of sunlight refracted by leaves, which looks like a heaven-sent beam in a biblical engraving; in the second he grasps at a star that his mother has told him shines at the bottom of a well, where it pierces perpetual night in a water-logged cave. Does cinema offer illumination or display an ignis fatuus, a fire that is called foolish because it deludes us?

By the time Scorsese made *The Last Temptation of Christ* in 1987, sunbursts were no longer enough to convert the doubters, who dare the Christ of Willem Dafoe to 'make a miracle for us, make us believe in you'. Curing blindness, he unmiraculously mixes a powder whose secret ingredient is his spittle; at the wedding in Cana, he surreptitiously grins when the water changes to wine, since his solution to the catering problem is a conjurer's trick. The resurrection of Lazarus is a greater challenge, to which he responds by using methods that remain obscure. At the door of the tomb, Christ issues an impatient order to the corpse within. While he remains outside, the camera advances ahead to probe the black interior. There are a few seconds of total eclipse; then the stiff arm of Lazarus abruptly pokes out, and Christ recoils in shock. The

mystery remains unimaginable, irreducible to imagery – a reminder that cinema is as much about darkness as about light.

* * *

In 1956 Frank Capra directed a television programme about solar astronomy, entitled *Our Mr. Sun*. In an animated cartoon jocund Mr. Sun congratulates himself on his longevity, which prompts Father Time to call him a 'hot gasbag'. To deflect the criticism, Mr. Sun modestly claims to be just 'an average, everyday kind of star', yet he has not forgotten that he was once worshipped as a god and personified, like a vainglorious Hollywood favourite, as the handsome golden boy Apollo. He chuckles contentedly when told that he has 'been photographed more than all the Hollywood stars put together', although when he is shown a view of a crowded galaxy, he concedes that there are 'billions like me': he now pretends to be a mundane commoner, as unpresumptuous as the heroes in Capra's populist parables *Mr. Smith Goes to Washington* and *Mr. Deeds Goes to Town*.

Nevertheless, the astronomer Dr. Research questions his mythical status, which incites a tantrum. Mr. Sun threatens to uninvent cinema and the other visual arts, and as the screen is momentarily blacked out he snarls 'If it weren't for me, you wouldn't have eyes, because there'd be nothing to see.' 'Keep your corona on,' snaps Eddie Albert, who plays the role of the film's writer. Unless solar power is harnessed, Dr. Research fears that the machine age will end when supplies of fuel run short; looking further ahead, Father Time more optimistically predicts that, thanks to the 'radiant riches' that warm us, we are on the verge of what will be known as 'the sun age'.

As its title proclaims, John Ford's 1953 film *The Sun Shines Bright* takes place in that age, though it is assigned to the past, soon after the Civil War, not to the future foreseen by Capra's Father Time. In Ford's comedy a genial glow that emanates from the aptly named Judge Priest spreads out around his old Kentucky home, diffusing Christian charity and healing a town divided by race, religion and political ideology. The same charm prevails, with supernatural assistance, in De Sica's *Miracle in Milan*. Squatters who erect hovels on a vacant lot are evicted by an

industrialist who wants to drill for oil on their patch of ground: gasoline, Zavattini's script points out, may eventually 'become a fire, a light to brighten their darkness'. Meanwhile the mendicants are warmed by another light that shines down on them from above. During a shivering, fog-bound night, the beggar Totò asks an impoverished little girl if she would like to see the sun. A wonder-working dove arranges for the miracle to occur, and the residents of the shanty town bask in a conical shaft of warmth that pierces the frigid darkness.

For Capra, Ford and De Sica, cinema was a demotic art, which is why they emphasized the egalitarian bounty of sunlight. More flashily, in the prologue to *A Matter of Life and Death* a Technicolor survey of blue outer space is pierced by a sudden blaze and a musical tintinnabulation. 'Hello!' says the narrator. 'There's a nova – a whole solar system exploding! It's not our solar system, I'm glad to say.' He goes on to wonder if someone has been 'messing about with a uranium atom'. With no risk of nuclear fission and no metaphysical or medical engineering, another luminous wonder flares up in an earlier Powell and Pressburger film, *A Canterbury Tale*, released in 1944. Here a cynic scoffs at the blessings that medieval pilgrims to Canterbury hoped to receive at the martyr's shrine. 'I'll believe that when I see a halo around my head,' says the sceptic, who is on a train that happens to be arriving in the city. As he utters the words, a nimbus of sunlight slices through hissing steam and forms an aureole behind him – a sudden, ephemeral cinematic beatitude.

Cinema's other power source, which was supposed to abolish night when cities were electrified, proved less reliable. Anthony Asquith's *Underground*, released in 1928, is about two rivals called Bill and Bert, respectively a cheery porter who guides passengers through the London Underground and a disgruntled electrician employed at the Lots Road power station in Chelsea, which in those days supplied energy for the subway network. The object of their dispute is Kate, a shop assistant whose main contribution to the plot's kinetic urgency is her mad pedalling of a Singer sewing machine in her drab flat. Jilted by Bert, Kate goes to Lots Road to accost him among the high-tension cables; when he knocks her down, she tumbles against the open door of the switch

box and brings the Tube system to a halt. In 1936 Hitchcock's *Sabotage* starts at the same point, after a terrorist clogs the Lots Road generators with lime. The film's first images suggest the almost medically vulnerable state of the whole urban organism: the thin, nervy filament of an electric light bulb tingles, a meter's needle falters, and London's landmarks – Westminster, Piccadilly Circus with its neon suns – are at once blotted out by darkness. A down-at-heels cinema called the Bijou interrupts its show, and the terrorist, who happens to manage the place, takes the opportunity to sneaks upstairs past the grey screen. Outside, grumbling customers who demand a refund are fobbed off with the excuse that the blackout was 'an act of God' – a Hitchcockian god with a cruel sense of humour.

God avoids blame in 1941 in Raoul Walsh's *Manpower*, where Edward G. Robinson and George Raft, employees of the Bureau of Power and Light in Los Angeles, struggle to repair uninsulated overhead lines that have been damaged in a storm. The men in Robinson's crew joke about electrocution. One brags that a charge of thirty thousand volts travelled right through him, so for a month when he kissed his wife her ears would light up; another says that his brother, hauled out to be executed, blew all the fuses in the electric chair and had to be shot instead. The Frankensteinian rekindling of life happens in earnest when Raft spends hours pummelling the apparently dead body of Robinson after an accident on a pylon. 'He ain't a corpse yet,' grunts Raft. 'Gimme the ammonia.'

Fire prevails in matters of cinematic sex, thanks to a symbol that displaces desire while flagrantly brandishing it. In *Manpower*, Marlene Dietrich saunters out of prison and lights her first cigarette for a year by touching its tip to one that Raft is already smoking: trouble inevitably follows. In 1926 William Daniels, the director of photography in Clarence Brown's *Flesh and the Devil*, inserted a tiny light bulb into the tip of John Gilbert's cigarette during a love scene with Garbo, to cast an intimate flush on their faces. Something more erotically sly happens in Visconti's *Ossessione*, released in 1943. A vagabond known as the Spaniard takes a fancy to the drifter Gino, played by Massimo Girotti. In their shared bedroom he eyes Gino longingly, then turns off

the overhead bulb; a moment later he strikes a match, but smoking is his pretext for studying the curled, sleeping body of the other man. In 1946 Howard Hawks's *The Big Sleep* ends with a shot of two abandoned cigarettes, fuming post-coitally side by side in a glass ashtray that serves as their double bed: we may assume that Bogart and Lauren Bacall, after wittily sparring throughout the film, have achieved consummation and are now relaxing.

* * *

Blaise Cendrars likened the beam from the projector to a leaping dolphin, and also to the sky falling in – an expression of nature's kinetic liveliness or a symptom of apocalyptic collapse? This uncertainty, dating from an essay Cendrars published in 1919, returned during his visit to Hollywood in 1936. He enjoyed the camera-friendly weather, but worried about the catastrophes concealed by the bland, cloudless Californian sky. Stars – the kind of which MGM claimed to have a monopoly – cast a 'tragic shadow' as they burned up or fizzled out, and when the actual sun sank into the Pacific, it was replaced, Cendrars said, by an 'artificial sun... that flares up every night in cinemas' and with its 'loud, luminous animated beam... troubles the brain'.

He was right about that dangerous glare. In Hitchcock's silent film *Downhill*, released in 1927, Ivor Novello suffers social disgrace when he is expelled from his public school for supposedly impregnating a waitress. He tries acting, then hires himself out as a gigolo. The reckoning comes as the curtains and shutters are thrown open in the Paris dance hall where he plies his trade: an intertitle declares that 'searching, relentless sun-light' enters, showing up the raddled patrons and tatty decor and compelling Novello to repent. In 1932 the light trained on the platinum-wigged Dietrich in *Blonde Venus* flattered her – she was 'made luminous', as Josef von Sternberg put it, by sheets of corrugated plastic that flecked her skin with spots of brightness – but also gave her an icy, unapproachable, photochemical sheen. The husband she deserts, played by Herbert Marshall, is an indirect victim of the silvery-white rays she emits: he is a commercial chemist, poisoned by the radium he uses in his research.

The flare-up that made Cendrars uneasy happens on a cosmic scale in Nicholas Ray's *Rebel Without a Cause*, where a lecturer at the Griffith Observatory in Los Angeles recapitulates the history of the universe for the benefit of a visiting school class. While the teenagers fidget and flirt in the darkened planetarium, behaving as if they were at the movies, the lecturer solemnly warns them about the self-destructive careers of heavenly bodies and the combustibility of our world. Before our earth is blotted out, he says, people will notice a new star in the night sky, 'increasingly bright and increasingly near'. He pauses after saying that 'this star approaches us', which allows James Dean, arriving late, to sidle into the room and tell a teacher the name of the character he plays, which is Jim Stark; the lecturer, bearing down on the verbal echo, says again 'this star approaches us', and predicts that as it does so there will be meteorological convulsions. Dean went on to act out the prophecy of doom: he was killed at the age of twenty-four when he crashed his racing car a month before the film's release in late 1955.

At the Observatory, the big bang then repeats itself, witnessed by stars that, as the lecturer gravely asserts, will be 'little moved by the shortness of time between our planet's birth and its demise'. Projected onto the dome of the planetarium and boosted by a red maelstrom of gas and fire that whirls through the air towards us, this fatalistic preview whips up a musical shriek of alarm. Sal Mineo, who has been taking advantage of the darkness to stare adoringly at Dean, crouches behind a chair in terror. Down by the Pacific at Malibu, Robert Aldrich's thriller *Kiss Me Deadly* – released a few months before *Rebel Without a Cause* – staged its own blinding holocaust. At the conclusion of the film a leather-encased box containing 'the Great Whatsit' is prised open, despite the pleas of a corrupt doctor who traffics in atomic material. A radioactive glow leaks out, melting a woman's body and reducing a beach house to cinders; two evacuees stagger into the ocean, which is where life began aeons ago.

Here was the ultimate cinematic spectacle, an end-of-the-world show. In 1956, refugees on a departing spaceship in the science fiction film *Forbidden Planet* watch as the planet they have left explodes. The sight, inconceivable before this decade, has a weirdly florid beauty: perhaps,

as Buñuel speculated when he described the bullet shattering a vase in slow motion, cinema existed to imagine such things.

For Alain Resnais, the atomic detonation in Japan demonstrated the malevolence of light: his *Hiroshima mon amour*, released in 1959, begins with a survey of blistered stones, metal girders twisted out of shape, bottle tops fused into a floral bouquet, and scraps of human flesh poisoned by radiation – an alternative creation, engendered in nine seconds by a bomb that was said to be more searingly bright than a thousand suns. Kubrick attempted to rehabilitate cinema's solar creed in *2001: A Space Odyssey*. Here the sun rises to the accompaniment of the fanfare from Richard Strauss's *Also sprach Zarathustra*; this blazing dawn inaugurates the evolutionary advance that the film charts as it sends a descendant of the apes into outer space. But as Kubrick's odyssey continues, other lights take over. When Keir Dullea squeezes into his pod to conduct repairs, blue and red reflections from a control panel dance across his face, so that we seem to be looking at the connections made by synapses inside his head; his final passage towards Jupiter and beyond is a trip through rivers and lakes of psychedelic colour. A film director in Antonioni's *Identification of a Woman*, released in 1982, muses about leaving an earth that is overrun with bothersome women and professional vexations, and imagines approaching the sun in a spacecraft that is a converted asteroid. If only we could understand 'what the sun is made of and its power', he tells his young nephew, we would be able to explain the universe. 'And then?' asks the boy. The director has no answer, and the film ends with a solar outburst that threatens to melt his travelling boulder. Light, like the darkness in the tomb of Scorsese's Lazarus, resists interrogation.

In 1972 in Tarkovsky's *Solaris*, the sun is shadowy or ashen: the film's title refers to a remote planet whose space station is an asylum for earthly ghosts, a mausoleum rather than a source of enlivening heat. Danny Boyle's *Sunshine*, released in 2007, speculates about a cure for this thermodynamic malaise. Here the sun is dying, and eight astronauts are sent to reboot it, riding a 'stellar bomb' that has a mass equal to Manhattan. Their mission is to create 'a star within a star', and when they deliver the payload there will be an 'extra brightness in the

sky'. The computer that controls operations is named Icarus: we are midway between Greek myth and the Hollywood mystique that cast Dean as an unruly asteroid on his visit to the Observatory. Although the crew in Boyle's film is in danger of 'burning up', these scientists still luxuriantly treat their ship as a solarium or tanning salon. When the psychological officer discovers the charred corpses of an earlier crew whose mission failed, he says 'They saw the light.' Never mind that the epiphany carbonized them: preparing to die, he remarks 'We're only stardust' and dons his shades to experience the final illumination.

As Boyle put it, the scientists who designed the atomic bomb asked 'Can we reassemble matter?' He implicitly addressed the accusing question to himself, because filmmakers, who atomize the world and then try to reassemble it in the editing room, are engaged in the same experimentation. Cinema is born of light, but so was Lucifer.

10

BENIGHTED OR BEDAZZLED?

'I am the Light of the World,' says Johannes in Dreyer's *Ordet*. Quoting Christ, this holy fool places candles in the window of his family's farmhouse to repel the encroaching gloom. But a doctor's visit to Johannes' pregnant sister-in-law Inger ends with a combative dance between light and dark, positive and negative. As the doctor's car reverses in the courtyard of the farm, its headlights shine directly into the dim room, raking across a wall so that the building itself seems to swivel or rotate. Johannes, impersonating Death with a scythe in his hand, says 'Look, now he is going through the wall.' A searing glare obliterates the structure, and at that instant the unseen Inger dies.

In 1921 in Fritz Lang's early film *Der müde Tod*, known internationally as *Destiny*, Death glances at the flickery tapers in a gloomy cathedral and says they are lives waiting to be snuffed out. As the German title declares, Death has grown weary of doing God's dirty work, although he finds the habit hard to break. When he picks up a newborn baby, it instantly expires: a light, as a grieving girl puts it, has been extinguished. But bodies in a film are never more than brief candles – photons pretending to be solid, or pixels that only cohere because they have been programmed to do so. In 1919 at the end of Gance's *J'accuse* the shell-shocked poet calls for the sun's fire to be quenched and summons up a sarcastic victory parade of the dead, victims of pointless military carnage. A field of crosses is replaced by a march of exhumed corpses with empty eye sockets and amputated limbs. A war widow, terrified by this waking dream, asks 'Sous quel

empire étions-nous donc?' Like the characters in *Ordet* and *Der müde Tod*, she is under the dominion of cinema.

At first vitalized by the sun, the new art found darkness equally congenial, and soon developed its own morbid mode of night vision. The occultist Albin Grau, who produced and designed Murnau's *Nosferatu* in 1922, declared that 'For cinema, shadow is more important than light. Cinema is the language of shadow. Through shadow, the hidden and dark forces become visible.' That superstition was bolstered by Grau's adhesion to the Fraternitas Saturni, a freemasonry devoted to esoteric lore; he fancied that his own father was a vampire, like the wasted, wild-eyed Count Orlok in *Nosferatu*. Grau is also credited with supplying the idea behind Arthur Robison's *Warning Shadows*, called simply *Schatten* in Germany, where it was released in 1923; its subtitle, *A Nocturnal Hallucination*, suggests that the shapes formed when light is obstructed derive from the nether side of the mind, and its wordless plot illustrates Grau's theory that cinema belongs in a psychosomatic shadowland.

As *Warning Shadows* begins, a jealous aristocrat watches through a translucent curtain as his flighty wife's body apparently entwines with the lovers who flutter around her: he is deceived by a masquerade, because what he sees are their separate shadows, telescoped and fused by the angle of the candlelight behind them. The delusion is exploited by a shabby conjurer, who twiddles his fingers to make non-existent beasts rear on the wall or sends Chinese silhouettes capering across a sheet hung in the dining room. After these magic-lantern shows, the conjurer goes on to terrorize or traumatize the people of the house by luring them into a compulsive cinematic fantasy; their shadows take on flesh and develop wanton or murderous lives of their own. Daylight, to which vampires are allergic, finally restores a semblance of reality.

This kind of spell retains its power. In Abbas Kiarostami's *Close-Up*, released in 1990, a real-life Iranian imposter re-enacts a confidence trick in which he passed himself off as a well-known director and defrauded a wealthy family by pretending that he wanted to cast its members in a film. Put on trial, the imposter argues that his sense of reality and his morals have been eclipsed by cinema. 'Exactly half my life,' he pleads, 'has been spent in the dark. It's all been a blurred

image.' He has, he admits, sealed a Faustian bargain: 'Psychologically, I sold my soul to the cinema.'

Martin Scorsese once summed up his allegiance to his chosen art by remarking 'I live at night'. Time spent in a private screening room that he calls his 'sanctuary' has made Scorsese a noctambulist, like Robert De Niro driving his cab on the graveyard shift in *Taxi Driver* or Griffin Dunne reeling through Manhattan between midnight and daybreak in the black comedy *After Hours*; Scorsese even cast himself in grimy, shady roles as a hit man in *Mean Streets* and a self-loathing passenger lewdly fantasizing about sexual revenge in *Taxi Driver*. While on location directing *The Last Temptation of Christ* in Morocco, he was dismayed to find he had acquired a suntan. Proud of his pallor, he winced when, during preparations for *The Color of Money*, he had to meet Paul Newman on a sundeck by the ocean at Malibu. Newman, Scorsese remarked, probably thought he had been visited by Nosferatu.

* * *

Frankenstein, who channels lightning as a source of power, is one of cinema's presiding monsters; the demons repelled by daylight in *Nosferatu*, Dreyer's *Vampyr* and Browning's *Dracula* represent his other half.

A written warning at the start of *Nosferatu* says that the title sounds 'like the deathbird calling your name at midnight'. We are advised against uttering the baleful word aloud, 'for then the pictures of life will fade to shadows', and this indeed is what happens in Murnau's film. As the carriage travels to Orlok's Transylvanian castle, the image projected is a negative, as skeletal as an X-ray. The coach was wrapped in white cloth so that our eyes would read it as black; the trees in the forest through which it passes have white ganglia for branches. When Orlok travels abroad to Wisborg, he stows the coffin in which he travels in a warehouse: to enter the locked building, he simply dissolves and reassumes material form on the other side of the wall.

In *Vampyr*, released in 1932, the hauntings occur in a world where 'lights and shadows', as an intertitle puts it, 'have a hidden meaning'. The wandering hero Allan Gray, played by the socialite Nicolas de Gunzburg, is introduced as 'a dreamer and fantasist' – in other words, a

cinephile. On his rural ramble he carries a fisherman's net, perhaps used to dredge up dreams; tapping on the doors and windows of a closed inn, he seeks entry to this hermetic realm and is shown to a room without even asking for one. Dreyer said that he wanted to present 'the inner not the outer life', and his camera photographs bodilessness or out-of-body experiences rather than the 'actualités' of the Lumières or Dziga Vertov's 'visible events'. A one-legged soldier is belatedly joined by the shadow he casts, which has an independent existence. Allan Gray is also a transparent being, and when he tumbles onto the grass and slumps on a bench to recover, an alter ego escapes from inside him; this filmy second self sees its full-bodied other half laid out in a coffin for burial, after which, as the funeral cortège passes the bench, the body lying on the bench regains solidity and jerks back into action. After traversing a mist-shrouded river – fording the Styx in the opposite direction – he is restored to the daylight: he has escaped from the cinema.

In *Dracula* the count slithers through a sticky veil of cobwebs on the stairs of his castle, as if he had a direct route to the obscurity behind the cinema screen, while the lawyer Renfield, following him, has to part the thick membrane with his walking stick to make an opening. Whereas the shadow play in *Vampyr* is an exercise in what Dreyer called 'realized mysticism', Dracula is immaterial, which should make him unrepresentable: the lid of a cigarette box reveals his secret when it does not reflect him, so he smashes it, explaining 'I hate mirrors.'

Béla Lugosi and Boris Karloff, separately cast in 1933 as Dracula and as the corpse revivified by Frankenstein, teamed up a year later in Ulmer's *The Black Cat*. 'Are we not both the living dead?' Karloff asks Lugosi, rejoicing in their affinity. Lugosi here plays a Hungarian psychiatrist, with Karloff as a deranged architect who practises Luciferian rites 'in the dark of the moon'. Karloff dotes on a collection of blonde female corpses – conquests he has embalmed and put on display in glass caskets – and plots to add a visitor's bride to his macabre harem; Lugosi saves the young woman by administering a narcotic, although this provokes her to slink about seductively in her nightgown and give her husband an overly impassioned kiss. Here are two opposed versions of what happens in the kingdom of shadows: cinema either preserves

beauty by a kind of taxidermy, or else it prompts characters to discard their clothes and inhibitions as they act out their fantasies.

Karloff played another ghoul in 1932 in Karl Freund's *The Mummy* where, after his coffin is disinterred, his shrivelled remains stir into a kind of stiff-limbed, parchment-skinned life. In the same year he appeared as a disfigured gatekeeper in *The Old Dark House*, directed by James Whale. This was based on J. B. Priestley's novel *Benighted*, which concerns the mishaps that befall travellers lost in a storm in the wilds of Wales when they seek shelter with a clan of neurotics in a creaky mansion that, as described by Priestley, sounds like a kind of unelectrified cinema. The dying master of the house explains that a connection to the mains would be unsafe because his mad brother is a pyromaniac; the inhabitants therefore 'make their own light' from faulty 'accumulators', which produce 'jumpy' flashes of illumination that seem 'crazier than darkness'. Sharing the premises with the Flemm family is like being 'in dreams' – or at the cinema, since the visitors are compelled to watch 'a shadow show' performed by the resident bogeys.

Michael Powell's *The Phantom Light*, released in 1935, varies the metaphor. Powell sniffed at the film's plot, in which conspirators on the Welsh coast disable a lighthouse beam in order to collect insurance payouts for the ships they wreck; what excited him was the atmosphere he could conjure up. He toured a factory where the lenses for lighthouses were made, and like Epstein in *Les Feux de la mer* he allowed the camera to study the angular modernity of the control room, with its faceted glass and revolving machinery. Yet the light in Powell's film is as freakish as that produced by the accumulators in the Flemm household: shining from the cliffs, it entices ships onto the rocks below. Other games are played on the border between shadow and substance. Someone repeats a tale about a prowling spirit that 'opens the door with invisible hands, and vanishes'. 'How can you vanish if you're invisible?' demands the new lighthouse keeper, played by the cockney comedian Gordon Harker. 'If you're invisible,' he points out, 'you've vanished before you've started.' Logically he may be right, but he has not reckoned on the phantasmagoria of cinema, which cheats our eyes to both frighten and delight us.

In 1961 in Jack Clayton's *The Innocents* – an adaptation of Henry James's ghost story *The Turn of the Screw*, with poetically creepy dialogue by Truman Capote – a girl who covertly consorts with spectres explains her bedtime routine. 'I always look in the dark,' says the questionably innocent Flora, deriding timid adults who keep their eyes shut. 'And what do you see?' asks her startled governess, played by Deborah Kerr. Flora says only that rooms get bigger when the lights are out; then, even more precociously, she wishes 'there were some way to sleep in several rooms at once'. Films allow us to do something like that, sliding into the reveries of others.

The Manichean clash of black against white seems like cinema's natural state, but Dreyer sought an ambiguous blend of the extremes, and he described the tonality of *Vampyr* as a 'muddle of greyish-white', which made even the interiors look foggy. He was pleased to discover that the rat-infested chateau he used as a location was mouldy with damp. Originally he intended to have the bloodthirsty doctor swallowed by a bog. Then, while scouting for locations in the Loire valley, he happened upon a building full of blanched shadows that were cast by what he took to be a 'white fire' – an icier version of the flames that consume the supposed witches in *La Passion de Jeanne d'Arc* or *Day of Wrath*. The place was a factory where plaster of Paris was made; fascinated by the powdery, gypsum-impregnated air, Dreyer decided to have the doctor buried alive in an avalanche of sifting flour, as if the mills of God were implacably grinding.

Dreyer often chose to conclude scenes by fading to white not black, perhaps to signal purgation or cathartic cleansing rather than the usual lapse into forgetful darkness. In 1964 at the end of his last film *Gertrud*, a grave, wise, white-haired woman – disappointed and deceived throughout her life, but refusing to renounce her belief in love – closes a white door and retires into solitude; we are left with a tabula rasa, an unmarked, unspoiled page. In another context, Fellini made a similar point in his 1970 documentary *I Clowns*. Fellini pitied and admired circus comedians, who represent 'the shadow within us', but he distinguished between what he called white clowns, with faces as bleached and blank as Buster Keaton's, and their grosser, more buf-

foonish colleagues. White clowns, Fellini thought, were 'morally ideal, the only undisputed deity', though they are fated to tangle with their rude, rowdy opposites in the other group. Watching their battles, Fellini said that we ask 'Is the shadow dead? Can the shadow die?' The shadow will only disappear, he added, if the sun is at its zenith, directly above our heads; then we can shed the demeaning caricature that drags us down. At noon, however, the film may be over-exposed and imageless.

In 1930 in an essay on Eugène Atget's photographs of Paris, the novelist Pierre Mac Orlan suggested that Atget's moody urban scenes – empty courtyards, shop windows displaying headless mannequins, parks after closing time – would have been desecrated by the glare of direct sunlight. The rule applies to cinema as well. When Marcel Carné filmed Mac Orlan's novel *Quai des brumes* in 1938, he supplemented the workaday port of Le Havre where the book takes place with a mistier, more baffling environment whose foreshortened perspectives were constructed in the studio – a setting more in sympathy with the existential gloom of the characters, and more to the camera's liking. Mac Orlan juggled noon and midnight by describing photography as 'a solar art at the service of night' and calling shadow 'the secret intelligence of light'. Black and white, he believed, were 'purely cerebral', which made them 'conductors of all the secret forces that govern the universe'. Samuel Fuller, cast as the director of photography on a chaotic, quarrelsome film set in Wim Wenders' *The State of Things*, put it more gruffly. 'Life is in colour,' Fuller's character admits, 'but black and white is more realistic' – or perhaps more symbolic, corresponding more closely to our mortal condition.

* * *

The doomed characters of film noir are denizens of the cinematic dark. In this cycle of death-obsessed mysteries, mostly made in the 1940s and 1950s, people repeatedly foresee what Edward G. Robinson in Lang's *The Woman in the Window* calls 'the end of the brightness of life' – a terminus that can be found in urban alleys and basements or in the shuttered recesses of neurotic heads. At its grimmest, film noir surrenders to blackness by blotting out the entire frame. In a scene from Lang's

The Ministry of Fear we are enclosed in a completely darkened room, and can only see after a gun fires a shot through the door and leaves a bright pinhole as it fells its target in the corridor outside.

Film noir shuns daylight, and finds multiple ways of proclaiming this preference. Raoul Walsh's *They Drive by Night* is about truckers with a bad safety record whose company is taken over by an insane, homicidal woman. The fugitive lovers in Nicholas Ray's *They Live by Night* anticipate Scorsese's slogan, but not as a joke. Anthony Mann's *He Walked by Night* could also be about a vampire, although it actually concerns a cop killer who goes to ground in the Los Angeles sewers. The veteran suffering from memory loss in Joseph L. Mankiewicz's *Somewhere in the Night* tries to discover who he is or once was by prowling through dives in Los Angeles, one of which is called The Cellar.

Other works from the same period announce their outlook in their tenebrous titles. In Roy William Neill's *Black Angel* spiritual values are reversed. An angelically beautiful but black-hearted singer gets herself murdered by one of her blackmail victims, while the blonde wife of a man who is wrongly convicted of the crime descends into the dim nocturnal murk to save him. Like a Rorschach inkblot, the mirror referred to in Robert Siodmak's *The Dark Mirror* duplicates the face of Olivia de Havilland: she plays identical twins, one of whom is homicidally jealous of the other. A psychiatrist attempts to differentiate them by administering a free-association test. When the doctor says 'dark', the twin he is examining logically answers 'night', but when he says 'mirror' she replies 'death'. Her startling response suggests that the act of mimesis is not necessarily a way of writing with light or composing a life-like replica; photographic negatives impart a darker truth about the process.

The detective in Joseph H. Lewis's *So Dark the Night* is as schizophrenic as cinema itself, torn between reality and fantasy. On a rest cure in the country, he investigates a series of murders that he realizes have been perpetrated by the other half of his split personality; after first saying that the killer is 'as elusive as my own shadow', he zealously incriminates, arraigns and executes himself. Henry Hathaway's *The Dark Corner* is about a man who says he is 'backed up into a dark corner', framed for a murder that occurs in the downstairs storage room of a Manhattan

art gallery. In Delmer Daves's *Dark Passage*, Humphrey Bogart clambers wearily up a long flight of steps on a San Francisco hillside just before dawn. The steps actually exist below Coit Tower, and the harbour and the Bay Bridge are recognizable behind him, but because a backstreet surgeon has just redesigned Bogart's face, his bandaged head makes him look as surreal as one of Gance's spookily re-arisen soldiers in *J'accuse* or Karloff stepping out of his sarcophagus in *The Mummy*. 'Had a hard night, bud?' jeer some workers trudging home from their shift on the docks; in fact he is a walking nightmare.

'I demand death,' says Robespierre as he condemns Danton in Anthony Mann's *The Black Book*. The book contains the tyrant's list of candidates for the guillotine; in revolutionary Paris, one of the locations where conspirators meet is the Café des Morts Vivants – an inhospitable-sounding establishment, but a suitable rendezvous for the characters of film noir. *Sunset Boulevard* is narrated posthumously by William Holden, who first appears floating face down in a swimming pool. Disappointingly, Billy Wilder was forced to cut a prologue in the morgue, where Holden, laid out on a gurney, told his sorry tale to his fellow cadavers. After carrying out a murder in Wilder's *Double Indemnity*, Fred MacMurray strolls nonchalantly away, then shudders because he is unable to hear his own footsteps in the empty street. 'It was the walk of a dead man,' he says. In Lang's *Fury*, Spencer Tracy escapes from jail when a lynch mob hurls dynamite into it. He hides in a cinema where he watches himself supposedly being burned alive in a newsreel, then reappears in court to seek revenge on his tormenters. 'You can't hurt a dead man,' he jeers, 'and I'm dead!' Siodmak's *Phantom Lady* is about the search for a chance acquaintance who might provide the hero with an alibi and save him from the condemned cell. At worst this elusive witness is a phantasm, a fiction; the film prefers to suggest that she might be a ghost.

Many film noir characters are corpses in waiting. 'You're a dead man, Harry Fabian,' the hero of Jules Dassin's *Night and the City* is told; he is then hunted across bomb sites in war-damaged London before he finally consents to his own demise. 'I feel all dead inside,' says the private eye in *The Dark Corner*. The poisoned man in Rudolph Maté's *D. O. A.* reports his own demise to the police: 'I walk and I talk,' he says,

'but I'm not alive.' The opening line of *Deadline at Dawn*, written by the dramatist Clifford Odets and directed by Harold Clurman, is spoken by a drunken floozy when she finds her importunate ex-husband at the door. 'Ain't you dead yet?' she snarls; soon enough he is, as is she. 'She was no lullaby,' grunts her brother, relieved to be rid of her. 'I was dead once,' says the naive young sailor who thinks he might have absent-mindedly killed her. He explains that he drowned in a river when he was a boy, only to be revived by a doctor; the next day he played two games of handball, then keeled over again in a faint. 'Nothing more can happen to me,' he wrongly calculates. A garage mechanic in Robert Aldrich's *Kiss Me Deadly* rejoices at an exception to the rule. 'I'm sure glad you're back, Mike,' he says, 'like Lazarus rose out from the grave.' He speaks too soon, because Mike Hammer will be contaminated by the nuclear explosion that concludes the film; long before this, a malefactor interferes with the hydraulics of a hoist and the mechanic himself is crushed by a car whose chassis he is working on.

By rights there ought to be something called film blanc, because a whiteout can be as alarming as a blackout. Edward Dmytryk's *Murder, My Sweet* begins with an accusing spotlight that marks a white circle on a table top; all around it is black. Dick Powell as the private detective Philip Marlowe is being questioned by the police, who suspect him of murder. A white bandage that inexplicably covers his eyes places him literally in the dark, and warns of a disorientation we share as we grope through the zigzags of the plot. Later, beaten up and knocked unconscious, he has a dream about climbing stairs that are 'made of dough', pursued by a medical orderly in a white coat who empties a cudgel-sized syringe into his arm. He wakes up, not in a hospital, under a sun that turns out to be another interrogatory overhead light. The title of Raoul Walsh's *White Heat* sums up the seething psychosis of James Cagney's gangster: at the start, one of his expendable cronies is scalded in the face by a jet of steam from the brakes of a train they have held up, and Cagney is finally killed in an explosive blaze after he fires his gun at a globe-shaped gas tank in a chemical plant. In Hitchcock's *Spellbound* Gregory Peck suffers swooning fits when he stares at a starched tablecloth or the gleaming tiles of a bathroom, both

of which remind him of a murder he may have committed somewhere in the snow.

Whiteness here is never a clean slate, with all guilt erased. Nicholas Ray's *On Dangerous Ground* begins in a dark, crime-ridden city and ends in a remote country town to which Robert Ryan, a detective prone to violence, is exiled. Ray at first planned to photograph the urban half in black and white, the pastoral half in colour, but changed his mind. The film proceeds from an inky underworld to the bright snow of a mountain in Colorado, and both settings are deadly.

* * *

Black is light's absence, white a ray of light that has not been diffracted. Colours occupy the region in between: they are sensations produced by rays of light that have decomposed. The mythological rainbow that stretched across the sky to announce the end of the biblical deluge sent a mixed message. Its range of colours sealed an accord between the creator and his miscreant subjects, but at the same time that spectrum acknowledged the prismatic imperfection of the world we have made.

As early as 1903, gunshots and dynamite in *The Great Train Robbery* produce flashes of sodium yellow. We see Murnau's *Nosferatu* through a succession of hazes: sickly jaundiced yellow for the interview with the estate agent Knock, a more burnished candle-lit orange at the Transylvanian inn, blue for an encounter with a mangy wolf, mouldering green during the final night when Orlok attacks and kills the heroine Ellen. Karl Struss, photographing the silent *Ben-Hur*, used rotating filters to facilitate one of Christ's miracles. We watch as a leper's mottled, rotting face is instantly cleansed of disease, and because there are no editorial cuts we have to believe our eyes – or do we? In fact Struss had the leper slathered in green make-up, then used a red filter to blacken the skin; after Christ's intervention, a green filter slid across the lens and pushed the red one aside, so the make-up now looked pale, as if an unblemished complexion had been restored.

The titles of monochrome films sometimes cited the dominant colours of the spectrum, although the red, blue and green they favoured remain metaphorical. In Dorothy Arzner's *The Bride Wore Red*, Lang's *Scarlet*

Street and Fuller's *The Crimson Kimono* the adjectives announce erotic scenarios involving scandalous women. Sternberg's *The Blue Angel*, Lang's *The Blue Gardenia* and George Marshall's *The Blue Dahlia* evoke a twilight sensuality: all three are the names of louche nightclubs, and the shared adjective hints at lewdness, as it did in the case so-called 'blue movies', which once were also colloquially said to be 'off-colour'. The musical *The Green Pastures* – a dramatization of biblical folklore as imagined by a black congregation in Louisiana – takes its title from a psalm, so there is no need to think topographically. The location of John Ford's *How Green Was My Valley* is an unsylvan Welsh mining village, blackened by the smoke and slag of its colliery; it is the narrator's fond memory of his childhood there that is evergreen.

Béla Balázs predicted in 1930 that the chance to see 'colours in motion' would 'open up a sphere of experience that penetrates to our innermost core', making it possible to study the way the sky alters as the sun rises or sets, or to watch in detail as a face blushes in embarrassment. Images like those mentioned by Balázs attuned cinema to the changefulness of nature and the vagaries of human feeling; scripture's pure white light and its black antithesis could be relegated to the past. But in 1935 the philosopher Rudolf Arnheim recoiled when he emerged from an early Technicolor film in Rome. The careful chromatic gradations on the screen left Arnheim unprepared for lilac hills, green pines and a blazing sky, which taken together looked 'chaotic, fiendish, discordant'. Cinema on this occasion made reality seem under-designed, woefully lacking colour coordination. Also in 1935 the New York reviewer André Sennwald complained that three-strip Technicolor had been used 'to bludgeon the intelligent spectator' in Mamoulian's *Becky Sharp*; he feared 'a blare of outrageous pigmentation' that would 'rape... the laws of harmony and contrast'. The term 'pigmentation' is accurate, because Technicolor was a dye, applied as a coating by a process that, a little drunkenly, was known as 'imbibition'. But bludgeoning, outrage and rape? Sennwald's objections were moral, resisting an assault on the eyes that made him wonder if in future 'only the colour-blind will consider it safe to venture inside a motion picture theatre'.

Sceptics objected to colour as an added extra, which meant that it was more pictorial than photographic. Colette recoiled when she first saw Marlene Dietrich with azure eyes, candied lips and gilded hair. She preferred the unapproachable being in Sternberg's films, who had a mouth 'the colour of chocolate' and a bosom that was 'pearl-grey': Dietrich in colour was as much of a profanation as Garbo laughing. Chaplin used one anathema to back up another. Denouncing the prospect of talking pictures, he said 'I would as soon rouge marble cheeks', probably unaware that Greek statues originally had painted faces. Hawks resisted using colour in *Red River* because he calculated that black and white would make everything look older – worn, wrinkled, and therefore truer to the dust-caked landscape of the cattle drive.

Orson Welles argued that good acting was possible only in black and white, because the application of cosmetic tints marred the subtle mutability of the face. Maybe so, but cinematic faces often need to be combat-ready, and colour supplies them with war paint. In Nicholas Ray's *Johnny Guitar*, released in 1954 in a two-strip process called Trucolor, Sterling Hayden begs Joan Crawford to say something nice, to tell him how much she missed him. The words he dictates to her are abjectly needy; her expression taut, she spits his phrases back at him through lips that are aggressively vermilion. Rainer Werner Fassbinder alludes to the moment in 1972 in *The Bitter Tears of Petra von Kant*, when Margit Carstensen begs for reassurance from her faithless lover Hanna Schygulla. Carstensen wears an auburn wig, her skin is ceramic pink, and the tear affixed to her cheek is a trickle of whiteish glycerine: the surface is necessarily artificial, bravely covering a moral collapse underneath. Cinema here has its own equivalent to the painted masks worn by actors in Greek tragedy.

Colour comes to film as an efflorescence, almost another cinegenesis. After a family tragedy in India, Renoir's *The River* ends during the Hindu rite of spring. At first we see trees on fire with tropical blossoms; then children hurl pigment from the bazaar at their elders and powder them with clouds of red and purple. Colours here are wind-borne, like seeds. Other chromatic bacchanals follow in Renoir's later films. In *French Cancan*, released in 1955, the legs of the high-kicking dancers

set off sunbursts, and in 1952, as the travelling players in *La Carosse d'or* cavort on stage, the diamond-shaped patches of colour on their costumes seem to shake loose, too vibrant to stay in place. Early in his career Fellini mistrusted colour because it seemed so heavy, clogging objects and separating them from the flux of moving images. Later, after taking LSD, he recognized that colours were free-floating, amorphous, as volatile as the rampages of Renoir's children and dancers.

The same overflow felt threatening and messy to Georges Franju. In daily life, he argued, we see the world in black and white, and we only stop to notice colours when they leap out at us: because they are exuded by bodies like splashes of blood, they ought to remain unseen, beneath the surface. He made his film about the Paris slaughterhouses in black and white, to spare us the gore that spurts from the slashed bellies of the beasts.

Monochrome and colour remain two different languages, each with its own register, and even when used as alternatives in the same film they seem as remote from each other as heaven and earth. In *A Matter of Life and Death* the post-mortem world is black and white, its cloudy hangars occupied by the muffled, shuffling cohorts of the dead; down below, the living enjoy an existence that is vivid and richly tinted. When Marius Goring descends to earth to collect David Niven, he pauses to inhale the scent from a scarlet rhododendron. 'One does so miss Technicolor up there!' he says in a guilty aside. The same vertical strata reappear in Wenders' *Wings of Desire*. Here the renegade angel played by Bruno Ganz looks down at grey Berlin, its grainy textures of stone, skin and worn fabric vouching for the miseries of the lower world. Then he falls in love, renounces his aerial status, and descends to inhabit a society that we now see in colour. He is startled by the orange washing machines in a laundromat or by the brash, loud graffiti on the Berlin Wall, and has to learn new words for these spurious, superfluous shades. As Goethe argued, colour does not inhere in things but depicts their secondary qualities: is the happiness of this fallen angel equally illusory?

American musicals advance from black and white to colour because they long for a heaven that can be accessible and affordable on earth. Judy Garland means it when she sings in 1939 about travelling over the rainbow in *The Wizard of Oz*: the tornado takes her out of old-fashioned,

sepia-toned Kansas and transports her to a chromatic realm where a road of yellow bricks leads to a city with an emerald-green skyline. 'When I first saw the light it was pink and amber,' sings Garland in 1954 in Cukor's *A Star is Born* as she reminisces about being born in a trunk backstage in the theatre where her parents were performing. Colour suited the homely comforts of Minnelli's *Meet Me in St Louis*, where, as James Agee said in his review, it contributes a fond patina to 'the sober mahoganies and tender muslin and benign gaslight' of the year 1903, when the film is set. But Technicolor could look dangerously febrile, and in 1946 it gives the Western settings of King Vidor's *Duel in the Sun* a burning heat that is as unnatural as the green face paint worn by the Wicked Witch of the West or the purplish Jell-O crystals rubbed onto the horse's skin in *The Wizard of Oz*. The moribund rancher played by Lionel Barrymore in Vidor's film stares at a crimson conflagration on the horizon and says that the 'funny glow' reminds him of a native legend about a bonfire lit in the sky when a tribal chieftain dies. We are watching the twilight of the gods, not a sunset.

Averse to colour, Italian neo-realists saw the world darkly or dirtily. The director Vittorio Taviani remarked on the 'bianco sporco' of Rossellini's films: in *Rome – Open City* the whiteness of the cassock worn by Anna Magnani's young son is sullied when he hurls himself onto her body after the Nazis shoot her in the street. In Rossellini's *Paisan* a bedraggled American soldier tries to wash himself in an apartment that has no water supply, and in De Sica's *Shoeshine* it is also the American GIs who insist on cleanliness, hiring Roman urchins to polish their boots.

By contrast with this grubby reality, Hollywood films advertised in garish hues the plenteous economy on the other side of the Atlantic. Agee thought that the colours in *Meet Me in St Louis* were appetitive, a stimulus to customers who were redefined as consumers: the white dresses of Judy Garland and her sisters looked 'cake-frosting white', and an autumnal ride in a buggy drawn by a black horse had a 'cider fragrance'. Eric Rohmer considered the appeal of colour to be tactile as much as optical. It made objects 'more tangible', encouraging viewers to think about touching, stroking, handling and buying them. In Cukor's comedy *The Women*, released in 1939, the fashion show attended by

the rich, idle New York wives was shot in colour, although the rest of the film remained monochrome. 'Lumière! Musique!' cries the mistress of ceremonies, who offers her clients 'a glimpse of the future'. Models pretend to play tennis in pastel tunics, eat a picnic lunch in lavender crinolines, and frolic among cardboard waves in swimwear adorned with un-maritime flowers. Presumably colour made these incongruous outfits more covetable. Images soon became marketing tools: in 1949 a promotional short called *Technicolor in Industrial Films* recommended colour to advertisers for its 'added eye-appeal' and 'attention-value'. A shot of a tropical parakeet demonstrated that nature is 'lavish in her use of colour', and 'smart manufacturers' were coaxed to follow suit, especially if they wanted to sell products that were not natural, like the new 'streamlined plastics' or fabrics such as rayon.

The commercial bonus is placed on show in *The Solid Gold Cadillac*, a comedy about business ethics directed by Richard Quine in 1956. Here Paul Douglas and Judy Holliday – a corporate executive and a pesky stockholder who starts with only ten shares – spend an entire black and white film accumulating dividends to secure control of a company called International Projects. In the unexpectedly coloured final shot they leave their headquarters at Rockefeller Center and drive off to enjoy their gains in the titular car, which as we now see is indeed golden. Douglas Sirk's *Imitation of Life*, released three years later, begins with another acquisitive fantasy. During the credit titles gemstones drop from on high like pennies from heaven, sparkling with glacial highlights or warmed by a rubicund glow; eventually they fill up the wide screen, which could be the display case of a very negligent jeweller – a comment, as we discover once the story gets underway, on the tawdry cravings that blight the lives of its characters.

Sirk said that he would have made *Imitation of Life* 'for the title alone', as those three words summed up the lies promulgated by Hollywood. His irony probably bypassed Lana Turner, cast as an aspiring actress who pursues success, glamour and other false values with an impervious face, unruffled hair and a multi-coloured wardrobe of thirty-four different costumes that cost, as the publicists boasted, more than a million dollars. In 1960 in *Portrait in Black*, another over-upholstered

melodrama, Turner sneaks out of her San Francisco mansion for a sur-
reptitious meeting with the lover who will soon obligingly murder her
rich, sick husband. On the way she takes an entirely gratuitous detour
through the Saks department store in Union Square, pausing at the
perfume counter. Once the husband has been disposed of, Turner's
stepdaughter realizes that she has been behaving suspiciously for quite
some time: 'All those shopping trips with no packages brought home,
and nothing delivered!' Expenditure would have been a convincing
alibi; such negligence counts as evidence of guilt.

André Malraux wittily contrasted the austerity of European neo-
realism with the opulent American style he called 'Neon-realism'. The
play on words was astute, although the fluorescent glow that Malraux
mocked sometimes did not even pretend to be realistic. In *Vertigo*, James
Stewart redesigns Kim Novak, making her a virtual reincarnation of the
dead lookalike who obsesses him. Transformed, she emerges from a
hotel bathroom in San Francisco and advances at a stealthy, pantherish
pace towards the alarmed but excited Stewart, surrounded by a cloud of
green light that spills in through the window from the hotel's neon sign.
Green here does not connote spring-like renewal; the tone is miasmal,
redolent of decay, and it makes the coupling that follows look deathly.
In 1957 Truffaut praised the equally unnatural palette of Sirk's *Written
on the Wind*, which explores the neurotic maladies of a rich Texan
dynasty: he gaped at the lacquered industrial colours of a blue bedroom,
a red corridor, a bright yellow taxi and a steel-grey plane, all of which
belonged, he thought, to 'the age of plastics'. He was equally startled
by a patch of acid-green alfalfa in Frank Tashlin's *Hollywood or Bust*,
by the gold-framed spectacles of the killer in Hitchcock's *Rear Window*,
and by the dyed hair of Marilyn Monroe and Jane Russell, who embody
a paradoxical blend of 'greed and lust, frigidity and nymphomania' in
Hawks's *Gentlemen Prefer Blondes*. Here, for Truffaut, was evidence of
America's 'luxury civilization'.

Europeans began to suspect that California itself had been designed in
one of Technicolor's laboratories. As a wartime refugee, Theodor Adorno
winced at 'the red, blue and violet activity' of the Pacific sunsets – hues
of an intensity that he thought 'in no way reproducible', even in the most

lurid magazine illustrations. Other visitors to Los Angeles thought that the actual city looked as brashly synthetic as its replica on film. Ingmar Bergman noted the 'poisonous yellow' of the smoggy sky. Cecil Beaton, in Hollywood to work on Cukor's *My Fair Lady* in 1963, complained about the 'hard and brittle' light, in which 'the colours of the spectrum are never muted by a blue haze'; the 'retina-irritant vermilion' of the uniforms worn by men repairing the highways caused him particular distress. At the Farmers Market on Fairfax Avenue in 1966, Cesare Zavattini was amazed to see people feasting on 'violently coloured foods'.

When Lee Marvin arrives in Los Angeles on his vindictive mission in John Boorman's 1967 thriller *Point Blank*, he at once reduces this polychrome allure to an ugly mess. He bursts into the apartment of his treacherous wife and, failing to find her at home, relieves his anger by knocking her phials of bath oil into the tub. As a replacement for bloodshed, the shattered bottles let loose green, orange and red rivulets that slither along the white porcelain and intermingle in a glutinous puddle that parodies the dripped, poured or flung pigments of Abstract Expressionist painters like Jackson Pollock. The coloured murk also interferes with our focus on a point that ought to be blank or perhaps black: the film's title refers to Marvin's imminent death, or to a death that may have already taken place at Alcatraz before the film began, since, like so many characters in film noir, he is probably a revenant. In 1976 Scorsese displayed another saturated inferno at the start of *Taxi Driver*. When De Niro drives through drizzly Times Square at night, the rain-soaked streets act as a screen on which messages from red, yellow and green neon signs blur and merge. Colour here is the nocturnal city's emission – spillage, effluvium, no longer a guarantee of wealth and costly excess. The palette of David Lynch's *Blue Velvet*, released in 1986, is malevolent in a different way. Here a brothel has sour green curtains, a corrupt cop known as the Yellow Man wears a citrus-coloured jacket that surely flouts the dress code at his precinct, and before Dennis Hopper beats up Kyle MacLachlan he bloodies him cosmetically by smearing lipstick on his face. Laura Dern guilelessly burbles about 'the blinding light of love', but Lynch's midnight tonalities, like the blue velvet that Bobby Vinton sings about on the soundtrack, make darkness visible.

In 1998 in Gary Ross's *Pleasantville*, monochrome is dismissed as antiquated, anaemic, irrelevant to gaudy modern America. A television repairman uses a remote control to send racy Reese Witherspoon back to the prim 1950s, where she and her brother are trapped in one of the black and white sitcoms that sang the praises of suburban wholesomeness. 'We're supposed to be in colour,' she complains. 'Look at me, I'm pasty!' But this free spirit from the future gradually coaxes the citizens of Pleasantville to see a more pigmented world. She deflowers a high-school jock, who discovers to his amazement that roses are red; after a bulbous sac of pink bubble gum is obscenely puffed out from a girl's rosy lips, an unheard-of female orgasm provokes a black and white tree to burst into excited orange flames.

The knowledge of good and evil that disrupts the timid, law-abiding garden is chromatic: Witherspoon's brother presents his boss with an art book that opens on a coloured plate reproducing Masaccio's picture of Adam and Eve being expelled from Eden – which, despite their grief, might be the best thing that could have happened to the human race. Finally, after a night of all-round sensual rebellion, the prismatic arc seen by Noah in Genesis shimmers over the satiated town. To depict human freedom, cinema needs all the colours of the rainbow.

* * *

While preparing *L'eclisse*, Antonioni travelled to Florence to film an eclipse of the sun. The interval of mortifying cold and paralyzed silence alarmed him, and the experience confirmed his belief in the sun's malevolence and its 'great capacity for irony'. But he chose not to use this documentary footage, and *L'eclisse* concludes instead with a metaphorical blackout that obscures or expunges the wayward, emotionally neutral couple played by Alain Delon and Monica Vitti. The evening rendezvous for which they do not turn up is replaced by a five-minute black and white montage of happenings in a nondescript Roman suburb. A listless nurse pushes a baby in a pram down an empty street, a plane leaves a vapour trail as it streaks across the sky, water dribbles from a spout to run off in a gutter, columns of ants go about their business on the trunk of a tree. An anonymous commuter alights from a bus and

strolls away holding open a newspaper report on the peril of atomic war, which recalls the blinding flash that outshone the sun in Hiroshima in 1945. Here there is no such moment of revelation, although in the final image of the sequence a single street lamp emits a seething glow and is then blotted out. In the absence of characters and of a story about them, this epilogue reduces cinema to its essence or to its contending elements: day against night, light against darkness.

When colour arrived in Antonioni's films, it derived from culture not nature. *Red Desert* – released in 1964, two years after *L'ecclise* – was filmed in and around Ravenna, in estuarine wastes stained by pollution. The apples on a stall in an ashen street were painted grey to match the tainted surroundings, although the petrochemical factory whose efflu-ent causes this blight has pipes and tanks that are arbitrarily coloured green, orange, yellow and blue – an exercise in what Antonioni called 'the psycho-physiology of colour', its power to alter our mood and even our metabolism. Richard Harris, playing a disaffected engineer, fixes his gaze on a row of blue-green bottles or a bright blue angular stripe painted on the wall, and while he tries to persuade a group of workers at the plant to migrate to Patagonia he launches himself into this blue yonder. Colour also deracinates the film's other protagonist, played by Monica Vitti. After a stay at a psychiatric clinic, she plans to open a gallery to sell ceramics. Cans of paint are stacked in the empty space; choosing green for the ceiling, she inverts the relation between earth and sky. When she tells her son a story, she indulges another chromatic fantasy. She describes a beach with rosy sand, and we see the place: it is supposedly in Sardinia, although the honeyed rocks, the sapphire horizon and the orange sail of a vanishing boat make it look as unearthly as Oz. The boy has his own version of elsewhere, and plays with extra-terrestrial toys – a robot, a flying saucer with a gyro-scope – that are painted in acid hues, like the stolen plane in *Zabriskie Point* which the rebellious young student parks in the desert near Death Valley and decorates with green, pink and orange graffiti, preparing it for a fantastic voyage of escape from utilitarian America.

On location for *Blow-Up* in 1966, Antonioni tinkered with the tonal values of sooty London. He had the lawns in a suburban park sprayed to

make the grass look more minty, then blackened the paths for contrast; a street down which David Hemmings drives was repainted blood red. A lump of translucent blue rock sits on the coffee table in Hemmings' studio, and two giggling groupies in pink and green tights tussle with him sexually on a crumpled bed of purple paper. Black and white make amends for this frivolity: Hemmings spends a night in a homeless shelter and returns with some stark documents of deprivation, taken on his behalf by the photojournalist Don McCullin. Yet monochrome proves incapable of capturing truth. When Hemmings accidentally photographs an illicit rendezvous and a possible murder in the park, he blows up the stills to examine what might be a gun or a body in the bushes; enlargement causes the scene to disintegrate into molecular blobs. Colour, essential to the affluent economy, continues its work of selling people things they do not need, while black and white fudge the difference between truth and fiction by blurring into a grisaille fog.

Kieślowski's *Three Colours Trilogy*, released in 1993–94, rehabilitates colours by yoking them to concepts. Usually colours are adjectival and therefore expendable, but here they stand for political ideas, which gives them the status of nouns. Kieślowski derived his trio from the French 'tricolor' – the flag whose blue, white and red bands correspond to the republican credo of liberty, equality and fraternity – though these abstractions are muddled, muddied and disarmingly humanized by his tragicomic characters. The blue story concerns a grieving widow (Juliette Binoche) who loses her husband and their small daughter in a car crash. Blue is the colour of melancholy; the film, however, is about liberty interpreted as liberation, a merciful release from illusion and from material cares – Binoche discovers that the man she mourns had a mistress who is pregnant with his child, and she frees herself from the past by making a gift of the marital home to her rival. The white instalment concerns marital equality, not the egalitarian creed of the revolution, as a Polish husband strives to regain the respect of the French wife (Julie Delpy) who despises him. The red panel in the triptych deals with fraternity in a society where technology connects us like a circulatory system that operates outside the body: it begins with the camera tracking the telephone cables that link Irène Jacob in

Geneva to her boyfriend in England, and the red tinge suggests that those wires are blood vessels.

With a more earnestly religious confidence Tarkovsky at the end of *Andrei Rublev* ascends in a jump cut from earth to an incandescent heaven. The narrative concludes with the fifteenth-century icon painter Rublev downcast beside the embers of a burned-out fire in the dirty snow. Then, in an epilogue, we are allowed to see the cathedral he has filled with his frescoes. The screen slowly flushes red, as if that fire doused by snow has suddenly flared up, and a choir vocalizes ecstatically; we are taken on a tour of Rublev's Nativity scenes, with acts of enraptured obeisance supervised by immense, impassive guardian angels. Examined at length, the face of Rublev's Christ becomes a portrait of the artist, whose unblinking eyes scrutinize us like cameras. The sky is gold, Christ's robe a celestial blue: Tarkovsky's palette is sacred, not therapeutic like Antonioni's in *Red Desert* or ideological like Kieślowski's in the *Trilogy*.

In *Stalker* Tarkovsky's questers inhabit a sullied, corroded city whose tonalities are those of mud and rust, and they return there after their trip to the dazing brightness of the Zone. This is their reality, just as Kieślowski said that Lodz, where he attended film school, could only be represented in black and grey: white had no place in this drab, soiled environment. *Andrei Rublev* resists any such compromise. After our perusal of the paintings, a thunderclap and a downpour return us to ground level for a glimpse of some horses frisking in the rain beside a river. Despite the poised state of grace in the frescoes, cinema is about being alive; although heaven may have a monopoly of blue and gold, here the irrigated earth is green, which signifies growth.

Tarkovsky worried that colour reduced filmmakers to using 'a painter's methods', and he resisted its commercial prettifying of life. 'The black and white image,' he believed, 'comes closer to the psychological, naturalistic truth of art' – the same point made by Mac Orlan in his essay on Atget and by Samuel Fuller in *The State of Things*. But if the truth happens to be spiritual or metaphysical, other resources are necessary. God began the process of creation by calling for light and declaring it to be good. In *Andrei Rublev* Tarkovsky seems to add a second command, which is 'Let there be colour.'

11

A NEW EYE,
AN OLD EAR

In 1929, on 8th Street just off Fifth Avenue in Manhattan, the architect Frederick Kiesler designed a small cinema for the New York Film Guild. Its darkness was pierced by diagonal lines of light on the walls and ceiling; these conducted all eyes towards a screen resembling a larger eye, set inside a curved, black-edged aperture – a circle whose rim opened, like an iris or the shutter of a camera, to disclose the silvery square onto which the films were projected.

Inside such cranial spaces, cinema conducted a course of optical retraining. The agenda was set by an intertitle in Feuillade's *Les Vampires*, where the detective tells one of his helpers 'We must keep our eyes open and stay silent.' Grace Kelly paraphrases the remark in Hitchcock's *Rear Window* when she quizzes James Stewart about his random observations of the courtyard behind his Greenwich Village apartment, where he suspects that a murder has been committed by one of his neighbours. 'Tell me everything you've seen,' she urges, 'and what you think it means.' Between Feuillade's line and Hitchcock's variant, the embargo on speech has relaxed. The change happened slowly after the late 1920s, and Hitchcock never ceased to regret it: as a sign of this nostalgia for the days before talking pictures, the playlets that Stewart photographs across the courtyard in *Rear Window* are dumb shows occasionally accompanied by music – the jazz that Miss Torso plays when doing her undressed callisthenics, the overheard love song that dissuades the spinster Miss Lonelyhearts from killing herself.

Cinema emboldens the eye, and its adjustments of focal length teach us new skills, as Stewart demonstrates when he attaches long-distance lenses to the camera he uses for his domestic espionage. The cinematic ear is equally confidential, and has its own equivalent to the close-up: microphones let us overhear actors whose voices might not carry across space as they do in a theatre. In 1948 Eric Rohmer protested that people in films had not yet learned to talk as eloquently as they did in plays (and as the hyper-articulate characters in his subsequent series of *Contes moraux* certainly do), but how else should a primarily visual art function? Actors on film – expert in the use of speaking looks, concerned as much with the way words sound as with what they signify – developed new styles of delivery. James Stewart endearingly hems and haws, Gary Cooper converses in bashful monosyllables that sometimes stick in his throat. Mae West mutters her innuendos, Marilyn Monroe's breathy whispers eroticize the blandest utterance. Brando and James Dean make mumbling an act of sullen rebellion. As the bereft father in Ozu's *Tokyo Story*, Chishu Ryu manages to be emotionally expressive without saying very much at all, as his vocal performance mostly consists of muffled grunts, pensive tonal adjustments, ambiguous throat-clearings, and exhalations or inhalations of breath. In Erich von Stroheim's case, a verbal mannerism had a visual motive: he explained his meticulous, over-deliberately enunciated French in films like Renoir's *La Grande Illusion* by saying that he spoke slowly in order to maximize his time on screen.

Language is supposed to be the noblest evidence of our rationality, which is why the biblical myth conferred on Adam the power of speech and awarded him authority over dumb animals. Even after cinema abandoned silence, it cast doubt on this ranking. In 1974 the mute foundling in Werner Herzog's *The Enigma of Kaspar Hauser* communicates without words, as does the wild child who grows up in the woods in 1970 in Truffaut's *L'Enfant sauvage*. Both films show these rudimentary Adams being coaxed or coerced to speak and to recognize linguistic signs. This is how they are inducted into membership of society, even though – like cinema itself in Hitchcock's opinion – they may have been better off in their speechless state.

* * *

Defending the pre-eminence of language and literature, Virginia Woolf thought that cinema seemed 'stupid' because it switched off the mind and relied on 'the ordinary eye, the English unaesthetic eye'. In her opinion that organ was a menial prop, useful because it kept the body from tumbling into coalholes; the eye 'licks [experience] up instantaneously', she admitted, hinting at disapproval of its slurping manners, but it can only interpret that visual glut if the brain comes to its aid. Cocteau likewise mocked 'the cow-eye of photography', which was capable of nothing more than 'stupid registration'. Like Woolf, Georges Bataille punished the eye for its dim-witted extroversion. At the end of Bataille's novel *L'Histoire de l'oeil* a voyeur gouges out the eye of a dead priest, which his female accomplice then stuffs into her vagina. Unlike the endoscopes now employed in keyhole surgery, it can send back no report on what it sees there.

Cinema in its early days took note of the eye's squashy vulnerability. In 1924 in his silent epic *Die Nibelungen*, Fritz Lang made a notable change to the tactics of the legendary hero Siegfried. Sent out to fight the dragon in Wagner's opera *Siegfried*, the naive young man asks the dwarf who has reared him if the beast has a heart; he then checks on its location, which is where he stabs it. Siegfried in Lang's film chooses a softer and more conspicuous point of entry: his sword punctures the eye of the fire-breathing beast, which squirts fluid. On the Odessa steps in *Battleship Potemkin*, a woman who turns to face the Cossack gunmen wears a pince-nez, and in the last brief shot of the sequence, we see that a shot has shattered one little pane and taken out her eye. Eisenstein cuts away immediately to the long cannon on the deck of the battleship, which retaliates through its loud, fulminating mouth. 'It is not a "kino-eye" that we need,' Eisenstein declared, 'but a "kino-fist".' This call for reinforcements was answered in Anthony Asquith's *Underground*. Brawling in a pub, Brian Aherne lunges forward and delivers a knock-out punch to the camera, which suffers a temporary concussion; his stunned rival experiences the blow over and over again as the clip of film is re-run to convey his dazed state. Even the lens is not safe from the affray of reality.

The painter Edvard Munch – a film fan who at one time fancied opening a cinema in Oslo – wished we had 'stronger eyes' that could 'see our external astral casing', rather than the internal or ulterior realm probed by Bataille's enucleated eye. For Abel Gance, the injunction to look was a mystical imperative: cinema, he thought, required people to 'listen with their eyes', which meant that they should be able to see voices, as the Talmud says Moses did when transcribing the commandments on Mount Sinai. Man Ray's 'cinépoème' *Emak Bakia*, made in 1926, begins with a staring human eye that is first superimposed on a camera lens and then placed between the headlights of a Mercedes racing car; at the end a woman has supplementary eyes painted onto her closed lids. She needs that extra pair because Man Ray's short film is, as he said, 'an exercise in the invention of light-forms': in it we see light broken up as in a prism or impressionistically blurred, and the play of breakers on a beach is a reminder that it travels in waves. The cinematic eye here has analytical powers its human prototype does not share.

Like a deity, the camera's eye keeps our miscreant bodies under surveillance. Sternberg bawdily jokes about this omniscience in 1934 in *The Scarlet Empress*, where the infantile Grand Duke spies on his mother and her paramour by using an outsize screwdriver to drill a hole through a bedroom wall in the Kremlin. On the other side of the wall, above the bed where Marlene Dietrich is misbehaving, hangs a holy icon representing Christ. One of the redeemer's eyes sorrowfully weeps at the spectacle of human sin; the erectile metal tip of the screwdriver, wobbling obscenely, protrudes from the other eye. Another god, lodged in a camera, keeps watch in Hawks's *The Big Sleep*. A pornographer has hidden his camera in the smiling head of a Buddha, and from that recess it studies a drugged and dishevelled young woman, propped in a chair as if sitting for her portrait with a freshly murdered corpse at her feet. Humphrey Bogart rescues the wayward girl, along with the film from the Buddha's head that was meant to be used for blackmail, and carries her home. 'You haven't seen me,' he instructs Lauren Bacall, her older sister, when he drops off his woozy charge. 'That bad, huh?' says Bacall, who understands his shorthand at once. If only the ever-vigilant gods were so willing to wink at our infractions!

For some directors the human eye, looking back at the cold, callous lens, makes the soul manifest. In Rossellini's *Europa '51*, Ingrid Bergman plays a socialite who salves her stricken conscience by performing acts of charity in the Roman slums. Her affronted family commits her to a psychiatric clinic, where a tachistoscope – meant to measure recognition speed – is trained on her; it flickers like a film projector, with her face as a screen. The technicians learn nothing from the test because Bergman's eyes remain shut, but when she opens them to train her wide-eyed, compassionate gaze on Rossellini's camera she confirms the 'spiritual power' that those who admire her find in her character, and also reminds us why cinematic close-ups were so revelatory. In 1951 a Communion candidate in Robert Bresson's *Journal d'un curé de campagne* pays attention to a sermon because she admires the young priest's beautiful eyes; a doctor says that the same eyes exude fidelity, like a dog's.

Bresson thought the eye was more than a passive receptor, and in his *Notes on the Cinematograph* he referred to its 'ejaculatory force'. If the idea of ejaculation seems over-excited, think of Anthony Perkins' burning eye as it peers through the hole in the wall in *Psycho* to watch Janet Leigh undressing. One of cinema's less respectable antecedents was the peepshow, and John Gilbert in *The Big Parade* recalls those origins when he invents his own rudimentary cinema. Away from the trenches in rural France, he borrows a wine barrel, hoists it into a tree and uses it for an improvised shower, with water spraying its puncture holes. On his way to return the barrel, he jauntily carries it on his head, and is teased by a peasant girl who finds the sight absurd. Stumbling around, he manages to frame her in the bunghole where the tap was fitted to the barrel: seen from inside the camera obscura that is his headgear, she is like an actress posing for a reaction shot.

The act of observation is not so good-humoured in Joseph Losey's *The Prowler*, released in 1951, which starts by showing a lighted oblong surrounded by a shady frame – an inset cinema screen? Actually it is a bathroom window, through which we watch as Evelyn Keyes primps before a mirror after bathing. She glances in our direction, screams when she sees that she has an uninvited audience, and angrily tugs down the blind; only then do the credit titles appear. The eye's deadly cruelty is

the subject of Robert Siodmak's 1946 film noir *The Spiral Staircase*, in which George Brent, obsessed with exterminating defective human specimens, stalks a deaf-mute servant played by Dorothy McGuire. Set in a storm-lashed New England mansion, the film begins with a view of the spiral staircase, seen from above so that it seems not to descend but to retreat into space like a corkscrew. Later close-ups fix on the hidden killer's eye, then move into it: the spiral now represents the kinked involutions of his brain. Shots from Brent's viewpoint are warped, so that when he looks at the unspeaking McGuire, her mouth is smeared or wiped out, identifying the affliction that justifies her elimination.

Because the eye is a sense organ, Buñuel licensed it to migrate around the body. In 1961 in *Viridiana*, the beggars who have invaded a country house treat themselves to a brawling feast, during which they pose in a lewd parody of the Last Supper. A ribald woman wants a souvenir of their blasphemy, and since she has no camera, she hoists up her skirts and pokes her pudenda at the revellers. Her third eye is between her legs: a photographic image is an act of exposure. Buñuel once claimed that 'A man with his hands tied can, by closing his eyes, blow up the world.' Those tied hands exempted Buñuel from physical involvement; he needed only to close his eyes and make a wish, and in doing so he generated fantastical scenarios that sabotaged the settled order of things, like the motiveless bombings staged by terrorists in his 1977 film *Cet obscur objet de désir*. At the start of *Un Chien andalou*, we see the saturnine Buñuel himself prise open a woman's lid and slice her eye – which actually belonged to a dead ox – with a straight razor. The blade's action rhymes with that of a thin cloud as it bisects the moon: no longer a sun play, cinema here probes our lunacy, and that surgical incision allows it to inspect our dreams.

Roman Polanski's *Repulsion*, released in 1965, opens with a dual citation of Buñuel and Hitchcock. An eye is horizontally slashed by the director's blade-like credit; then, as in the credit titles Saul Bass designed for *Vertigo*, the camera moves closer to inspect the milky white sclera and darkly flecked pupil behind the hirsute fringe of lashes. This eye – which belongs to Catherine Deneuve – is often plugged to a peephole in the door of the South Kensington flat where Deneuve, a

sexually repressed manicurist, goes murderously mad. Polanski had the glazed aperture in the door made as large as a ship's porthole, which allowed his camera to film the two-way traffic that passes through it. On one occasion the eavesdropping ear and prying eye of a prurient landlord appear in the hole, trying to gather information about what is happening inside; later Deneuve clubs her young suitor to death with a candlestick as he looks out through the fishy lens, desperate to regain contact with external reality.

Cinema privileges one sense over the others, and the favoured organ transfers its natural powers to a machine. *Peeping Tom* is Michael Powell's account of this fetishistic practice; here Powell is less a 'high priest of the mysteries', as he once declared himself to be, than a black magician whose art is profane, cruel and perverse. Carl Boehm plays a photographer who uses the camera as both a sexual aid and a murder weapon. His equipment protects him from human contact, insulating him almost like a prophylactic, but it also supplies him with his only means of consummation. His day job is as a focus puller at Pinewood Studios, where he regulates the distance between movie cameras and the women they are aimed at. At home, when his neighbour Anna Massey lightly kisses him before walking away, he completes the embrace photographically: he rubs the rounded lens of his camera on his skin, with its nozzle as a substitute for her mouth. Stalking a prostitute, he eyes her through the camera's viewfinder, and before he follows her upstairs he tosses a Kodak film packet into the garbage can, as if discarding the wrapper of a condom. Then, as he closes in for the kill, a leg of his camera's tripod erects itself to release a swordstick, and after he removes a rubber stopper it stabs the woman. She sees herself dying in a circular mirror mounted on top of the camera; his gratification comes when he watches the footage and jerks spasmodically in his chair.

Reviled when first seen in 1960, *Peeping Tom* wrecked Powell's career. He invited this condemnation by casting himself as Boehm's father, a psychiatrist whose research studies 'the reactions of the nervous system to fear'. Flashbacks reveal that for this Hitchcockian project he enlisted his young son as a laboratory specimen, filming the boy's terror when he finds an iguana in his bed or his distress at being forced to keep a

vigil beside the bed of his dying mother. Powell made the set-up more candidly confessional by casting his own son Columba as Boehm's younger self and filming the episodes of mental torture in his London home. In *Psycho*, released a few months after *Peeping Tom*, Hitchcock has an analyst explain Anthony Perkins's insanity, then gives the madman the last word as he smirks at the camera and proclaims that he wouldn't hurt a fly. Powell's conclusion is less sneakily ironic. To escape arrest, Boehm impales himself on the blade in the camera – but as he does so he films his self-directed death and offers it to us, his fellow scopophiles who gather in the cinema to collude in his fantasy.

Powell's peeping Tom has a female colleague in *The Eyes of Laura Mars*, directed by Irvin Kershner in 1978. Here Faye Dunaway is a New York photographer with teleprophetic powers: her waking dreams of murder, seen from the killer's point of view, act out the flashy, gory tableaux she arranges for fashion magazines. Blame, inevitably, reverts to Buñuel, and in one of her scenarios she sees a blade puncturing a victim's eye. The film begins with an assignment for which Dunaway piles up crashed, burning cars in Columbus Circle and choreographs a vicious brawl between models clad in fur coats and scanty lingerie. When her photographs are held to be responsible for the copycat atrocities, she defends herself by arguing that once she presses the shutter, the models freeze, harmlessly attitudinizing; her nightmares, by contrast, are moving pictures, which advance unstoppably towards death. The murderer turns out to be a deranged detective, but Dunaway perhaps identifies the real culprit when she points to the video camera set up in her studio: cinema is a machine powered by scenarios of desire or dread that we concoct in our heads.

In 1987 Dario Argento advanced to a new and more gruesomely refined stage in ocular torments in his horror film *Terror at the Opera*. Here a victim is shot as she squints through a keyhole to check the identification of a supposed cop: the bullet goes straight into her eye socket. The killer wants another young woman to witness his savagery, and he keeps her eyes open by taping razor-edged spikes below them, which will blind her if she tries to close her lids. Finally, however, a raven pecks out the sadist's own eye and makes a meal of the jellied globule.

The camera, exulting in its own immunity, makes a target of the eye it has supplanted or superseded, which is bombarded with barbed, potentially deadly images. During the vogue of 3-D in the 1950s, cinemagoers wore polarized glasses that showed visual shrapnel speeding towards them. *It Came from Outer Space*, about a meteorite that turns out to be a spacecraft, was advertised by a poster that declared 'FANTASTIC SIGHTS LEAP AT YOU!', which was the cue for an alien vehicle to zoom straight into the pupil of a staring eye. In George Sidney's musical *Kiss Me Kate*, the rambunctious performers toss bowling pins or handfuls of glitter off the screen in our direction; Ann Miller unpeels a pair of long pink gloves and flings them at the camera, and Kathryn Grayson as Shakespeare's shrew launches a pewter saucer and tankard into the air during a tantrum. In John Farrow's *Hondo*, audiences had to dodge knives when John Wayne fights an Apache, and the blades of the scissors used as a weapon by Grace Kelly in Hitchcock's *Dial M for Murder* lunge at the paying customers before being thrust into the back of the man who is trying to strangle her. Here was another of cinema's unsettling mysteries – a new optical menace, sometimes jocular and at other times not.

* * *

Jean Epstein, impressed by the compelling, even predatory power of the cinematic eye, remarked that 'One can't evade an iris.' Even so, Epstein believed that cinema needed 'an iconoscopic retina'. The iconoscope was an electronic camera tube invented in 1923 by Vladimir Zworykin, which, by breaking down images into pixels and transmitting them to a receiver, eventually made television possible; Epstein challenged the retina to match its powers. Photographic man honed our sight by making the eye a precision instrument: the hired killer in Graham Greene's novel *A Gun for Sale* has eyes 'like little concealed cameras' that pinion his victims in mortifying snapshots. Cinematic man, dealing with bodies that moved, could not afford to remain so detached. When a lynch mob invades the jail in Lang's *Fury*, a newsreel cameraman at the site rapidly assembles the right equipment for recording the riot: he excitedly calls for a two-inch lens, and is glad he has a supply of

hypersensitive film with enlarged stop-action. His camera can now give chase to its chosen quarry.

After commenting on the camera's improved retina, Epstein added 'This is a cyclopean art, a unisensual art.' His reference to Cyclops points ahead to the piratical eye patches worn by directors like John Ford, Nicholas Ray, Raoul Walsh and André De Toth, each of whom relied, like the cameras that executed their orders, on a single eye. De Toth's patch was not a professional affectation: he had lost the sight in one eye, and although he directed *House of Wax* in 3-D his lack of depth perception meant that he could not actually see the pink geysers of boiling wax as they splashed from the screen and threatened to scald the audience. Late in his career, Fritz Lang often wore both a monocle and a patch – a glassy lens gripped in the socket of one eye; hiding the other, a cover as impartial as the blindfold worn by allegorical figures of justice. Although he needed both because of a war injury and the onset of glaucoma, he turned the symptoms of disability into symbols of authority.

Buñuel called Lang's *Metropolis* 'a brand-new poem for the eyes' – for the eyes, and also about them. Rotwang's metal robot has pinholes in the centre of her eyes, and the absent irises suggest that she may have a camera stored in her cranium. Later, the eyes of the male patrons who watch her dancing in the nightclub spring from their heads with an almost erectile excitement. Whenever Lang cast the exopthalmic actor Heinrich Gotho, he achieved the same results without special effects. In *Woman in the Moon* Gotho tends exotic plants, one of which a visitor idly massacres with a pair of scissors he plays with while using the phone. When Gotho notices the damage, his bulbous eyes roll together like marbles and he faints. In *Spies* he puts those protruding eyes to better use: it is he who notices the serial numbers on some incriminating banknotes.

Once its vision has been boosted or corrected, the eye in Lang's films has uncanny aptitudes. In *M*, released in 1931, the child-murderer played by Peter Lorre is identified by some evidence that the inspector discovers when he studies a letter with his magnifying glass. The impression left on the paper by the ridged, splintery texture of a

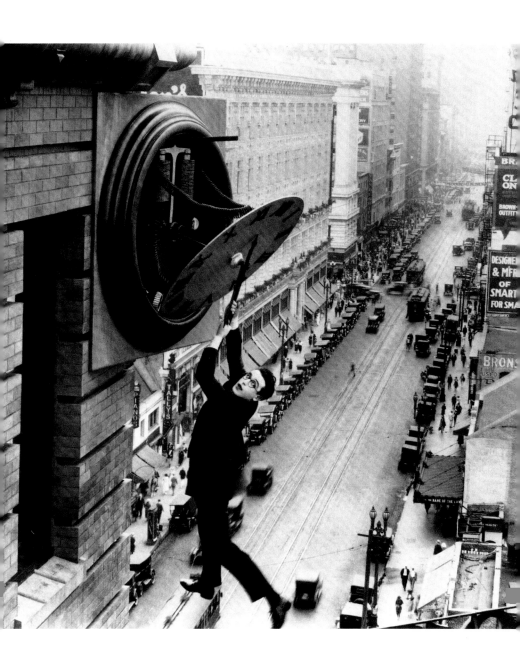

29 Harold Lloyd in *Safety Last!* climbs the outside of a downtown Los Angeles office building as a publicity stunt: here he is at the halfway stage.

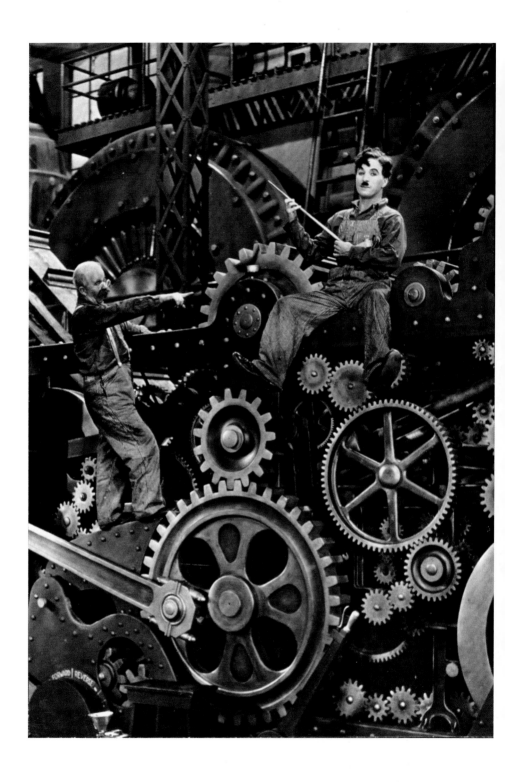

30 Charlie Chaplin and Chester Conklin at the reopened mill in *Modern Times*, 'repairing the long idle machinery' (which responds by gobbling Conklin up).

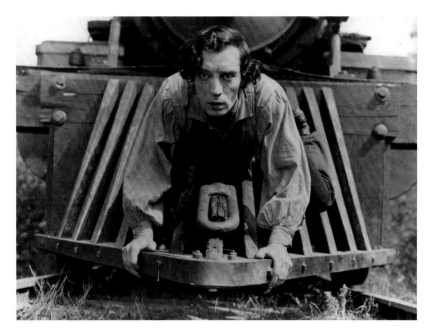

31 Buster Keaton as the engineer Johnnie Gray in *The General*: he has turned his locomotive into a weapon of war for the Confederacy, and rides on the cow-catcher to remove logs that Union agents have dropped on the tracks.

32 John Wayne at the end of John Ford's *The Searchers*, hesitating on the border between a domestic interior and the vacancy of Monument Valley: he turns away and the door closes, shutting him out and obliterating the image.

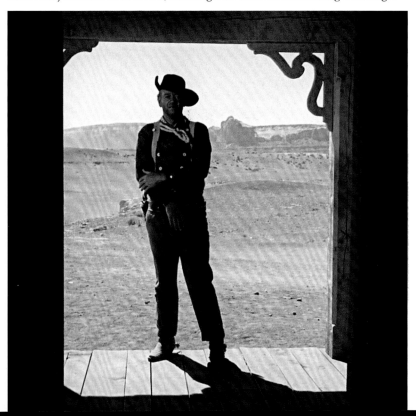

33 Gaby Rodgers as Lily Carver opens the case of radionuclide, melting herself and blowing up the house in Robert Aldrich's *Kiss Me Deadly*.

34 The red eye of the malevolent HAL, the heuristically programmed algorithmic computer in Stanley Kubrick's *2001: A Space Odyssey*, with Keir Dullea as the astronaut Dr David Bowman.

35 The winged Moloch in Carthage in Giovanni Pastrone's *Cabiria*, fed on a diet of sacrificed children who are consumed by the furnace in its gullet: the bronze statue used in the film is on display at the Museo Nazionale del Cinema in Turin.

36 The industrial Moloch from Lang's *Metropolis*, a machine that seems to be consuming the enslaved toilers who tend it.

37 Werner Fuetterer as the Archangel in Murnau's *Faust*.

38 The funeral procession of Allan Gray, played by Nicolas de Gunzburg, in Carl Theodor Dreyer's *Vampyr*: his open-eyed corpse stares back at the shadow of his living self.

39 The cadaverous shadow of Count Orlok, the vampire played by Max Schreck in Murnau's *Nosferatu*.

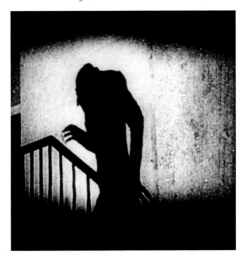

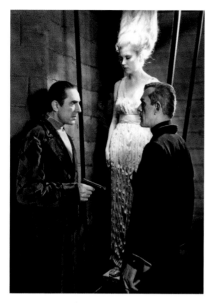

40 Béla Lugosi as Dr Vitus Werdegast and Boris Karloff as Hjalmar Poelzig in Edgar G. Ulmer's *The Black Cat*, with one of Poelzig's embalmed mistresses suspended in a display case.

41 Humphrey Bogart, as the private eye Philip Marlowe, locates the blackmailer's hidden camera in Howard Hawks's *The Big Sleep*.

42 Margaret Hamilton as the Wicked Witch of the West, Judy Garland as Dorothy and Ray Bolger as the scarecrow on the yellow brick road in Victor Fleming's *The Wizard of Oz*.

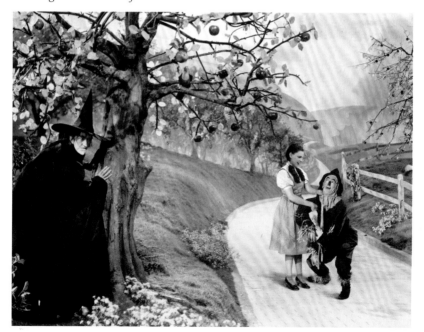

43 The slashed eye at the start of *Un Chien andalou*, directed by Luis Buñuel and Salvador Dalí: Buñuel himself wields the razor, to mark the change from sight to vision or from reality to dream.

44 The erogenous eye in Alfred Hitchcock's *Psycho*: Anthony Perkins spies on Janet Leigh as she undresses.

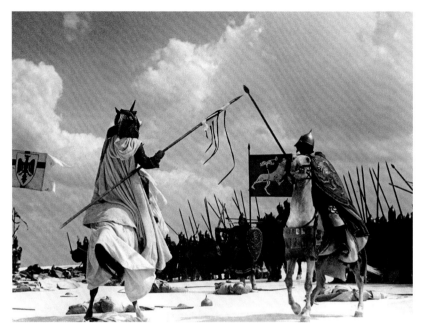

45 The battle on the ice in *Alexander Nevsky*: Eisenstein described the patriotic defeat of the Teutonic knights on the frozen lake in 1242 as 'an unexpected, breath-taking miracle'.

46 Jeremy Irons as the twin gynaecologists in David Cronenberg's *Dead Ringers*.

47 The bone thrown into the air by the hominid in Kubrick's *2001: A Space Odyssey*, which in a jump cut instantaneously mutates into an orbiting spacecraft.

48 Pier Paolo Pasolini directing Orson Welles on the set of *La ricotta*, in which Welles plays an abject, impotent director.

49 Marcello Mastroianni as the director Guido Anselmi in Federico Fellini's
8½, organizing a final circus parade by the characters in a film he has been
unable to make.

50 Alfred Hitchcock's assisted walk-on at the airport in *Topaz*: moments later,
he forgets his need for the wheelchair and stands up to greet a friend.

51 Francis Coppola directing newsreel footage during an actual battle in *Apocalypse Now*.

52 François Truffaut as the harassed director Ferrand, on set in *La Nuit américaine*.

53 A magic-lantern show at the cinema in Wim Wenders' *Kings of the Road*: while the projectionist is repairing a speaker before a children's matinee, his friend flicks a switch behind the screen and their silhouettes entertain the audience.

54 Jane Wyatt as Sondra and Ronald Colman as Robert Conway at Shangri-La in Frank Capra's *Lost Horizon*: Hollywood as the earthly paradise.

Anarene, Texas, 1951.
Nothing much has changed...

COLUMBIA PICTURES Presents **A BBS PRODUCTION**

THE
LAST
PICTURE
SHOW

A Film By
PETER BOGDANOVICH

Official
Selection
New York
Film
Festival

starring
TIMOTHY BOTTOMS/JEFF BRIDGES/ELLEN BURSTYN/BEN JOHNSON/CLORIS LEACHMAN

Directed by Screenplay by

introducing and CYBILL SHEPHERD as Jacy / PETER BOGDANOVICH/LARRY McMURTRY and

Based on the novel by Executive Producer Produced by

PETER BOGDANOVICH LARRY McMURTRY BERT SCHNEIDER/STEPHEN J. FRIEDMAN

Original Soundtrack Album on MGM Records.

55 Peter Bogdanovich's elegy for a closing cinema and for Hollywood's golden age.

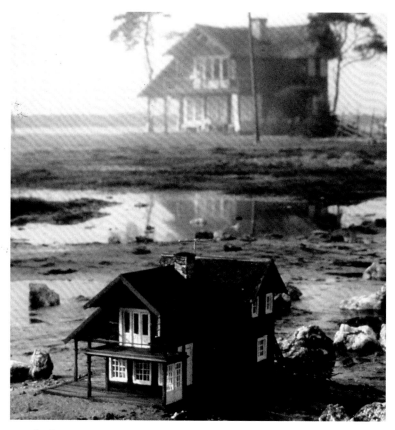

56 The house in Andrei Tarkovsky's *The Sacrifice* and its microcosmic model: for Tarkovsky, a cinematic image was 'an entire world reflected as in a drop of water'.

57 Malcolm McDowell as Alex is made ready for a course of visual re-education in Kubrick's *A Clockwork Orange*.

58 Salvatore Cascio as Toto, the younger self of the adult film director, helping out in the projection booth in Giuseppe Tornatore's *Cinema Paradiso*.

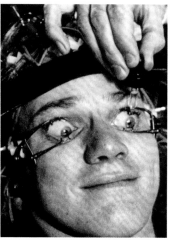

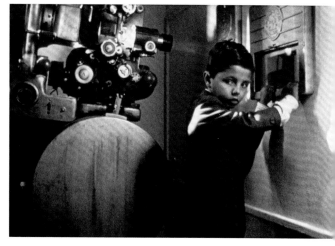

59 The ultimate cinematic spectacle: the mother ship touches down in Steven Spielberg's *Close Encounters of the Third Kind*.

60 Another small cinematic universe constructed from light: Teri Garr in the custom-made Las Vegas built for Coppola's *One from the Heart*.

window ledge tells him where it was written, and a red speck from the writer's pencil on the sill confirms his suspicion. In 1937 a sinister pair of ownerless eyes appears in Lang's *You Only Live Once*, during the bank robbery for which Henry Fonda is framed. The camera closes in on a getaway car parked outside in the rain; its wet, blurred window is a metal visage, screened off except for a horizontal slit through which those eyes keep watch. The intriguers in *Spies* deploy eyes that are more cunning than those in our heads: a spy camera the size of a finger is concealed in a lapel, and another camera spots a radio transmitter inside a vase.

Man Hunt, directed by Lang in 1941, begins as the sharpshooter played by Walter Pidgeon creeps through the woods near Hitler's mountain retreat at Berchtesgaden and fixes the Führer in his rifle's viewfinder at a distance of 550 yards. Since this is a sporting stalk, a chase that only mimes a kill, he refrains from pulling the trigger, and as a chivalrous gesture he grins and salutes the distant target before getting ready to leave. Only then does he reconsider, load the rifle with a single bullet, and take aim in earnest. But before he can fire it, a drifting leaf blocks his sightline. The same mishap proves fatal to Siegfried in Lang's *Die Nibelungen*. After killing the dragon he bathes in its blood to render himself invincible; but a linden leaf attaches itself to his shoulder blade during these magical ablutions, and because of this blockage, one spot on his back remains defenceless against his enemies. The leaf in *Man Hunt* is equally fateful: it is the blind spot of a character whose weapon doubles as his telescopic retina.

Mabuse, in the first film of Lang's trilogy about his criminal network, uses opera glasses to focus his hypnotic gaze on a tycoon's heir who is his next victim. Pretending to be someone else during a court appearance, Mabuse wears a pair of spectacles held together by a cross on which a bat is perched: these are supposedly Chinese, and once he has stared at the prosecutor through them, Chinese calligraphy is all that the befuddled lawyer can see. The prosecutor is lured to a room at the Hotel Excelsior, whose hung-over occupant may be Mabuse concealed by yet another disguise. But the sloppy fellow has allowed his glasses to drop into a chamber pot, and when roused he has to fish them out

and shake them dry. Mabuse would surely never have been so optically insanitary.

'He has evil eyes,' says the Russian countess in *Dr Mabuse the Gambler*, referring to the mesmeric mastermind. Eyes that paralyze you, adds one of Mabuse's keepers in the madhouse in *The Testament of Dr Mabuse*. They are the eyes of a seer and a voyeur, and in *The 1000 Eyes of Dr Mabuse* the malignant genius is both. Here, universalizing his reach, he has bifurcated into a pair of alter egos. One is Cornelius the supposedly blind psychic, who wears whited-out contact lenses 'as in an American horror film'; the other is Jordan the equally phony therapist, who peers into the privacy of the people he manipulates by way of multiple cameras installed in their rooms. Mabuse extends the resources and the range of the art that Epstein called 'cyclopean'. Maintaining his control of the world from a panopticon of screens in the basement of the Hotel Luxor, he has as many visual receptors as a fly.

* * *

At first, the new eye did without the ear's assistance. An early company called its peepshow the Mutoscope – an oxymoron, which asks us to imagine a speechless eye. In the architect Frederick Kiesler's definition, the first cinemas were 'houses of silence', and in fact a theatre named the Silenzioso had opened in Milan in 1919: the name advertised its sound-proofed projection booth, though that benefit was cancelled out by the behaviour of its notoriously noisy audiences, especially when at screenings of Westerns starring Tom Mix.

Virginia Woolf may have objected to the cinema's preference for the eye, but one of her characters in *The Voyage Out* says that he wants to write 'a novel about Silence, the things people don't say'. This was in 1915: would anyone have thought of such a thing before the arrival of cinema, which challenged us to decipher unspoken thoughts by reading facial expressions and body language? In 1927 René Clair suggested that Mallarmé had anticipated the appeal of cinema in his poem 'Brise marine', where he wearily remarks that he has read all the books and is pleased when a blank page points him towards a new world that consists only of images. Adding to this lyrical rhapsody, Clair described

cinema as 'a means of making us appreciate silence', freeing us from our 'old bondage to speech'.

The advantage is evident in Clair's *The Italian Straw Hat*, a version of the farce by Eugène Labiche and Marc-Michel, released in 1928. Silence here is a fortunate defect, like the deafness of the elderly uncle whose blocked ear trumpet lets him sleep through a violent altercation between the bridegroom and a soldier; it also spares us from having to listen to the verbose address of the judge who presides at the marriage, which has the guests twitching impatiently or yawning and nodding off. The only sound the film requires is that of our laughter. Before pictures began to talk, silence was occasionally enforced by a stern embargo, as if it were a choice not a technical condition. An intertitle in DeMille's *The Cheat* reports that the husband says 'I *forbid* you to speak!' to his distraught wife. She has killed the Japanese merchant who blackmailed and molested her; to protect her reputation, her husband confesses to the crime and stands trial for it, which is why he orders her not to reveal what actually happened. His wife gets the guilty verdict overturned, but she does so by showing rather than telling: in court, she sensationally tugs her dress off her shoulder to expose the ivory brand incised on her flesh when she was assaulted.

Yet when Maria in *Metropolis* tells her flock about the tower of Babel and its collapse, she makes it an allegory of economic co-operation and does not bother to explain that the misunderstandings between bosses and workers were caused by their lack of a shared language. She is able to reinterpret the myth in this way because silent films had overcome the polyglot confusion that stopped work on the tower. 'We have gone beyond Babel, beyond words,' D. W. Griffith announced to Lillian Gish. 'We have found a universal language.' The Babylonian section of *Intolerance* identifies a precursor for cinema in the wedge-shaped inscriptions of cuneiform, and when the priests of Bel reduce this 'universal written language' to 'an unknown cypher', an intertitle accuses them of 'the greatest treason of all history'. In *Les Mystères du Château de Dé*, Man Ray jokes that the wavy reflections on the walls around the indoor swimming pool might be cabbalistic messages, like the curse spelled out by the bodiless hand at Belshazzar's feast – hieroglyphs that are the automatic writing of light.

At his last appearance before his disciples in DeMille's *King of Kings*, Christ prophesies that those who follow him 'shall speak with new tongues'. Cinema showed how we could speak with no tongue at all, and exercised its power by playing seditious games with words, chopping them up or scrambling them. The pleasure zone in *Metropolis* is called Yoshiwara, though it has nothing Japanese about it, and in passing we see Jabberwockian neon signs or placards that announce PARITOL and DAVIOSAN (which sound like patent medicines), EGUNAL-TA (maybe a faddish food or beverage), or DONKROPTERIA (presumably a shop, selling who knows what). In *The Testament of Dr Mabuse* the detective illegibly scratches Mabuse's name back to front on glass, and the police inspector in *M* similarly muses about a clue by breaking down the name on a cigarette packet into its syllables, 'Ar-is-ton', and silently repeating them while his forefinger wiggles up and down, as if he were reading braille in the air: the exercise helps him by sparking a connection to a previous crime.

The beggars in *M* conduct their own manhunt, and one of them identifies the murderer by transferring a chalked initial from his palm onto the back of Peter Lorre's coat. This telltale M matches the X that Kriemhild in *Die Nibelungen* stitches onto Siegfried's tunic to pinpoint the spot unprotected by the dragon's blood, which is where she tells Hagen to aim his spear. In *Scarlet Street* Edward G. Robinson plays a character called Chris Cross, who is trapped by Joan Bennett and her blackmailing boyfriend: the sign that dooms Siegfried supplies this man with a name and in effect crucifies him. The M and the X are hardly even letters; they function as brands, like the scorched mark of sexual ownership in *The Cheat*. Another of Lang's graphic riddles occurs in *Fury*, where the untying of the plot depends on a spelling error, as Spencer Tracy's habitual mistake in writing 'mementum' not 'memento' confirms that he is the sender of an anonymous letter. Although this written evidence clears him of the crime for which he was jailed, it still alludes to the way words on a page memorialize the past and keep us from moving ahead: the infuriated Tracy is right to prefer the momentum of cinema.

We learn language by exchanging pictures for verbal insignia, replacing the image of a cat with three arbitrary letters that represent it. Silent films save us from this abstraction, as Paul Czinner does in

his adaptation of Arthur Schnitzler's *Fräulein Else*, released in 1929. In Schnitzler's novel a Viennese girl is prodded by her parents to ask an ageing family friend for an emergency loan. The rich man agrees, but sets a condition. He first resorts to a foreign language to tell Else 'Je vous désire'. Then he is more explicit, but still indirectly so. He merely asks, he says, to reverently contemplate her beauty – meaning that he wants to see her naked. In Czinner's film no intertitles articulate the proposal. Instead Albert Steinrück as the stout, stealthily lecherous Herr von Dorsday gestures towards a nude statuette on a table in the room where he is sequestered with Elisabeth Bergner's fretful Else. After a few puzzled moments she understands what is required: the image makes further words redundant. In *The Big Parade* John Gilbert is more briskly successful as a seducer. He woos his French girlfriend by teaching her how to chew gum, an imported American skill; his friend the Irish bartender receives a steamy letter from another local woman, but derives no thrill from its insinuations because he cannot read French.

Along with the dumb show used in *Fräulein Else* and *The Big Parade*, cinema ingeniously devised other ways of communicating. Felix the Cat extricates himself from danger in his cartoons by thinking with graphic punctuation marks: **?** hovering above his head means that Felix is considering his options, **!** announces a brainwave. Harold Lloyd improvises a system of semaphore in *Speedy*. Employed as a soda jerk, he listens to a baseball game being broadcast from Yankee Stadium and signals with the food on his counter to relay the score to colleagues who are out of earshot in the kitchen. A donut is 0, a finger-shaped pastry is 1, and a pretzel, after he bites it in half, triumphantly announces a tally of 3. In 1929 in *The Godless Girl* – a silent film which had dialogue added to its final reel – DeMille's delinquents reverse the process by translating numbers back into words. Arrested in a riot, the atheistic girl and the Christian boy are sent to a brutal reformatory; they clasp hands through the prison fence, and when the chain links are electrified they are left with stigmata – the sign of a cross burned onto their palms. Eventually they escape, and silently review their experience by inverting the numbers assigned to them in prison and reading the digits as letters. His number was 7734: turned upside down and back

to front, with an extra stroke added to the 4, this spells HELL, which is what he says he suffered in jail. 'Your figures add up wrong, Bob,' says Judy in an intertitle, 'let's try mine.' She was prisoner 3107, and once the 1 is doctored and the numerals are made to stand on their heads, the word they pronounce is LOVE.

The talkies officially began in late 1927 with *The Jazz Singer*. Although the film still used intertitles, it contained two minutes of synchronized dialogue as well as half a dozen musical numbers performed by Al Jolson. This was cinegenesis all over again: God, otherwise known as Logos, spoke or perhaps sang the world into being, but *The Jazz Singer* gave audiences a choice between sacred and profane sources. At the synagogue a cantor intones the Kol Nidrei, while in the saloon Jolson warbles 'Toot-toot-tootsie goodbye' and delivers a gushing hymn to mother love that rhymes 'Mammy' with 'Alabamey'. Samson Raphaelson, who wrote the story and play on which the film was based, saw Jolson as 'an evangelical man' but described his caterwauling as 'prayer distorted, sick', which conjured up 'a vision of cathedrals collapsing' – or being converted into picture palaces? In 1929 the critic Herman Weinberg also wondered if sound might not be a curse. Like Man Ray in his comment on the light from the swimming pool in *Les Mystères du Château de Dé*, Weinberg cited the malediction on Belshazzar's wall that announces the imminent fall of Babylon, MENE MENE TERKEL UPHARSIN, and produced his own wittily pessimistic version, 'Mene Mene Talkie Upharsin'.

In 1930 Ufa's first sound newsreel entered into a solemn covenant with the German public: in a spoken prologue, Emil Jannings assured cinemagoers that 'Nothing will ever happen anywhere in the world without your being an eye- and ear-witness to it.' This statement of mission gave the eye priority, but in the same year Jannings still had to grapple with the divisive tribal rules that complicate language. As the fuddy-duddy schoolmaster in Sternberg's *The Blue Angel*, he spends an English lesson taking his rowdy class of German boys through Hamlet's soliloquy about suicide. At the end of Hamlet's first line 'the question' proves to be contentious, because Jannings objects to the way his pupils pronounce the dental fricative. When he comes face to face with a lad who turns 'the' into 'ze', the lesson degenerates into a spitting contest.

Jannings then sets the class a written test, asking 'what would have happened if Mark Antony *hadn't* delivered his funeral oration' in *Julius Caesar*. Here too, silence might have kept the peace, because Antony's rabble-rousing speech incites a civil war. The woman who rents a room to Jannings is more briskly dismissive: noting that his pet canary has not sung for a long while, she throws its little body into the stove. At the end of the film, having been corrupted by the Lola of Marlene Dietrich, the verbose pedant is reduced to onomatopoeia, and he entertains her customers by crowing 'Cock-a-doodle-do' in the sleazy cabaret.

Recorded sound forced language to compete with a barrage of untempered noise. In G. W. Pabst's *Westfront 1918*, also released in 1930, the German infantrymen in their trenches joke, swear, sing or gasp and groan, while their commanders bark futile instructions into faulty telephones or trust a dog to deliver a message to headquarters. The fates of all are meanwhile decided by inarticulate sounds: the rat-tat-tat of gunfire, bells that warn about poison gas, the intermittent screech of shells and the ensuing explosion. Garbo in 1930 condescended to speak by gruffly ordering a whisky in a waterfront bar in *Anna Christie*: her vocal debut was a calculated self-desecration. The film begins with Marie Dressler as a sloppy harridan yodelling out of tune to a tinny gramophone and then drunkenly hiccuping while a barrel organ churns in the street. Garbo later tells the sailor played by Charles Bickford that he has a voice like a foghorn. Chaplin refused to let his voice be heard until 1936, when he performed a song in *Modern Times*. In his dressing room he rehearses mutely: 'I forget the words,' he tells Paulette Goddard, using an intertitle to do so even though a band and some singers can be heard on the soundtrack. Goddard scribbles the text on his cuff, but it comes loose when he bounds onstage, so he sabotages language by making up a vaguely Italianate mumbo jumbo:

> La spinash o la bouchon
> Cigaretto Portobello
> Si rakish spaghaletto
> Ti la tu la ti la twah.

Four years later, derisively impersonating Hitler in *The Great Dictator*, he harangued and ranted at length – but he did so unintelligibly, because the demagogue's oratorical sound and fury signified nothing.

Even after sound and image were indissolubly wedded, cinema sometimes pined for earlier, quieter days. In Richard Boleslawski's *The Garden of Allah*, released in 1936, a simmering Dietrich tempts Charles Boyer to abandon the silence of his Trappist monastery. His defection is announced in dumb show, as a monk bursts into the refectory carrying Boyer's discarded robes. Since this is an emergency, he is given leave to speak, and he utters the fateful sentence 'He has broken his vows.' Boyer later explains his apostasy by saying 'I listened to the voices of women': that was somehow more sinful than looking at Dietrich as she skimmed across the Sahara in beige chiffon. Gloria Swanson, playing a relic of silent cinema in *Sunset Boulevard*, objects to dialogue – 'I can say anything I want to with my eyes,' she rages – and William Holden sarcastically adds that now in the era of talking pictures they sell popcorn in theatres so people can stuff it in their ears. When Swanson visits DeMille on set at Paramount, a microphone grazes the peacock feather in her hat; she swats it aside, as if repelling a pest.

In 1923 George Bernard Shaw mocked the notion of 'speechless drama', and said that audiences only loved Mary Pickford because they knew she would never say anything – but when Asquith filmed Shaw's *Pygmalion* in 1938, he made it a drama about the pains and perils of speech. During the flower girl's arduous phonetic training, Asquith emphasized the Frankensteinian cruelty of the technology that recorded sound: the laboratory of Leslie Howard's Professor Higgins contains grisly anatomical models, a gramophone with a distended horn and a surgical-looking needle, screens with agitated signals like seismographs, and a flame that is snuffed out when the Eliza of Wendy Hiller aspirates. We are reminded of how unforgiving the talkies were, abruptly terminating the careers of silent actors like John Gilbert who were thought to have unpicturesque voices. Eliza survives the trial, but comes out resembling the *Metropolis* robot with plummier vowels, especially an 'e' that Higgins tells her must be pronounced 'as in mach*ine*'.

In 1946 René Clair hinted that he was still not entirely reconciled to sound. His comedy *Le Silence est d'or*, released the following year, is about the ageing director of a silent film and two actors who are his protégés. The title, however, wittily refers to the over-tactful behaviour of the young people, who when not in front of the camera keep up a discreet silence about their feelings for each other. The director, played by Maurice Chevalier, helps them along by revising the script; talking to prompt the pair while the camera rolls, he arranges a happy ending. Since no sound is being recorded, he knows that his intervention will remain a secret.

Was sound an uncouth cacophony, ruining a mystique that silence preserved? Not for Bresson, who called the eye 'superficial' but considered the ear to be 'profound and attentive'. The eye is scatter-brained, distracted by what happens in front of it; the ear is a cavity, a resonance chamber, oriented towards what Bresson called 'the within'. 'Regarde!' says a boy as he drops his pants to scandalize the persecuted heroine of *Mouchette*, but the abused waif in this 1967 film does not look, and neither does Bresson's camera. By contrast, when someone says 'Écoute le cyclone!' the ear pays attention to a rainstorm that sounds like a biblical deluge. True to his ascetic principle, Bresson preferred to cast performers over the phone: 'that way,' he said, 'my eyes don't confuse me'. He then coached the people he chose – whom he referred to as models or 'jiggling puppets', not actors – to speak their lines expressionlessly, and wore them down with multiple takes so that their delivery would be drained of nuance.

Bresson argued that on film 'what you hear is more revealing than what you see', and what you hear in *Mouchette* is not primarily talk. Inarticulate sounds define the heroine's downcast state: the dumb concussion of her wooden clogs, their squelching as she tramps through the mud. A tractor is heard in the fields, then briefly seen just before the despairing girl wraps herself in a shroud and rolls downhill to drown in the lake; almost chorally, the machine represents life's heedless continuation. Elsewhere a bird strangled by a snare briefly thrashes in the bushes, and another bird's wings flap in rhythmic elation when a gamekeeper frees it. At such moments we eavesdrop on the travails of

the soul or its ecstatic release from physical entrapment. Such sounds extended, Bresson believed, into a 'third dimension': rather than careening towards us like the missiles in 3-D films, they recede elegiacally into the distance, or echo back from a metaphysical realm.

* * *

Towards the end of his career Bresson toyed with the idea of filming Genesis, and when asked where his narrative would stop, he replied 'Either with the Flood or at the Tower of Babel, with the invention of languages.' That was not necessarily a dead end: cinema has sometimes attempted to heal the breach between our jabbering idioms and idiolects.

Linguistic borders are toppled in Pabst's bilingual *Kameradschaft*. Here German volunteers cross the border in Lorraine to help rescue French colleagues trapped underground when their coal mine caves in; to the consternation of the fussy French guards, they speed through a customs barrier, and in the flooded tunnels they demolish gates that established an underground frontier when the political map was redrawn in 1919. The title of Renoir's *La Grande Illusion* refers to an ideal like that which prompts Pabst's miners – not so much comradeship as fraternity, imperilled by the 1914–18 war but salvaged thanks to the multilingual sympathy between the French, Russian and English soldiers and their German captors. The affinity partly derives from music, with its Esperanto of the emotions. The French internees perform a snatch of Gounod's opera *Faust*, which demonstrates that the Germans do not have a monopoly of Goethe's hero, and a guard gives Jean Gabin a mouth organ to cheer him up in solitary confinement. When Gabin tries to tell the monoglot English prisoners that a tunnel is being dug under their barracks, their ignorance of French means that they miss a chance to escape. The wily Erich von Stroheim, playing the commandant of the prison, later uses English to talk a French runaway down from the battlements: that way, the other Germans will not know how unpatriotically merciful he is being. According to cinema, Europe's wars can serve as a school of language-learning. In Rossellini's *Paisan*, a Sicilian girl serves as a reluctant guide for GI Joe from New Jersey after the Germans are expelled from her village in 1943. Helped along

by mime and his snapshots, they fumble towards an understanding; then they are killed.

Jean-Pierre Melville's *Le Silence de la mer* is about an elderly Frenchman and his niece who are obliged to billet a German officer during the Nazi occupation. A cultivated fellow, probably a dissident, their unwelcome guest tries to converse with them in the long shut-in evenings; by way of protest, they refuse to reply. The film is not silent – the old man recalls the events in a voice-over narration, and the German delivers well-meaning lectures about his country's cultural bonds to France, which his hosts tune out – but words here matter less than Woolf's 'things people don't say'. The bodies of the characters speak for them. The niece, played by Nicole Stéphane, at first has the straight-backed rectitude of a caryatid, though she responds with an inimitable Gallic shrug when her uncle suggests that her behaviour is inhuman. Once, in an enormous close-up, she fixes her pale, pained gaze on the German. 'Oh, welch' ein Licht,' he says as he retreats, a hand shielding his face: her eyes emit a light that pierces him. She gradually relents, while her uncle relies on his pipe to keep his mouth pursed shut. Announcing his departure – presumably for the eastern front, where he will no doubt be killed – the German's hands twitch in nervous distress, and as a final peace offering he plays Bach on the harmonium. The niece's head droops, as if her thoughts and feelings, tenderized by music, were an overpowering weight. It comes as a shock and an almost ecstatic release when she addresses a single word to the German, almost inaudibly whispering 'Adieu'. Her lips hesitate, rehearse, let the utterance escape; then her downward gaze signals instant repentance.

In the novel by Vercors that was Melville's source, an uncomfortable silence is said to invade the room like a suffocating gas. Although a film cannot illustrate that oppressive metaphor, stray noises recorded by Melville tensely stir the air. A clock ticks, a dog barks outside, the stairs creak as the German, having once more failed to win a concession, goes up to his room. There could be no better evidence for Bresson's claim that 'The soundtrack created silence'. But the silence carries with it a burden of moral responsibility: although the novel appeared in 1942, Melville's film was released in 1949, and it adds a scene in which the

officer during a trip to Paris is informed about Treblinka and the Third Reich's policy of mass execution in gas chambers. Silence for the French is a form of passive resistance; for the German it implies complicity, perhaps consent.

Today we inhabit a smaller, more interconnected world, in which cinema challenges us to recognize variant forms of our human nature. That is at least the hope of Iñárritu's *Babel*, released in 2006, which deals with cultural confrontations in Morocco and on the border between California and Mexico. But a shared language does not make peace between an American and an obnoxious Englishman, who come to blows during a bus tour through North Africa. Neither does it prevent immigration enforcers from tearing apart a family in San Diego when they summarily deport an undocumented Mexican woman who is a virtual mother to the 'gringo' children she looks after. In the Tokyo episode of *Babel* a deaf mute is estranged even from her own language. Unable to articulate her longing for acceptance, she strips naked and abjectly offers herself to a young policeman; when he backs away, she writes a long message on the note pad she carries with her, slips the page into his pocket, and silently implores him to read it later. He takes it out in a restaurant, and the camera teases us by peering over his shoulder. But it remains untranslated – forever secret, like the mysteries that Cupid barred Psyche from imparting when he sealed her lips.

Empathy extends further when cinema invites us, as no other art can do, to look into the eyes of creatures lacking language. Gabin in *La Grande Illusion* befriends a German cow, which seems to appreciate his French chatter. The German rescuers in *Kameradschaft* put their trust in a level-headed French horse from the mine's subterranean stable. As it plods ahead of them through the sooty catacomb, one man regrets that it does not understand German, but another points out that dumb animals are sometimes smarter than people. If not smarter, they are certainly as capable of suffering, which is why in 1966 Bresson treats the donkey in *Au hasard Balthazar* as a tragic hero, even a Christian martyr: the persecuted animal – likened by Bresson to Chaplin's long-suffering tramp – is named after one of the Magi who travelled to Bethlehem to greet the Nativity. At one point in the film, montage

organizes an exchange of speaking looks between Balthazar and some circus animals. The donkey is docile, blinking to scatter flies not to admit unease; the hunched and apparently depressed polar bear looks away; the elephant's eye, tiny for so huge a body, withdraws behind its folded layers of skin; the chimpanzee's expression is alert, mocking, genuinely observant rather than watchful like the glaring lion. Perhaps the way we read these intersecting glances is an exercise in projection: we attribute our own emotions to animals that may not be capable of feeling them. But the pathetic fallacy does not lessen the value of the sympathy the scene induces.

In 2018 Wes Anderson's stop-motion animated film *Isle of Dogs*, set in Japan, leaves the dialogue of the human characters in the original language or has it garbled by a tone-deaf interpreter and a clumsy electronic translator. The barking of the canine cast, however, is verbalized in English and eloquently voiced by the likes of Edward Norton, Bryan Cranston, Tilda Swinton and Scarlett Johansson – an act of reparation that honours what the film's merely human hero describes as 'the finest living beings in the world'. And in 2013 in the Coen brothers' *Inside Llewyn Davis*, the bohemian folk singers of Greenwich Village prove to be less free-spirited than an orange tabby cat that haughtily ignores them as it roams free, escaping through open doors or windows and periodically reappearing when it chooses to do so. Cinema is about liveliness, made manifest by movement not speech, and there could be no better symbol of this than the camera's pursuit of a slippery cat.

12

ANATOMY LESSONS

The poet Hilda Doolittle believed that cinema was, or ought to be, an emission of 'redemptive light', and Cesare Zavattini imagined that light serenely passed through the camera to shine on man, establishing the 'dignity of every human being' and assuring audiences that despite their anonymity 'they are the true protagonists of life'. Such noble accounts of cinegenesis ignore the disjunctive, expedient way that films come into being. The eye, as Bresson said, 'demolishes what it sees and puts it back together according to its own idea'. Likewise the numbered scenes and shots in screenplays are never photographed consecutively, and the footage with its multiple versions of the same thing is rearranged as an editor sees fit. In pre-digital days, a blade chopped into the reels, and the resulting assembly – called a montage, to rhyme with the collages made by the cubists – was held together by tape, glue or acetate cement.

Procedures like this make for a shaky, provisional compound. In the opening essay of *The White Album* Joan Didion recalls a period in the late 1960s when, while living in Hollywood and occasionally working as a screenwriter, she felt distracted, unsettled, and muddled through her days as if she were someone else or several other people, all of them strangers. She describes this jangled state of mind cinematically. She seemed, she says, to lack a script for her existence; those years were 'not a movie but a cutting-room experience', because any narrative order imposed on such spasmodic moments would be arbitrary, only too easily revised. She brilliantly sums up her condition in a phrase that hints at the shuttling and flickering of a film strip and the automatism of the figures we see on the screen: her life felt 'rather more electrical than ethical'.

Machines are better able to withstand this assault than human minds. Léger praised the sharp-edged, unstable vision of Gance's *La Roue*: the film, he declared, followed the plastic imperative of modern art, which was 'the fragmentation of the object'. The designer Saul Bass exemplifies this divisibility in Frankenheimer's *Grand Prix*. To show the fiddly technicalities of preparation in the pit before a Formula 1 race, Bass splits the Cinerama screen into a lattice of squares, multiplying the tasks of maintenance that are repetitively performed by mechanics as they fit spark plugs and tighten nuts with wrenches while needles on tachometer dials dart to and fro. During laps of the course in Monte Carlo, the screen breaks vertically into three panels, or dodges between views of the track at ground level and wider angles from grandstands or an overview from a low-skimming helicopter. The driver played by James Garner says that he shifts gears 2,600 times during a race, which means a change every three seconds. Editors, when they occupy the driver's seat, likewise make constant small recalibrations of a film's pace, so we watch in the same alert, possibly agitated way.

Early in cinema's history the Soviet filmmaker Lev Kuleshov demonstrated that montage can alter our assessment of cause and effect. To a close-up of a man's face he alternately added shots of a meal laid out on a table, a dead baby in its coffin, and a beautiful woman lying availably on a divan. Audiences assumed that in the first case the man looked hungry, in the second grief-stricken, in the third lustful, even though the initial neutral close-up was the same; editing encouraged an association of ideas, followed by a summary judgement. In *Bande à part* Godard has Claude Brasseur conduct the same experiment with Anna Karina during a trip on the Métro. He tells her to study a man dozing in his seat. Does she surmise that he is taking a toy home to his sick daughter? If so, she will read his expression sympathetically. But if she suspects him of carrying a bomb, he will look fiendish to her. There is no evidence for either supposition, and the man's expression has not changed. Montage knowingly applies blinkers: in deciding what we see, it prohibits us from seeing something else – and sometimes what we do see should not be believed. Hitchcock caused a small scandal when he began *Stage Fright* with a flashback narrated by Richard Todd, which

shows Marlene Dietrich in a blood-stained dress confessing to a crime which Todd himself has committed. We may think we are eyewitnesses, but we have been hoodwinked. As Godard declared, 'every edit is a lie'.

The so-called 'Kuleshov effect' is the uncertainty principle applied to cinema: the camera's act of observation alters what is being observed. In *Pandora's Box*, for instance, the choices made by Pabst as he stages and edits the showdown between Louise Brooks and the crazed, cuckolded Dr Schön of Fritz Kortner work to exonerate Lulu, or at least to avoid incriminating her. Telling Lulu that she has no right to go on living, Schön first forces her to take his gun and tries to make her aim it at herself. There seems to be no good reason for her to oblige: as she says in Wedekind's *Erdgeist*, it is hardly her fault if men destroy themselves for her sake. Then, as Schön closes in on her, Pabst directs the camera to watch from behind them. The gun cannot be seen, and because the film is silent it cannot be heard either; only the smoke that puffs out between their bodies testifies to the discharge of bullets. Schön turns away, with no evidence of a wound on his white-fronted evening clothes: he might have been struck down by some inner convulsion, not by Lulu. He staggers to the bed, sits, hauls himself upright, lurches back towards her, clasps her head, then crouches on all fours at her feet, still doggedly devoted. At last he is able to die, with a trickle of blood from his mouth and his eyes upturned. He wanted Lulu to help him by committing suicide; Pabst makes it look as if he has committed suicide with a little help from her.

Another montage blurs cause and effect when Lulu, reduced to prostitution in London at Christmas, picks up a harmless-looking man who turns out to be Jack the Ripper. As they climb the stairs to her attic, her client covertly pulls out his knife and throws it away, literally disarmed by her kindness to him, and their encounter begins sweetly, with no hint of violence. He sits her on his knee for a cuddle and crowns her with mistletoe; then, quite by chance, a close-up edited into the sequence of shots directs his attention to a breadknife on the table, its blade gleaming in the candlelight. Is the weapon to blame for tempting him, or should Lulu be held responsible because she left it there? We do not see the Ripper using the implement, because the camera once

again is looking at something else. As they embrace, her hand, which is clasping him, suddenly loosens; her arm falls slack, to signify what might be an erotic surrender – or is this an act of expiation by a victim who acquiesces in her own murder?

At the climax of King Vidor's *Street Scene* – an adaptation of Elmer Rice's play, made in 1931 – two gunshots announce a double murder inside a New York apartment where a husband has surprised his wife and her lover. The camera jumps upwards from street level, but can only see two windows with their blinds lowered during the day; then a man stumbles against the glass, breaks it, and collapses inside the room. Some lookers-on peer out from their own windows, while others, cued by a series of staccato musical beats, leave nearby shops and rush forward into momentary close-ups. There is no crowd, only a succession of isolated individuals – including a Chinese worker from a laundry and a black man from a grocery store – who are thrust into proximity by urban congestion. As the camera withdraws, the people it has singled out congeal into a mob, the men effaced and equalized by their hats or caps. Then the rumble of the El train on the corner resumes, the departing ambulance keens, and the tawdry drama is compressed into a sensational newspaper headline. Vidor's flurried montage of happenings suggests that these unseen deaths belong to the viewers – to the inquisitive neighbours who push and shove, to tabloid readers like the nursemaids who push prams along the street the next day and gossip about the case, and to all of us in the audience. Chopped up editorially, the victims are sacrificed to the city and to cinema.

Although editing divides, it does so in order to reunite. Eisenstein thought that montage worked like a chemical reaction, or perhaps like the process of dialectical reasoning that advances towards a merger of divergent opinions. 'Any two pieces of film stuck together,' he said in 1938, 'inevitably combine to create a new concept.' This happens in 1960 in Mikhail Kalatozov's *Letter Never Sent*, about an expedition by Soviet geologists prospecting for diamonds in Siberia. Before a wildfire strands the group in the wilderness, montage generates a creative friction between the scraps of film it assembles. Stalwart toilers, naked to the waist, smite rocks with their picks; their hammers strike sparks

that ignite into an almost industrial blaze. This conflagration then subsides into the embers of the cigarette that the hero smokes beside a tame domestic campfire, as he daydreams about the economic benefits of their quest. The logic of the editing spells out a parable about the way nature can be pulverized or punished to release the power that is latent in it.

Although Eisenstein emphasized inevitability, at their best such conceptual jumps produce a shock, a gasp of wonderment, or both at once. In the prologue to Kubrick's *2001*, a pre-human cave-dweller realizes that a bone from a zebra's skeleton can be used as a battering ram, and with it he fends off a tribe of simian competitors. Violence then instigates a momentous creative leap. As the ape hurls his weapon into the air to celebrate victory, its place is taken by a white Pan Am shuttle that commutes between planets to the sound of a swooningly circular Viennese waltz. Bone and spacecraft are both projectiles, and the association between them projects us in an instant from brutish prehistory to a remote galactic future.

An equally unexpected cut in Karel Reisz's *The French Lieutenant's Woman*, released in 1981, elegantly falls back through time rather than vaulting ahead across millennia. Jeremy Irons and Meryl Streep act out two parallel plots: a Victorian gentleman becomes infatuated with a disreputable woman, and a pair of modern actors play those characters in a film of the story while furtively conducting an affair of their own. In one scene, assuming their roles as the Victorian couple but without the benefit of period costumes, Irons and Streep rehearse a diffident early encounter in the woods. The script calls for them to look at each other with a jolt of recognition, after which Streep, recoiling, stumbles as she catches her dress on a bush. The vegetation is missing from the hotel room where they are practising their moves, so she drops onto a bare floor in the 1970s as rain beats at a window; in a startling cut Irons reaches out and catches her in the sunnier nineteenth century. Now dressed in their old-fashioned identities, they settle onto a grassy hillside to begin a nervy, inhibited flirtation.

In *2001* an impromptu idea kick-starts evolution, making the ape a precursor of the astronaut. In *The French Lieutenant's Woman* an

emotion released by a small physical mishap changes the relationship between two people and merges them with their prototypes in the past. The change is epochal in *2001*, whereas its equivalent in *The French Lieutenant's Woman* is subtle, delicate, but still decisive. The scissors in both cases slice through consecutive time and across contiguous space, editing the world.

* * *

In 1925 René Clair hailed the liberties available to what he called 'cerebral cinema'. 'You are mine, dear optical illusion,' he said, 'mine this reconstructed universe, whose obliging perspectives I reorient as I wish... We must admit that reshaped nature is at least as expressive as "natural" nature.'

Clair's *Le Voyage imaginaire* explores that unnatural realm. A fortune-telling fairy lures a bank clerk down a rabbit hole into a wonderland whose obligingly reoriented perspectives are a catalogue of special effects. The timid clerk flies, clings to the ceiling, uses a twirling umbrella as a helicopter, and – as superimposition reveals – is temporarily trapped inside the belly of a bulldog. Hags dissolve into nubile starlets when kissed. In another case of cinematic animism, the waxworks in the Musée Grevin start into life after hours and brawl about a guillotining that went wrong. During the squabble, one of them loses his head a second time, and the bulldog vainly endeavours to eat it. Less magically, Fritz Lang reshaped nature for an outdoor sequence in his second *Mabuse* film. He razed a section of forest on the outskirts of Berlin, replanted it with geometrically arranged trees that hung on wires, and even made his own tidy arrangement of the long-stemmed grass blades.

Renoir worried that this editing of reality had a destructive motive. In 1968, in an essay paying tribute to Dreyer, he asked 'Did God give us the world so that we could take it apart and analyse it? That is what man is doing today.' The analytical tendency was responsible for cinema and also for nuclear fission: analysis is about breaking things down, anatomizing them, and not even the atom remains intact, as Jacques Rivette pointed out in 1969 when he said that Soviet directors like Eisenstein and Vertov dynamized montage with their 'atomization of

shots'. Saul Bass's credit titles for Otto Preminger's *Anatomy of a Murder* act out just such an anatomy lesson, as the parts of a cubist corpse are seen separately, pulled apart but never rejoined, with the painful breaks marked by the wailing chords of Duke Ellington's jazz band. 'There are still some pieces missing,' says Ben Gazzara when asked to recollect the details of the killing for which he is on trial.

Bass loved contriving such graphic catastrophes. In 1963 his credit titles for Stanley Kramer's *It's a Mad, Mad, Mad, Mad World*, a comedy set in motion by a car crash, sketch a globe that changes to an egg once a hen sits on top of it, though what it hatches is a series of stick figures chasing loot; later it mutates into a wind-up bomb, only to be sliced longitudinally like a sardine can opened by a key or ventilated from inside by windows and doors. A zip fastener undoes it around the equator, and a saw bites into it, after which the missing segment is nailed back into place. The eggshell's top lifts off to let out a firework display; a balloon bursts, then is re-inflated by a pump. Finally a pair of scissors, the editor's indispensable helper, make a paper chain of the film's cast. The inventive energy is terrifying, because the broken globe and the cracked egg can never be repaired.

Renoir joked in his essay about 'the sin of Dreyer', whose camera, contemplating but also tormenting a saint in *La Passion de Jeanne d'Arc*, contributed by almost surgical means to our knowledge of human nature. With cruel incisiveness, Dreyer turned Falconetti's Jeanne into an 'abstraction', as Renoir put it, by making her shave her head. Although Renoir placed Dreyer on the side of the angels by calling him a 'distributor of spirit', the editing of *La Passion de Jeanne d'Arc* does take things apart, sometimes with jarring illogic. As the condemned woman is tied to the stake, she clutches a crucifix and prays; this image is intercut with brief shots of a child in the crowd of witnesses, sucking a plump bare breast. Thesis and antithesis collide, as in Eisenstein's dialectic, and the synthesis is left up to us. Do we conclude that religion is for milksops? Is the patriarchal church being challenged by the sympathetic, maternal women who gather around the pyre? Or is this a comment on execution as a spectator sport like the cinema, staged for audiences who want bread as well as circuses?

A decade before his essay on Dreyer, Renoir confided some of his alarm and implicit remorse about the modern analytical habit of mind in his television film *Le Testament du docteur Cordelier*, a version of the Jekyll and Hyde story with Jean-Louis Barrault as both the psychoanalyst Cordelier and the feral ogre Opal into whom he changes when he drinks a potion. A colleague accuses Cordelier of a blasphemy against matter – another way of complaining about the immateriality that Renoir had come to think of as the shadow side of cinema. Cordelier drugs his female patients and makes love to them while they are unconscious, which puts into practice the surrealist belief that cinema can penetrate our dreams. When he defends himself by saying that the hirsute, bestial Opal is 'le reflet transparent de mes instinctes', Cordelier's choice of adjective is telling: film is transparent, and Opal has an unashamed levity that prompts him to do a little Chaplinesque jig after knocking down a passer-by. At the end, with normality restored, Renoir's directorial voice-over describes Cordelier's experiment as his 'recherche spirituelle'. Worried by this dangerous affinity between science and an unholy spirituality, Renoir late in life turned from cinema to the earthier, more grounded art of ceramics – a reminder that in Genesis the first man was moulded from clay rather than being an offshoot of light.

'There is spirit and there is matter,' Renoir wrote in his homage to Dreyer. 'There is God and there is the Devil,' he added. Epstein, who belonged to the Devil's party, said that cinema brought about the 'liquefaction of the universe into unidentifiable and incommensurable forms'. An example might be the climax of the battle on the ice in Eisenstein's *Alexander Nevsky*, released in 1938 – a welter of warriors and horses, thrashing about as the frozen lake cracks into shards beneath the German knights. This liquefaction involved another of cinema's experiments in constructing a small universe that was rigged to destroy itself. Because the film was made in summer, Eisenstein had to manufacture the ice sheets by coating a pond with a surface of chalk and liquid glass. He then had the interlinked slabs mounted on pontoons that, when deflated, pulled the angular blocks apart to engulf the Germans. Elsewhere, with an ironic wink, Eisenstein lets us see how such illusions are put together. The German army expects war to have a soundtrack, and a

hooded monk with a glowering, skull-like face plays on an organ during the strife – an odd amenity, explained when we see that the instrument is dragged about on a sledge, with two assistants bent over the bellows that puff air into the pipes.

Eisenstein described montage as 'a mighty weapon', as if it belonged in the armoury of spears, axes and hooks proudly tempered by the patriotic smith in *Alexander Nevsky*; the way he edited the combat matches the ruthlessness with which the Russians hack to pieces the invading Germans. Orson Welles likewise militarized montage in *Chimes at Midnight*, his digest of Shakespeare's history plays, and he edited the ten-minute battle at Shrewsbury so that, as he said, 'every cut seemed to be a blow, a counterblow'. He was already thinking cinematically when he filleted *Richard III* for a staged adaptation while still at school: he treated the complete text as a carcass and himself as its editorial butcher, and explained that 'of the original kill, the choicest cuts have been preserved'.

Films are artefacts that have been carved and sutured, like bodies in an operating theatre. 'How's the arm?' someone asks a wounded Korean War general in Samuel Fuller's *Fixed Bayonets!* 'Still on,' grunts the patient. When the doctor threatens him with amputation, he says 'Clean it, dress it, tape it and forget it.' Later a medical orderly who has to operate on his own leg is brusquely told 'Start cutting!' When an infantryman has his ear shot off, his colleagues pocket it for safekeeping, though they are told to throw it away because it is too damaged to be sewn back into place. David Lynch's *Blue Velvet* begins with the discovery of another human ear on a suburban lawn. 'Looks like the ear was cut off with scissors,' says the coroner who is investigating the mutilation; his remark is joltingly followed by the snap of scissors that cut through a yellow police tape at the crime scene.

So much aesthetic carnage can feel threatening. After seeing *La Passion de Jeanne d'Arc* in 1928, Hilda Doolittle felt she had been lacerated by the editorial scalpel. 'Do I *have* to be cut into slices by this inevitable pan-movement of the camera... all rhythmical with the remorseless rhythm of a scimitar?' she asked. She was right to flinch. Montage tests our nerves, as James Cagney finds in *White Heat* when the machines in

the prison's metal shop bring on one of his deranging migraines. His brain is rhythmically battered by gnawing drills, percussive stamps and presses, and lathes that strike sparks under the glare of neon tubes. The pain, he says, feels like 'a red-hot buzz saw in my head': as with the scimitar, an editorial tool shreds consciousness.

At its most frenetic, montage can seem to penetrate the white surface on which the images are projected. The shower scene in *Psycho* crams seventy-eight editorial cuts into fifty-two seconds, and it is not only Janet Leigh's body that is ripped and gashed. Joseph Stefano's script called for 'the impression of a knife slashing, as if tearing at the very screen, ripping the film'. A more deliberate act of directorial or editorial murder occurs in Robert Lepage's *Le Confessional*, in which reminiscences of Hitchcock's visit to Quebec to make *I Confess* in 1952 are the pretext for a second plot, set in the 1980s, about the snarled relations between two brothers who have grown up in the interim. Near the end of Lepage's film, the actor cast as Hitchcock orders the camera to roll and calls 'Action!', letting his arm drop like a Roman emperor ordering a death; the colour film then melts into a monochrome excerpt from *I Confess*, with Montgomery Clift as the priest who discovers a murderer hiding in his church. After the scene is played out, Hitchcock says 'Cut!' The command resonates through time and abridges space, connecting two moments that are almost as remote from each other as Kubrick's bone and spacecraft: thirty years later in Japan, the estranged brother obeys Hitchcock's command by picking up a straight razor with which he opens his veins in a bathtub. The technical metaphor once again turns literal and lethal.

Hitchcock, as Godard pointed out, made a habit of cutting on a look, and when he followed a character's eyes he traversed dimensions that physics and the arts traditionally separated, 'destroying the notion of space in favour of that of time'. The example mentioned by Godard is from *The Man Who Knew Too Much*, released in 1956. At a concert where a noisy climax will cue an assassination, Doris Day's gaze darts from the conductor to the cymbals – still at rest on a pair of red velvet chairs – to the brass player who waits for the precise moment when he will pick them up and bang them together; that is the cue for the

tiered chorus, whose tuned outcry will help to muffle the sound of the gunshot. She also sees the skulking gunman in his box, and the bald domed head and complacently plump body of the politician who is his target. Crying as distress and confusion overcome her, her eyes meet those of the assassin, who stares back at her through the insect-like goggles of his opera glasses. Her increasing panic as she looks to and fro is a reminder of Godard's claim that montage is a heartbeat, although here that cardiac rhythm is dangerously irregular, almost fibrillating when the impatient camera skims ahead along the bar lines of the orchestral score to glance at the moment when the cymbals will sound their thunderclap and a life will end. Montage ratchets up tension for ten excruciating minutes, and relieves it just as the female chorus in Arthur Benjamin's *Storm Cloud Cantata* announces, in an outburst of shrilled high notes, that the clouds have broken to discharge their load of rain, 'finding release'. The result, however, is an anticlimax: Day's warning cry fractionally anticipates the clash of the cymbals, which distracts the assassin, whose bullet merely grazes the dignitary's arm. The spoiled shot disrupts the synchronicity between music and action, and dares us to admit how disappointed we are to be deprived of the promised kill.

Godard in his comments on the concert in *The Man Who Knew Too Much* said that montage is a form of foresight; Pier Paolo Pasolini saw it as a kind of foreshortening, a drastic rearrangement of the 'infinite film sequence-shot' that makes up a human life. In an essay written in 1967, Pasolini suggested that montage always works in reverse, tracking backwards from the predestined end. Our internal cameras promiscuously record everything we see until at last, preparing to die, we review our accumulated experience. We then editorially single out the events that have mattered most and rearrange them into a plot, giving shape to our existence.

Something analogous happens in 1968 in Pasolini's *Teorema*, where the complacent members of a bourgeois household in Milan are sexually aroused and spiritually awakened when a stranger, played by Terence Stamp, makes them question who they are. The revaluation is destructive: they each in different ways find truth, and in doing so they

fall apart. When their visitor leaves, the father abandons his factory to the workers and purgatively strips naked in a railway station, the mother consoles herself by picking up young men on the roadside, the daughter lapses into catatonia, the son drops out and devotes himself to art, while the maid becomes a miracle worker and a self-immolating martyr. The continuity between their old lives and these rebirths is snapped, illustrating Pasolini's theory that 'montage plays the same role in cinema as death does in life'. Aptly, the Greek myth of the Fates equipped Atropos with shears, and she used them to edit and abbreviate human lives.

* * *

When D. W. Griffith first proposed photographing a character in close-up, a studio executive objected that this would be poor value for money. 'We pay for the whole actor, Mr Griffith,' he said. 'We want to see *all* of him.' Griffith retaliated by pointing out that our view of other people seldom extends from head to toe. Breaking up performances into snippets that were later edited into a sequence, he thus invented what the Dadaist Hans Richter brilliantly called 'mosaic-acting'.

In a little documentary made in 1918, Chaplin defined himself as a collage of inorganic accessories. At the studio, we see him preparing his persona for the day's work by trimming his 'million-dollar moustache' with horticultural clippers, and removing his 'greatest treasure', those outsize boots with their leaky soles, from the bank vault where they are stored. Erich von Stroheim's mystique as an aristocratic seducer in *Foolish Wives* – directed by Stroheim himself in 1922 – depends on fancier paraphernalia: the shine on his knee-length military boots, what an intertitle calls the 'powerful magic' of the brass buttons on his tunic, the monocle through which he studies potential victims, and a cane that is as indispensable as Chaplin's. His borzoi retrieves this phallic accessory after it is swept away in a torrent, and Stroheim takes it with him when he clambers up a ladder into the bedroom of a deaf mute he intends to rape. He also uses it to kill an unpropitious black cat that crosses his path. The 'whole actor', here and in Chaplin's case, is the sum of parts that the camera studies separately.

Cinema refuted our assumption that identity can only be established by a frontal view of the face. James Cruze, directing Stroheim as a fiendish ventriloquist in 1929 in *The Great Gabbo*, said that 'Von' could dominate a scene with his back turned: his columnar neck, surmounted by the battering ram of his shaved head, expressed his glowering will, just as Mae West's undulating bottom gesticulated on her behalf. Emil Jannings also often acted from the rear. In Dupont's *Variété*, having been reduced to a number by the 28 on the back of his prison uniform, he shuffles down a long, arched tunnel, sits facing the warden with the camera trained on his hunched shoulders, then collapses forwards onto the desk as he reads a letter from his wife. Recovering, he begins a retrospective narrative, appropriately delivered with his back turned because he is looking into his past. The climax of Dreyer's 1925 silent film *Master of the House*, about a domestic tyrant who is humbled by his womenfolk, depends on a tactful, unsentimental avoidance of faces. When Johannes Meyer's daughter is restored to him, Dreyer respects the privacy of the moment. The father is seen from behind, his stance still stiff, his shoulders squared; the young woman, who is shorter, remains invisible in front of him, and we see only the hands she raises and clasps behind his neck. As an epilogue, a close-up of his lower extremities wryly confirms his redemption: a nurse, entering with a tea tray, notices his dusty trousers, which indicate that he has been kneeling to beg forgiveness.

Alastair Cooke joked that Russian film editors ignored the head as a matter of political principle, because it was 'the most bourgeois member of the body'. Nikolai Cherkasov, cast as the Czar in Eisenstein's *Ivan the Terrible*, escaped decapitation but complained that the director bent and contorted him to fit the frame. At Ivan's coronation, Eisenstein made matters worse for the actor by giving priority to the ceremonial objects – crown, sceptre, orb – in which the Czar's power is invested. All we see is a finger that reaches out for his regalia; Cherkasov is shown only from behind until, having assembled the accoutrements of majesty or terror, he turns to deliver his proclamation. During his illness, his head is covered again by a jewelled and gilded holy book, placed half-open over his face like a tent. He slyly wriggles out from under it for a moment: his eye, a totalitarian searchlight, remains watchful.

Hitchcock had an unpolitical reason for introducing a character from behind, as he does in 1964 in *Marnie*. 'There's no such thing as a face,' he told Truffaut during their conversation about cinematic technique. 'It's nothing till the light hits it... It's a function of pure cinema.' The opening shot of *Marnie* makes even the head an afterthought: it introduces the heroine in a close-up that fixes on a leather handbag tightly gripped under her arm, its puffy, puckered skin bisected by a metal clasp. With her back turned, she walks away from the camera down the long perspective of a railway platform, wearing what looks like a stiff black wig. Notwithstanding her retreat and her disguise, that shot fixing on the handbag presents us with a caricature of Marnie's private parts, the unseen centre of a story that is about her supposed frigidity. It also identifies the strong box in which she secretes the money she steals: the employer she has just robbed clinches the identification between sex and loot when he remembers how coyly she tugged 'her skirt down over her knees as though they were a national treasure'. We see the handbag again, still locked in place under her arm, as she walks down a hotel corridor, this time appraised by Hitchcock himself when he emerges from an adjacent room. A frontal view of Tippi Hedren follows, but only after she immerses her head in a washbasin, rinses out the black dye, and surfaces as the latest incarnation of the generic Hitchcock blonde.

In *Le Mépris* Brigitte Bardot presents herself sectionally. At the start of Godard's film she lolls in bed and allows the camera to take inventory of her various erogenous zones. Bathed in filtered light – first a scorching red glare, then a golden glow, after that a bath of velvety blue – she asks her husband if he likes her legs, her thighs, her knees, her breasts, her shoulders, and requires separate confirmation for each part as it is examined in close-up. Her face, in its tousled nest of hair, is only visible halfway through the tour. A cinematic body, like any machine, is a kit of parts, and each of its segments must be ready for its close-up. When Gloria Swanson prepares for a fancied comeback in *Sunset Boulevard* she undergoes a specialized series of top-to-toe torments. Electric shocks are applied to lax muscles, and her chin is braced; she sweats in a sealed steam tub, is pummelled by masseurs, has her chest smeared with mud

and her hands swathed in rubber mittens; a cocoon of fabric around her head makes her look like a space alien.

For Bresson, cinema's reluctance to show 'the whole person' was a way of rejecting 'everything that is theatrical'. Faces interested Bresson less than hands, which are responsible for our engagement with the world. In *L'Argent* they gather hazelnuts and in *Pickpocket* they steal wallets, while the young priest in *Journal d'un curé de campagne* refers to 'the miracle of the empty hands' as he extends to his flock the blessing of a peace that he does not personally possess. Feet attach Bresson's downtrodden characters to the earth. *Au hasard Balthazar* documents the painful ritual when the donkey is shod, which redefines him as a beast of burden.

The body's outer limits have their own stories to tell. A close-up of Lillian Gish's limp finger as a ring is eased onto it in Sjöström's *The Wind* catches the misery of her loveless marriage to a man whose face we do not need to see. Hitchhiking in *It Happened One Night*, Claudette Colbert pulls up her skirt and demonstrates to the ineffectually gesticulating Clark Gable that 'the limb is mightier than the thumb'. Two films of the same story – Robert Wiene's *The Hands of Orlac* in 1924 and Karl Freund's *Mad Love* in 1935 – indulge a fantasy about amputation. Orlac is a pianist whose hands are mutilated in an accident; those of an executed killer are attached to his stumps, and they prove to be more adept at murder than music. As Orlac in Wiene's film, Conrad Veidt allows his gnarled, veiny hands to hang heavy, disowning them or yearning to be rid of them so that he can be spared responsibility for the crimes they commit. In Freund's remake, Peter Lorre is the gnome-like, bug-eyed surgeon who performs the operation on Orlac. He later torments the pianist by dressing up as a con man and pretending to wear the guillotined head of the murderer whose transposed hands Orlac now sports; he even displays a neck brace of steel and leather that supposedly keeps the graft in place. The macabre playfulness of all this follows logically from cinema's anatomical vision.

Feet, usually more inconspicuous than hands, make intimate disclosures of their own. Edwin S. Porter's *Gay Shoe Clerk* excited a frisson in 1902 with a close-up of a female ankle. As the clerk ties the laces on

the shoe he is fitting, his customer pulls her skirt up almost to the knee, which prompts him to kiss her; the woman's plump matronly companion, outraged, punishes him with her umbrella. In *The Temptress*, directed by Fred Niblo in 1926, the camera first passes down the length of the table at a banquet attended by Garbo the vamp, and notices that the guests are politely eating, drinking and talking. Then it looks underneath the table at what their lower halves are up to. People who are well behaved from the waist up have their shoes off; some merely scratch or wiggle their cramped toes, though one woman's silk-stockinged leg flirtatiously rubs up against the men on either side of her. Stroheim's selective gaze was more fetishistic. At the cabaret in his version of *The Merry Widow*, three close-ups of Mae Murray define in descending order the particular tastes of the customers who watch her dancing. An adoring youth focuses on her face, a more seasoned lecher appraises her bosom, but the ancient crippled roué who eventually marries her directs his opera glasses at her footwear. Such kinky connoisseurship is of course unknown in the healthier American outdoors. In *Man of the West* Gary Cooper sceptically glances at the frilly shoes of the the saloon singer played by Julie London, which are ill-suited for their hike across the Texan hills. His concern is practical; nevertheless she says 'You're the first man that looked at that part of me since I was fourteen years old.'

The camera can experimentally distend or shrink the bodies it examines. Buñuel claimed that in his earliest cinema-going days he believed zoom shots showed heads blowing up like balloons about to burst. In Tod Browning's *The Devil-Doll*, released in 1936, Lionel Barrymore miniaturizes animals and then human beings, sending them off as undetectable killers to dispose of his enemies. This may be absurd science, but cinema can make it happen: as Dr Pretorius in *The Bride of Frankenstein*, Ernest Thesiger exhibits a collection of bottled homunculi, including a twirling ballerina and a tetchy tyrant dressed as Henry VIII.

At its most cunning, the camera arranges for bodies to overlap or merge, as it does in Jean Negulesco's *Humoresque*, where John Garfield plays a virtuoso violinist. In close-ups during the film's concerts the actor received help from a professional: Isaac Stern crouched beneath

the camera and donated his arm to Garfield, who nuzzled the instrument under his chin and conscientiously emoted while Stern worked the bow. Cloning was practised in cinema long before it became possible for medical science. Bette Davis twice played identical twins, first in *A Stolen Life* in 1946 – the same year as Olivia de Havilland's self-duplication in *The Dark Mirror* – and then in *Dead Ringer* eighteen years later. The first film is a dualistic face-off between a demure artist and a vamp; in the second, the combatants are an elegant socialite and her dowdy, disadvantaged facsimile. In 1988 David Cronenberg attempted something more ingenious and tortuous in *Dead Ringers*. Here the identical twins played by Jeremy Irons are both gynaecologists, who use their interchangeable personae to invade the heads and bodies of the women they treat. The end comes when one brother, afloat on drugs, disembowels the other and lies down to be symbiotically reunited with the corpse. For their last embrace – a perverse Pietà, with one man slumped in the other's lap – digital magic seems to have reattached a pair of Siamese twins. Advancing beyond the conjuring tricks of Méliès, cinema has here become a radical technology that can alter our physical form.

* * *

The producer in Scott Fitzgerald's *The Last Tycoon* casually formulates a rule for the medium when, paying a call in the Hollywood hills, he notices a householder mowing his lawn at midnight. He attributes this to a restless midsummer mood, and reflects that 'one tried anxiously to live in the present – or, if there was no present, to invent one'. Films do precisely that.

Mental adjustments were required. Griffith's *Intolerance* bewildered its first audiences by cross-cutting between events in ancient Babylon, the Judea of the New Testament, Renaissance France and contemporary America. History was here cancelled out by the invention of a continuous present, with events happening on parallel tracks in those four places. Cinema specialized in what the Lumières called 'actualités', life captured in the act; past and future did not register. In *The Kid* Chaplin planned to have the illegitimate child's mother meet up in later life with the man who wronged her. Their encounter was to be summarized by the image

of a biblically ponderous volume labelled 'The Past', which would open at the end rather than the beginning to display a page headed 'Regrets', but Chaplin rightly cut the awkward contrivance. In 1934 in *La signora di tutti* Max Ophuls had to explain a flashback that occurs while the heroine is in surgery. 'Under the anaesthetic,' an intertitle explains, 'her past life reappears in a vertiginous dream.' This at least spared viewers from having to share that dizziness.

Whereas characters in plays ponder their options before they act, like Macbeth arguing with himself about killing Duncan, people in films perform gratuitous acts and leave us to decide on their reasons after we recover from the surprise of seeing them do so. Bresson proclaimed one of cinema's unique liberties when he suggested 'Let the cause follow the effect, not accompany it or precede it.' Kim Novak leaps into San Francisco Bay in *Vertigo*, and William Petersen bungee jumps from a bridge into the harbour at San Pedro in Friedkin's *To Live and Die in L.A.* At the end of *The Searchers*, John Wayne spares the niece we expect him to kill, and Elliott Gould just as unexpectedly guns down his friend at the end of Robert Altman's *The Long Goodbye*. In Bob Rafelson's *Black Widow*, Theresa Russell felt that she needed to know why her character murders a succession of rich, doting husbands, and does so with such apparently tender finesse. Although the writer Ronald Bass obligingly made up a scenario that involved a childhood trauma, he prohibited Russell from telling the secret to Rafelson; our experience in watching the film – which is all about studying Russell's intriguingly ambiguous face – also depends on our not sharing that spurious knowledge.

Godard conceded that films must have a beginning, middle and end – but, he added, not necessarily in that order. On film, even sex can happen in reverse. In Nicolas Roeg's *Don't Look Now*, a scene with Donald Sutherland and Julie Christie tangling naked in bed is broken down into shots lasting fifteen seconds or less, then intercut with glimpses of Sutherland and Christie dressing to go out to dinner afterwards. He adjusts his tie and she applies her lipstick post-coitally, but the Kuleshov effect, suggestive as always, folds these self-repairing actions into their sexual play and slyly eroticizes them. Godard's declaration licensed directors to scramble their narratives as Roeg does

here; nowadays it is often the viewer who must assemble the final cut. In Tarantino's *Pulp Fiction* we see John Travolta being killed by Bruce Willis; despite his death Travolta reappears in later episodes, including a scene in a diner where he learnedly discusses miracles with Samuel L. Jackson as they wonder whether some kind of divine intercession enabled them to dodge the bullets fired at them in a previous incident. 'To be continued,' says Travolta as he adjourns the debate to go to the toilet. When he re-emerges, just in time to foil an armed robbery, is his continuation a resurrection? Not quite: Tarantino, juggling several narratives, has shuffled the chronology, and he expects us to reposition the scene in the diner before the showdown with Willis.

Christopher Nolan's *Memento* is about a man trying to trace his wife's killer – a quest that is complicated because the hero, played by Guy Pearce, suffers from anterograde amnesia and has to rely on Polaroids and even tattoos as mnemonic aids. As the film begins, a Polaroid blanks out rather than developing, and is then swallowed up by the camera that should have disgorged it. This is an image of Pearce's problem: as he says, 'I can't make new memories – everything fades.' Befuddled, he pauses during a shoot-out to ask whether he is chasing his adversary or being chased by him. For those of us watching the film, happy consumers of kinesis, it hardly matters. Pearce's deductions about what has happened are photographed in colour and projected in reverse order, interspersed with scenes in monochrome that advance forward; the two finally come together to fill in lacunae for us, though not for the still bemused Pearce, whose last line is 'Now, where was I?'

The experience can be bewildering, at least until we organize the visual data into a plot, which Pearce tries to do when he fixes moments with his annotated Polaroids. In *21 Grams* Alejandro Iñárritu sets us a similar test by doling out unconsecutive, contradictory scraps of visual information about his characters. We see Naomi Watts as a bright sub-urban mother and as a sleazy drug addict. If she is both, which came first? And why is the born-again, altruistic Benicio del Toro locked in a filthy jail cell? Did he shoot Sean Penn, as he claims? 'I don't know when anything began any more,' says Penn, who is expiring in a cardiac ward, 'or when it's gonna end.' A transplanted heart that he receives from an

organ donor has failed, which makes him ask 'How many lives do we live? How many times do we die?' The central incident connecting these people – Watts's loss of her husband and her two daughters, killed by a hit-and-run driver – remains unseen, a noise outside the frame. A gardener who rushes off to help the victims drops a leaf-blower, which goes on negligently puffing out air and agitating the fallen leaves as if disposing of human lives. Is death just a sanitary cleansing? Another repeated image of birds taking to the air at sunset suggests otherwise: perhaps there might be a transmigration of souls as well as a transplantation of organs. Penn, whose character is a mathematician, explains to Watts that the fragments of their story are fractals. Colliding atoms or random numbers hide the invisible order of the universe, so perhaps the crash that ruined her life was not an accident at all.

The editing we have to do in *21 Grams* is chronological as well as causal or philosophical; in Paul Haggis's *Crash* – which concerns a series of entirely uncontingent traffic accidents – the editorial task is geographical and social, a search for links between disparate areas of Los Angeles and the ethnic groups that live there. The fractal geometry cited by Penn in *21 Grams* offers a solution to this puzzle as well, suggesting that the apparent disorder depends on our vantage point: if the camera retreats to a vertical distance, it can see how all these disconnected, inimical people are actually related, and a sequence that Haggis chose to delete tidies up some of the loose ends by revealing that the district attorney in one plot has a Salvadorean housekeeper whose daughter is the detective in another plot, while her partner in the patrol car happens to be the brother of a young man shot by a policeman elsewhere in the city, and so on. The transitions between separate stories in *Crash* are covered by blurry blobs or dots which represent out-of-focus traffic signals or car headlights. Tarantino begins *Pulp Fiction* with two dictionary definitions of pulp, which hint at a similar visual chaos. One entry says that pulp is moist, shapeless matter; the other refers to the rough, unfinished paper on which comics and trashy novels were printed. Either way, pulp remains raw, like the unedited life and uncensored language in Tarantino's film or the pulverized bodies and smeared fragments of brain left behind by his characters.

Altman's *M*A*S*H*, released in 1970, is defined by a double meaning that is equally permissive. The title is the acronym of a mobile army surgical hospital that struggles to patch up wounds during the Korean war, but the word also points to the way that Altman mashes up and sometimes gleefully mangles the film's multiple episodes.

A more casual overlapping occurs throughout Los Angeles in Altman's *Short Cuts*, based on a collection of short stories by Raymond Carver. Transferred in 1993 to a film that changes the setting from the Pacific North-West to Los Angeles, the title of the book becomes a pun: the shortest distance between two points is not the city's clogged freeways but the jump cuts or montages that eliminate the gaps Carver left between his stories. Characters immured by the writer in their own little narratives now bump into each other, unaware that they are all part of the same grand design. Altman arranges for the fishermen who discover a dead body in the river to cross over into another story when they leer at Lily Tomlin's backside on a visit to the diner where she works. One of the fishing buddies, collecting his snapshots of their trip at the photomat, exchanges packages with Lili Taylor, a character in yet another story about a couple who snoop in the apartment of their absent neighbours, and Tomlin veers off into an adjacent Carver tale when her car knocks down a schoolboy and leaves him with an injury that proves fatal.

'Accidents happen every day. Some are harmless,' says an unctuous voice advertising insurance on television as a glass of milk tumbles over. For Altman accidents are a kind of free association, seconded by the peripheral vision of a camera that is reluctant to exclude anything from the frame. As with the snowfall that smudges and smooths over the evidence of one more traffic accident at the end of *Crash*, or the miraculous rain of frogs in Paul Thomas Anderson's *Magnolia*, it all coheres when seen from above. Los Angeles is unified in *Short Cuts* by the Medfly spray showered down at night from helicopters that resemble the insects they are trying to exterminate.

As the film ends, an earthquake suddenly rocks Los Angeles, threatening to mash or pulp the flimsy city. The subterranean ructions coincide with an unprovoked murder in Griffith Park, which is blamed on falling rocks. Checking on characters in other parts of town, Altman

finds them crouching under tables, huddled in a doorway while swigging cocktails, or splashing in a hot tub that shudders in response to the seismic rumbles. Relieved but a little disappointed when the turbulence subsides, they decide that this was not 'the big one', the ultimate Los Angeles spectacle. Cinema is a happy apocalypse: it shakes up the world, jolts its atoms out of place, and reminds us, when the bits and pieces settle back into place, that it was never more than a loose assemblage, begging to be reconstructed.

13

META-MOVIES

At D. W. Griffith's funeral in 1948, a eulogist said that the dead man's mourners were gathered 'in the presence of the Almighty Supreme Director of the Universe to pay tribute to the master mortal director'. An inaudible capital letter was the only difference between one director and the other.

That might and supremacy are questionable, because films bring together multiple groups of specialized technicians who collaborate in an industrial operation. But the emphasis on this single function was a necessary fiction if factory products were to qualify as art. 'A work is good,' Orson Welles declared, 'to the extent that it represents the man who created it' – a statement of faith that Truffaut borrowed as the epigraph for a collection of his own critical essays. This myth of authorship had a theological underpinning. Tarkovsky thought that cinema was 'the one art form that allowed the author to see himself as the creator of an unconditioned reality – his own world'; all the same, he cautioned his colleagues against the temptation to 'play at being a kind of demiurge'.

The warning came too late. The 'supernatural, despotic power' that Aragon attributed to the new art was first invested in a succession of militaristic men, egotists mounted on cranes who thundered commands like the Old Testament deity. Gance described Napoléon as 'the world's greatest director', and took the imperial conqueror as his own model. Griffith managed crowds with the aid of assistant directors, one of whom carried a .45 at his hip and a bundle of coloured flags under his arms to signal to contending armies of extras. DeMille referred to himself as 'the director-general', bellowed orders through a bullhorn, and affected

lace-up military boots, supposedly as support for his weak ankles; in *Sunset Boulevard* he appears in the leggings worn by infantrymen in long-ago wars. Sternberg dressed for the part in jodhpurs and knee-high boots, accessorized with a martinet's cane. Once at least he carried an air rifle, with which he punctured the carnival balloons that bob around Dietrich in *The Devil is a Woman*. Fritz Lang personally fired the flaming arrow that torched the Gibichung hall at the end of his *Nibelungen* saga. Much later, Akira Kurosawa likened the sets of his samurai films to battlefields, with himself as the strategizing commander.

Sometimes the Napoleonic manner was a reflex of ill humour or self-aggrandizing conceit: Preminger's nickname was Otto the Terrible, and at Twentieth Century Fox Darryl F. Zanuck, presiding in the front office at a distance from the fray, enjoyed being addressed as 'Colonel', although his wartime service had been confined to the Signal Corps. But there was more to all this than posturing. Military discipline had its uses: when cameras were still hand-cranked, marches were often played to ensure that the wrists of the operators maintained a steady rhythm. For Marcel L'Herbier, the 1914–18 war, during which he produced and edited newsreels and propaganda films, served as a professional training. Busby Berkeley learned to direct dances by drilling troops as a lieutenant in the artillery, and his apprenticeship pays off in *Gold Diggers of 1937*, where a female platoon, skimpily uniformed in white and wearing high heels, struts out to proclaim that 'All's Fair in Love and War', armed a little unfairly with bombs, field guns, and perfume flasks that discharge poison gas. At the end of the 'Shanghai Lil' number in Berkeley's *Footlight Parade*, sailors parade with their rifles; seen from far above, their white caps are arranged into the outline of the American bald eagle as they fire off volleys of shots. In *Babes in Arms*, directed by Berkeley in 1939, Mickey Rooney, Judy Garland and their young friends are promoted to 'babes in armour' and advance through town in a torchlit parade that is threatening rather than jubilant.

During the decade when dictators were bamboozling Europe, Frank Capra worried that a director had 'the enormous power to speak to hundreds of millions of his fellow men for two hours, and in the dark', rather like Hitler delivering a harangue at a nocturnal rally. Although

Lang claimed that he fled Germany to escape persecution, Goebbels and Hitler found his *Nibelungen* so ideologically sympathetic that they wanted him to take charge of the national film industry. After Lang established himself in Hollywood, Bertolt Brecht worked on the script of his *Hangmen Also Die*, about resistance to the Nazi occupation of Prague, and in late 1942 the director invited him onto the film's set. The 'lord of the lens', Brecht noted in his journal, was 'unapproachable', except by the German émigré physician who waited to administer his vitamin injection. In Brecht's account, Lang resembles a Mabuse-like mesmerist or Rotwang managing the robotic Maria: from the sidelines Brecht watched him manipulate Anna Lee, the daughter of an Anglican rector who was labelled 'the British bombshell' by the studio although she looked to Brecht like 'a smooth doll with no character'.

Hitchcock used the transitory walk-ons he made in his films to dramatize the paradox of the director, who is absent but omnipresent. Often he appears in the guise of an anonymous onlooker or passer-by, but occasionally he plays a bumbling loser – missing a bus in *North by Northwest*, shooed away as he tries to take a photograph outside a police station in *Young and Innocent*. Pretending to be hapless in front of the camera, Hitchcock the hidden god enjoyed total control behind it. Orson Welles was less lucky. Given absolute power to write, direct, produce and act in *Citizen Kane*, he described the RKO backlot as 'the biggest electric train set any boy ever had', but soon enough his untrammelled playtime was halted by producers or studio executives who refused to subsidize his elaborate games. In 1963 in *La ricotta*, Pasolini cast Welles as a director responsible for a disastrous re-enactment of Christ's crucifixion, with one of the thieves nailed dead to his cross after fatally gorging himself at the buffet laid on for the famished extras. An unmoved mover, Welles lolls in his chair, apathetically contemplating the mess of his miscreant world.

'You have to be strong and powerful,' said Rouben Mamoulian in a tribute to George Stevens, 'otherwise you cannot be a director.' In other words, you had to be a man. Harvey Keitel responded warily when Jane Campion, the first female director he had worked with, cast him as a tattooed wild man in *The Piano* and a sexually abusive guru in *Holy*

Smoke. 'Jane Campion is a goddess and I'm a mere mortal,' said Keitel in an interview. 'I fear being struck by lightning bolts.' Relaxing a little, he went on to call her 'a warm breeze, at play'. The metaphor was apt: in 2009 in *Bright Star*, Campion's film about John Keats, a fluttering curtain suggests the respiration of nature, briefly enlivening the closeted house of the poet's muse Fanny Brawne. 'I was desperate for that to happen,' Campion said later, 'but I refused to use a wind machine. And the air outside was so still. We got sick of waiting and shot it anyway. Then, just at the right moment, the curtain quivered. I seem to be good with winds, even though I wouldn't pretend to be directing them.'

The wind she summoned up in that scene was a manifestation of the creative spirit – known in less grudgingly demotic days as genius, and in even remoter times attributed to God or a goddess. At Cannes in 2009, complaining about the lack of equal opportunities in her profession, Campion said 'After all, women did give birth to the whole world!' She only played the demiurge for a moment, but her exclamation was not entirely ironic.

* * *

The first filmgoers gathered in amusement arcades or paid five cents for admission to stuffy, uncomfortable nickelodeons installed in shopfronts. Then the spectacle migrated to luxurious picture palaces, while the art's more esoteric mysteries were placed on view in cinemas that, as Ricciotto Canudo hoped, served as secular temples or tabernacles.

In Bertolucci's *Before the Revolution*, released in 1964, a convert to this new religion leaves the Supercinema Orfeo in Parma after having spent four hours in the Orphic underworld watching Godard's *Une Femme est une femme* twice. Accustomed to such marathons, he brags of having seen *Vertigo* eight times and *Journey to Italy* fifteen times, and when his friend accuses him of being addicted he asks indignantly, 'How can you live without Hitchcock and Rossellini?'

French critics in the 1950s – most of whom, like Truffaut, Godard, Rohmer and Claude Chabrol, went on to direct films of their own – emphasized the metaphysical or moral temper of the authors they favoured: Hitchcock's obsession with guilt, Rossellini's interest in forgiveness and

salvation, Lang's determinism, Ford's honour codes. In *La Nuit américaine*, Truffaut invokes the aid of the canonical authors he reveres. Playing a harassed director on a chaotic film set, he consoles himself by ordering a package of books on Dreyer, Hitchcock, Bresson, Buñuel and Godard; he also films a dream in which he steals a set of lobby cards advertising *Citizen Kane*, a larcenous act of homage to Welles that the young Truffaut had actually performed. Scorsese jokes about two of the sainted authorial names in 1969 in *Who's That Knocking At My Door?* Here Harvey Keitel notices a still from *The Searchers* in *Paris Match* and uses this as an excuse for chatting up the woman who is reading the magazine on the Staten Island ferry. 'Man, that was some picture,' he says. 'It'd solve everybody's problems if they liked Westerns.' *The Searchers*, it seems, is what everybody is or should be searching for. Keitel later takes the woman from the ferry to see Howard Hawks's *Rio Bravo*, a Western that celebrates community and companionship as well as inculcating useful life lessons: Angie Dickinson as the saloon siren Feathers is, Keitel explains, a broad – fun to be with, but not someone you'd marry.

Cinema began as a happily forgetful medium, selling mass-produced wares that were replaced every few weeks by a new version of the same thing. The auteurism promoted by French critics opened up the history of the art and rescued old masters from oblivion, but ancestor worship can be uncomfortable, especially if the venerated elder is still alive. In a television interview with Godard, Lang described himself as a dinosaur, due for inevitable extinction, and conceded that the art belonged to the young. *Nick's Film: Lightning over Water*, an elegy for the moribund Nicholas Ray directed by Wim Wenders in 1980, makes the same point about the generations, with a slight hint of Oedipal impatience. It begins as Wenders arrives outside Ray's loft in Lower Manhattan after a night flight from Los Angeles, looking, as Bertolucci put it, like a hired killer in a B movie. But Wenders is not required to rub out the cancer-stricken Ray, who is already cadaverous, wracked by coughs, his shrivelled backside briefly exposed as he clambers out of the bed he shares with his stuffed toys. Wenders blames his equipment for its morbid prognosis: the camera, he says, shows that Nick's time is nearly up, and on videotape he looks wraith-like.

At the end of Wenders' *Alice in the Cities*, released in 1974, the demise of another auteur serves as a liberation. On a train to Munich the blocked writer played by Rüdiger Vogler happens upon a newspaper obituary of John Ford, entitled 'Verlorene Welt' – lost world. He looks pensive; then, when the child with whom he is travelling asks what he will do in Munich, he replies 'I'll finish this story.' They open the window and look out as the camera, in a climactic helicopter shot, soars above the train as it travels along the Rhine, scans the cliffs beside the river, and tilts to survey a vista of sunlit fields beyond. America's western frontier has closed, but here is another, open for exploration in the road movies that Wenders made in Europe.

Auteurism assumed that directors were god-like, or at least high-minded: what if they had less exalted motives? In his two-part film *I Am Curious*, which titillated audiences in the late 1960s, the director Vilgot Sjöman casts himself as a fumbling lecher who slavers over his much younger heroine, expects sexual favours in return for casting her, and disparages the boyfriends she chooses for herself. Ingmar Bergman's directorial manipulation on one occasion took a medically and ethically sinister turn. Having cast Gunnar Björnstrand in *Winter Light* as a priest whose faith is wavering, Bergman worried that the actor looked too sanguine; he persuaded Björnstrand's doctor to diagnose a grave ailment, and was pleased when the actor's distress improved his performance. Michael Haneke has been charged with devising plots that torment his characters for no good reason: in *Funny Games* two young men amuse themselves by elaborately massacring the members of a blameless family, along with their dog. In 2012 in *Amour*, Haneke said that his aim was to take Jean-Louis Trintignant and Emmanuelle Riva 'beyond acting', and he demanded that Riva, then eighty-four, strip naked for a scene in which she is bathed by a bossy nurse. The daughter played by Isabelle Huppert watches impassively as her mother is undone by dementia and her father veers between grief, rage and disgust. For Haneke, Huppert's character represents the 'bad conscience' of an audience that pays to witness the anguish of fictional characters. Meanwhile his own conscience remains untroubled, and when asked by interviewers about his intentions, he typically shrugs and says

'I don't have such a good relationship with the author', though of course he is that author.

Godard set limits to the authorial persona by denying that he possessed authority and likening himself to a journalist rushing to catch up with events. He defined *Masculin-Feminin* as 'a film in the process of being made'; in *Le Mépris* the process of making the film is so disputatious that the final product remains in doubt. The rundown Cinecittà backlot on which Godard's characters are filming the *Odyssey* is up for sale, which for Jack Palance, the obstreperous producer, portends 'the end of cinema'. A more optimistic quotation from André Bazin concludes the credit titles. 'The cinema,' according to Bazin, 'substitutes for our gaze a world more in harmony with our desires'; despite this prescription, the desires that run amok on the set in *Le Mépris* are unharmonious. Fritz Lang, playing the director, is obliged to hire a nubile pop singer as Nausicaa, the princess who helps the shipwrecked Odysseus, just as Godard was badgered to cast Bardot as the wife of the film's blocked writer. Palance orders the nymphet to disrobe on the beach at Capri as a publicity stunt; Bardot likewise had to be provided with occasions for undressing, which is why she exhibits herself piecemeal to her husband at the start of the film. Godard took a symbolic revenge on both the meddling producer and the superfluous star by having them abruptly killed in a car crash. When the company at last gets down to work, Godard himself makes an appearance as Lang's assistant, charged with relaying the director's instructions to start the camera. All the same, the machine has a mind of its own, and as Odysseus sights his homeland, it looks away from the film's characters and its harried crew and instead surveys the blue, blazing, undirectable Mediterranean.

La Nuit américaine, Truffaut's good-humoured reply to *Le Mépris*, also questions the director's monopolistic status. It begins with an elaborate street scene, where a violent climax is marred because a bus arrives late and a kitten will not follow orders. Truffaut, supposedly in charge, is pestered by technicians wanting decisions about props, wigs, special effects and the breaks for meals specified in union contracts. The actors add to the mess by elaborating little off-screen dramas of their own,

which they find more engaging than the murderous family feud that is the subject of their film. Jean-Pierre Léaud falls extravagantly in love with his leading lady, Jacqueline Bisset. His problem is that he spends all his spare time at the cinema, believes what he sees on screen, and therefore condemns himself to dissatisfaction. Truffaut tells him that only in films do lives run smoothly 'like trains in the night', and Bisset tries to persuade him that she is not the magical being he thought he fancied. Graham Greene briefly appears as an insurance man who rules against reshooting scenes with another actor when Jean-Pierre Aumont is killed in a car crash. Change the script instead, he orders: such emergencies are unknown in novels, where characters live and die at the whim of the writer. When filming ends, a fractious but comradely family of actors and technicians disperses, after which the camera withdraws into the air and circles above the Studios Victorine in Nice. Now we see that a snowy Paris square has been mocked up beside the Mediterranean, with incongruous palm trees visible on the margins. Ever since Méliès, cinema has enjoyed exposing its own tricks, confident that we will go on believing in its wizardry.

In Godard's *Passion*, released in 1982, a dotty director organizes cinematic re-enactments of paintings by Rembrandt, Delacroix and others. Producers rail at this expensive folly: paint is cheap, whereas everything the camera sees has to be made or hired and paid for. When the director finds fault with the lighting in his staged version of Rembrandt's *Night Watch*, the cameraman Raoul Cotard makes a sarcastic allusion to *La Nuit américaine*, retitled *Day for Night* in foreign markets. The scene, he says, ought to be called *Day Watch*, because he had to use so many electrical facsimiles of the sun. Perhaps the aim of these filmed tableaux is to underscore the liveliness of the moving image. The posed actors pretending to be Rembrandt's troopers shift their weight or at least breathe, and the Arab horses wrangled for a reproduction of Delacroix's *Women of Algiers* pace restively. Because cinema is the cult of kinesis, there is no resisting the tug of movements that lead away from the confinement of the studio. Godard is distracted by intrigues at the motel where the crew is lodged and by labour disputes in a nearby factory; eventually his leading players abandon the film and travel to

Poland to join the Solidarity campaign, while the producer, chasing the unlikely prospect of funds from MGM, decamps to Los Angeles.

* * *

In *8½* Fellini suspends production of his ninth film: hence the title, which stalls his alter ego Marcello Mastroianni at a preparatory stage before shooting begins. Like the directors in *Le Mépris* and *La Nuit américaine*, Mastroianni has to pacify meddling producers and flighty stars, but what paralyzes him is a gnawing doubt about his right to have other people enact his fantasies. Improvising a scenario to cover his adultery, he tells his wife 'It's just a film.' 'A film!' she scoffs. 'Another invention, another lie.' When he decides to abort the project, a critic applauds him for fashionably nihilistic reasons: as when Rimbaud renounced poetry, the non-existent film will be an offering to the nothingness that is our ultimate destination.

The breakdown dramatized in *8½* actually happened, and while the actors waited and the producer fretted, Fellini felt like a magician whose spells no longer worked. In his autobiography he says that he overcame this sense of creative dryness when he 'listened to a fountain and the sound of the water'. That liquid source is metaphorical, but it has replicas throughout his work – in the spa where Clauda Cardinale dispenses draughts of healing water in *8½*, in the fountain that foams around the cavorting Anita Ekberg in *La dolce vita*, in the river where Giulietta Masina fails to drown in *Nights of Cabiria*, and in the sea that swallows and then regurgitates the boats of the sleeping villagers in *Amarcord*; the 'scena madre' or main scene in a Fellini film always involves this amniotic, maternal element. As *8½* concludes, Mastroianni chooses plenitude rather than emptiness. Calling off a trip in an unbuilt spacecraft – another of cinema's fantastic extraterrestrial voyages – he welcomes back to earth his multitudinous cast of nymphs and matrons, priests and sybarites, grotesques and monsters. Mostly clad in white in preparation for an afterlife as angels, they troop down a staircase and fill up an open field, before being organized into a circus parade on a ring-shaped platform. These characters do not make up a convivial society like the cheerfully promiscuous crew in *La Nuit américaine*, but

neither do their conflicts warn of social breakdown, as do the frictions on set in Godard's films. They are taking part in a festive comedy that is Fellini's dance of life – his answer to the dance of death, led by a reaper brandishing a scythe, that we see in silhouette on the hilltop at the end of Bergman's *The Seventh Seal*.

Another director's crisis of conscience, enigmatically concealed, occurs in Bergman's *Persona*. The film is supposedly about the symbiosis between the catatonic actress Elisabet (Liv Ullmann) and Alma, the chatty nurse who looks after her (Bibi), although its real subject is the way the camera studies the two women and takes possession of them, even physically joining them in a shot that makes a composite of their faces, fusing them into a compound person. Bergman's preferred title for the film was *Kinematography*, which his producer vetoed. Undeterred, he prefaced the story with an elliptical visual essay on the methods and morality of his art.

This 'poem in images', as Bergman described it, presents its own flagrantly irreligious version of cinegenesis. A lamp shining through a projector has an almost incendiary glare, and this, added to the excited clatter of the film as it spools through the bright aperture, justifies a metaphorical insert of an erect penis: the machine is a creative furnace, a brain hot-wired to a directorial sex organ. The projector's carbon arc light next causes the celluloid to catch fire, yet this brilliance is surrounded by haunted gloom, and soon the demons resident in Bergman's head come out to play. A scrap of silent film, quoting a Méliès skit, has an actor dressed as a skeleton dragging a colleague into his coffin; in an animated cartoon a stationary female bather variously swims, dives or shudders on the spot, though this artificial vivification is of no help to the bodies we are shown laid out in a morgue, their sunken faces fixed in a last expression. Is cinema's claim to reproduce life a delusion? Resorting to the Necroscope, Bergman adds a montage of animals being slaughtered and viscerae spilling from a corpse as it undergoes an autopsy.

Again challenging theatrical pretence, a crucifying nail is driven into an open palm, and fingers twitch in anguish as the metal draws blood. For Bergman, physical pain authenticated images that would otherwise be counterfeits: in her hospital room, Elisabet watches television footage

of the Buddhist monk who incinerated himself on a busy Saigon street in 1963 – a political protest that might have been performance art if the performer had not actually died. *Persona* tests its characters by pressing them to tiptoe along this border between life and death. Alma scratches her wrist with her fingernails, and Elisabet vampirishly fastens her mouth on the trickle of blood; later Alma lets Elisabet tread barefoot on a sliver of broken glass, after which the image cracks into shards, then scorches like flammable celluloid and turns blank. After this we see an extreme close-up of an eye. The razor Buñuel wields in *Un Chien andalou* might be somewhere in the vicinity, but there is no need for it: the veins that wriggle across the sclera are already bloody enough.

At the end of the prologue, a boy lying on a bed – who first appears to be another corpse in the mortuary – wakes up and puts on a pair of owlish spectacles to read a book. Then, progressing beyond literature, he envisions a blurry female face on the wall or on a screen and reaches towards it. A white-out erases it before he can make contact. Cinema tantalizes us with remote, unreadable faces onto which we project our own thoughts and feelings, as Alma does when she tells Elisabet that after seeing her in a film she went home, looked in a mirror and told herself that there was a resemblance between them. Elisabet knows better. On a stony beach she holds a still camera and, ignoring Alma who is behind her, points it at Bergman's movie camera, alerting us to the undeclared presence of the observer. Finally, as Alma leaves the house on the island, there is a startling glimpse of the cinematographer Sven Nykvist hovering with his camera in an eyrie above Elisabet: stretched on her bed, she is held captive by the viewfinder, detained in the illusory world that Alma has quit. Bergman breaches a technical taboo by acknowledging the camera's presence, and in doing so he perhaps assuages his guilt about the power it confers on the director. The boy from the prologue then returns, still trying to grasp that fuzzy face but apparently only able to touch a cold glazed surface. In another anatomy of the machine, we see the film coming unwound, which demonstrates the makeshift nature of the gadgetry the Lumière brothers invented. The phallic flare burns out, light is engulfed by darkness, and the film has no choice but to stop.

Alain Resnais made his own film about making a film in *Hiroshima mon amour*. At first he planned a documentary on the aftermath of the bombing in the flattened city; instead he produced a work of fiction that accuses itself of falsity. Emmanuelle Riva, who plays an actress playing a nurse, stands out of costume on the sidelines in one scene to watch an anti-nuclear protest. Beside her is a Japanese extra whose peeling, irradiated flesh has been applied by cosmeticians in the make-up department; arc lamps and reflectors mimic the glare of the blast. Even worse is the blatantly phony reconstruction in a film Riva sees when she visits the Peace Museum in Hiroshima: children with wounds harmlessly painted onto their bodies ford the city's river, which in reality would have been a seething inferno. Photographic stills of actual survivors shame the artifice. One victim has an empty eye socket, another a mouth like the crater left by a bomb, a third displays hands twisted by genetic mutations. The actress reconciles herself to the film she is in by likening it to a commercial touting the virtues of soap, but the Japanese architect who has been her lover during her stay in the city tells her 'You saw nothing in Hiroshima. Nothing.' How can we fabricate images of an unimaginable event? Should we even attempt to do so?

Bertolucci's aim in *Last Tango in Paris* was to present life in the rough, with female pubic hair, dirty talk, and anonymous rutting on the floor of an unfurnished apartment; like Bergman or Resnais, he found himself unable to escape from what he called 'cinema within the cinema'. *Last Tango*, released in 1972, consists of two competing films within a film, which are so irreconcilable that their protagonists never meet. One meta-movie is an illicit documentary on Marlon Brando, who said when he saw the result that he felt 'violated' by Bertolucci. The other is a romantic folly that is being made by Jean-Pierre Léaud, an apprentice director who might be a caricature of the young Truffaut (whom he played as an adolescent in 1959 in *Les Quatre Cents Coups*); his ambition, he says, is to record his fiancée's existence on 16-millimetre film, capturing every moment of her waking life.

Brando's American in Paris personifies the spirit of his country's cinema – the 'intelligent primitivism' that Luc Moullet admired in Samuel Fuller, the hysterical violence that thrilled Rohmer in James

Dean's performances. Bertolucci encouraged Brando to play a tough guy or a naked ape, as he does when he brutally attacks a streetwalker's timorous customer; he also coaxed him to reveal his weakness, which is placed on show in his vigil over his wife's corpse. Acting here is psychological regression, abandoning the persona that disgusts Liv Ullmann in Bergman's film. Of course Brando can become someone else, as when he pretends to be a stagey Englishman with a strangulated accent. But at other moments in *Last Tango* – while he relaxes between takes, lolling on the floor as he stuffs himself with a snack or discusses hair loss and middle-aged corpulence – we seem to be spying on the actor himself with his guard down.

By contrast with this candour, Léaud assumes that life happens for the camera's benefit, waiting to be fitted into the oblong frame he forms with his hands. Everything in this part of *Last Tango* is a quotation. When it rains, Léaud expects his crew to continue filming while he dances down the splashing street like Gene Kelly in Stanley Donen's musical. 'Tonight we improvise,' giggles Maria Schneider, referring to this supposed exercise in unscripted 'cinéma-verité': her phrase, however, is the title of a play by Pirandello. 'If I kiss you,' Léaud says to her, 'that might be cinema.' They therefore perform a smoochy love scene on a railway platform, just as later on the Canal St-Martin they exchange endearments that have to be shouted over the noise of water gushing through a lock and projected to a microphone on an adjacent boat. Léaud then tosses overboard a lifebuoy that purportedly belongs to L'Atalante, the barge that is home to the married couple in Vigo's film.

All that Brando and Léaud have in common is Schneider. For Brando she is a partner in casual sex, for Léaud a muse. In one case she is demeaned, in the other idealized; neither man worries much about who she might really be. And is Léaud in love or, like the character he plays in *La Nuit américaine*, suffering from over-ardent cinephilia? He declares Schneider to be a composite of Rita Hayworth, Joan Crawford, Kim Novak, Lauren Bacall and Ava Gardner, although she is a frizzy-haired moppet not a sculptural Venus. 'The film is over,' she screeches after quarrelling with Léaud in the Métro, but this too is part of the meretricious drama they are acting out. When Brando gestures at her with his

shaving razor, she says 'You want to cut me up?', as if she expects to be edited, not killed. At the end she shoots him with a gun that has been clunkily planted in the apartment much earlier: the outcome illustrates a pronouncement by Godard, who once said that 'All you need for a movie is a girl and a gun.'

Brando derides the cosmetically touched-up corpse of his wife, 'a fake Ophelia drowned in the bathtub', yet he keeps his clothes on during carnal bouts with Schneider, which suggests that sex like death is faked. The manager of the dance hall is outraged when they grind their bodies together on the floor during the tango contest, and as she expels them she shrills 'Go to the movies to see love!' While aiming for visceral truth, *Last Tango* has to admit that what it offers is a simulation.

<p style="text-align:center">* * *</p>

Griffith and DeMille saw the director as a controller of chaos. More modestly, the directors placed on view in *La Nuit américaine*, *Le Mépris* and Pasolini's *La ricotta* do their best to cope with the havoc on their sets. Wes Anderson has suggested a third possibility: directing, in his opinion, involves 'creating new forms of chaos'. The definition fits Fassbinder's *Beware of a Holy Whore*, released in 1971, which takes place behind the scenes of what could be a Fassbinder film. In a Spanish hotel, work is sidelined by the sexual shenanigans, drug-befuddled antics and cliquey tiffs of the cast and crew. Lou Castel plays the eruptive director, clad in the battered motorbike jacket that was Fassbinder's equivalent to the military regalia of DeMille, while Fassbinder himself, to deflect blame, plays a timid production manager whose nickname is Mutti. In Wenders' *The State of Things*, made in 1982, the director of a science-fiction film is left beached in Portugal when the producer goes missing; in Fassbinder's film the producer's cheque bounces, which leads to a scramble for emergency funds. Art may be holy, but it depends on whoring.

To establish their autonomy, two directors eluded interfering executives and financiers by disappearing to remote locations to work on films that are allegories of auteurism unbound. In *Apocalyse Now*, made between 1975 and 1979 in the Philippines, Francis Coppola organized an action replay of the Vietnam war. For *Fitzcarraldo*, Werner Herzog

spent the years from 1977 to 1981 staging a war of his own against nature, gravity and sanity in the Amazon.

Introducing *Apocalypse Now* at Cannes, Coppola said that it was not just about Vietnam, 'it *is* Vietnam!' War and cinema here become audio-visual extravaganzas, designed to induce shock and awe. As Willard, Martin Sheen is not so much the film's narrator as its ideal spectator, who glides up the river staring wide-eyed at the inanities and obscenities that pass by as if on a screen – a beach party, a concert for which shimmying showgirls are flown into the war zone, a downed helicopter pinioned in the branches of a tree, a sacrificial rite at a jungle temple. William Wellman and Howard Hughes recruited private air forces for *Wings* and *Hell's Angels*; operating on a larger scale, Coppola expected the U.S. Defense Department to supply him with Chinook helicopters. Rebuffed, he borrowed aircraft belonging to the regime of Ferdinand Marcos, though he complained when these were recalled to fly raids against communist rebels. Coppola can be seen briefly in the film, in a moment of rueful self-parody: wearing fatigues scavenged from the actual combatants, he is directing footage for a television newsreel. 'Don't look at the camera,' he tells the soldiers who are evacuating wounded comrades, 'pretend you're fighting.' It seems that he can no longer tell life from art, and wants the harried combatants to share his confusion. Similarly obsessed, one of the film's designers planned to stock the compound of the genocidal Colonel Kurtz with actual corpses, bought in bulk from a grave robber whose business was to supply specimens to medical students. The production wisely made do instead with extras feigning death.

The renegade Kurtz is marked for execution because the CIA judges his methods to be 'unsound'; the same might have been said of the spendthrift director. But when Brando belatedly arrived on location to play the insane warmonger, Coppola had to submit to a higher power – or perhaps to a power that was simply more truculent and more highly paid. Brando, elephantine in bulk, could not squeeze into a Green Beret uniform and had to be filmed in shadow. He was also unable or unwilling to learn lines. Coppola halted work for a week to read him the script, then agreed that Brando could free-associate or recite from

a copy of T. S. Eliot's poems. Kurtz's native followers worship him as a white god, and Brando received the same deference.

Apocalypse Now inherited the ambition of Wagnerian opera, which the composer thought of as a compendium of all the arts. Wagner's representative in Vietnam is Lieutenant Colonel Kilgore, the strutting cowboy played by Robert Duvall, who equips his squadron of heli-copters with stereophonic speakers so they can broadcast the keening aerial cavalcade from *Die Walküre* as they swoop in to strafe a village and torch it with napalm. Although Wagner's warrior maidens are audible not visible on this occasion, Kilgore has realized a prediction about the cinematic future made by Abel Gance, who said that on film 'the Ride of the Valkyries will become a possibility'. When the choppers have cleared a beach for use, Kilgore asks the surfing dude Lance for his opinion. 'Wow, it's really exciting,' says the dim-witted Lance. Kilgore expects him to be appraising the waves not the performance of the gun-ships, but it is an apt response. War is being staged as a thrill ride, like one of the catastrophes prescribed in the stage directions of Wagner's operas – the shipwreck in *Die fliegende Holländer*, the collapse of Valhalla and the flooding of the Rhine in *Götterdämmerung*.

Fitzcarraldo in Herzog's film, played by the wild-eyed Klaus Kinski, has an affinity with Kilgore. He intends to use the profits from his rubber business to construct an opera house in the jungle; although he values music as a benediction not a battle hymn, he is as ruthless as Coppola's character in devising and executing his aesthetic scenario. One of Fitzcarraldo's engineers also thinks like Kilgore, and when natives in canoes block their passage on the river he suggests tossing sticks of dynamite at them. Fitzcarraldo vetoes such violence, because the war he prosecutes is more metaphysical than military. Like Sisif in Gance's *La Roue*, he aims to achieve the impossible: the explosives level the terrain in preparation for a truly Sisphyean labour which, after much anguish, is successfully accomplished when eleven hundred natives drag his three-storeyed, three-hundred-ton steamship over a mountain between two rivers so that he can bring his cargo of rubber to a port on the Atlantic. Herzog, as exigent as his hero, refused to use models or special effects for the portage, wanting the winches and pulleys he rigged up to be

authentically arduous. He had no need to make a personal appearance, like Coppola telling the soldiers to pretend they are still fighting; Kinski's almost maniacal Fitzcarraldo was the director's surrogate.

Whereas Kilgore celebrates victory, which is announced by the stink of napalm, Fitzcarraldo experiences a sublime defeat. Once over the mountain, his boat is sucked into the rapids, where it is churned, concussed and shattered as Caruso goes on melodiously declaiming from a gramophone on the deck. Unable to build his opera house, Fitzcarraldo has to be content with importing a company of Italian singers, who sail down the river at Iquitos performing an excerpt from Bellini's *I puritani*. Herzog too acknowledged that his dreams were inordinate, impractical and absurdly expensive. By contrast with the buccaneering exploits of the other characters he chose Kinski to play – the homicidal Spanish explorer in *Aguirre, the Wrath of God*, the Brazilian bandit in *Cobra Verde* – Herzog called himself a 'conquistador of the useless': he set himself to execute feats that are merely conceptual, just as Willard in *Apocalypse Now* risks his life to accomplish a mission that, according to a CIA operative, 'does not exist, nor will it ever exist'.

While Coppola was tripped up by Brando's obstinacy and his unphotogenic bulk, Herzog faced a yet more intractable force. He described the teeming rainforest on the border between Ecuador and Peru as 'violent and base', apparently determined to fight back against the incursions of technology, and he attributed his own rage to the supreme auteur. This, he suggested, was 'a land that God, if he exists, created in anger'. The river in *Apocalypse Now* conducts Willard to his destination like a film unreeling at a fixed speed, but Herzog thought that the Amazon possessed a 'majestic indifference and scornful condescension', sabotaging human efforts to make it a highway just as it batters and splinters Fitzcarraldo's vessel.

'I am running out of fantasy,' Herzog announced during one crisis: imagination alone could not move mountains. 'I should not make movies any more,' he added, 'I should go to a lunatic asylum right away.' But gods are not permitted to step down, and auteurs go on attempting to discipline their little worlds while secretly enjoying the cosmic commotion they have stirred up.

14

THE SECOND ERA
OF THE IMAGE

In 1927 Abel Gance proclaimed the inauguration of a new epoch: 'The era of the image has arrived!' Myths, legends, heroic tales, even the cosmic riddles of religion – the accumulated literary lore of the past, he predicted, would undergo a 'shining resurrection' on film. Although Gance later sought the Pope's support for a life of Christ which he thought of as his *Divine Tragedy*, his aim in all this was to supplant both the Old and New Testaments. In the beginning would be the moving image and what Gance called its 'animating potential', not the intellectual principle of Logos or the Word.

'Here,' said Aragon in his welcome to films and their technical magic, 'is the time of the life to come.' Modern men and women were to be children of the cinematic sun, basking in its vital rays, grateful for its humane boons. Not coincidentally, Hollywood's preferred religion was Christian Science, which advised against medical intervention and promised that all ills could be healed by prayer, described as 'mental surgery' by the church's founder Mary Baker Eddy. Who could resist a creed that, like popular films, offered such warmly reassuring wish fulfilment? Hawks, Capra and Vidor were Christian Scientists, along with dozens of stars – including Jean Harlow, Ginger Rogers, Elizabeth Taylor, Val Kilmer and Robin Williams – whose professional activity more or less followed the church's admonition to 'Let your light so shine before men, that they may see your good works.'

In 1937 Capra filmed James Hilton's novel *Lost Horizon*, for which he constructed a Tibetan earthly paradise on a studio ranch in Burbank,

with bleached Art Deco pavilions, plashing fountains, and flights of euphonious pigeons with flutes attached to their legs. A sagacious host, like the manager of a celestial hotel, welcomes refugees from the war-torn lower world by assuring them that 'Shangri-La will endeavour to make your stay as pleasant as possible'. This was not quite the Buddhist hidden land imagined by Hilton's novel; what it offered was more like the eugenic idyll on display in Hollywood movies. 'A perfect body in perfect health is the rule here,' the new arrivals are told, since the benign climate and the affluent 'sufficiency of everything' will guarantee them an indefinitely prolonged youth. Ronald Colman, the diplomat who becomes a convert to Shangri-La's values, salutes the 'glorious concept' of the place. The phrase suits cinema at its most luminously optimistic.

In the first era of the image, a visual culture undertook to unify a world split apart by linguistic disputes. Chaplin's endearing tramp did just that, and Disney's cartoons, according to Eisenstein, restored 'man's forever-lost childhood and mankind's Golden Age' and brought back an 'emotional plurality' that survived in music but had been 'displaced from language, which seeks precision'. The rejoicing turned out to be premature. Chaplin lost his latter battles against fascism in *The Great Dictator* and industrialism in *Modern Times*, and his performance as the serial killer in *Monsieur Verdoux* upset his followers by disclosing a chilly misanthropic aesthete, very unlike the universally loved and pitied tramp. By 1943, when Eisenstein extolled the 'ecstasy – serious, eternal' of Disney's *Bambi*, his call for a return to 'evolutionary prehistory' could only seem puerile.

Gance's 'gospel of tomorrow' had been forgotten by the early 1950s, the period in which Peter Bogdanovich set his 1971 film *The Last Picture Show*, about a failing cinema in rural Texas. The Royal, as the establishment is called, seems to have been an out-of-the-way arthouse, since it displays posters for Ford's *Wagon Master*, Walsh's *White Heat*, Alan Dwan's *Sands of Iwo Jima*, Anthony Mann's *Winchester '73* and Fuller's *Fixed Bayonets!* – auteurist classics now but recent releases back then. But in Bogdanovich's numb, immobilized town the new technology of television has changed society, with game shows and sitcoms as the solace of frustrated housewives, and the Royal's few remaining

patrons are teenagers who come to neck in the back row. The anomaly during the final weeks before the place closes is Minnelli's *Father of the Bride* – less appropriate for the dusty plains than Westerns or war movies, but chosen by Bogdanovich because its version of domestic bliss is so remote from the tedium of the lives in which his characters are trapped. One scene provokes drab teenage girls in the audience to glare resentfully at Elizabeth Taylor as she licks a spoon. Do movies make reality harder to bear?

The last picture show at the Royal is Hawks's *Red River*. Like Visconti in *Bellissima*, Bogdanovich includes an excerpt from the cattle drive. Whereas Anna Magnani watches the herd crossing a river and marvels at a meaty wealth that represents American affluence on the hoof, Bogdanovich chooses to emphasize the advance into the West, with Wayne giving Montgomery Clift the order to 'Take 'em to Missouri, Matt!' Larry McMurtry, in the novel on which the film is based, called the town Thalia; Bogdanovich changed its name to Anarene, which rhymes with Abilene, the destination of the cattle drive in *Red River*. But in the main street outside the Royal, the echoes of that thriving, questing past are faint. The shopfronts are boarded up, and the traffic is mostly tumbleweed; the frontier has closed, so the cinema, once synonymous with freedom and fantasy, can close down as well.

Decrepit and disgraced, the Sicilian theatre in *Cinema Paradiso* is dynamited at the end of Tornatore's film to make way for a car park. The cinemas on West Germany's eastern border in Wenders' *Kings of the Road* are still open in the 1970s, but in a sorry state. Rüdiger Vogler, playing a technician who repairs projectors, does the rounds to administer life support. One manager keeps a portrait of Fritz Lang tacked to the wall of the projection booth, although he has given up screening the worthless films currently on offer. Elsewhere Vogler visits a squalid establishment that stays in business by showing pornography. The image on the screen is poorly framed and out of focus; when he goes upstairs to investigate, he finds the projectionist masturbating, as reels of celluloid coil around his feet like snakes. Dream and desire – for the surrealists, the motive forces of cinema – remain potent, but grubbily so. The ticket-seller remembers that a woman recently suffered vaginal

cramps while copulating with her boyfriend in a back row; the pair were carted away in an ambulance, to be prised apart. As his professional comment on the show, Vogler cuts out a few frames, glues them into a loop and projects a repetitious digest of cars that crash and burn and a naked female torso grinding through a mechanical parody of sex. The contraband reel of censored kisses with which *Cinema Paradiso* ends preserves the history of the art. The footage that Vogler feeds into the projector, by contrast, sums up the crass current output of the industry.

In 1979, three years after *Kings of the Road* was released, Kieślowski made *Amator*, in which the art reaches an even more dejected terminus. A worker called Mosz buys a small Russian 8-millimetre movie camera, which he uses, as Auguste Lumière once did, to document the first months of his infant daughter's life. Later he aims it at the street outside his flat, and when a friend asks what he is filming, Mosz replies 'Anything that moves' – the same answer the Lumières would probably have given (and like them, he photographs workers leaving a factory, though the drab, weary scene is no longer fresh and novel as it was in 1895). The camera also notices what is not moving in Poland: mildewed plaster and broken office furniture, faces drained of hope, everywhere a leached greyness that negates the coloured film Mosz uses. Cast out from the family life he intended to record, wracked by guilt because his work has told dissident truths that compromise his friends, Kieślowski's 'camera buff' at last opens a can of undeveloped film that contains his report on economic malaise at the local brickworks. He ruins it by exposing it to the light, then sends the reel skidding along the ground to go nowhere.

* * *

The first era of the image did not last for long. In 1952, exactly a quarter of a century after Gance's rallying cry, Godard complained in an essay 'We have forgotten how to see', and in 1968 he added that talking pictures had made directors forget 'the importance of the image'. For Herzog the problem was not our forgetfulness. In 1983 he declared that 'there aren't many images around now': to find a true image, the correlative of an inner truth, he thought it might be necessary to conduct

an archaeological dig, to 'go into the middle of a war' as he did a decade later in Kuwait, or even to fly to Mars or Saturn.

Or is the problem that we have seen too much? In this second era of the image, we mistrust visual stimuli because they are so prolific, so mendacious, so arousing, and often so mercenary; the state of visual abundance can cause indigestion, or worse.

'We're just going to show you some films,' the social engineers in Stanley Kubrick's *A Clockwork Orange* say to Alex (Malcolm McDowell), the young thug whose consciousness and character they are retuning. 'I like to viddy the old films now and again,' replies the patient, expecting to be entertained. He is then bound in a straitjacket, with electrodes clamped to his cranium and calipers on his eyelids to keep them open: the injection will resemble the force-feeding of Chaplin in *Modern Times*. At first Alex enjoys a montage of squishy, slurping, wine-red blood. 'It's funny,' he says, 'how the colours of the real world only seem really real when you viddy them on screen.' The adverb in 'really real' catches the paradox of cinema, which so uncannily transforms the actual into the artificial. A doctor gloats at Alex's increasing discomfort as he exhibits 'deep feelings of terror and helplessness'. Distress turns to agony when he has to watch a film of Nazi atrocities, and what starts as aversion therapy ends as mental torture; the terrifying potency of such images means that they are never simply medicinal, and they can just as well prompt copycat killings. Kubrick may have hoped that *A Clockwork Orange* would discourage gang violence, but politicians and tabloid columnists in 1971 accused it of having the opposite effect, and in a spirit of indignant pique he withdrew the film from circulation in the United Kingdom for the rest of his life.

In *Zardoz*, released in 1974, John Boorman projected the era of the image into a future that almost a half century later no longer seems very far off. Here an elite of Eternals enslaves an underclass of Brutals by inventing a deity known as Zardoz, a truncation of the equally phony Wizard of Oz. The Eternals owe their power to a technology that can suck dreams and memories from the heads of the troglodytes and make those scenarios visible behind a glass screen on a wall. 'Show me pic-tures,' one member of the ruling caste demands as she probes the mind

of the brutish exterminator Zed, played by Sean Connery. But she has Platonic scruples about what is exposed to view, and warns that 'these images will pollute us'. Zed is trained for a career of killing and sexual coupling by being compelled to watch a blitz of violently erotic images. His hardest test comes when he confronts his cinematic alter ego: in the novel that Boorman and his collaborator Bill Stair derived from the film, this is described as 'a flat image, brilliant in its construction but false, only a coloured copy in light', and Zed saves himself by killing it.

Also in 1974 the same story was told without allegorical trappings by Alan J. Pakula in *The Parallax View*. Here Warren Beatty is a newspaper reporter who discovers the existence of a syndicate that recruits misfits and puts them to work as political assassins. When Beatty presents himself to Parallax as a candidate for re-engineering, he submits to a less punitive version of the trial endured by the characters in *A Clockwork Orange* and *Zardoz*. 'Just sit back,' says a voice in the darkness of the screening room. 'Nothing is required of you except to observe the visual materials that are presented to you.' There is no need for electrodes, so long as he keeps his fingers clasped to the armrests of his chair, where hidden instruments register his responses as the images quicken his pulses and agitate his brainwaves. The voice wishes him 'a pleasant experience', after which a neurocinematic montage starts with words like HAPPINESS, LOVE and HOME, calculated to unleash an emotive charge. The concept of FATHER is illustrated by a still from the Western *Shane*, in which Alan Ladd paternally comforts Brandon deWilde. The vocabulary becomes more embattled as COUNTRY, GOD and ENEMY throb on the screen, exemplified by images of warheads and superheroes and accompanied by a brassy, belligerent score. At the end, the viewer is meant to be riled up, itching to shoulder arms as a vigilante; the purpose of the experiment is to find out if an applicant is – to use Jean-Pierre Melville's word – traumatizable.

Parallax lets slip the truth about its brainwashing techniques in its name. The word refers to an optical conundrum whereby a fixed object like a star will seem to shift its position when seen from different viewpoints. The montage of 'visual materials' is a version of the Kuleshov effect: depending on the assumptions you are browbeaten into making,

a man with a gun can be a lonely maniac, a selfless freedom fighter, or a brainwashed dupe. Between the incitements to patriotic violence that Beatty watches, a photograph taken by J. R. Eyerman for *Life* in 1952 repeatedly flashes up. It shows a cinema audience wearing dark glasses to watch a film in 3-D – an exercise in parallax vision, because the three-dimensional illusion relied on two projectors fitted with Polaroid filters, and only worked if seen through polarized spectacles. These 'megaloptic creatures', as *Life* called them in its caption, choose to believe the lie their eyes tell them. The warning is unheeded: Beatty is accepted by Parallax, then used as a disposable scapegoat in the next assassination.

James Cameron's *Aliens*, released in 1986, has its own more ambitious version of Parallax. Here the Weyland-Yutani corporation is in the business of 'terraforming' or (according to its slogan) Building Better Worlds. In effect this means contriving simulacra, like the landscape in which Sigourney Weaver recuperates from a hypersleep that has lasted for fifty-seven years. After a period of relaxation in the woods, with sun shining and birds singing, she switches off the back projection: she has been in an ersatz cinema, not at home on the outmoded earth. Cameron extends the illusion in 2009 in *Avatar*. On a habitable moon named Pandora, a paralyzed ex-Marine is able to feel mobile again with the aid of a genetically matched hybrid being, an avatar whose actions he controls. Thanks to this exercise in projection, he falls in love with a native of Pandora and fights battles on her behalf – but from a distance, by remote control, as in a video game.

The assault on our eyes and minds that began in *A Clockwork Orange* has grown ever more alarming. This may be what we secretly want – to see something that counts as a revelation, or to be shocked awake. In 1992 in David Fincher's *Alien 3*, Sigourney Weaver says 'I have to see it.' What she insists on seeing is a sonogram of the non-human creature gestating in her womb, even though she is warned that the view on the monitor is 'horrible'. In Tarantino's *The Hateful Eight*, released in 2015, Samuel L. Jackson describes a vicious, vindictive scene and demands that Bruce Dern visualize it. After the Civil War, Jackson, a major in the Union army, is taunting the elderly Confederate general

played by Dern with an account of how he tormented and then killed the old man's son. A flashback shows us a tableau of racial and sexual abuse in the Wyoming snow; as Jackson adds obscene details, he says to Dern 'Startin' to see pictures, ain't you?' His revenge is to lodge those images in his former enemy's head or, even more cruelly, to make him responsible for conjuring them up. Dern, perhaps mercifully, can only listen to the narration and is spared the sight of his son's humiliation, from which none of us in the audience avert our eyes.

Because we can be so deftly manipulated by images, the act of looking has lost its innocence. In addition, we are all on guard against being looked at, aware that we live in a panopticon where security cameras constantly track our movements in case we commit misdemeanours. The result is a bristling paranoia. 'You looking at me?' demands Robert De Niro in *Taxi Driver* as he challenges his own reflection in the mirror. In *Blue Velvet* Dennis Hopper takes a whiff of mind-altering gas and bellows 'What you looking at, fuck? Don't you look at me, fuck!' No one else is present, so he is addressing all of us out there in the dark. *Camera*, a very brief film made by David Cronenberg in 2000, documents the panic of a retired actor who explains that once at the movies he dreamed that he had begun to age at a terrifying rate and felt himself falling apart. Now a movie camera has invaded his home, and he tries to hide from the death sentence pronounced by its lens.

Even so, 'I like to watch' – a line from three different films – serves as a mantra for our latter-day era of the image, an admission of both prurience and impotence. It is uttered first by Peter Sellers as the dim-witted, apathetic gardener in Hal Ashby's *Being There*, released in 1979. All he means is that he likes to watch television, but Shirley MacLaine assumes that he is referring to a sexual predilection, and obliges with an autoerotic display. In 1980 in William Friedkin's *Cruising*, Al Pacino declines a sexual invitation in a Greenwich Village leather bar by saying 'I like to watch'. The man he rebuffs is enraged: participation is compulsory here – otherwise why not go to the cinema to peek at this sweaty subculture? And in 1984 in Brian De Palma's *Body Double*, Craig Wasson has to say 'I like to watch' at an audition for a porn film. He recites the line from the script somewhat shiftily, since he has spent

recent evenings staring through a telescope at a glamorous neighbour who masturbates in full view. As a delaying tactic, Wasson asks 'What is it we're watching?' The sleazy producer mocks him for being 'some kinda Method actor' and tells him to strip.

These characters want to watch, not to be looked at; they consume images, and desire no other consummation. In De Palma's *Hi, Mom!*, a man in the neighbouring seat at a porn theatre fondles De Niro's leg; a producer of skin flicks who is sitting nearby remarks 'He needs a movie'. This was in 1970, a few decades before eroticism and electronics sealed a compact to deliver satisfaction privately at home to any solitary viewer who owned a computer. In Steven Soderbergh's *sex, lies, and videotape*, released in 1989, James Spader has compiled a video archive of intimate confessions by women. His camera confirms his detachment: 'I'm recording,' he tells one of his subjects, which means that he is not responding sexually. The same numb neutrality afflicts the characters in Shohei Imamura's *The Pornographers*, who receive commissions from weary businessmen to make crude 8-millimetre films of romps by schoolgirls and purported virgins. 'Doing it yourself is much better,' says one of the partners: masturbating, he does not need to give directions to a cast. His colleague enjoys the company of a docile sex doll who is his 'Dutch wife'.

Sometimes pornographic performers are more engaged, but their enthusiasm can be technically inconvenient. As Mark Wahlberg and Julianne Moore gasp their way towards a climax in 1997 in Paul Thomas Anderson's *Boogie Nights*, glimpses inside the camera warn that the reel of film is reaching its end; it terminates before the indefatigable Wahlberg does, and a technician calls a halt: 'We've rolled out, gotta change mags.' 'You're a wonderful actor,' Moore tells her priapic co-star while they wait to resume work. The pornographic industry here, headquartered in suburban ranch houses in the San Fernando Valley during the late 1970s, is Hollywood on a lower budget. The director in *Boogie Nights*, played by Burt Reynolds, brags that a movie can now cost as much as thirty thousand dollars; after haughtily refusing to compromise with the new media, he at last tells his employees that he intends to make 'film history... right here on videotape'. He understands the etiquette of

the art, and when he recruits a passer-by to have sex with his protégée Rollergirl on the back seat of a limo, he tells the young man not to 'ram it in' but to be 'cinematically sexy'. Holding forth in a diner, he outlines his own auteurist manifesto. He wants, he says, to make a film with a story that 'sucks them in' and keeps customers in their seats after they've spurted their 'joy juice' – a seamier variant of the theory promoted by the surrealists, who saw cinema as an upsurgence of fantasy, implicitly pornographic (and explicitly so in Buñuel's *L'Age d'or*, where a woman couples in public with her lover and then, when her partner withdraws to answer the telephone, greedily fellates the toes of a marble statue).

Less sunnily, pornography returns cinema to its starting point in Gorky's kingdom of shadows. Paul Schrader's *Hardcore* and Joel Schumacher's *8mm*, released in 1979 and 1999 respectively, describe parallel descents into this netherworld – Orphic quests either to rescue a victim from degradation or to exact revenge for a death that cannot be reversed. In *Hardcore* George C. Scott plays a starchy mid-Western Calvinist who tracks his runaway daughter to California, where she has been spotted in an amateurish porn film. In *8mm* Nicholas Cage plays a surveillance expert engaged to advise a wealthy widow on the veracity of a snuff movie discovered in her husband's safe; he travels from Pennsylvania to Hollywood to unearth the young runaway who appears to have been killed on camera. Both films include screenings as painful as the session of therapy in *A Clockwork Orange*. Scott is convulsed by sobs when shown the film of his daughter's initiation, and even after he yells 'Turn it off! Turn it off, please!' the white light from the projector continues to shine bleakly on his scrunched-up face. Cage fidgets, squirms, writhes, coughs and finally hides his eyes while watching the snuff movie. Both recover by reverting to cinema's default mode and behaving like action heroes. Scott beats up a pimply hustler, then hoses him down in a cold shower; Cage dispenses a more lethal justice to the murderous pornographers.

In *Hardcore* Scott catches up with his suddenly penitent daughter, blames others for her infractions, and takes her home to his pious clan in Michigan. Cage too goes back to the suburbs in *8mm*, but carries with him a warning from the salesman in a porn emporium who has served

as his guide through this nocturnal realm: 'There are things you're gonna see that you can't unsee.' Haunted by those sights and by his own reactions, Cage implores his wife to rescue him. 'Save me,' he begs her – from his memories, and also from the temptations of cinema.

* * *

In 1933 in *The Testament of Dr Mabuse*, Lang's evil genius daringly adopts the tactics used by the Nazis to justify their putsch. He threatens society with fiery annihilation and sponsors irrational crimes that profit no one – arson in a chemical factory, the poisoning of the water supply – so he can take credit for saving the situation at the last moment. 'Schreck und Entsetzen', terror and horror, are for Mabuse a means of gaining and cementing power; they can also serve as an aesthetic policy. Walter Benjamin argued that Nazi dramaturgy encouraged people to 'experience their own destruction as an aesthetic pleasure'. Goebbels made that appeal explicit in April 1945 when he delivered a last morale-boosting address to loyalists at the Ministry of Propaganda in crumbling, bombarded Berlin. A century from now, he told them, someone was bound to make 'a beautiful colour film about these dreadful days that we are living through': surely they would all want to be acclaimed as heroes in this future obituary? If so, they were encouraged to die as if they were swashbuckling for the benefit of a camera.

Hollywood developed its own version of Mabuse's gratuitous outrages. Theodor Adorno, in exile in Los Angeles in 1945, diagnosed local culture as 'the arouser of masses', which employed 'the destructive intoxicant, shock as a consumer commodity' – exactly the tactics employed by Mabuse, or by the Nazis when they set fire to the Reichstag. Blockbuster movies, named after Allied bombs that busted entire blocks of German cities, now take pleasure in rendering our world insecure or uninhabitable. Buildings that once were landmarks – points of orientation, symbols of the state like the Reichstag – regularly collapse or burst into flames in a digital rehearsal for Doomsday. In *Armageddon*, a meteor shower rips through Manhattan, toppling skyscrapers and gutting Grand Central Station. A directed-energy weapon launched by aliens pulverizes the White House in *Independence Day*. Because the Houses of Parliament

at Westminster had already been torched in *V for Vendetta*, the James Bond film *Skyfall* had to move a mile upriver and bomb the MI5 headquarters at Vauxhall. Films excite us by offering previews of disasters that with luck we will never have to witness. Global cooling grips New York in the rigor mortis of ice in *The Day After Tomorrow*, and in *2012* a seismic rift unseams California and tips Los Angeles into the ocean. A superlaser instantly disintegrates the planet Alderaan in *Star Wars*. In Lars von Trier's *Melancholia* a maverick star emerges from behind the sun and advances towards a collision with our earth. Flaring nebulae, scythe-shaped lightning strikes and a storm of purifying hail announce the extinction of all human life – not a matter of regret to Kirsten Dunst, the film's wan heroine, who shrugs 'We won't be missed.'

Such visual feats would once have been called mind-blowing, which is not necessarily a figure of speech: in 1981 in Cronenberg's *Scanners* a psychic uses telepathic powers to make another man's head explode. Could images produce the same hydrostatic shock or neural damage as bullets? Alex in *A Clockwork Orange* squirms and writhes as he suffers what feels like an ocular fusillade: 'I could not get out of the line of fire of the pictures,' he moans during his session of re-education. In Cronenberg's *Videodrome*, released in 1983, the Spectacular Optical Corporation, the front for a manufacturer of weapons, disseminates scenes of orgiastic killing sprees that cause brain tumours. James Woods imagines a slot opening in his body so that videocassettes can be inserted: technology and the malevolent dreams it incites are part of his metabolism. A little tenuously, Danny Boyle's *28 Days Later* in 2002 blames motion pictures for the collapse of society. Chimpanzees tethered in a research laboratory have been forced to watch endless filmed documentation of violence; the visual diet enrages them – makes them rabid, in the strict sense of the word – and when they are released by animal liberationists their tainted bodily fluids cause a pandemic that reduces Londoners to homicidal fiends.

Buñuel replaced Gance's 'resurrection to light' with a searing atomic flash that might be generated, he said in 1953, if 'the white pupil of the cinema screen could reflect the light that is its own'. This no longer sounds harmlessly theoretical. We are so habituated to such

pyrotechnics that people nowadays almost automatically compare the latest natural disaster or terrorist attack to 'something from a movie'. The 9/11 conspirators had just such an equation in mind: in their Afghanistan camps they used a videocassette of Roland Emmerich's *Godzilla* as a training manual, and vowed to outdo the ravages of the mutant lizard that marauds across Manhattan, lashing skyscrapers with its tail, flattening taxis with its webbed feet, and chomping holes out of the helicopters that attempt to zap it. In November 2018 the *New York Times* reported that a Hawaiian expert on climate change had described the wildfires, hurricanes, floods and heatwaves that threaten us as 'like a terror movie that is real'. President Trump, looking on from half a world away as American troops hunted down Abu Bakr al-Baghdadi in October 2019, reported that it was 'as though you were watching a movie'. And in March 2020 one of the Italian mayors who protested on YouTube about breaches of the coronavirus quarantine order cited a post-apocalyptic thriller in which a virologist patrols deserted Manhattan with his German shepherd dog. 'Look,' the irate official told a man who was using an over-exercised dog as his excuse for being outdoors, 'this isn't a film. You are not Will Smith in *I Am Legend*. You have to go home.' For Andrew Cuomo, the governor of New York, the frustrations of a continuing lockdown during the same emergency were 'like *Groundhog Day*, living through this bizarre reality that we're in'.

Fact and fiction are equally interchangeable for people on the screen. In 1986 in *F/X*, a special-effects expert played by Bryan Brown is hired to stage a mock-assassination. He works through his repertory of tricks – an oil slick to deter pursuing cars, exploding balloons, a mirror image of himself as a target – but the imaginary guns he uses have real bullets in them. In Fincher's *The Game*, released in 1997, a company called Consumer Recreation Services rigs up an entire make-believe environment to enliven the existence of a weary tycoon who discovers, after reeling through a succession of meticulously scripted disasters, that it was all a charade staged as a birthday present. When John Frankenheimer filmed a similar story in *Seconds*, the bored banker who is being given a new life has to endure excruciating surgery, during which he is given dental implants, different vocal cords and revised fingerprints. All this

is followed by months of recuperative physiotherapy, and only then is he unveiled in the camera-ready person of Rock Hudson. That was in 1966; in *The Game*, made thirty years later, virtual reality and digital technology eliminate the need for medical intervention. 'No customer has ever been unsatisfied,' says the phony doctor who administers a psychological test to Michael Douglas before the game begins. 'I think you mean "dissatisfied",' sniffs Douglas, although the doctor's word better suits the circumstances. Films create appetites that can never be wholly satiated – for thrills, speed, motion and mania. As on a rollercoaster, screams are a sure sign of enjoyment.

There is no point in tut-tutting, as cinema has always delighted in destruction. When Samuel Fuller made *Fixed Bayonets!* or *Merrill's Marauders*, he wanted to give audiences the sense of being involved in combat. But to do so, he reflected, 'you'd have to shoot at them every so often from the other side of the screen, and casualties in the theatre would be bad for business'. Perhaps not: in 1942 in *Saboteur*, Hitchcock had already sardonically balanced losses and gains. Here a gunfight in the aisles of Radio City Music Hall coincides with a farcical scene on the screen, where a blustering husband and his wife's weasel-like lover threaten each other with weapons of their own. The audience laughs along with the filmed showdown, and assumes that the gunfire close at hand comes from the soundtrack. But while aiming at his pursuers, the saboteur by mistake kills an audience member, who slumps into the lap of his hysterical wife. 'He was only kidding, I swear,' says the wife in the film as the paying customers mirthfully hoot; her reassurance does not revive the dead man.

Bogdanovich edges closer to Fuller's scenario in 1986 in *Targets*, where a sniper hiding behind the outdoor screen at a Los Angeles drive-in picks off the projectionist in his booth, then sprays the fleeing crowd with bullets. *Il Boss*, directed by Fernando di Leo in 1973, opens with an episode that surrenders to the same fantasy. A Mafia family has here arranged a screening of a Scandinavian porn film as a treat for its operatives; before it begins, a hit man from a rival gang sneaks into the booth, shoots the projectionist, then aims a grenade launcher into the auditorium. The mashed-up corpses of the guests are taken to

a police morgue, where relatives weep and wail over the remains. 'This isn't a cinema!' exclaims a commissioner, irritated by their histrionics.

Tarantino has always refused to apologize for the pile-up of corpses in his films, and in one indignant interview he insisted 'That's why Thomas Edison created the motion picture camera – because violence is so good.' Sickened or not, he added, at least 'you know you're watching a movie'. It is the creed of an aesthete, not a psychopath or sociopath: the kung-fu combats in *Kill Bill* and the gunfights in *Django Unchained* are ballets, and geysers of blood spray-paint the walls in sheer exhilaration. Here is kinesis at its fastest and most furious, with elegance as a bonus. And despite the carnage, Tarantino's executions sometimes serve the same benign purpose as the guardian angel's intervention in *It's a Wonderful Life*: the members of the Manson gang are eliminated in *Once Upon a Time in … Hollywood* before they can murder their first victims, with Leonardo DiCaprio repeating the role of armed avenger for which he has rehearsed in one of the gung-ho action movies we see him making earlier in the film.

In *Inglourious Basterds*, Tarantino revises history even more providentially by arranging for Hitler to be assassinated in Paris in 1944, which ends the war early. The mission is entrusted to a Jewish Dirty Dozen, for whom killing Nazis, as their leader Brad Pitt says, is 'the closest we ever get to going to the movies'. Luckily they are able to combine the massacre with movie-going: their plan is called Operation Kino because it coincides with the premiere of a Third Reich military epic, when the Jewish owner of the cinema has the doors bolted and then sets alight a funeral pyre of 350 flammable nitrate films, which burn the place down. The regime collapses, and so presumably does the German film industry, since the celebrity guests include such stars as Emil Jannings. Rather than destroying the world, cinema saves it, and chooses to destroy itself instead. It remains unclear whether Tarantino would make the same decision.

Even Scorsese, who has made films about sainted peacemakers like Christ and the Dalai Lama, claims the right to indulge in the odd explosion. After the decorous restraint of directing Edith Wharton's characters in *The Age of Innocence*, he says that he liked the idea of 'a

very physical film where you can blow everything up', so *Casino*, released in 1995, starts with De Niro hurled sky-high by a car bomb in a Las Vegas parking lot. As he spins through the flames in slow motion – still intact, though he would have been splattered by the blast – the consoling chorale that concludes Bach's *St Matthew Passion* elevates a Mafia hit job to the status of a purgative tragedy. Or had Scorsese decided to send the gambling and entertainment industries plummeting together into the inferno? *Casino* attracted him, he added, because he wanted to 'hurl a grenade at the system'.

The blitz does abate to allow for product placements. F. Scott Fitzgerald accused the movies of taking away our dreams, which he called the worst of betrayals. In fact the movies only too eagerly pander to those dreams, especially if they involve the purchase of goods. Escaping from a mob in pestilence-stricken London, the survivors in *28 Days Later* raid a deserted supermarket and fill their trolleys for free. The camera takes stock of such diurnal items as Kellogg's cereals and a Terry's Chocolate Orange before moving on to some fancily boxed bottles of Lagavulin single-malt whisky; later, when night falls and the stressed refugees try to relax, the virtues of Valium are touted. *The Game* winks knowingly at such consumerist interludes when Douglas hurls his shoe at an attack dog that has chased him onto a fire escape in a greasy Chinatown alley. 'There goes a thousand dollars,' he says. 'Your shoes cost a thousand dollars?' asks a waitress who is also trying to fend off the dog. 'That one did,' says Douglas.

In 2013 in Emmerich's *White House Down*, a terrorist reaches for a gun on the floor and grabs at one of the Nike sneakers that the President of the United States – an action hero, played by Jamie Foxx – happens to be wearing. They are immaculate, unscuffed Air Jordan IV Fire Reds, whose logo is a silhouette of Michael Jordan leaping towards a baseball hoop. After pausing to allow for a close-up of his footwear, the President pummels the terrorist and rhythmically roars 'Get your hands off my Jordans!' For this incumbent, defending the sanctity of a premium brand is as much a duty as upholding the Constitution. Here is a succinct example of the law propounded by Guy Debord in his study of the way that advertising has taken over society, invaded our emotional

lives, and redefined art: 'The spectacle is capital accumulated to the point where it becomes image.'

Olivier Assayas has condemned the price-tagged superficiality of what he calls 'our detestable image culture' and commended the serials of Feuillade because, in days when audiences still had unjaded eyes, those early films suggested that the environment observed by the camera had a more secretive and irrational underside. Making his own *Irma Vep* in 1996, Assayas tried to recreate this sense of mystery. The director of his film within a film is a survivor of the Nouvelle Vague, played – almost inevitably – by Jean-Pierre Léaud; Irma's exoticism is guaranteed by the casting of the Hong Kong martial arts star Maggie Cheung, who plays herself playing a feline burglar. But Léaud's collaborators disparage Feuillade as a drag, and the designer reduces Irma from a demon to a 'plastic toy' by zipping Cheung into a latex catsuit bought in a sex shop. Finally, before suffering a nervous breakdown, Léaud adds an extra layer of pigment to the exposed film, with black oblongs sometimes covering the eyes of characters like masks and stippled gunfire darting between their bodies. The image is now pure surface, like the squeaky rubber that encases Cheung.

Industrial Light and Magic, the name George Lucas gave to his production company, sums up the current state of the art. Light is emitted by diodes not the sun, magic is sketched by computers and overlaid on a green screen, and industry has busily converted these simulacra into the more than thirty billion dollars of profit so far raked in by the *Star Wars* franchise. The names of the Spectacular Optical Corporation and Consumer Recreation Services – the specious companies in *Videodrome* and *The Game* – suggest that they are in the same business as Lucas: they exist to dispense monetized mayhem.

15

SEEING OTHER WORLDS

Rudolf Arnheim claimed in 1930 that cinema had given rise to a 'spiritual epidemic', provoking a hunger that could only be appeased by the wonder of 'living photography'. Artaud praised the art in similarly messianic terms. He believed that film 'exalts matter' and answers to our 'yearning for light'. Jean Epstein's *Coeur fidèle* offers examples of what this might mean: the camera views the stained tabletop in a Marseille tavern, the stiff greasy netting at its door and the tattered wallpaper in a bedroom with tender reverence, while the glowing hair of the hero, a chivalrous dockworker, gives him an Olympian aura even when he is indoors.

On film, we see things transfigured not merely reproduced – alive and therefore dying, rather than safely extracted from time as in still photographs. Garbo's face, staring blankly into the distance as she sails away at the end of Mamoulian's *Queen Christina*, has a Platonic perfection that cannot last, and our eyes search for signs of the pain and distress that will fracture this immaculate mask. The needy father in De Sica's *Bicycle Thieves* climbs a ladder to glue a poster of Rita Hayworth to a scarred and pitted Roman wall; straining upwards to smooth the paper, he is performing a devotional act – yet as he concentrates on this worshipful task, the bicycle on which his livelihood depends is stolen.

Artaud believed that the camera levels hierarchies and restores 'the original order of things'. The teenager with the camcorder in *American Beauty* paraphrases this elevated tribute when he explains that his video of an air-borne plastic bag is a glimpse of an 'entire life behind

things' – a moment of adolescent presumption, or a specimen of the democratized, Americanized beauty revealed by cinema? The gawky young man in Mendes' film has also videotaped the corpse of a homeless woman frozen on the pavement: as he did so, he says, he felt that God was looking at him and that he could look right back. Patrick Bauchau, playing the film director in Wenders' *The State of Things*, adopts a similarly metaphysical vantage point. Trying to soothe his restive cast and crew as they wait for the light, for the next page of the script, and for the errant producer to return with some money, he tells them they should enjoy their idleness, and concentrate on experiencing the course or passage of time as it flows through space, which is what cinema exists to record. Unconvinced, someone sneers 'The Book of Genesis'.

The subject recurs when the director follows the producer from Portugal to Los Angeles, where he is hiding from irate creditors in a mobile home on Hollywood Boulevard. As the vehicle travels through the bleary streets before dawn, the director justifies his meandering, plotless film by arguing once more that 'stories only exist in stories, while life goes by in the course of time without the need to turn into stories' – such is the true state of things. The producer, played by Allen Garfield, blames this snobbery about narrative for the uncontrolled cost of the project, and insists that 'Cinema's not about life going by.' But the view through the windows of the mobile home proves him wrong. As in a Lumière documentary, it is the city that goes by, with its drive-in restaurants, noisy advertising billboards, and derricks prospecting for oil on some scraps of unbuilt land – details that are bizarre despite their banality, momentarily intriguing but soon effaced as the desultory tour continues. At last the vehicle stops and the two men step out in a parking lot where, without warning, they are gunned down at the behest of the money-laundering investors whose funds they have frittered away. A movie camera held by the director drops to the ground but goes on working, even though the eye that looked through the viewfinder is dead: film is as unstoppable as Renoir's rivers or the Los Angeles freeways.

In 1969 Jean-Pierre Melville regretted that cinema was no longer 'a sacred thing', as it had been for Griffith, Gance and Murnau. There

have been occasional efforts to rescue it from profanation. Wenders in his documentary *Tokyo-ga* describes the work of Yasujirō Ozu as 'ein Heiligtum des Kinos' – a shrine or sanctum, an antidote to the noisy products of Hollywood. Paul Schrader, in a critical book published before his own cinematic career began, praises Ozu, Bresson and Dreyer for their 'transcendental style' in films that are ascetic studies of domestic privation and resigned suffering. Brought up in a Calvinist family like that in *Hardcore*, Schrader first went to the movies at the age of seventeen, when he sneaked out of the house to see an inane Jerry Lewis comedy. '"Images",' as Schrader conceded, 'had little place in… a theology which could lead, in its excesses, to iconoclasm.'

In *Fata Morgana*, Herzog draws on a more recondite cosmology to explain the otherworldly fascination of cinematic images. His film is a loose compilation of mirages photographed in the Sahara, organized to illustrate a Mayan creation myth that describes our earth as 'the planet Uxmal… discovered by creatures from the Andromeda nebula'. 'How shall light shine?' ask the Mayan creators, and their answer goes against the version of Genesis voiced by DeMille in *The Ten Commandments*: man, they decide, will be born 'in darkness and night'. As a sequel, Herzog made *Lessons of Darkness* after the Gulf war in 1992, introducing it with Blaise Pascal's prediction – confirmed by Hollywood blockbusters – that our universe will end, as it began, in grandiose splendour. The incineration of Kuwait's oil fields converts gushers into pillars of fire in what Herzog calls 'Satan's national park'. Black clouds suffocate the sky, and bulldozers resemble foraging dinosaurs. Finally the workers who have hosed down the inferno and capped the wells toss lighted torches at two of the spouts, which flare up all over again. Now they once more have something to extinguish: the cinematic factory manufactures heat not light.

Another kind of cinema manages to be transcendental without having to stoke up demonic bonfires. Jane Campion told Ben Whishaw, her Keats in *Bright Star*, that romantic poetry possessed an 'openness to the divine', and her camera composes pantheistic lyrics made of light in scenes like the drowning of Holly Hunter's treasured instrument in *The Piano*, the petal shower that begins *In the Cut*, or the butterfly farm

housed in a hot, closed room in *Bright Star*. Terrence Malick has the same capacity to infuse reality with radiance. 'I seen another world,' says Jim Caviezel, playing a dreamy-eyed deserter who drifts away from the war zone at Guadalcanal in *The Thin Red Line*. 'Sometimes I think it was just my imagination,' he adds, but we see it too when Malick's camera skims above coral reefs or looks up at the moon or notices white butterflies peaceably fluttering in the grassy battlefield just before Caviezel is shot dead. 'Eden lies all about us,' says Christopher Plummer, playing the governor of the fledgling settlement at Jamestown, Virginia, in Malick's *The New World*, even though the biblical garden in which he stands is still a mucky waste inhabited by starving malcontents. 'Look at the glory all around us,' says Brad Pitt in *The Tree of Life*. A Texan paterfamilias addressing his offspring, he sounds like God introducing Adam and Eve to their own new world, and as Malick's camera ponders his small suburban yard, a dribbling hose, a tent for games of camping out, and a suddenly blooming magnolia do become glorious. Another Eden, thick with wheat that we have seen sprouting underground, is consumed by a plague of locusts in *Days of Heaven*. But in Malick's magnified close-ups the insects poised on the stalks resemble green and golden extra-terrestrials, sleek and knowing, not at all pestilential: why should we take the farmer's side and assume that only his crop is sacrosanct?

The title of Tarkovsky's *Nostalghia* does not simply refer to the homesickness of Russians exiled in Italy. Tarkovsky once said that 'cinema lives by its capacity to resurrect the same event on the screen time after time – by its very nature it is…*nostalgic*', and this replaying of time teases us with intimations of an eternity that is beyond time. In *Nostalghia*, released in 1983, a robed statue of the Madonna is carried into a Tuscan church; its vestments open, and a flock of birds fly out of the icon's body. A single feather then falls from the air and settles among the golden ranks of candles burning on the altar – evidence of an angel's passage? Such winged messengers, at home in the realm of Hermes, often invisibly ruffle the air in Tarkovsky's films. In 1986 in *The Sacrifice*, a philosophical postman tells a story about a technical miracle that is also a nostalgic resurrection: a son for whom a widow is grieving nostalgically materializes by her side in a photograph taken long after

his death. After this the postman slumps to the floor, still breathing but somehow stricken. Hauling himself upright, he says that an evil angel must have given him a push while in transit through the room.

The Sacrifice is about the threatened end of the world, which is forestalled when Alexander (Erland Josephson) vows to render up all that he owns and loves as a burnt offering if God will spare the human species from a nuclear holocaust. After an overheard missile attack, colour bleeds from the film, like light decaying or blood draining away. But next morning colour gradually steals back and the electricity works again, as does the telephone: salvation means that the current revivifies our technology. Alexander therefore holds up his end of the bargain by setting fire to the house in which he lives on an island off the Swedish coast. This is taken to be a mad act of arson, and before the fire burns out he is hauled away in an ambulance.

Against the advice of his crew, Tarkovsky filmed the scene with only one camera, which tracked to and fro between the fire and the open field where Alexander runs in distracted circles, chased by his family. Although the plan was for the single take to last for as long as it took the flames to consume the dwelling, the camera jammed when the house was already alight, aborting the shot. Tarkovsky railed at the machine's treachery, and joked that it should be tossed into the sea, as unfaithful wives once were in Iceland. His technicians assured him that the footage could be patched into a plausible montage, but he refused to compromise. He had the charred site cleared, rebuilt the house, and incinerated it all over again.

The scene shows us time at its implacable work. First a single flame licks at the white curtains, and a pillar of smoke fumes through the shingles of the roof. This grows into an explosive red inferno, boosted by the eruption of a parked car. Finally the rickety wooden skeleton of the house is exposed, standing upright for a few moments before it collapses. Meanwhile the camera also slides sideways through space to follow Alexander's crazed victory laps, the despair of those he has dispossessed, the brisk efficiency of the ambulance men, and the approving gaze of an Icelandic woman who is reputed to be a sorceress, all of which is set against the flat, bare, placid terrain of the island and

the unruffled calm of the glinting sea. Through these circumlocutions, cinema fulfills what Tarkovsky thought of as one of its primary tasks, which is 'to juxtapose a person with an environment that is boundless, collating him with a countless number of people passing by close to him and far away'. Even so, there was a further hitch. The scene ends abruptly, because after six minutes the film in the camera ran out – the same mishap that is blamed on Mark Wahlberg's sexual stamina in *Boogie Nights*. Tarkovsky, despite his perfectionism, was dissuaded from trying a third time.

Alexander is a celebrated actor who, like Elisabet in *Persona*, quit the stage because he became disgusted by the need to fake emotions; early in the film, verbosely criticizing philosophical verbiage, he quotes Hamlet's dismissive comment about the book he is reading, which contains nothing but 'words, words, words'. Though speaking Swedish, he utters this phrase in English, as a reminder of the polylingual Babel that cinema promised to overcome. Tarkovsky replaces such divine pronouncements with elemental or numinous images – breath misting a window pane and then evaporating; the systolic flaring of the midnight sun as a curtain blows aside in a bedroom; water poured into a bowl and blackened when Alexander, in an act of purification, washes his muddied hands; the model of the house meticulously crafted by the postman, which resembles a miniaturized world seen from a god's point of view.

The Sacrifice begins with Alexander replanting a withered tree on the shore, helped by his son, who is mute after a throat operation. As they work he tells the boy a story about a monk who replanted a dead tree, prayerfully watered it every day, then waited for three years until it came back to life. The film ends with the child, fondly known as Little Man, taking up the burden: we watch him emptying a can of water onto the tree's dry roots, after which he lies down under the bony branches.

His throat has apparently healed, because it is now that he utters his only line. '"In the beginning was the Word,"' he says. In Swedish, 'word' is 'ord', as it is in Danish: the quotation is an inadvertent allusion to the miracle filmed by Dreyer in *Ordet*, where the prayers of the holy fool revive the dead Inger. The Word in the title of Dreyer's film is a synonym

for God, and here it backs up Alexander's dismissive citation of Hamlet, for whom words are so wittily profane and casually expendable. Then, after quoting the Bible, Little Man asks 'Why is that, Papa?' Because his father is no longer there, he may be addressing another creator as he stares up into the sky. Following the boy's unanswered question, *The Sacrifice* ends with a protracted view of the sea, seen through the branches of the palsied tree – still a crown of thorns, though agitated by a marine breeze, which suggests that it might one day return to life. As we watch and wait, on the soundtrack a singer pleads for God's mercy in a lengthy aria from Bach's *St Matthew Passion*. Eventually, as the sun that sparkles on the waves loses focus, the screen fades to white and then blue, either blinded by the primal light or dissolving into nature.

When the icon painter in Tarkovsky's *Andrei Rublev* is commissioned to decorate a church at Vladimir, he demurs. Like Alexander sickened by the theatre, he explains that he cannot fake suffering in representations of the Last Judgement; in any case, the whitewashed walls could not be more beautiful than they currently are. But although he temporarily gives up painting, he continues to look, and that for Tarkovsky is a sacred calling, which the camera exists to memorialize. Before setting out on a journey, an itinerant monk stops to study an unremarkable birch tree. Why is it worth his rapt attention? Because, he explains, he will never see it again. Tarkovsky makes us view things with a mixture of astonishment and anguish, as if we are setting eyes on them for the first and last time. The world when filmed, as Virginia Woolf suggested, becomes 'not more beautiful' but somehow 'more real': we behold objects 'as they are when we are not there', freed from having to serve as the background to our lives. Everything is potentially an icon.

* * *

As Rublev paces fretfully in the unpainted church, an unseen voice quotes another scriptural admonition. 'See,' it tells him, 'through a glass darkly.' Cinema with its phantasmagoric hauntings permits us to do so, in a variety of old and new dark houses. In the process it suggests that obscurity is not a defect of our sight, as the Bible's phrase implies; films enable us to see truths that have been hidden, which can be terrifying

as well as enlightening. In 1961 in Ingmar Bergman's *Through a Glass Darkly* – or *As in a Mirror*, to translate its Swedish title literally – the schizophrenic heroine reports that she has seen God in the form of a sexually predatory spider behind some tattered wallpaper in an attic. Leaving God out of it, one of the art's aims has been to confront us with images that make our fears visible. In 1968 Jacques Rivette declared that it was cinema's special vocation 'to take people out of their cocoons and to plunge them into horror'. Perhaps our ultimate initiation comes in 1988 in George Sluizer's *The Vanishing*, which ends by immuring us in a box with a young man who has been buried alive.

Cinema, however, has another, less nightmarish vocation. It can be genuinely visionary, retrieving scenes preserved somewhere in our slumbering minds or photographing things we are hardly capable of imagining.

In 1987 in Bertolucci's *The Last Emperor*, made on location in the Forbidden City, a sulky, bored infant despot totters down the steep steps from his throne, then runs towards a curtain that is as glaringly yellow as a sunrise; a wind lifts it up and allows him to advance into a vast courtyard full of geometrically arranged subjects kowtowing to His Majesty the Child. Which of us would not want this to be an account of our triumphant entry into the world? A complementary moment, quieter and more tentative, occurs at the start of Campion's *An Angel at My Table* in 1990. The camera looks up at a looming shadow, an indistinct form with the sun behind it. The shape rocks to and fro, then leans forward; it extends arms that might belong to a seraph who compassionately embraces the world. Lying on grass as pristine as that in Eden, a baby stares at a figure bending down from the sky. A voice that is at once maternal and directorial says 'Come on, come on darling, come on', and the baby's feet toddle along with brave independence. We seem to be watching our own earliest memories.

Sometimes our delight derives from being shown a perfect microcosm, a home-made world. In 1947 in *Black Narcissus*, Powell and Pressburger lift us onto blue Himalayan peaks where a Hindu sensualist's abandoned palace is perched at the edge of a plunging crevasse – a sublime landscape entirely created using painted flats in a studio in the London suburbs. In 1982 in *One from the Heart*, Coppola constructs

his own studio-bound Las Vegas out of fizzy neon tubes and blazing bulbs, and places it in a sifting desert whose dunes have the porous contours of a female body. He even annexes the city's airport, which is scaled down so that a jumbo jet looks like a flying orange elephant as it takes off, barely clearing the roof of the terminal.

In 1991 at the end of *Grand Canyon*, Lawrence Kasdan brings an assortment of discontented, feuding characters from Los Angeles to the rim of the canyon and chastens them by making them contemplate infinity. They line up to gape at the scene, and fail to find words that are worthy. The camera responds on their behalf, and its sublime flight takes them out of their bodies. It soars aloft, then plummets into the gulf where it dips and dives like a bird riding thermal draughts, skids along the grey-green Colorado River, and effortlessly scales sheer cliffs while sunset burnishes the rock. On another occasion, what appears to be an entire celestial city descends from the velvety night sky. In 1977 in Spielberg's *Close Encounters of the Third Kind*, a spacecraft studded with a galaxy of blue and red beacons – actually a miniature, pieced together in part from model train sets veined with fibre-optic cables – touches down in Wyoming; it communicates, as films do, by synaesthetic semaphore, with flashing lights that correspond to chirping or booming musical tones. In 1986 Rohmer ends *Le Rayon vert* with an optical epiphany that, for all its lack of special effects, is no less uplifting. The film's heroine drifts through the summer, wary of involvement with others but given hope by stories about a green flash on the horizon at sunset that magically penetrates the defences we erect around ourselves and clarifies our emotions. Keeping a vigil on a promontory at Biarritz, she watches as a golden sun heavily sinks into the ocean. Just before it disappears, she has a momentary glimpse of the precious ray, and so do we. Rohmer believed that on film 'immanence leads to transcendence', and thought that the camera should try to see into 'that world beyond'; here, for an instant, it does just that.

Cinema began as a shadow play, but it is just as much about brilliance, iridescence; it widens our eyes as well as exhibiting the murky pictures that form behind them when they are closed. With its intercession, we are able to see through a lens brightly.

ACKNOWLEDGMENTS

At United Agents, Caroline Dawnay helped me to clarify my thinking about this project, and made me feel that, thanks to her advice, I was at long last learning how to write a book proposal. At Thames & Hudson, I am grateful to Sophy Thompson for her enthusiastic support, and for the time she spared for me while juggling innumerable other matters; to James Attlee for his perceptive comments on the text; and to Julia MacKenzie for incisively guiding me through the later stages of the book's production. Annalaura Palma, who assembled the illustrations, has my admiration for her detective work and for her discerning eye, and I thank Hilary Bird for the meticulous and supremely useful index. During the anxious, immobilized spring of 2020, it was a delight to work once more with the copy editor Richard Mason, who deftly incorporated Charlie Chaplin, Buster Keaton and Fred Astaire into the curriculum of the young son he was home-schooling, and commended some of cinema's prime movers to the next generation.

PICTURE CREDITS

INDEX